Phototextualities

INTERSECTIONS OF PHOTOGRAPHY AND NARRATIVE

Edited by
ALEX HUGHES and ANDREA NOBLE

University of New Mexico Press
Albuquerque

Library of Congress Cataloging-in-Publication Data

Phototextualities : intersections of
photography and narrative /
edited by Alex Hughes and Andrea Noble.—1st ed.
p. cm.
Includes bibliographical references and index.
ISBN 0-8263-2825-3 (paper)
1. Photography—Philosophy.
2. Images, Photographic.
3. Literature and photography.
I. Hughes, Alex, 1960–
II. Noble, Andrea.
TR185 .P58 2003
770'.1—dc21
2003004066

■

Design: Melissa Tandysh

Contents

Illustrations

Acknowledgments

We would like to thank the following people and organizations for their generous support of this project: Lalo Alegría, Paul Julian Smith, Heather Fenwick, and Sue Pritchard; Thomas Doubliez at Agence VU; the British Academy and the University of Birmingham for financial support; the anonymous reader for extremely productive and constructive criticism of the original manuscript; Sheila Berg for her meticulous copyediting; and David V. Holtby and Ev Schlatter at the University of New Mexico Press.

Notes on Contributors

MARIE-CLAIRE BARNET is based in the Department of French at the University of Durham. Her research interests lie in the areas of surrealism, autobiography and photography, contemporary writers, feminist theory, and psychoanalysis. Her book on surrealist women writers, *La Femme cent sexes ou les genres communicants* appeared in 1998. She has published articles on Lise Deharme, surrealist book illustrations, Sarraute and Duras, Leiris and Ponge, and Hélène Cixous. She is currently working on Robert Desnos and on autobiography and representations of childhood and parents in contemporary French fiction.

PATRIZIA DI BELLO is Senior Lecturer in Photographic History and Critical Theory at London College of Printing, London Institute, and Associate Lecturer in the History of Art at Birkbeck College, University of London, where she is also completing her doctorate on photographic albums compiled by women in nineteenth-century London and aspects of photography in the culture of femininity.

JUDITH FRYER DAVIDOV is Professor of English and American Studies at the University of Massachusetts, Amherst. Her books include *Women's Camera Work: Self/Body/Other in American Visual Culture,*

Felicitous Space: The Imaginative Structures of Edith Wharton and Willa Cather, and *The Faces of Eve: Women in the Nineteenth-Century American Novel*. She is at work on a collection of essays on photography and American culture called *Character Studies* and also on a book on photography, place, and memory.

CATHERINE GRANT is Lecturer in Film Studies at the University of Kent at Canterbury. Her research interests are film authorship, Latin American and European cinema, feminist theories, and transnational cinema. Her recent publications include a special issue of *Screen*, coedited with Jackie Stacey, on Latin American cinema and articles on cinema, culture, and feminist theory in journals such as *Screen, Feminist Theory,* and *Journal of Latin American Cultural Studies*. She has also contributed to a number of books, including *Feminism and Sexuality: A Reader* and *An Argentine Passion: María Luisa Bemberg and Her Films*, and in edited volumes on Latin American cinema.

JOHNNIE GRATTON is Professor of French at Trinity College, Dublin. He is the author of *Expressivism: The Vicissitudes of a Theory in the Writing of Proust and Barthes* (2000) and coeditor of *Modern French Short Fiction* (1994), *La Nouvelle hier et aujourd'hui* (1997), and *Subject Matters: Subject and Self in French Literature from Descartes to the Present* (2000). His articles include studies of Barthes, Breton, Colette, Proust, Sarraute, and Jean-Loup Trassard.

WENDY GROSSMAN is an independent art historian and curator currently organizing an exhibition titled "Object and Image: Re-Presenting African Art through the Modernist Camera Lens." Her chapter in this volume is adapted from her dissertation, "Modernist Gambits and 'Primitivist' Discourse: Reframing Man Ray's Photographs of African and Oceanic Art," which she has recently completed at the University of Maryland. Her publications include "Only the Shadow Knows: Warhol's Art of Self-Invention and the Legacy of Man Ray," in *Reframing Andy Warhol: Constructing American Myths, Heroes, and Cultural Icons*, exhibition catalog (1998); "Das Faszinosum Afrikas in den Photographien Man Rays," in *Man Ray 1890–1976, Photographien*, exhibition catalog (1996); and "Afrikanische Fotographie: Tradition im Wandel."

MARIANNE HIRSCH is Professor of French and Comparative Literature at Dartmouth College. She also teaches in the Women's Studies Program. Hirsch has edited and coedited many books, including *The*

Voyage In: Fictions of Female Development (1983), *Conflicts in Feminism* (1991), *Ecritures de Femmes: Nouvelles Cartographies* (1996), and *The Familial Gaze* (1999). Her recent major publications are *The Mother/Daughter Plot: Narrative, Psychoanalysis, Feminism* (1989) and *Family Frames: Photography, Narrative and Postmemory* (1997). She was the curator of an exhibition *The Familial Gaze* at the Hood Museum of Art at Dartmouth College in 1996.

ALEX HUGHES is Professor of Twentieth-Century French Literature at the University of Birmingham. She has published on French women's and gay and lesbian writing and on French autobiography. She is coeditor of the *Routledge Encyclopaedia of Contemporary French Culture* (1998) and *Gender and French Cinema* (2001). Her most recent book is *Heterographies: Sexual Difference in French Autobiography* (1999). She is currently working on a major new project on intercultural imaginings between France and China in the twentieth century.

JON KEAR is Lecturer in History and Theory of Art at the University of Kent at Canterbury. He has published on various aspects of nineteenth- and twentieth-century painting, photography, and popular culture. His most recent publications have included a book on the filmmaker Chris Marker titled *Sunless* and an anthology of nineteenth-century art criticism. Currently he is working on a book on the painter Paul Cézanne.

ANDREA NOBLE is Lecturer at the University of Durham, where she teaches and conducts research on visual culture in Latin America. She is the author of *Tina Modotti: Image, Photography, Texture* (2000) and has published articles on Mexican photography and film in journals including *Women: A Cultural Review*, *History of Photography*, *Screen*, *Framework*, and *Tessarae*. She is currently working on a book titled *Mexican National Cinema* for the Routledge National Cinemas series.

JOHN D. PERIVOLARIS is Lecturer in Hispanic and Caribbean literatures and cultures at the University of Manchester, with research interests in colonialism and postcolonialism in the Spanish Caribbean, as well as in diasporic literatures in Spanish and English, photography in the Hispanic world, and the cultural repercussions of translation. He has published articles on Carlos Fuentes, Luis Rafael Sánchez, Julia Alvarez, Esmeralda Santiago, Edgardo Rodriguez Juliá, Hispanic Caribbean and Latin American politics, media, travel writing, ideas, literature, censorship, and cinema. He is the author of *Puerto Rican*

Cultural Identity and the Work of Luis Rafael Sánchez (2000) and coeditor of *The Cultures of the Hispanic Caribbean* (2000). He is currently researching and writing his next book, titled *Photography and the Hispanic World*.

NANCY SHAWCROSS teaches at the University of Pennsylvania in the English Department and the Comparative Literature & Literary Theory Program. She is the author of *Roland Barthes on Photography: The Critical Tradition in Perspective* (1997), and her article, "The Filter of Culture and the Culture of Death: How Barthes and Boltanski Play the Mythologies of the Photograph," appeared in *Writing the Image after Roland Barthes*. She has recently completed an essay on the American phototext, 1935–48.

ELIZABETH SIEGEL is Assistant Curator of Photography at the Art Institute of Chicago. She is completing her Ph.D. in art history at the University of Chicago with a dissertation titled "Collections of Recollections: A History of Nineteenth-Century American Photograph Albums." An essay on instructions for how to keep a photograph album has appeared in the collection *Layered Memories: Essays on the Commonplace Book, the Scrapbook, and the Album* (2002).

CHRIS TOWNSEND is Lecturer in the Department of Media Arts at Royal Holloway, University of London. His 1998 book, *Vile Bodies: Photography and the Crisis of Looking* accompanied a BAFTA-nominated documentary series for Channel 4 TV. He is currently working on a major exhibition on the relationship of art and fashion since 1970, opening at the Barbican Art Gallery in London in 2002, and a book about the British artist Boyle Family.

Introduction

ALEX HUGHES AND ANDREA NOBLE

Contexts and Beginnings

> The intelligibility of the photograph is no simple thing; photographs are *texts* inscribed in terms of what we may call "photographic discourse," but this discourse, like any other, engages discourse beyond itself, the "photographic text," like any other, is the site of a complex "intertextuality," an overlapping series of previous texts "taken for granted" at a particular cultural and historical conjuncture.
>
> *Victor Burgin, "Looking at Photographs"*

In the edited volume *Thinking Photography*, published in 1982, Victor Burgin thus invokes the complex textuality of the photograph.[1] His remarks were made at a moment when photography was emerging from a state of invisibility to be constituted as a legitimate object of study. The essays in *Thinking Photography*—including an introduction and three chapters by Burgin himself—represent a key intervention into "photography theory"—a body of work that, according to Burgin, hardly existed in the early 1980s. Burgin's collection shifted debates on photography away from auteurist paradigms derived from art history to a reading practice that privileges the

specificity of photographic textuality. This, *Thinking Photography* suggests, is a textuality that is materially grounded and bound up in semiotics and psychosocial issues.

In its anatomization of photographic textuality—that is, of the way in which photographic meaning is generated—*Thinking Photography* seeks to establish a nascent metadiscourse on photographic representation and practices, whose primary sources are psychoanalysis, Marxism, and semiotic theory. That metadiscourse resonates with a cluster of other interpretational metanarratives produced in the context of the 1970s and 1980s and inflected by poststructuralism (metanarratives of art history, literary studies, anthropology, etc.) and is thus very much a product of its time. Concomitantly, the metadiscourse that *Thinking Photography* works to institute endeavors to crystallize a way of looking at photography that hitherto was only disseminated and diffracted, through a collection of diverse "pre-texts" concerned with the photographic act. These pre-texts include the English translation of Walter Benjamin's "The Work of Art in the Age of Mechanical Reproduction" (1969), which deals with the impact of photography on the art object and with the "optical unconscious" revealed by the camera's eye; John Berger's *Ways of Seeing* (1972), which explores the connections between seeing and knowing; the English translations of Barthes's "The Photographic Message" and "The Rhetoric of the Image" (1977), which offer a structuralist reading of photographic meaning that hinges on the key concepts of connotation and denotation; and Susan Sontag's *On Photography* (1977), which addresses photographic reference and the ethics of photography.[2] In its consolidation of the discourses on photography that such pre-texts proffer, *Thinking Photography* invites us to open the photographic up, not least, to questions of production, reception, and ideological framing.

In the years following the publication of *Thinking Photography*, abetted by the turn to the visual in cultural theory, photography studies has established itself as part of the academic landscape. A signal that it has come of age is the existence of publications such as Liz Wells's *Photography: A Critical Introduction* of 1997, a textbook that rehearses key issues pertaining to photographic representation.[3] This is not to say, however, that the study of photographic practices has become entrenched in any single disciplinary context. Rather, in keeping with the ubiquity of the photographic object, photography studies cuts across a multitude of disciplinary boundaries. That this is the case is reflected by the locations within which the contributors to the present volume of critical essays, *Phototextualities*, work:

locations ranging from art history and comparative literature through national/cultural studies to film studies.[4]

We have opened the introduction to *Phototextualities* with a quotation from Burgin's *Thinking Photography* for two reasons. First, we have done so to acknowledge the fact that the essays it introduces, even if separated from those of Burgin's collection by a gap of twenty years, are no less focused on the matter of photographic textuality.[5] And second, *Phototextualities* shares squarely in *Thinking Photography*'s desire to foreground photographic specificity while relating that specificity to the concerns of a particular cultural and historical climate: concerns that, in the early twenty-first century, turn on debates over space, place, memory, and identity. Burgin's quotation functions as a starting point for all the analyses pursued in this volume. What, then, some two decades after the publication of *Thinking Photography*, are the resonances and implications of the observations that Burgin offers for an understanding of photographic signification? Most obviously, his comments provoke reflection on a series of issues allied to the relationship between the photo-image and the written text and between the verbal and the visual: a relationship thrown into relief by artifacts such as the photograph album; the photographic essay; the magazine photo-story; and the advertisement. Burgin's statement encourages us to think about how photographic texts incorporate linguistic material and vice versa; about the tensions intrinsic in mixed media works; about the complexities of the image/text dynamic; and about the disjunctions of visual and textual literacy.

These questions are central to explorations of visual culture such as W. J. T. Mitchell's seminal book, *Picture Theory* (1994), which includes a pertinent discussion of the photo-essay; and Clive Scott's *The Spoken Image: Photography and Language* (1999), which at once invokes the ways in which photographs are "harassed" by language and the photograph's capacity to complement and replace language in narrative enterprises.[6] Equally such questions are foregrounded in the essays in *Phototextualities*, which, as one contributor, Johnnie Gratton, puts it, address "the different kinds and degrees of relation that hold between image and language across a wide range of contexts" and, more particularly, the antagonisms that verbal/visual dynamics admit.

It would be quite wrong, however, to deduce that Burgin is simply advocating that we should read the visual through preexisting verbal paradigms. It is no less imperative, he implies, to attend to the particularized forms of signification that the photograph

evinces; to the gamut of genres and modes of narrative practice with which photo-images intersect, as they work within "photonarrative" constructions; and to the range of intertextual connections with which such constructions are inevitably enmeshed. The essays in our volume do precisely that. They are centrally concerned with photonarrative constructs, by which we mean any kind of storytelling artifact that relies in any way on the centrality of the photograph. (We would, for example, consider the following instances of such constructs: family photograph albums; magazine and newspaper advertisements; photographic montages; documentary and feature films that privilege photographs in the diegesis; written narratives that embed photo-images either directly or ekphrastically.) And they speak of the narratives that photographs contain, communicate, and interact with, as well as of the intersections between photographs and their contexts.

If the essays in *Phototextualities* are diverse in their content, focus, and methodology, they share a number of key preoccupations. Most saliently, they recognize that the uniqueness of photographic textuality resides in the unassailably referential nature of the photographic entity. They acknowledge that what distinguishes the photo-image from any other form of representation is its inextricable, material link to reality.[7] And they play with the tension that obtains between the culturally fabricated nature of the photographic artifact and its fundamental indexicality, that is, its status as "a trace of the real"; and an evidential manifestation of "what has been." In so doing, they return time and again to elements of the seminal meditation on the photograph elaborated in 1980 by Roland Barthes in *Camera Lucida*, a work that has now become one of the canonical foundations of photography studies.[8]

Barthes's critical essay not only provides theoretical concepts that are essential to the readings evolved in *Phototextualities* (readings that nonetheless, as will become apparent, evince a post-Barthesian sensibility), but is also emblematic of the *types* of narrative genre the chapters in this volume address, as they investigate narrative practices that are seduced or invaded by, or rely on, photo-images. In its combination of autobiographical and biographical reflection and photography analysis, its mixture of the intensely personal and the objective, *Camera Lucida* reminds us of the kinds of narrative contexts with which photographs have a natural affinity. These contexts—which are richly illuminated in *Phototextualites*—include numerous forms of life-writing, the testimonial or fiction film, and travelogues.[9]

The notion of indexicality, as the contributors concur, is the founding element of photographic representation. The indexicality of the photograph, Geoffrey Batchen states, links the image to its objects, via a relation of physical causality or connection. As Batchen succinctly puts it, "As an index, the photograph is never itself but always, *by its very nature*, a tracing of something else."[10] And indexicality is crucial to processes of memory work, as they operate in and through photographs. This is because the indexical sign, as *relic* of past reality, takes us back to the scene of memory in ways that are not permitted by other modes of textuality.

Not surprising, in their discussions of constructions that belong to the photonarrative domain and of the concerns found in such constructions these essays dwell at length on stories of remembrance and commemoration that engage with the photographic and on the ways these stories function. As they do so, they draw our attention to the fact that, as Linda Haverty Rugg affirms, photographs "perform as metaphor for the processes of perception and memory" and are "analogues of memory."[11] These essays assert that photographs are the very stuff of memory and of the types of narrative that trigger and effect memory work. At the same time, however, they warn us not to forget that photographs, like the memories they stand in for, are never pure or unmediated: photographs and memories, and photographs as the products and magnets of memory, constitute, as cultural theory reminds us, artifactual constructions, hence sites of contestation and dispute. It is here that *Phototextualities* starts to part company with Barthes. In *Camera Lucida*, Barthes unequivocally argues that the photograph *blocks* memory, quickly becoming a countermemory. But, in a gesture that chimes with the work on family photographs, remembrance, and self-representation elaborated by Marianne Hirsch in *Family Frames*, *Phototextualities* flags the photograph as something that, as it is traversed by modes of textuality, powerfully *shapes* personal and collective memory. So *Family Frames*, in its contemporary mediation of Barthes—particularly its fascination with the "continuing power and 'burden' of photographic reference"—serves as an important touchstone for the volume.[12]

Memory, public and private, is inextricably bound up with questions of affect, identity, and location.[13] In their investigations of photo-centered textual constructs—autobiographies, photograph albums, documentary films, travelogues, mixed media montages—that deal in memory work, both personal and extrapersonal, or testimonial, the contributors to *Phototextualities* make this connection plain. They do so by signaling the degree to which photographs—

and metaphotographic texts that put photo-images in commemorating narrative contexts—foreground phenomena related to visceral response and to place. The contributors show, for example, how phototexts make their appeal to the viewer-reader not simply on an intellectual or even purely visual level but rather on a multisensual basis. And they suggest thereby that phototexts can work against the culturally consecrated primacy of intellect over emotion, of mind over body. The implication is that as we engage with the realm of the photographic we are given access to alternative ways of knowing: ones that offer the possibility of understanding, differently, matters of self, Other, history, and culture.[14]

The more affective response that photographs and photonarrative creations elicit is one that is arguably stimulated, at least in part, by the fact that photographs deal with location. By virtue of their indexical nature, photographs inevitably return us not just to scenes of memory but, at the same time, to *sites* of memory, sites that are unfailingly imbued with an emotional charge. In their journeys through a body of phototexts, the chapters in *Phototextualities* emphasize the manner in which phototextual objects spotlight questions of geographic, cultural, historical, physical, and personal place. And they peruse, likewise, the situations and ways in which photographs, as and in textual entities, are themselves physically placed. Conventionally, photographs have tended primarily to be located in narrative texts in an illustrative role, with the result that their own complex textuality has been rendered invisible. But these chapters refuse to allow photo-images to sit silently or uninterrogated on the page, the cinema screen, or the gallery wall. They carefully scrutinize the intricacies of photographic containment and contextualization, demonstrating how, if photographs are bounded images, their frames and framings are rarely hermetically or permanently sealed. Rather the photographic frame is one that always allows for seepage.

Phototextualities emerges out of a two-day interdisciplinary and collaborative workshop held at the University of Durham in April 2000. The overview of our project that is sketched out in the preceding paragraphs is by no means exhaustive. Other vectors of analysis inflect the discussions it brings together. Phototextual practice, for instance, is necessarily interimplicated with narratives of gender, sexuality, and racial and ethnic identities, and such narratives find their place in the readings performed in our collection. The volume is divided into six parts. In what follows, its constitutive parts are set out.

Contents of the Volume

Part One: Photography and Testimony •

The chapters in Part One examine the relationship between the photographic image and the (political) act of witnessing. The photographic artifacts they address and the narrative constructs these artifacts constitute or interact with testify to significant public events of the twentieth century: the Holocaust in Europe, the development of the atomic bomb, the internment of Japanese Americans in U.S. camps during World War II, and the "Dirty War" in Argentina and its aftermath. Within the images and narratives the essays scrutinize, these events are represented, re-membered, and re- or decontextualized, in ways that powerfully affect the reading position of their viewers-consumers.

Marianne Hirsch explores how archival photo-images that she defines as "perpetrator images" and which were produced as part of the machinery of Nazi genocide are appropriated in post-Shoah, late-twentieth-century visual texts. She examines practices of retrospective witnessing manifest in representational works by Samuel Bak, Judy Chicago, David Levinthal, and Nancy Spero. In addressing the manner in which these visual narratives reemploy Nazi photographs, she establishes gender-oriented analysis as a vital component of interpretational projects centered on the rhetoric and politics of stories told in the context of post-Shoah testimony. Equally, though, she points to problems that arise when matters of gender and sexuality are accorded too primary a place in post-Holocaust artifacts. At the same time, she critiques photonarrative constructions that, in recirculating and repositioning perpetrator photographs, neglect to prevent the spectator from simply occupying the space/place of the "Nazi gaze."

Drawing on analyses by Hirsch and Barthes, Judith Fryer Davidov dissects narratives evolved in contemporary visual artifacts that tell "postmemorially" of World War II events, events from which the artifacts' creators are generationally distanced. She examines how the evidential force of "what was there" in particular U.S. locations at a key moment in history is communicated in multimedia collages by Meridel Rubenstein that address the evolution of American weapons of destruction but also present more personal histories and in the photographic work of Joan Myers that dialogues with the written history of Japanese American detention. Davidov's chapter illuminates the ways in which the testimonial visual projects of Rubenstein and Myers reconstruct (hidden) stories of historically charged place. These are stories allied with Los Alamos, inhabited not just by the

Manhattan Project scientists but also by other individuals whose tales take shape in Rubenstein's assemblages, and stories conveyed in the object remnants Myers photographs on the sites of the internment centers she documents. Davidov's analysis foregrounds the diversity of modes of testimonial retelling that postmemorial photonarrative work admits.

In dialogue once more, with Hirsch and Barthes, Catherine Grant considers the interpolation of still photographs in recent and contemporary narrative films, specifically documentaries, that treat of and perpetuate acts of memorialization, mourning, and political resistance engendered by Argentina's Dirty War. Her reading targets the modalities of framing to which photo-images of the Disappeared are subjected in these films, as the films operate their gestures of remembrance. More centrally, it foregrounds how such film-narratives play with the affective responses the photo-images stimulate. And it speaks compellingly of the effects produced by the reproduction, in the medium of commemorative film, of photographic artifacts.

Part Two: Photography and Narrative Commemoration

The essays in Part Two illuminate some of the ways in which the photographic image as text, textual component, and site of intertextuality intersects with narratives of life, death, and rememoration. In this, they work in parallel with those in Part One. Like those essays, they unpack formal modalities of photonarrative telling allied with memory, documentation, and the preservation or revivication of "what has been." Unlike the essays in Part One, however, these do not privilege visual artifacts imbricated in the public discourse of history. Rather, in exploring how the photographic or photonarrative constructs they scrutinize contribute to stories of death, loss, identity, and remembrance, they speak of the realm of the individual, the private, the particular, the marginal, or the everyday.

Nancy Shawcross's discussion deals with photographic images included or invoked in written narratives that belong, variously, to the auto/biographical domain. It enumerates debates on the relationship between the photo-image, past time, and the expression of "what has been," before moving to investigate the way in which visual images are referenced in a corpus of mid- to late-twentieth-century literary texts that recur to the photographic as part of a project of personal and familial recollection. Dissecting these works, Shawcross highlights how the embedding of the visual image in the

written artifact enhances but also complicates the writer's effort to reanimate past moments of being.

Chris Townsend takes as his object Nan Goldin's photographic documentations of bohemian milieus she inhabited in Boston and New York in the 1970s and 1980s. His essay examines Goldin's evolving visual representations of her subcultural world of transvestites, drug users, and marginal subjects, riven all too rapidly by the depredations of AIDS. Townsend offers readings of Goldin's *Ballad of Sexual Dependency*, an artwork, slide show, and book of images he views as a locus where Goldin's community tells stories of itself; and of the documentary film *I'll Be Your Mirror*, a visual text he establishes as a variant of the phototext *The Ballad* began life as. Like Shawcross, he focuses on the manner in which the photographic image functions in the context of a biographical re-presentation, by an individual, of the community and environment within which that individual has existed. He examines how Goldin's commemorative documentary work treads a fine line between pursuing an "authentic"—unmediated—articulation of her bohemian space and proffering a self-conscious, staged rendering of that space, intertextually inflected by other accounts of bohemian life. More particularly, Townsend conveys how Goldin's memorializing activities dialogue with the oral and written narrative form that is the Ballad: a form with which Goldin equates her own photographic documentations and which, like her nonstatic treatments of her milieu, is grounded in testimony, community-oriented representation, and narrative evolution.

Part Three: Photography and Narratives of Difference

The chapters in Part Three attest a common interest in photographic images that are inflected by, or invoke, questions of difference and Otherness. Andrea Noble's essay, like a number of those in Parts One and Two, examines photographs that bespeak death. Its focus is an image of a woman participant in the Mexican Revolution, whose role in the revolutionary combat of early-twentieth-century Mexico was that of a "nurse of death." In unpacking this photograph, Noble frames it as a visual locus traversed not simply by a historical narrative—the historiography of revolutionary Mexico—but also by a narrative of sexual difference. The latter narrative, she claims, can all too easily be occluded by the historical narrative with which the photo-image interacts. Moreover, once exposed to scrutiny, it risks being contained by a restricted gender-political analysis that does no more than enclose the female protagonist of the image in an entrenched subject/object

dichotomy. Endeavoring not to perform a reading that perpetuates fixed paradigms of gender difference, Noble examines issues relating to the contexts with which the photograph is linked and to the modes of looking with which it intersects. She positions herself as a critical detective-viewer, framing the photo-image she investigates in a meta-narrative derived from the sphere of detective fiction. And she privileges a reading stance that subjects the photograph she scrutinizes to an interpretation that disturbs frameworks of cultural analysis that cloud our vision of (gendered) alterity.

Wendy Grossman, like Andrea Noble, discusses a visual image created in the 1920s: Man Ray's famous *Noire et blanche*. And, like that of Noble, her project is to elaborate a reading—a reading of a specific photograph—that problematizes categories of differentiation grounded in binary polar oppositions but undercut in the image she peruses. Grossman addresses the manner in which the particular photographic text she examines—created in a European milieu but anchored in African art forms—overlaps with associated texts and contexts: linguistic, photographic, aesthetic, historical, and cultural. These con/texts, she argues, have certainly influenced the reception Man Ray's photograph has been accorded. But, she suggests, the fact that they have an impact on or are inscribed in *Noire et blanche* in a particularly complex fashion has not been adequately recognized. She contends, further, that their interaction with Man Ray's image must be explored in depth, in order that the narrative of sexual and racial difference it emits, and its status as a canonical modernist art object and "paragon of primitivism," can be interrogated.

Finally, John D. Perivolaris maps differences between the midcentury photographic work of the American W. Eugene Smith and the more recent photography of the Spaniard Cristina García Rodero—differences evinced by their images of Spain. He reads/contrasts the work of these photographers not in terms of gender specificity but in relation to the narratives of place their visualizations of Spain construct. Thus he displays a concern with the manner in which geographic location features in photonarrative work likewise evident in Davidov's chapter. He focuses, moreover, on the contribution made by the photographer's historical and cultural situation to the production of his or her phototexts: an issue foregrounded by many of the essays in our collection. His particular object of interest, however, is the relation that the photonarrative artifacts elaborated by Smith and García Rodero enjoy with the values of humanism. He argues, on the one hand, that such values are much more overtly advocated in the work of Smith than in the photographs of García Rodero: photographs that, in their

embrace of the grotesque, interrogate humanist images of the nation and the individual and mount a "sympathetic opposition" to Smith's Spanish photography. Perivolaris suggests, on the other hand, that García Rodero's images do appeal, even as they contest the humanist stance, to the ideals of freedom and democracy that humanism affirms.

Part Four: Photography and Narratives of Identity

The chapters in Part Four deal with the interplay of photographic and written auto/biographical representation, addressed by Shawcross in her treatment of the role performed by visual images in memorializing textual accounts. In contrast to Shawcross's chapter, however, these chapters concentrate on the manner in which the presence or invocation of photo-images in self-referential "photobiographical" writing causes us to reflect on the "truth-telling," indexical force of the texts in question. And they focus, moreover, on French-authored phototextual productions.

Alex Hughes explores Hervé Guibert's *L'Image fantôme* (1981), a meditation on photography that is paradoxically devoid of accompanying photographic images and forms part of Guibert's broader autobiographical project. Measuring *L'Image fantôme* against Guibert's shifting stance on the possibilities and limit(ation)s of autobiographical self-rendering, she argues that his photo-essay is less a set of reflections on the photographic than a work of self-transcription in which textualized photo-images accorded variant referential qualities are used to metaphorize modalities of narrative self-portraiture embraced or rejected in the pages of Guibert's treatise on "ghost" images. She concludes that if Guibert seemingly seeks to evolve in *L'Image fantôme* a mode of "photographic" self/life-writing that lays no claim to strong, "pure" reference, his *photobiographie* nonetheless strikes the reader as one in which some if not the truth of its autobiographical subject is transmitted.

Johnnie Gratton, in his discussion of the work of Sophie Calle, a friend and contemporary of Guibert's, dissects a number of issues parallel to those probed in Hughes's essay. Gratton takes as his object Calle's *Des histoires vraies* (1994). He reveals how, on the one hand, Calle's play with "photobiographical" units—narrative elements where photo-images and texts work in tandem—locates *Des histoires vraies* in a postmodern space dominated by skepticism about the truth-telling possibilities intrinsic in photography and autobiography alike. But, he contends, if *Des histoires vraies* deploys photo-images in a way that appears to ironize the photobiographical genre—an

ironization that proceeds through an interrogation of the evidential force of the photograph—it tends ultimately to pursue a photonarrative practice that goes beyond irony. This practice, for Gratton, embraces a form of self-representation that seeks to restore to the "true stories" that compose *Des histoires vraies* something of their truth.

Part Five: Phototextual Momentum

Part Five brings together two rather different discussions that explore modes of momentum inscribed in narrative texts constructed around the photographic image. Marie-Claire Barnet introduces us to a narrative of "identity" that, like *L'Image fantôme* and *Des histoires vraies*, encourages us to ponder on the relationship between the written text and the photograph and on mechanisms of photonarrative reference, evidence, and "truth." The narrative in question—*La Contre-Allée* (1999), coauthored by Jacques Derrida and Catherine Malabou and constellated with portraits of the former—is a narrative of Derridean selfhood but also a travelogue: a story of a traveling philosopher. Mired in structural and intertextual slipperiness, it pursues and takes its reader on a "journey without truth." In so doing, claims Barnet, *La Contre-Allée* undercuts its own referential effect. It presents itself as a work whose authorship is "unlocatable" and as a work in which pictures of its principal referent, Derrida, strike us less as conduits to the real than as elements in a sophisticated visual game of stereotypes, (self-)ironization, and teasing. *La Contre-Allée*, Barnet argues, systematically manipulates the preprogrammed responses readers bring to life- and travel writing. The record of a series of journeys that illuminates a good deal more than Derrida's relationship to travel, *La Contre-Allée* represents, in itself, a narrative journey whose movements involve complex drifts, halts, and restarts. And it embarks the reader, unsettlingly, on trajectories of motion, drifting, "traveling with": processes in which Derrida and Malabou equally partake and which leave us unsure as to how to receive the narrative they offer.

Jon Kear examines modalities of movement in Chris Marker's *La Jetée* (1964), a cinematic narrative created out of a montage of photostills. The relation between photography and film, adumbrated by Catherine Grant in Part One, is certainly more "intimate" than that which binds/divides the photo-image and the written text: however, the static character of the photographic picture, its reifying capacity, constitutes it, no less, as that which the film-text works against. Invoking the manner in which Marker's use of the photo-still has an impact on the messages *La Jetée* conveys about temporality, subjec-

tivity, and memory, phenomena unfailingly invoked by photographs, Kear's essay underscores the dynamics of motion and stillness that Marker's film animates. It locates the originality of *La Jetée* in its ability to reimagine cinematic momentum, by returning filmic movement to its photographic origins. And it attributes the production of motion in *La Jetée* to the viewer, who must reconstruct/revive its movement(s), in a process that makes the spectator of Marker's film no less a partner in narrative momentum than the reader of *La Contre-Allée*.

Part Six: Phototextual Constructions

In Part Six the chapters by Elizabeth Siegel and Patrizia Di Bello illuminate a particularized mode of photonarrative montage, constructed within the pages of the photograph album. Siegel's chapter takes as its point of departure a send-up of the family album, written in 1915. She works with the messages this parody conveys about the structure and function of album phototextuality, to trace the history of narratives encoded in American photograph albums from the 1860s onward. Such narratives, she explains, deployed the text/image dynamic in evolving ways, as the familial genealogy that albums created came to rely more heavily on visual than written textual material. They generated new modalities of self-presentation to others. They enmeshed personal histories, and personal practices of commemoration, with public stories of national history and identity and social and cultural change. But in their different manifestations, which modified as album formats developed, these narratives consolidated a mode of showing and telling particular to the practice of album making and display. And they set up conventions of family storytelling that help us to contextualize and understand how we transmit information about families today.

Pursuing a line of analysis that resonates with Siegel's, Di Bello deals with a corpus of overlapping photographic narratives. She focuses on discourses on photography that evolved in the nineteenth-century British popular press (specifically, the woman's magazine); on the photonarrative form constituted by Victorian women's photograph albums; and on the narratives of gender, social, and visual practice these albums communicate. She urges us to read metanarratives of/on the photographic elaborated in nineteenth-century England—and, more especially, to read the photonarrative construct created by the female aristocratic album maker—with an eye to issues of authorship, sexual difference, fashionable social practice, and the production of photographic meaning. Her discussion presents two photomontages

contained in the album of Lady Filmer, an aristocratic collector whose album dates from the 1860s. These images, Di Bello proposes, offer a narrative of feminine performance that complicates notions of the Victorian feminine as confined within the domestic-familial. Equally, they play with representations of the album-image as a memorializing text, destined to provoke in its consumer an affective-sentimental, "feminine" response.

Phototextualities

We have positioned *Phototextualities* as powerfully marked by the groundbreaking work of, among others, Victor Burgin and Roland Barthes. But, coming two decades after the publication of *Thinking Photography* and *Camera Lucida*, *Phototextualities* seeks equally to map out a post-Burgin and post-Barthesian mode of photo-criticism. So how does it do this? Burgin's *Thinking Photography* mounted a strategic resistance to approaching photographic representation as an art form, emphasizing, rather, the sheer diversity of photographic practices and highlighting how such practices cut across a range of cultural and social arenas. It did so in order to break away from the auteurist paradigm derived from conventional art history that had previously constricted photo-criticism. Similarly, in *Camera Lucida* Barthes disregarded the taker of the photograph (whom he disparagingly termed the "Operator") and the photographic act, concentrating, like Burgin, on the "Spectator": that is, on the act of photographic looking and decipherment. In a move away from the rejection of photographic author to which *Thinking Photography* and *Camera Lucida* both attest, *Phototextualities* reinstates the photographer and, symptomatically, includes essays that focus diversely on photography as art practice. But this reinstatement emphatically does not signify an uncritical return to an outmoded auteurist stance. Instead, it signals that in the early twenty-first century it is politically expedient to bring the author back into the frame. This is because to ignore the author is to occlude significant issues of production that, contemporary thinking affirms, can no longer be overlooked. Such thinking is, for example, clearly evident in Marianne Hirsch's discussion of the photograph as a fabrication of the "Nazi gaze."

Whereas *Thinking Photography* takes proper cognizance of the way in which context—social, cultural, and historical—affects (the reception of) the photographic text, *Camera Lucida* fights shy of contextualization as a means of reading Barthes's chosen photographs.

However, a contextualizing approach is resolutely adopted by many of the contributors to *Phototextualities*. This approach translates into a concern both with the geographic, cultural, historical, and personal spaces and places charted in the photographs that are investigated and with the sites these photographs themselves inhabit. *Phototextualities*, in other words, reflects a contemporary theoretical agenda, in which the abstracting work of poststructuralism and psychoanalytic semiology has been displaced. Its critical idiom deals in matters of cultural specificity, identity, and location. This is perhaps unsurprising in an era in which key questions of globalization and transnationalism, with their totalizing potential to elide the local, have ironically forced critics to return to and reconsider what identity, location, and specificity might now mean.

The attention to location, and to the implications of location, that *Phototextualities* bespeaks is not just an indication that the volume is driven by a will to engage with and build on preexistent theoretical debates on photographic signification. It testifies, no less, to the deliberately expansive and inclusive ambit of the anthology. *Phototextualties* actively works to juxtapose chapters on photonarrative artifacts made, for example, in (post–)"Dirty War" Argentina, revolutionary Mexico, twentieth-century Spain, and contemporary France. And it endeavors thereby to extend beyond the usual Anglo-American purview of exercises in photo-analysis, offering its readers new photographic texts and contexts to look at, as well as different ways of looking at them.

Notes

1. Victor Burgin, ed., *Thinking Photography* (London: Macmillan, 1982), 144. •
2. See Walter Benjamin, "The Work of Art in the Age of Mechanical Reproduction," in *Illuminations*, trans. Harry Zohn (London: Jonathan Cape, 1969); John Berger, *Ways of Seeing* (London: Penguin, 1972); Roland Barthes, *Image-Music-Text*, ed. and trans. Stephen Heath (London: Fontana, 1977); Susan Sontag, *On Photography* (New York: Farrar, Straus and Giroux, 1977). A notable omission from this list is, of course, Barthes's *Camera Lucida*, published in English translation in 1981 and in the original French in 1980. We come back to the status of this text as a touchstone for contemporary photography theory later on in this introduction.
3. For a useful overview of the late-twentieth-century embrace of the visual, see Catherine M. Sousslouff, "The Turn to Visual Culture," *Visual Anthropology Review* 12:1 (1996): 77–83; Liz Wells, ed., *Photography: A Critical Introduction* (London: Routledge, 1997).
4. Those contributors working in the areas of national-cultural studies have cited foreign-language secondary or critical texts in their original as well as translated versions; other contributors, however, use English-language translations only. Across *Phototextualities* a range of foreign-language texts and films are referenced.

5. In privileging *Thinking Photography* in the opening of this introduction, we wish to indicate our sense that, since its publication, Burgin's volume and the pre-texts whose discourses it consolidates have not been "displaced" by new, seminal metadiscourses on the photographic. Photography theory, in other words, if it has consolidated its position as an element of the academic map, has also been dogged by a curious kind of stasis.

6. See W. J. T. Mitchell, *Picture Theory: Essays on Verbal and Visual Representation* (Chicago: University of Chicago Press, 1994); Clive Scott, *The Spoken Image: Photography and Language* (London: Reaktion Books, 1999), 13.

7. In this context, Marianne Hirsch reminds us that in the age of ever more sophisticated digital technologies, the link to reality evinced by the photo-image becomes increasingly problematic. See Marianne Hirsch, *Family Frames: Photography, Narrative, and Postmemory* (Cambridge, Mass.: Harvard University Press, 1997), 6. Equally, however, Hirsch powerfully affirms her own enduring belief in the force of that link. The same belief resonates throughout *Phototextualities*. Symptomatic of this is the absence from our volume of a discussion of the impact of digital photography. The complexities of such a discussion would warrant a separate and different study from our own.

8. In addition, certain of the essays in this collection read questions of photographic indexicality and reference through the discussion offered in Philippe Dubois, *L'Acte photographique* (Paris: Nathan, 1983). Curiously, this significant contribution to photography studies has not been translated into English; however, it reviews key aspects of photographic meaning, drawing on the pragmatic philosopher Charles Sanders Peirce's dissection of the sign as symbol, icon, and index. And it helps us to understand how the photograph as index enjoys a relationship of contiguity with the real object it represents, functioning in an analogous fashion to, say, a footprint that is the material trace of the referent.

9. The late 1990s witnessed an upsurge of interest in the relationship between photography and autobiography. In addition to Hirsch's *Family Frames*, see Annette Kuhn, *Family Secrets: Acts of Memory and Imagination* (London: Verso, 1995); Linda Haverty Rugg, *Picturing Ourselves: Photography and Autobiography* (Chicago: University of Chicago Press, 1997); Timothy Dow-Adams, *Light Writing and Life Writing* (Chapel Hill: University of North Carolina Press, 2000). An earlier body of work deals with the interactions between photography and film and includes essays by Barthes, Raymond Bellour, Christian Metz, and Peter Wollen.

10. Geoffrey Batchen, *Burning with Desire: The Conception of Photography* (Cambridge, Mass.: MIT Press, 1997), 9.

11. Haverty Rugg, *Picturing Ourselves*, 25.

12. Hirsch, *Family Frames*, 6.

13. For a volume that summarizes how various disciplines approach the question of memory, see Susannah Radstone, ed., *Memory and Methodology* (Oxford: Berg, 2000). Radstone's book productively maps the connections that prevail among memory, affect, identity, nationhood, and place. It is indebted to Pierre Nora's seven-volume *Les Lieux de mémoire*.

14. See Hirsch, *Family Frames*, 8. For a discussion of the role of rhetoric and affect in visual culture, see Bill Nichols, "Film Theory and the Revolt against Masternarratives," in *Reinventing Film Studies*, ed. Christine Gledhill and Linda Williams (London: Arnold, 2000), 46.

PHOTOGRAPHY AND TESTIMONY

Nazi Photographs in Post-Holocaust Art: Gender as an Idiom of Memorialization

MARIANNE HIRSCH

[H]e raised his eyes and looked at me[;] . . . that look was not one between two men; and if I had known how completely to explain the nature of that look, which came as if across the window of an aquarium between two beings who live in different worlds, I would also have explained the essence of the great insanity of the third Germany.

Primo Levi, Survival in Auschwitz

Photography was a routine part of the extermination process in Nazi Germany.

Sybil Milton, "Photography as Evidence of the Holocaust"

If you had to name one picture that signals and evokes the Holocaust in the contemporary cultural imaginary, it might well be the picture of the little boy in the Warsaw ghetto with his hands raised (fig. 1.1). The pervasive role this photograph has come to play is indeed astounding: it is not an exaggeration to say that in assuming an archetypal role of Jewish (and universal) victimization, the boy in the Warsaw ghetto has become the poster child of the Holocaust.[1] In Lawrence Langer's terms "the most famous photograph to emerge from the Holocaust," it has appeared in Holocaust films, novels, and poems

and, almost obsessively, on the covers of advertising brochures for Holocaust histories, teaching aids, and popular books.[2] It serves as the cover image not only of such popular publications as *The Jewish Holocaust for Beginners*, or the CD ROM Holocaust history *Lest We Forget*, but also of recent scholarly texts.[3] Its international reach and recognizability is further emphasized in its prominent place on the cover of Yad Vashem's primary English-language historical booklet, *The Holocaust*. The photograph was featured in Alain Resnais's 1956 *Nuit et brouillard* (Night and Fog) and in Ingmar Bergman's 1966 *Persona*, and in 1990 it became the object of a documentary video examining the contention of Holocaust survivor Tsvi Nussbaum that he is the boy with his hands up. It was also the catalyst for Jaroslaw Rymkiewicz's novel, *The Final Station: Umschlagplatz*, originally published in Poland in 1988,[4] and it inspired a number of poets and visual artists, including Yala Korwin, Samuel Bak, and Judy Chicago.

The picture's well-known history, however, mostly remains invisible in its contemporary representations: representations that actually enable viewers to forget, or to ignore, its troubling source. The picture

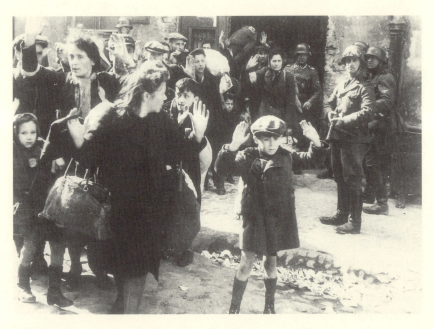

FIGURE I.I.
From the Stroop Report on the destruction of the Warsaw ghetto.
Photograph courtesy of the United States Holocaust Memorial Museum
Photo Archives.

of the little boy was originally included in the report by Major-General Jürgen Stroop, commander of the operation to liquidate the Warsaw ghetto. Titled "The Jewish Quarter of Warsaw is no more!" (Es gibt keinen jüdischen Wohnbezirk in Warschau mehr!),[5] the report collected the daily communiqués on the progress of the operation that were teletyped from Warsaw to Friedrich Wilhelm Krueger, Higher SS and Police Leader East in Cracow. The *Bildbericht*, consisting of fifty-four photos, was added to the communiqués and the whole was presented to Himmler as a memento. In the image the young boy stands among a group of Jews herded out of underground bunkers toward the Umschlagplatz where they would await deportation. Surrounded by soldiers with machine guns aimed at them, they are photographed in the most vulnerable of poses. This photographic addition to the record of the ghetto's liquidation shows more than the details of the roundup and deportation: it can show the particular ways in which Jews were overpowered and humiliated by their captors. Stroop's caption, never included in the contemporary reproductions of the image, reads "Removed from the ghetto by force" (Mit Gewalt aus Bunkern herausgeholt). This photo thus illustrates Sybil Milton's contention, cited in an epigraph to this chapter, that "photography was a routine part of the extermination process in Nazi Germany."[6] It illustrates, as well, the broken look that shapes photography in the context of an eliminationist racism—a look that Primo Levi tries to understand when he faces a Nazi official during his chemical examination in Auschwitz-Buna "which came as if across the window of an aquarium between two beings who live in different worlds."[7]

The little boy's picture is a perpetrator photograph, taken by perpetrators as an integral part of the machinery of destruction, and it can thus help us to understand the particularities of perpetrator images. But the enormous cultural attraction to it, the obsessive manner in which it appears just about everywhere these days, enables us to address a different question as well. How can perpetrator images—images shaped by the broken look Levi describes and evidence of photography's implication in the death machine—have come to play an important, even a prevalent role in the cultural act of memorializing the victims? How have contemporary artists—even Jewish artists of the second generation—been able to incorporate them so widely into their memorial work?

This chapter addresses the politics of retrospective witnessing, the politics of the act of appropriating and recontextualizing archival images in post-Shoah memorial texts. I argue that if perpetrator images can mediate the visual knowledge of those who were not there, it is

only because their contemporary reproductions mobilize very power-
ful idioms that obscure their devastating history and redirect the geno-
cidal gaze that shaped them. In order to look closely at some of these
mitigating idioms, I examine several specific Nazi photographs and
their reproduction by contemporary artists: the little boy image, sev-
eral images of Einsatzgruppen killings in the East (fig. 1.2), and an image
of the execution of the famous partisan from Minsk, Masha Bruskina
(fig. 1.3).[8] The reuse of these images in contemporary publications and
artistic works serves to illustrate one such idiom particularly well: the
infantilization and feminization of victims and the concomitant hyper-
masculinization and consequent depersonalization of perpetrators. By
making gender a determining if hidden idiom of memorialization, these
artists, however unwittingly, mythologize the images they use, obscure
their sources, and thus allow them to become appropriable.

Before developing these points, I would like to comment directly
on the implications of highlighting gender in a reading of how these
Nazi photographs are recirculated in post-Shoah art. In the last twenty
years, feminist scholars have complained about the overwhelmingly
masculine story that has come down to us from the Holocaust and have

FIGURE 1.2.
David Levinthal,
from "Mein
Kampf." Courtesy
of the artist.

Nancy Spero, "The Torture of Women." Courtesy of the artist.

tried to unearth the forgotten and ignored stories of women. Thus if gender has entered Holocaust studies, it has primarily been used as a lens through which to understand the particularities found in women's testimonies and memoirs. My own interest here is somewhat different: I wish instead to explore the rhetoric and the politics of memory and representation. I see gender as a vehicle that mediates the ways in which certain images have been able to circulate in the visual culture of the postmemorial generation. A feminist analysis, I would argue, can enhance our understanding of the structure and politics of memory and transmission, illuminating not just what stories are told, or what images are seen, but how those stories are told and how those images are constructed. In pursuing such an analysis, my discussion illustrates a key trend in recent feminist scholarship—an acknowl-edgment that, to be illuminating, gender as an analytic category need not radically supersede other categories of analysis. But, my reading affirms, neither can our understanding of the rhetoric and the politics of postmemorial representation be adequate without an analysis of the functioning of gender.[9] As we shall see, in fact, the more sophisticated our analysis of gender dynamics, the more responsible and subtle we can be in our memorial work.

Perpetrator Images and the Nazi Gaze

Most contemporary viewers, confronted with images from the Holo-caust, do not readily distinguish their source or the context of their pro-duction. Indeed, in the vast archive of photographic images that has come down to us from the Holocaust (Milton calculated the figure at two million in the mid-1980s, before the opening of the Soviet archives and before the massive collections undertaken more recently), this

information is often difficult to detect. Many images appear in collections with poor labeling, and when they are reproduced some are identified by their present owner rather than by the date and place of their production. Contemporary viewers tend to know few images, which are repeated over and over, in different contexts, and are used more for their symbolic or affective than for their evidentiary or informational power. All images associated with the Holocaust, moreover— whether they are prewar images of destroyed Jewish communities or images of bulldozers burying bodies at the moment of liberation—are marked by our retrospective knowledge of the total death that divides the people marked for extermination from us as retrospective viewers.[10] It is this knowledge that shapes our viewing, and thus one could say that the photographer's identity is immaterial.

And yet I want to argue here that the identity of the photographer—perpetrator, victim, bystander, or liberator—is indeed a determinative if often unacknowledged element in the photograph's production and that, as a result, it engenders distinctive ways of seeing and, indeed, a distinctive textuality. Perpetrator photos are ruled by what I have elsewhere termed a "Nazi gaze" that deeply shatters the visual field and profoundly reorients the basic structures of photographic looking.[11] They are fundamentally shaped by the history of their production, and since for many images that history is coming to be more thoroughly documented, its erasure in their current recirculation is extremely problematic.

There are, of course, many different kinds of perpetrator images and many different kinds of uses to which they have been or can be put. The well-documented photographs I am looking at in this chapter—all frontal images of victims looking at executioners in which the photographer, the perpetrator, and the spectator share the same space of looking—illustrate particularly well the structure of the genocidal gaze of the Nazi death machine. Thus, in the Warsaw ghetto image, guns are pointing at the boy from the back and side, even as the camera records the encounters between perpetrators and victims. The camera thus embodies the gaze of the perpetrator who stands in a place identical with the weapon of roundup and execution: it mirrors, head-on, the most visible soldier's gun. This structure suggests, disturbingly, a conflation of camera and weapon that constituted, until the 1980s, a dominant view of the power differential between the photographer and his subject. Although more recent theories of photography have stressed instead the multiplicity of looks structuring a photographic image, contesting the idea of the monolithic and deadly power of the photographic act, the use of photography in

the context of Nazi genocide certainly recalls this equation.[12] So the act of photographing the violent evacuation of the ghetto, and of using these humiliating images to illustrate the report, merely underscores the cruelty and violence perpetrated by the SS. The picture of the Warsaw boy and his compatriots, like all perpetrator images, is deeply implicated in Nazi photographic practices.[13] It is evidence not only of the perpetrator's deed but also of the desire to flaunt and advertise the evidence of that deed. The Stroop report, for example, was just that: a letter addressed to Himmler, a gift of joyously and victoriously embraced cruelty. The act of photographing the roundup is like the exclamation point in the title of the report: "The Jewish Quarter of Warsaw is no more!" It is a sign of excess, connecting the perpetrator's gaze to the perpetrator's deed. Thus when we as spectators confront perpetrator images, we look at the image as the implicit Nazi viewers did, under the sign of that exclamation point. What is often most astounding about perpetrator photographs is not what they show but that they even exist.

If, as Susan Sontag has so powerfully said, "all photographs are *memento mori*," then the negotiation between life and death is fundamental to the very temporality of the photographic look.[14] Photographs freeze one moment in time, and if, as Roland Barthes has stated, the photograph proves the "having-been-there" of the subject, its past, then the viewer situates herself in two presents—the moment of looking and the moment when the picture was taken. The power of the photograph derives from the effort, in looking at the person depicted, to reanimate the past by undoing the finality of the photographic "take." The work of looking consists in the physical, bodily act of connecting the past with the present. The retrospective irony of every photograph, made more poignant if death separates the two presents, consists precisely in the simultaneity of this effort and the consciousness of its inevitable impossibility. As we look at photographic images, we hope nothing less than to undo the very progress of time.[15]

But in the context of the "total death" of Nazi genocide and its destruction not only of individuals but also of an entire culture, such an act of undoing seems doomed and the photograph's finality utterly, hopelessly irrevocable. No retrospective irony can redeem or humanize the images produced in the context of Nazi genocide. These images can signify nothing less than the lethal intent that caused them and that they helped to carry out. The soldier pointing his gun at the boy, with his characteristic helmet and uniform, is an embodiment of genocidal intent. The camera gaze mirrors the machine gun and announces the gas chamber. A system that reduces humans to "pieces" and ashes

through mechanized genocide creates a visual field in which no look between perpetrator and victim can be exchanged or returned. The subjects looking at the camera are also victims looking at soldiers whose machine guns help to herd them off to trains and extermination camps. As they face the camera, they are shot before they are shot.

But this image of the boy in the Warsaw ghetto also qualifies such a monolithic view of an overpowering determining gaze, by showing that the perpetrators are individual soldiers, each with his own embodied, individual look, motivated by individual as well as collective forms of will and desire. The notion of a Nazi gaze that is shaped by the forces of totalitarianism must not obscure the looks that operate under its shadow: the force of individual responsibility, the personal, human encounter between photographer and subject, executioner and victim. Of course, as Primo Levi makes clear in the passage that serves as the first epigraph to this chapter, the looks exchanged between victim and perpetrator in a racist Nazi universe are not subject to the same conventions as the looks of ordinary human interaction. And yet if we discuss or reproduce perpetrator images in our retrospective memorial work, we have the burden of acknowledging both the massive genocidal program of which they were a part and the individual acts of choice and responsibility that enabled the killing machine to function.[16]

I believe that this totalized notion of a Nazi gaze, qualified through a recognition of the individual soldier's broken look, helps to define the particular quality of perpetrator images. The murderous quality embedded in them remains, even fifty years later, dangerously real. It continues to disable the retrospective irony that is so fundamental to the act of photographic looking. Perpetrator images carry this excessive history—this double act of shooting—with them. How then has the picture of the boy in the Warsaw ghetto been able to assume its pervasive memorializing role? What enables viewers to identify with the boy, to invoke his presence, despite the fact that his raised hands, mirroring that exclamation point in the report's title—"The Warsaw Ghetto is no more!"—become the sign of utter unredeemable annihilation?

Infantilizing and Feminizing the Victim

Cropping is the most common reproductive strategy used by contemporary post-Shoah artists and publishers. Most reproductions and recontextualizations of the boy's picture not only leave out but actu-

ally deny the original context of its production by focusing on the boy himself, isolating him from the community in which he was embedded and removing the perpetrators from view. They thus universalize the victim as innocent child and reduce the viewer to an identificatory look that disables critical faculties. If anyone else is included, it is usually the one soldier standing behind the boy, aiming his gun at the boy's back. This is how, for example, the boy appears in a painting by Rebecca Shope that is on the cover of *The Jewish Holocaust for Beginners*. Victim and perpetrator are enclosed in a large frame, the actual street scene is erased, and, out of the Warsaw context, all that remains is a mythic encounter between innocence and evil that removes the picture from both its greater and its more specific historical context.

Cropping is also a strategy used in a 1995 series of studies, mainly self-portraits, by child-survivor artist Samuel Bak, which are part of a larger and extremely successful project titled "Landscapes of Jewish Experience" (fig. 1.4).[17] Bak best illustrates the boy's ready availability for viewer projection and identification. In his images, the little boy's face is replaced by a number of other faces, including that of the artist himself. Bak multiplies the image and transposes it into a variety of well-known iconographic motifs, ranging from the Crucifixion to the felled tree of life to more specific representations of concentration camp life—the striped uniform, the so essential shoes. Like his other images included in this larger series, these "landscapes of Jewish experience" are ruined landscapes, populated only by the most obvious symbols of Jewish life and death—the star, the tree, the candle, the tomb—and, surprisingly, by Christian motifs as well—outspread arms, a cross and nails. The image is completely decontextualized, perpetrators are invisible, and thus the viewer is sutured into the image through a look of empathic identification with the archetypal victim. Bak's narrative becomes a mythic narrative of "Jewish experience" rather than the particular narrative of the Warsaw ghetto, or even the Shoah.

Like Bak, the Polish protagonist of Rymkiewicz's *The Final Station: Umschlagplatz* identifies with the boy: "'You're tired,' I say to Artur. 'It must be very uncomfortable standing like that with your arms in the air. I know what we'll do. I'll lift my arms up now, and you put yours down. They may not notice. But wait, I've got a better idea. We'll both stand with our arms up.'" These are the empathic words of a fictional character, but even the Yugoslav writer Aleksandar Ţisma, himself a survivor, asked by the newspaper *Die Zeit* to send in a photo of himself that holds some particular meaning for him, sent this picture

FIGURE I.4.
Samuel Bak,
"Study F" from
"Landscapes of
Jewish Experience."
Courtesy of the
Pucker Gallery.

instead. "There are no photos of me that I connect to an important memory," he writes. "I send you instead the photograph of another that I actually consider as my own. . . . I immediately saw that the boy with his hands up in the right-hand corner of the picture is me. It's not only that he looks like me, but that he expresses the fundamental feelings of my growing up: the impotence in the face of rules, of humanity, of reality. . . . I recognize myself in him, in him alone."[18] Again Ṭisma emphasizes the general—impotence in the face of rules—rather than a more specific history that, after all, he shares with the boy. Identification in itself need not necessarily be a form of decontextualization, but, in these particular cases, the discourse of identification simplifies and distorts, becoming so overarching as to foreclose a more oblique, critical, or resistant retrospective look. Neither does identification need to be as transparent or projective as it seems in these

cases. Indeed those of us who have been working on the politics of postmemory have been trying to define a more complicated post-memorial aesthetic based on a mediated, nonappropriative, indirect form of identification that would clarify the *limits* of retrospective understanding rather than make the past too easily available.

Bak's dozen or so studies and these other fictional and autobiographical acts of what one might call "transparent" or "projective" identification clarify some of the mediating discourses that have allowed this Warsaw ghetto image to occupy the role of "most famous Holocaust photograph." The image is of a child, and of a child who performs his innocence by raising his hands, and it is an image of a child who is not visibly hurt or harmed or suffering. Images of children are so open to projection that they might be able to circumvent even the murderousness of the Nazi gaze. Geoffrey Hartman's suggestion that the image of the boy from Warsaw emblematizes Nazism as the loss of childhood itself underscores the power of the *figure* this image embodies: the figure of *infantilization*.[19] In the post-Holocaust generation we tend to see every victim as the helpless child, and, as Froma Zeitlin has noted in a recent article on post-Holocaust literature, we enact a fantasy of rescuing one child as an ultimate form of resistance to the totality of genocidal destruction.[20] Images of children readily lend themselves to universalization. Less individualized, less marked by the particularities of identity, children invite multiple projections and identifications. Their photographic images, especially when cropped and decontextualized, elicit an *affiliative* as well as a *protective* spectatorial look marked by these investments: a look that promotes forgetting, even denial. To achieve a more triangulated and nonappropriative encounter with images of children, they need to preserve some of their visual layers and their historical specificity.[21]

Judy Chicago's *Holocaust Project* incorporates the boy's cropped picture into a panel titled "Im/Balance of Power" that illustrates effectively the gendered dimensions of the victims' infantilization.[22] Chicago surrounds the boy with other images of hurt or threatened or hungry children (fig. 1.5). The boy from Warsaw is just at the center of the scale that will measure a universalized im/balance of power, and he shares the center panel with a painted caricatured Nazi soldier who, in Chicago's reversal, points his enormous gun right at the boy's chest. The boy is the only European child—the starving children in the other panel squares are Asian, African, or Latin American. In the lower right-hand corner, diagonally beneath the Warsaw boy, is the famous photograph of a Vietnamese girl burned by napalm, naked and running: in Chicago's reappropriation, painted bombs point directly at her

head. Chicago's crude iconography shows here that infantilization is also, structurally, a figure of feminization: the running girl is over-powered not only by the crassly phallic bombs but also by a cartoon figuration of a masked soldier who wears a badge marked "AGGRESS . . ." Similarly, on the back cover of the Yad Vashem brochure, for example, there are three boxes with close-ups: one of the little boy's face and the faces of two of the women in the image. If the victim is infantilized, then the perpetrator is hypermasculinized, represented as the ultimate in masculine, mechanized, suprahuman evil. In inscrib-ing the perpetrator in such an exaggerated way, she also points to his absence in the cropped representations of the boy. In spite of her stated desire to raise the world's consciousness about the powerless-ness and neglect suffered by today's children, Chicago's panel invites viewers to assume the subject position of victim, as it is the only posi-tion available. In inscribing themselves only into the place of the vic-tims who are both infantilized and feminized, viewers are made to participate in the hypermasculinization and ultimate depersonaliza-tion of perpetrators that allows for an erasure of the agency of perpe-tration—of the individual soldier who aims his gun, who takes a picture, who looks at it afterward. The profound impact that the machinery of destruction has performed on our very ways of seeing is mitigated in Chicago's troubling representations. Her direct, unmediated look at children's images explains the despair she describes in her journal as she works on this panel.

But images separated from their original context can certainly function on many different levels. It may therefore not be surprising that Langer's "Mona Lisa" of the Holocaust should be an image from the Warsaw ghetto. The name Warsaw is associated with heroism and resistance, and this boy can thus be both the ultimate victim and the archetypal hero: he can be feminized in the visual image even as he is remasculinized for those who know of his connection to Warsaw. So, for example, this image is reenacted in an Israeli play by Hanokh Levin titled *HaPatriot*. Here a little Arab boy Mahmud stands, like the boy from Warsaw, with his hands up, as an Israeli soldier holds a gun to his head. Lahav, the Israeli character, addresses his mother as he aims the revolver: "He will avenge your blood and the blood of our murdered family, as then, mother, when your little brother stood alone in front of the German at night."[23] In this complex and politically charged passage, the boy can be both victim and hero, but the gender roles are clearly differentiated: perpetrators, whether Nazi or Israeli, are male, whereas victims, whether Jewish or Palestinian, are children of grieving mothers. If the memory of the Holocaust is

FIGURE 1.5.
Judy Chicago, "Imbalance of Power" (detail) from
The Holocaust Project. Courtesy of Through the Flower.

invoked to shape contemporary politics, it is by relying on familiar gender stereotypes that are facilitated by the use of easily available archetypal imagery.

"Mein Kampf"

This oppositionally gendered politics of representation becomes clearer still in the work of the American artist David Levinthal in his series "Mein Kampf" (fig. 1.6).[24] Levinthal is known for installations using toys: installations that he photographs with a 20 x 24 Polaroid Land Camera that, when the aperture is wide open, yields glossy shallow-plane, blurry, and ambiguous images. In photographing toys, Levinthal has dedicated himself precisely to exposing cultural myths and stereotypes. Searching for authentic Nazi toys in amateur shops, Levinthal

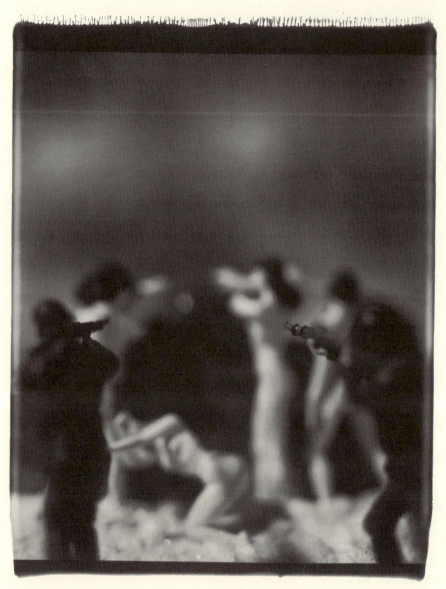

FIGURE I.6.
David Levinthal, from "Mein Kampf." Courtesy of the artist.

came upon dolls of Hitler, of Nazi soldiers, and of Reichsbahn cars. In "Mein Kampf" he was thus able to create a number of reenactments of perpetrator images, some of which remain faithful to their originals, while others are reinterpreted or reimagined.

Most troubling, perhaps, are his reenactments of the frequently reproduced photographs of Einsatzkommando executions in Poland, Russia, Latvia, and Lithuania that show groups of victims, women and men, often undressed, sometimes cradling babies or small children, facing the camera just seconds before they are to be put to death. In the original photographs, the camera is located in the same place as the executioner, and perpetrators are visible in the image primarily through this disturbing co-implication. The presence of these images on museum walls and in Holocaust textbooks is troubling, especially because in most of these contemporary contexts, the role of photography in the act of genocide remains implicit and unexamined. But their reappearance in the work of contemporary second-generation artists such as Levinthal raises another set of questions still.

Perpetrators are represented in each of Levinthal's pictures; they are never absent. And the victims also are there, in their utter vulnerability and nakedness. Thus if Levinthal's images circumvent the full impact of the Nazi gaze, it seems to be primarily through their aestheticization, since, in other ways, his recirculation of perpetrator images appears to offer a counterexample to the work of Bak or Chicago. Unlike the writers or historians using the little boy image, Levinthal is as interested in perpetrators as he is in victims, and in reenacting the encounter between victim and executioner, he certainly underscores both the reality of the crime and the excess performed in photographing it. Levinthal's images do not enable us to forget that exclamation point in the title of Stroop's report: in fact, in his restagings, soldiers are moved to the front of the image and their guns, often the only items in clear focus, are pointing right at the victims.

In James Young's reading of "Mein Kampf," Levinthal's work is posited as significant for post-Holocaust representation because it acknowledges that "when he sets out 'to photograph' the Holocaust, . . . he takes pictures of *his* Holocaust experiences—i.e., recirculated images of the Holocaust." For Levinthal, the pictures are "intentionally ambiguous to draw the viewer in so that you make your own story."[25] The pictures' composition ensures that this intense imaginary projection on the part of viewers includes the role of the perpetrator as well as the victim. But in shooting the pictures, Levinthal himself occupies the place of the Nazi photographers, just as in his title "*Mein* Kampf" he does not hesitate to

claim the most abject space in this representational structure. As Levinthal retakes the image of the Nazi photographer and reenacts the perpetrator gaze, we as his viewers are invited to stand in the space of the Nazi viewers who were the addressees of the image. That space is disturbing in a number of ways. Looking is necessarily and, I believe, intentionally an act of revictimizing the victims, however miniaturized they are in their doll-like forms. The Nazi toy soldiers, like all such simulacra, are, like Chicago's constructions, hypermasculinized—they are deindividuated, generalized, clichéd amalgamations of body and weapon. The soldiers are seen from the back as, disturbingly, we look over their shoulders. As recirculated toys they can embody the totalizing quality of the Nazi gaze, but they can also mitigate any consciousness we might have of the individual soldier's act of murder.

To stage the victims, Levinthal used naked sex dolls made in Japan for the European market. These busty female dolls with their nipples showing are the perfect demonstration for what happens in the insane logic of such representations: as the victims are infantilized and feminized, the perpetrators are hypermasculinized and derealized. In the encounter of such figures with one another, the radical power difference between them thus becomes eroticized and sexualized. As an alibi, and in response to both James Young's and Art Spiegelman's personal objections to these female dolls, Levinthal maintains that he is only repeating the eroticization of Nazi murder in the popular imagination that is exemplified in films such as *Night Porter, Sophie's Choice, The White Hotel,* and *Schindler's List.*

Levinthal is making us conscious of the uncomfortably tainted position we always occupy when we view perpetrator images. His photographs not only point out the implicit presence and defining role of gender in all the relationships and positions associated with perpetrator images, but they also reveal how gender can serve as a means of forgetting. Hence I would argue that his critique, or his reenactment, of the perpetrator-photographer's position—critique and reenactment are never easily distinguishable—entails also a form of obfuscation. If there is blurring in these blurred images, it is the blurring between sexualization and "racialization": to the contemporary postmemorial viewer, like Levinthal, these *female* victims may have maintained their sexuality, but, to the murderers, these *Jewish* victims were surely no more than vermin, *Stücke* to be added to the statistics of extermination, indistinguishable by gender, class, age, or other identity markers. David Levinthal's images, in eroticizing the power relationship between perpetrator and victim, also "deracialize"

it. And in subjecting the scene of execution to a pornographic gaze, he moves it into a different register of looking altogether, circumventing the murderousness of the Nazi gaze that shapes the pictures on which his work is based.

Levinthal says, and Young surprisingly agrees, that sexual humiliation in the victims' last moments was one of the tactics of the Nazis' dehumanization of their victims. Certainly Jewish women were more sexually vulnerable than men, and there was rape and sexual abuse in the ghettos and camps. Stories of such horrors are often repressed narratives that feminist scholars have only begun to recover. Yet there is no evidence, in anything that I have read about the Einsatzkommando killings in particular, that the killers in any way recognized the victims' sexuality, or that there was anything sexual in these murders. In fact, the opposite seems to have been the case: the victims were dehumanized precisely by being *desexualized*. Robbed of any subjectivity in the impersonal machine of destruction, they were also robbed of their sexuality. Nazi killers were not deviant sexual perverts but "ordinary men" whose murderous work became routine.[26]

Levinthal's hypermasculinized and hyperfeminized figures and his pornographic gaze allow for a great amount of obfuscation and appropriation. A responsible and ethical post-Holocaust discourse needs to enable us to think about perpetrators and victims in ways that take their relationship out of the realm of caricature and cliché. Images that enable us to read both perpetrator and victim, both gender and race, may not be as easily appropriable as these have become. Work that is historically informed as well as self-conscious about its own dynamics of gender and power would certainly resist the use to which these archival perpetrator images have been put in the memorial work of some contemporary artists.

Beyond Cliché

I would like to end these reflections with an account of an alternative use of perpetrator images as featured in the American artist Nancy Spero's installations, based on the photographs of the execution of the seventeen-year-old Russian partisan Masha Bruskina, the heroine of Minsk (fig. 1.7). The eight surviving archival photos of Masha were taken by a Lithuanian battalion member collaborating with the Germans. On October 26, 1941, Masha was one of three Communist resisters who were paraded through the streets of Minsk and publicly hanged. The gruesome photos of their humiliation and execution were

made public just after the war, but only the two men were identified: the girl carrying signs and executed with the men was denied an identity, especially a Jewish identity, until 1968, when the Russian filmmaker Lev Arkadyev initiated an investigation about the "unknown girl." Eyewitnesses provided detailed descriptions and stories about this Jewish seventeen-year-old, who lightened her hair and changed her name so that her Jewish identity would not interfere with her resistance work. They not only identified Masha, but they told about her remarkable demeanor on the day of her execution.[27]

Spero has included the execution photos in a number of installations that are part of her series "The Torture of Women" or that focus exclusively on the images and the story of Masha Bruskina.[28] The installations are built around the archival perpetrator photos, but here the images are presented through various alienation devices: they are surrounded with text, with other related images, with figures from Spero's large corpus of goddesses and mythological characters. They are cropped, multiplied, reproduced at various angles and in unexpected spaces such as the bottom or the top of a gallery wall, on the ceiling, in a corner. These strategies prevent the viewer from simply looking at the Nazi image head-on, repeating the spectatorial gaze of the Nazi viewer. Instead, Spero's installations make us conscious of the looks that structure the image itself, of the screens and mediations that separate them from us in the present, of the artist's and our own compromised relation to them. The texts speak explicitly about the photographs, thus removing any simple transparence from them and restoring their original context. Significantly, Spero's photographic intertextuality enables a consciousness on the part of the viewer about the interaction among perpetrators, victims, and bystanders. The bystander testimonies are part of the texts, and the perpetrators are included in the images. Spero's installations are self-conscious, as well, about the gender dynamics that shape the heroization of Masha, about the "racial" dynamics that erased her Jewish identity, and about the politics of its reclamation. Masha herself, like the sign she carries, becomes a symbol, but Spero needs to redirect the Nazi gaze in her installations and redefine the symbolization to which Masha has been subjected. Confronted with Spero's collages and installations, the viewer must read as well as look, thereby extricating herself from any unilateral identification with either victim or perpetrator. In one installation, Spero crops the image slightly, removing one of the men, thus highlighting Masha's heroic role. In another, she superimposes another picture, found in the pocket of a member of the Gestapo and showing a naked woman bound with a noose around her neck. Unlike

int.

ed

n

on

e

ed

Twenty years ago Lev Arkadyev, a screen writer working on a film about the war, saw the photographs in the minsk Museum and resolved to identify the unknown Partisan. He enlisted Mrs. Dikhyar, then a reporter for the Soviet Youth radio station "Yunost," and they began a pain staking investigation..

FIGURE I.7.

Nancy Spero, installation "The Torture of Women." Courtesy of the artist.

the picture of Masha, this is a spare, formal, almost classical image that emphasizes the mythification of the female victim or hero, especially when it is placed in relation to Spero's mythic goddesses. This image of a bound woman does reveal the pornographic dimension of the perpetrator-victim relationship, which might seem to corroborate Levinthal's interpretation. Certainly some Nazi killers did sexualize the act of murder, but while Spero shows this by reproducing an image that is already pornographic, Levinthal adds a pornographic dimension to images that exist in a different register altogether. And by confronting these two images, Spero multiplies feminine roles and complicates gender stereotypes.

Spero surrounds these pictures with poems: Bertolt Brecht's ballad about Marie Sanders who slept with a Jew; a poem by Nelly Sachs; one by Irena Klepfisz. Thus Spero's representations of Masha always hover between the mythification of the resistance hero and the attempted individualization of the girl from Minsk. She makes it clear that surviving archival images cannot evade appropriative discourses of transmission and mediation. Those discourses have now become part of the images themselves, but Spero implicitly acknowledges that fact rather than simply reenact it.

As she extricates the girl from Minsk from the Nazi gaze, Spero thus nevertheless inscribes her in other mythic frameworks. By surrounding her image and story with some of her stock mythological figures, she comments on the monumentality of her own installations, on her own signature and relation to these haunting figures from the past. Masha becomes part of the story Spero herself tells about the torture of women, about war and the particular victimization of women in war, and about female resistance. This is also a gendered story that rests on binary oppositions between victims and perpetrators. But by including text, Spero highlights the historical specificity of Masha's victimization. She allows her to be both individual and symbol.

Spero may be no less appropriative, no less invested, than Bak, or Chicago, or Levinthal. But I would say that in her layered images, she reveals a greater level of consciousness and responsibility about her role as retrospective witness. Her imaginative aesthetic strategies allow Spero to resist a too-easy identification with the female victim, or a mere repetition of the perpetrator gaze, and to replace these with an act of denunciation. Spero thus refocuses our look without repairing what has been irrevocably broken. At its best, then, her use of Nazi photographs in her memorial artwork would allow us to be conscious of photography's implication in the dynamics of gender and race, power and powerlessness, seeing and being seen.

Notes

Versions of this chapter have appeared in *Crimes of War: Guilt and Denial,* ed. Omer Bartov, Atina Grossman, and Molly Noble (New York: New Press, 2002); and *Gedächtnis und Geschlecht,* ed. Insa Eschebach, Sigrid Jacobeit, and Silke Wenk (Frankfurt: Campus, 2002).

1. In a related article, I briefly discuss this image as one of a number of images of children that have been frequently seen and reproduced in works of Holocaust memory. See Marianne Hirsch, "Projected Memory: Holocaust Photographs in Personal and Public Fantasy," in *Acts of Memory: Cultural Recall in the Present,* ed. Mieke Bal, Jonathan Crewe, and Leo Spitzer (Hanover, N.H.: University Press of New England, 1999), 3–23.

2. Lawrence Langer, *Preempting the Holocaust* (New Haven: Yale University Press, 1998).

3. Stewart Justman, ed., *The Jewish Holocaust for Beginners* (London: Writers and Readers, 1995); Götz Aly, *"Final Solution": Nazi Population Policy and the Murder of the European Jews* (London: Arnold, 1999); *Lest We Forget: A History of the Holocaust* (Endless S.A., Sitac, and Media Investment Club, 1998).

4. Jaroslaw M. Rymkiewicz, *The Final Station: Umschlagplatz,* trans. Nina Taylor (New York: Farrar, Straus and Giroux, 1994).

5. Jürgen Stroop, *The Stroop Report: The Jewish Quarter of Warsaw Is No More!* trans. Sybil Milton (New York: Pantheon, 1979).

6. Sybil Milton, "Photography as Evidence of the Holocaust," *History of Photography* 23:4 (1999): 303–12.

7. Primo Levi, "The Chemical Examination," in *Survival in Auschwitz: The Nazi Assault on Humanity,* trans. Stuart Woolf (New York: Collier Books, 1960), 105–6.

8. In the latter two cases, I have chosen not to reproduce the actual images themselves but the contemporary works that incorporate them. Even though I shall argue that these works to some degree retain and perpetuate the power of the Nazi gaze, I would feel that I would be contributing to the problem I identify in this chapter were I to expose these archival images to further viewing.

9. On the issues I raise here, see Judith Stacey, "Is Academic Feminism an Oxymoron?" *Signs: Journal of Women in Culture and Society* 25:4 (Summer 2000): 1189–94.

10. See my discussion of the co-implication of these two kinds of Holocaust photographs in Marianne Hirsch, *Family Frames: Photography, Narrative, and Postmemory* (Cambridge, Mass.: Harvard University Press, 1997), 20, 21. See also Cornelia Brink's response and elaboration of my argument. Cornelia Brink, "'How to Bridge the Gap': Überlegungen zu einer fotographischen Sprache des Gedenkens," in *Die Sprache des Gedenkens: Zur Geschichte der Gedenkstätte Ravensbück,* ed. Insa Eschebach, Sigrid Jacobeit, and Susanne Lanwerd (Berlin: Edition Hentrich, 1999), 108–19.

11. Marianne Hirsch, "Surviving Images: Holocaust Photographs and the Work of Postmemory," in *Visual Representation and the Holocaust,* ed. Barbie Zelizer (New Brunswick, N.J.: Rutgers University Press, 2000), 215–46.

12. See, in particular, Christian Metz, "Photography and Fetish," in *The Critical Image: Essays on Contemporary Photography,* ed. Carol Squiers (London: Lawrence and Wishart, 1990), 155–64. Metz contends here that a monocular and thus inherently violent perspective rules the field of vision. Theorists of visuality have profoundly contested Metz's notion as they have identified a more complex visual field in which

power is shared in more complicated ways. But in Nazi photography, disturbingly, the corollary between camera and weapon reemerges with force.

13. For other useful analyses of Nazi photographic practices, see Sybil Milton, Judith Levin, and Daniel Uziel, "Ordinary Men, Extraordinary Photos," *Yad Vashem Studies* 26 1998); Bernd Hüppauf, "Emptying the Gaze: Framing Violence through the Viewfinder," *New German Critique* 72 (Fall 1997): 3–44; Alexander B. Rossino, "Eastern Europe through German Eyes: Soldiers' Photographs 1939–42," *History of Photography* 23:4 (Winter 1999): 313–21; Daniel Jonah Goldhagen, *Hitler's Willing Executioners: Ordinary Germans and the Holocaust* (New York: Alfred A. Knopf, 1996), 245–47, 405–6.

14. Susan Sontag, *On Photography* (New York: Anchor Doubleday, 1989), 15.

15. See Roland Barthes's moving discussion of this photographic temporality in *Camera Lucida: Reflections on Photography*, trans. Richard Howard (New York: Hill and Wang, 1981), 76, 77, 80, 81.

16. For the distinction between gaze, look, and screen, see Jacques Lacan, *Four Fundamental Concepts of Psychoanalysis*, trans. Alan Sheridan (Harmondsworth: Penguin, 1994); and Kaja Silverman, *Threshold of the Visible World* (New York: Routledge, 1996).

17. See Lawrence Langer's discussion of Samuel Bak, in *Preempting the Holocaust*.

18. See Rymkiewicz, *The Final Station*, 326; Aleksandar Tisma, "Mein Photo des Jahrhunderts," *Die Zeit*, October 14, 1999.

19. Geoffrey Hartman, *The Longest Shadow: In the Aftermath of the Holocaust* (Bloomington: Indiana University Press, 1996), 131.

20. Froma Zeitlin, "The Vicarious Witness: Belated Memory and Authorial Presence in Recent Holocaust Literature," *History and Memory* 10:2 (1998): 5–42.

21. See my discussion of this more triangulated exchange in "Projected Memory."

22. Judy Chicago, *Holocaust Project: From Darkness into Light* (New York: Penguin Books, 1993).

23. I am grateful to Sidra Ezrahi for calling this play to my attention. See her discussion of this moment in "Revisioning the Past: The Changing Legacy of the Holocaust in Hebrew Literature," *Salmagundi* (Fall–Winter 1985–86): 245–70.

24. David Levinthal, *Mein Kampf* (Santa Fe: Twin Palms Publishers, 1996).

25. James Young, *At Memory's Edge: After-Images of the Holocaust in Contemporary Art and Architecture* (New Haven: Yale University Press, 2000), 44, 51. The second element of the quotation is a citation from Levinthal.

26. Se Yitzhak Arad, Shmuel Krakowski, Shmuel Spector, eds., *The Einsatzgruppen Reports: Selections from the Dispatches of the Nazi Death Squads' Campaign Against the Jews, July 1941–January 1943* (New York: Holocaust Library, 1989); Christopher Browing, *Ordinary Men: Reserve Police Battalion 101 and the Final Solution in Poland* (New York: HarperCollins 1992).

27. For a discussion of these photographs, see Nechama Tec and Daniel Weiss, "The Heroine of Minsk: Eight Photographs of an Execution," *History of Photography* 23:4 (1999): 322–30.

28. See John Bird, Joanna Isaak, and Sylvère Lotringer, *Nancy Spero* (London: Phaidon, 1996).

Narratives of Place: History and Memory and the Evidential Force of Photography in Work By Meridel Rubenstein and Joan Myers

■■■■■■■■■■■■■■■■■■■■■■■■■■ ⚅ TWO

JUDITH FRYER DAVIDOV

"Before a photograph you search for what was there," John Berger writes with wonderful ambiguity about the nexus of memory and photography. Memory he understands as a field where different times coexist—the time of the subject, of the photographer, of the viewer—and as a field that is continuous in terms of the subjectivity that creates and extends it.[1] "Before" refers not only to confronting, or standing before, a photograph but also to the fact that a photograph implies a time prior to its making and a time afterward, thus linking subject, maker, and viewer. Understanding "what was there" can only be fragmentary, like memory, and like photographs: before a photograph, the time of its making must literally be re-membered. "What was there" refers also to Roland Barthes's *Ça-a-été*, his *"That-has-been"*: the formulation insists on the material reality of the past, or the indexical relationship between the trace that the photograph is and a moment in time, authenticating both occurrence and loss. A photograph is not a "copy" of reality but "an emanation of past reality," as Barthes writes: it "possesses an evidential force" whose testimony bears on time.[2]

What was there, how it is re-collected, re-membered, co-memorated, is central to two recent photographic projects—Meridel Rubenstein's *Critical Mass* and Joan Myers's *Whispered Silences*—

which in very different ways create or reconstruct conflicting narratives of specific places. Because the events they depict are so extraordinary in the way that they have marked us and continue to resonate in our lives, these narratives require of their makers, and of us as viewers, an extraordinary attention. Marianne Hirsch, in writing about the Holocaust, calls this the complex work of *postmemory*—a link to the past distinguished from memory by generational distance and from history by deep personal connection. Mediated not through recollection but imagination, postmemory characterizes the experience of those who grow up dominated by narratives that preceded their birth, by stories of traumatic events that can neither be understood nor re-created.[3] Making meaning from Rubenstein's multilayered collages and from Myers's deceptively simple presentations of artifacts compels each of us, confronted with pictorial clues to our national past, to engage in the act of imagining what was there.

Deeply interested in the sense of place, Meridel Rubenstein lives and works in Santa Fe, New Mexico, adjacent to San Ildefonso Pueblo and between Los Alamos, where Manhattan Project physicists worked in secrecy in the 1940s, and Trinity, where the first atomic bomb was tested. "What was there" refers to the deep and continuous past of this place and to something that forever changed not only it but also the world. *Critical Mass* documents people and objects associated with Los Alamos in the 1940s. Its title refers ambiguously to the assemblage of physicists at Los Alamos—literally to the amount of fissionable material necessary to sustain a nuclear chain reaction and more generally to a coming together of cultures and traditions. Transcending the boundaries of what we think of as documentary photography, this multimedia work, conceived by Rubenstein and performance artist Ellen Zweig and presented in collaboration with videographers Steina and Woody Vaskula, is an assemblage of historical and imagined fragments with a suspended moral judgment. That is to say, the layering of images, still and moving, with voices involves the reader-viewer-listener, also still and moving (literally pausing and moving through the exhibit but also moving between layers of past and present memory), in the complexity of what was there. The history of our weapons of mass destruction, weapons with the potential to poison the earth, the waters, the very air we breathe, is not only the achievement of a group of men working in secrecy. We witness in *Bohr's Doubt* (fig. 2.1) the misgivings of physicists who realize that contradictory proofs can exist for a single occurrence—Heisenberg's "uncertainty principle," which "hinged on the ineluctable involvement of the spectator in the outcome of the spectacle."[4] We see women implicated in the project; we see

FIGURE 2.1.

Meridel Rubenstein, *Bohr's Doubt*, 1989, from *Critical Mass*

Pueblo Indians working side by side with Los Alamos physicists to build a house for one of these women. We hear that woman's voice in conversation with Enrico Fermi, Niels Bohr, and Robert Oppenheimer: she gives them her recipe for chocolate cake. We overhear a conversation between her Indian companion, Tilano, and Albert Einstein. To all of this, perhaps with memories of the loss of loved ones to cancer, like the woman herself, the viewer bears witness.

The photographic collages are huge sculptures, monumental metal frames, some more than eight feet high, enclosing richly textured palladium prints, some grouped as triptychs of gothic windows, such as *Three Missiles* and *Archimedes Chamber*. In the case of *Bohr's Doubt*, images are mounted directly on a massive slab of steel. In any one of these multilayered pieces, single photographs are combined in a deliberate crossing of boundaries—a mixture of symbolic and documentary imagery, of portraiture and landscape—but presented in exact symmetry, almost as if they were not still photographs but pieces of a moving picture, a cinematic montage. In the installation, fragments

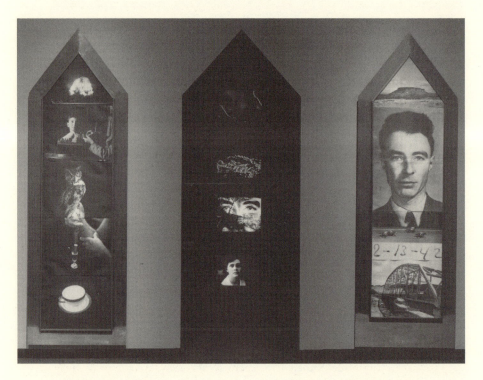

FIGURE 2.2.
Meridel Rubenstein, *Archimedes Chamber,* 1991, from *Critical Mass*

mirror and resonate for the viewer who moves: the viewer whose witnessing eyes, whose remembering mind, whose physical presence becomes, as it were, the projector.

A viewer walking through the exhibit would, while looking, hear the words of Ellen Zweig: "They spoke to the angels. To Raphael, angel of science and of knowledge, angel of health, of force, angel set over all the diseases and over all the wounds of men, angel of the West. They spoke to Uriel, the fire of God, who watches over thunder and terror, angel who guards the gates of Eden, alchemist, angel, physicist, angel of the abyss, of chance and destruction, angel of the South whose open hand holds a flame."[5] Entering *Archimedes Chamber* (fig. 2.2), she would meet Oppenheimer's predecessor, who in the third century B.C. gave up his theoretical work to help defend the city of Syracuse from the Roman invaders and construct horrible weapons, the most deadly of which was a set of large bronze mirrors or lenses with which he could focus the light of the sun onto the approaching Roman ships so that they burst into flames. Thus do photographer and physicist, ancient and modern history, converge, as viewers see enlarged images moving on a video monitor and hear, repeating and with variations, in fragments:

My whole body is trembling and my hairs are standing on end. I remember there was candlelight. Archimedes, an excitement, a spectacle, an investigation of the physical. My skin is burning and I am forgetting myself. I remember the house and everything that was in it and around it. Archimedes, mathematics, theoretical, an invention of the physical. My mind is reeling and I am overcome with grief. I remember red soil, red river, like blood in an open artery. Archimedes, desert landscape, experimental, a fiction of the physical.[6]

My first introduction to this project was a photograph called *Fat Man and Edith* (fig. 2.3), a puzzling collage of a bomb, light against a dark ground, egg or womb-shaped, and inside it, or superimposed on it, a portrait of a woman, a teacup and saucer. I was familiar with Brian Easlea's and Evelyn Fox Keller's analyses of the Manhattan Project as a male attempt to uncover the secrets of nature, especially female fecundity; and with documents such as the cable sent to Secretary of War Henry Stimson after the Alamogordo test: "Doctor has just returned most enthusiastic and confident that the little boy is as husky as his big brother." I was familiar, too, with director of the Manhattan Project Robert Oppenheimer's quotation from the

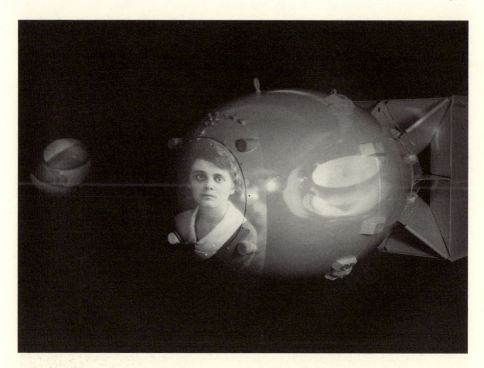

FIGURE 2.3.
Meridel Rubenstein, *Fat Man and Edith*, 1993, from *Critical Mass*

Bhagavad Gita as the bomb exploded, "If the radiance of a thousand suns were to burst into the sky, that would be like the splendor of the Mighty One," and, as the radioactive cloud spread, "I am become Death, the shatterer of worlds."[7] But this photograph seemed to suggest more than a shattering of the domestic world with its rituals of tea and sympathy: there is a troubling sexual ambiguity that implies an enigmatic connection. If the woman of the photograph was in some way implicated, then what of the viewer whose inquiring gaze, as she seeks to understand the puzzle, unavoidably implicates her as well?

The woman pictured in the bomb is Edith Warner, whose words from an unpublished manuscript, "In the Shadow of Los Alamos," are used as the epigraph to the exhibit: "This is a story of a house that stood detached, between the Pueblo Indian world and the Anglo—a house destined to play a part in the lives of the men and women who brought into being the atomic bomb."[8] This is her house (fig. 2.4) but not her first house. She came West in 1922 as a neurasthenic thirty-year-old woman in search of a bracing climate, lived for a time at a

guest ranch in Frijoles Canyon, and then returned in 1928 to settle into a run-down shack on Indian land, on the banks of the Rio Grande. In exchange for the house, the Los Alamos School for Boys hired her to safeguard mail and supplies sent by train from Santa Fe and unloaded at Otowi Bridge. Warner was on good terms with the Pueblos. They not only gave their permission to the arrangement but helped her to renovate the house, which she furnished with Pueblo pots and Navajo rugs. Tilano Montoya, a former governor of San Ildefonso

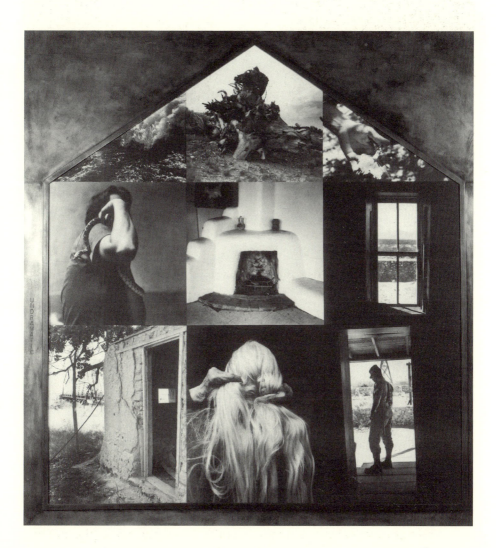

FIGURE 2.4.
Meridel Rubenstein, *Edith's House*, 1992, from *Critical Mass*

Pueblo, moved in to help her with the arduous work of growing food (fig. 2.5), providing wood and water and keeping the house in repair, and stayed on as her companion. They lived there until 1946, Warner earning a little money with her tearoom and later guest house, and after 1942, from dinners served, with the help of her Pueblo friends, to Los Alamos physicists and their wives. When the old bridge gave way to modern transportation and the encroachment of workers and material to Los Alamos forced her and the eighty-year-old Tilano to move, men from Los Alamos worked together with Pueblos to build her a new house.

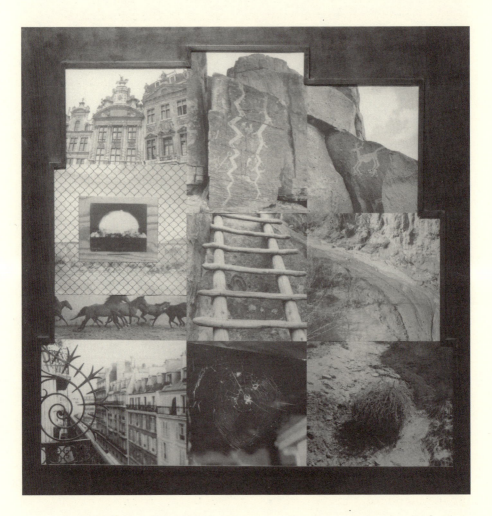

FIGURE 2.5.
Meridel Rubenstein, *Tilano's Garden*, 1993, from *Critical Mass*

Robert Oppenheimer also came to Frijoles Canyon in 1922 for his health, although he and Warner did not meet until 1937, when he stopped at her tearoom. From his first pack trip, he too fell under the spell of the desert Southwest. He and his brother leased a house in the Pecos Valley and returned repeatedly for camping trips in the mountains. In 1941 he brought his wife to Warner's tearoom, which he had remembered as a kind of refuge, and in 1942 he brought General Leslie Groves. His dream, he wrote to a friend, was to bring together "my two great loves[,] . . . physics and desert country."[9] The Los Alamos site must have seemed ideal: it was remote, sparsely populated, cheap, ripe for acquisition—the frontier, in other words, between civilization and the wilderness, chosen for the usual reasons associated with western settlement.[10] Remoteness was important because the work carried on there would be shrouded in secrecy. The nature of the project was concealed from the Japanese, the Germans, the American public, and the wives of the men who worked on the bomb. On days off, the physicists did not go far: they hiked or skied in the hills surrounding Los Alamos; they went to Edith Warner's little house by the river for dinner.[11]

Secrets function to articulate boundaries. Boundaries, as we know from Mary Douglas, are highly ritualistic: they demarcate a separate domain, set apart the communal inside from the alien outside. The greatest of secrets, that of life, Keller argues, has been the secret of women from men. Thus the ultimate goal of science, both in the case of DNA research and of the Manhattan Project, has become to develop "a *method* for undoing nature's secrets—the secrets of life and the secrets of death." Here, for example, are the words of the physicists Richard Feynman, "One of my things in life is that anything that is secret, I try to undo"; and Leo Szilard, "If secrets exist, they must be explainable."[12] Hence the egg-shaped, womb-shaped bomb: the secret community of Los Alamos had an interior, and what was produced out of this interiority was "Oppenheimer's baby," a baby with a father but no mother.[13] And what becomes of the actual secret interior of women's bodies is that, as was the case for Edith Warner, their cells mutate into deadly cancers that claim their lives. As Zuni Edmund Ladd warns, referring to the conch shell whose sound pierced the hearts of aggressors and was last used by his people to defeat the Spaniards in 1680: "There's always a thing about dangerous material like this because if you don't know the ritual, know the right prayer, the right chants and use it, you do harm not only to yourself but to your community and to the world at large. . . . And it's dangerous, it's a dangerous piece of equipment, it's almost like radioactive material."[14]

The images in *Fat Man and Edith* are also part of the *Archimedes Chamber* section of *Critical Mass*: Warner and her teacup; the face of Robert Oppenheimer; the atomic explosion. In this piece, the magic lenses that reflect the sun refer to the act of looking, to photography itself, to the makers of such mirrors and to the viewer, who in looking at them bursts into flames. We are forced to look, to see, to know. We are left with the consequences of seeing: when power is used by those who do not understand the rituals governing its use, we are all vulnerable to its abuse. What we see in the reflecting mirrors is that we, no less than Edith Warner, are "the genius of the place," implicated in and exposed to the radioactive result of these unleashed secrets.

In her focus on the propensity of human beings to invent devices that wound human bodies—shells that produce heart-piercing sounds, mirrors that cause flesh and bone and muscle to burst into flames—Rubenstein has been influenced by Elaine Scarry, whose book *The Body in Pain* establishes a dichotomy between those who are voiceless, embodied, and vulnerable and those with voice, or power, who are disembodied. *Critical Mass* works with Scarry's dichotomy while blurring its absolute boundaries: those who have been disempowered are pictured alongside representations of those in power. Oppenheimer is pictured and his voice echoes in *Archimedes Chamber*: "Of all that is material and all that is spiritual in this world, know for certain that I am both its origin and its dissolution." In the video installation "The Dinner" all of the participants—men and women, Anglo-Europeans and Pueblos—meet at Warner's house; they speak to one another. Ultimately, however, it is Oppenheimer's words that pierce our hearts, that invade Warner's body. She says: "I am become death. I am bodies of water, blood and semen." She becomes a seer: "Rainwater, collected in gullies, arroyos. Streets of blood, boiling floods, waters; waves, torrents, horrible water. Holy waters. The surface of the human skin." "Get out of me," she shouts. "Seeing this, seeing that. The eye rolls in my head. Dam it up. Shut it. I tell you, this is the inside of the body turned inside out."[15]

Given the destination of "Little Boy" and "Fat Man"—the first products of Los Alamos, used to bomb Japan—there is an eerie resonance between Rubenstein's *Fat Man and Edith* and Joan Myers's *Pan and Cup*. *Pan and Cup* (fig. 2.6) was my introduction to photographs of object remnants found on the sites of Japanese American internment camps. It is part of a series called *Whispered Silences: The Japanese American Detention Camps 50 Years Later*, a traveling Smithsonian exhibit and book by Myers and historian Gary Okihiro.

I saw two simple objects set against a dark background, as in a

museum case displaying precious objects (in a museum of fine arts) or archaeological objects (in an ethnographic or natural history museum). Placed and lighted in this way, they seemed to invite an analysis focused on style or on context: that is, it seemed to me that I was confronting not an *image* but *things* that I might use methods drawn from art history, anthropology, or material culture studies to understand. Such work would attempt to place these objects in relation to other objects or to social and historical circumstances. With only this picture, however, seen apart from the exhibit or book, these tools did not take me very far. As for style, I could only say that the pan and cup are made of enamel, dating from sometime in the last three centuries and that they are chipped and the pan dented, from use or from collision with other objects or with the earth after disuse. And these utensils are decontextualized. The title of the project, of course, and other images from that project, do provide a visual context and an understanding that these objects were used at a Japanese

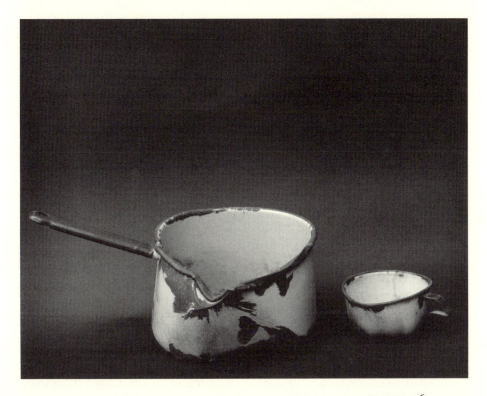

FIGURE 2.6.
Joan Myers, *Pan and Cup*, 1984, from *Whispered Silences*

internment camp—one of ten, in which some 110,000 people of Japanese descent were imprisoned during World War II. They had been rounded up from California, Oregon, Washington, and parts of Arizona and "relocated" in converted fairgrounds, horse-racing facilities, or hastily constructed sites in California, Arizona, Utah, Colorado, Idaho, Wyoming, and Arkansas. But who used them? These objects might have been brought to one of the camps as precious possessions, but does their anonymity suggest that they were supplied as government issue?

Placed together and seeing the word "Japanese," one might infer that the pan and cup were used for tea, for a domestic and communal ritual preserved in the midst of abrupt and frightening dislocation, crowded and unsanitary living conditions, intense heat, cold, and blowing dust that came up through the floorboards and thickly covered every surface: a ritual like ikebana, haiku, calligraphy, or bonsai that was a way of preserving cultural identity. But given the physical conditions of the camps—the noisy, crowded mess halls in which everyone ate together—the pan and cup might also stand as markers of the rupture of the fabric of family and cultural life.

Because these simple objects raise so many questions that I cannot answer, I need to find the photographer—and I need to say here that authorial intent *matters*. The first thing Myers tells me is that all the shadows of meaning I am perceiving around these objects are there by intent. It matters that her brother is an archaeologist and that she looked at "lots of archaeological photos before deciding what to do." She affirms that "these images are done in the old style of archaeological photos where the shadows are visible, not in the modern style where objects are shot on a light table and the shadows removed."[16] She also tells me that the pan and cup *were* standard government issue. As such, then, they signify erasure, not preservation, of ritual. For those who used these objects, they must have marked a sharp and painful contrast to remembered ritual. And to a viewer with this knowledge—at least for me—they evoke a sense of shame.

Myers's images of long buried or ignored relics are very different from earlier documentary photographers' work made at the time of the internment. For example, Dorothea Lange, working for the War Relocation Authority, concentrated on dislocated persons, some of whom were her friends and neighbors in San Francisco. She photographed them as victims of injustice by portraying them as the ordinary middle-class American citizens that they were, foregrounding their faces and writing captions that made clear her own outraged point of view: captions that were meant to arouse viewers' emotions.

Ansel Adams concentrated on the Nisei, in the Manzanar internment camp in California, posing them against the familiar, redeeming terrain of the Sierra Nevada: an environment which he believed would shape their experience in a positive, "thoroughly American way."[17] And inside Manzanar, with smuggled lens and old pieces of wood and metal, the Los Angeles photographer Toyo Miyatake constructed a camera that he used to document everyday life—activities such as baseball games, school exercises, and the construction of gardens. Myers's work from the 1980s is unique in focusing so closely on recovered objects in order to engage the viewer in imagining, from the clues that she has assembled, what life inside the camps might have been like. She takes us to the remains of gardens, uncovers the tools used to work these gardens, highlights stones carefully placed for ornament, and reminds us of the feet of the gardeners (figs. 2.7, 2.8).

It is Myers's intention that these photographs "speak" to us. When I suggested this to her, she replied, "The objects do speak, and they have a tactile presence in the original platinum prints; they have the feeling that they have been touched and used. But I [also] wanted clear voices to accompany them. There has been too much silence."[18] Written and visual narratives, recovered and newly created, emphasize the stultifying silence that surrounded and pervaded the internment. That is the context from which Myers's pictures emerge: a silence that has been private, cultural, and official. "We were like the victim of a rape—we could not bear to speak of the assault, of the unspeakable crime," Edison Tomimaro Uno wrote in 1971 after a pilgrimage to Manzanar. "I knew that I was there for no crime other than the color of my skin and the shape of my eyes. I knew, too, that the excuse my captors gave—that I was there for my own protection—was sheer hypocrisy, that there was some deeper and more sinister reason for my incarceration."[19]

Myers conceived this project as a collaboration with a Japanese American who could weave together oral history material. Her pictures are not meant to illustrate but rather to resonate with the written context Gary Okihiro provides for them. Okihiro writes of the Japanese-language books and records, letters from kinfolk—things that constituted a veritable and literal buried past—that were destroyed: "My mother told me how my grandfather smashed her prized collection of Japanese records. . . . Any connection, any link with Japan, any expression, any thoughts indicative of Japanese culture and ethnicity, invited others' suspicion, he had told her."[20] Cultural silence would have extended to possessions left behind when the Japanese Americans were rounded up in 1942; they took only

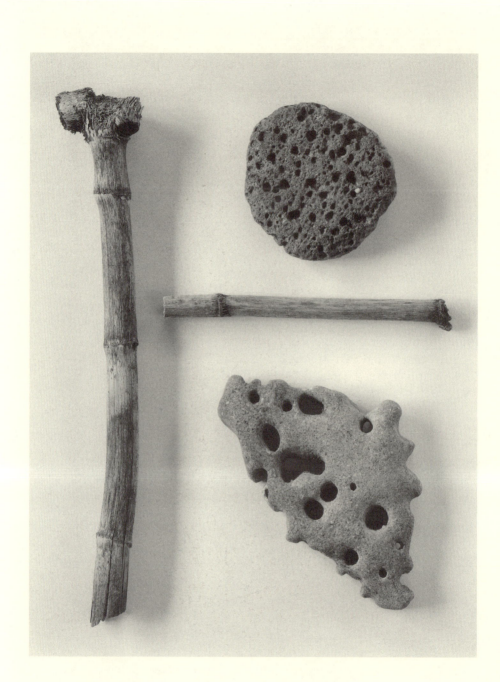

FIGURE 2.7.

Joan Myers, *Garden Objects*, 1984, from *Whispered Silences*

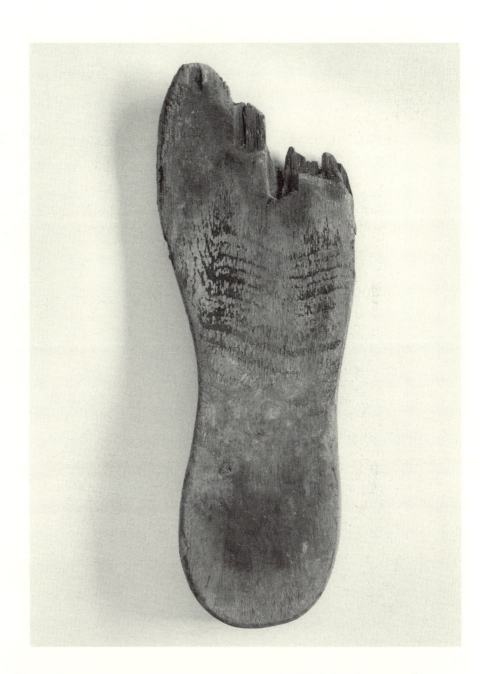

FIGURE 2.8.

Joan Myers, *Wood Shoe Sole*, 1984, from *Whispered Silences*

what they could carry: bedding, toilet articles, extra clothing, enamel plates, and eating utensils. The official silence refers, of course, to U.S. government secret documents and to a general shrouding of this chapter in our history. "When my search began, in the early 1970s, through the remains of Manzanar's past," Okihiro writes,

> I encountered a silence so deafening that I thought I would explode. Only a few of my generation knew or cared about the injustices of World War Two, and even fewer *issei* and *Nisei* offered to talk about that dark past. Now in retrospect, I understand that the silence formed a wall around Japanese America, creating a safe space for children to grow up free from the violence and hatred of the world beyond. But the silence was also a harsh lesson learned in the classrooms of the instigators and keepers of the concentration camps. "Be quiet," they told us repeatedly. "Ignore the slurs, scornful gazes, harmful deeds. . . . Disappear and you will eventually be rewarded. Be quiet or else." The camps, like all traumas, loomed large upon our collective memory. They told us that we mattered little, we were disposable, we were vulnerable and powerless. Silence brought us peace . . . but it also required a forgetfulness of the past, an absence of speech and expression, and a negation of identity and self. (221)

Like other photographs in this series—a broken fly swatter, handmade from window screen and wire, looping to form the handle with such elegance that an ordinary object becomes a thing of beauty (fig. 2.9); expressive arrangements of tools; a pail handle and nails; a translucent medicine bottle—this photograph speaks as a record of what has been buried and exhumed. It also speaks in its own right—that is, as a photograph—in terms of the strong light on the pan and cup against the dark ground. It is as if the camera sees what we have been unable to see: a literal bringing to light, and an assembling of shards and fragments to piece together a story. The way these images are put together and presented, arranged and lit, is artful. In the case of the pan and cup, handles create a strong diagonal line and the dark rims, especially of the pan, whose lip faces the viewer, shapes a rounded interior; a flat, two-dimensional surface begins to seem three-dimensional, and everyday kitchenware becomes something of value. In other words, these are not simply documents, as the title might lead us to think. Myers is not doing only ethnographic work but a picturing that commands the attention and respect of priceless objects.

The result of this strategy—of the artistic and moral decisions Myers has made about presentation, lighting, and in many cases, decontextualization—is a visual and psychological irony. Exhibited so cleanly and beautifully and respectfully, these objects collectively and simultaneously represent a distancing (they are isolated relics from another time), eliciting an intellectual, aesthetic—a cool— response *and* a bridging of distance (an unearthing of what has been covered up), engendering in the viewer a profound disturbance. And I think that Myers's seemingly neutral offerings are intended to create this disjunction and discomfort. That is, in exact proportion to heightened attention and respect is a keener awareness of what else has been uncovered in the last half century: to read these photographs together with Okihoro's narrative, as we are meant to do, we must hold in mind the awful simultaneity of our government's secret work of building bombs to be detonated above Japanese cities and its public work of rounding up and incarcerating all American citizens of Japanese descent living on the West Coast. Many of those interned had sons and daughters in the American military: about twenty-five thousand Japanese American men and women served in the U.S. Armed Forces in World War II, according to Okihiro, whose father left Hawai'i knowing that his parents were in a little village just outside Hiroshima, that his brother was probably in Japan's military, that his own country distrusted him and his kind, and hoping that his service would shield his two younger brothers from internment. Okihiro's mother, a new bride, performed a daily ritual: she placed "cooked rice daily before the family altar in a bowl with a lid to keep it fresh." "If the moisture was gone from the lid," Okihiro recounts, it would mean "that my father had been killed. My mother performed the ritual religiously each day, forgetting only once and discovering to her horror that the lid was nearly bone dry" (214). She learned shortly afterward that her husband had been seriously wounded.

It is the purity of that new bride's ritual that Myers's visual narrative, in counterpoint to Okihiro's written narrative, suggests and denies. The accretion of bent and broken pieces is the material evidence of rituals shattered and preserved and of the literal wounding of sentient human bodies, of "the making and unmaking of the world."[21] Yet Myers's role, in unearthing, recording, and memorializing these objects, is that of transcriber—in her own naming, a visual archaeologist, working in sites that are more than ruined gardens and china dumps. These are her photographs, but she is outside the story, unlike Okiihiro, who describes his search for his story

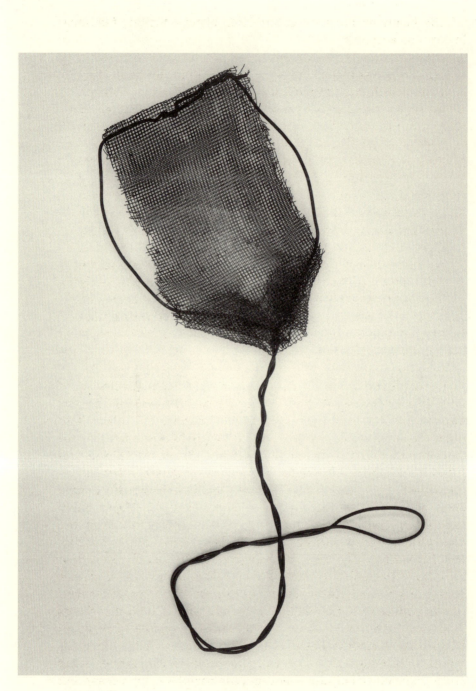

FIGURE 2.9.

Joan Myers, *Fly Swatter*, 1984, from *Whispered Silences*

within the master narrative of American history. Visiting Manzanar in 1972, he writes:

> The place was indeed sacred. I felt it within my bones, as I wandered through the remains of the camp. I easily made out the concrete foundations and support blocks, and determined which ones served as barracks for the internees and which ones as the toilets, washrooms, and mess halls. I could see them, as clearly as the desert sky, the flimsy structures of two-by-fours covered with tar paper nailed to joists with wood strips. Small windows let light into barren rooms barely ten by twenty feet, but they also let in the cold and heat and the ever present dust and sand. Row upon row of these barracks, spare and drab, extended in straight lines that converged where earth met the sky. Voices still echoed in that empty desert place. . . . And because of the lucid stillness, I distinctly heard Manzanar's women and men in the broken china and bent forks heaped at the garbage dump, in the stone paths that led to their living quarters, in the ruin that was once a magnificent reflecting pool. (92)

These shards and utensils, present also in Rubenstein's re-creation of Edith Warner's dinner parties for Los Alamos scientists, link the very different work of Myers and Rubenstein as narratives of place. Both photographers would agree, I think, with philosopher Edward Casey's notion that "lived bodies belong to places and help to constitute them," that "places belong to lived bodies and depend on them," and also with his sense that the peculiar hold that places have on us has to do with the way in which places *gather*. Places gather experiences and histories, languages and thoughts, memories and expectations.[22] For Myers, each thing gathered offers itself to our contemplation as a way of re-membering the smallest detail: recovering, recording, and offering remnants of a buried past are a way of *con*figuring place. If these gatherings "speak" to us, we understand that inanimate things connote animate entities and also that things held onto have a hold on us. For Rubenstein, on the other hand, because Los Alamos is a place of convergence, what that place gathers can only be suggested, or must be imagined, by re-creating a sense of the collision of cultures—not only by the photographer and her collaborators, but in a way that demands the viewer-listener's active participation as interanimating presence. In her complex layering of objects and people and cultures as pieces of installations, her own

work is not only picturing but also touching and shaping, and that of her audience is to make something of the constructed concurrence of visual, aural, and tactile forms.

In writing this piece, in thinking about history and memory and place, especially cultural histories and memories that are so difficult to sort out and acknowledge, I found it helpful to turn to Rachel Fermi's linear photographic history of Los Alamos, which she compiled in an attempt to come to terms with the heritage of her grandfather, Enrico Fermi. Her book, *Picturing the Bomb,* is a much more literal account than Rubenstein's; yet she, too, grounds the Manhattan Project in the place, Los Alamos, using this quotation from Edith Warner as an epigraph: "Mesas and mountains, rivers and trees, winds and rains are as sensitive to the actions and thoughts of humans as we are to their forces. They take into themselves what we give off and give it out again."[23] Warner's words are deeply unsettling in retrospect, particularly when juxtaposed to the projects of Myers and Rubenstein, which remind us that beyond the long-range damage to the environment that now threatens us all, a particular race was targeted by the work that went on in those mesas and mountains.

In closing, I want to dwell on the issue of race by returning to the site of the development and testing of the atomic bomb. What happened to the trees and the rivers and the mountains and also to the Pueblos whose land it was is the subject of Laguna Pueblo writer Leslie Marmon Silko's book *Ceremony,* in which a Pueblo man named Tayo returns from military service in Japan as a dysfunctional human being. Understanding finally comes to him through his grandmother, who tells him the story of seeing something "so big, so bright even my old clouded-up eyes could see it." Mystery unravels when he realizes that Trinity Site, where the first atomic bomb was exploded, is only three hundred miles to the southeast; and that the top-secret laboratories at Los Alamos, still surrounded by high electric fences, on land taken from the Pueblos, deep in the Jemez Mountains, are only a hundred miles to the northeast. "There was no end to it; it knew no boundaries; and he had arrived at the point of convergence where the fate of all living things and even the earth, had been laid," he realizes. "From that time on, human beings were one clan united by the fate the destroyers planned for all of them, for all living things; united by a circle of death that devoured people in cities twelve thousand miles away, victims who had never known these mesas, who had never seen the delicate colors of the rocks which boiled up their slaughter." Tayo kneels at a mine shaft and picks up an ore rock:

The gray stone was streaked with powdery yellow uranium, bright and alive as pollen; veins of sooty black formed lines with the yellow, making mountain ranges and rivers across the stone. But they had taken these beautiful rocks from deep within earth and they had laid them in a monstrous design, realizing destruction on a scale only *they* could have dreamed. He cried the relief he felt at finally seeing the pattern, the way all the stories fit together—the old stories, the war stories, their stories—to become the story that was still being told. He was not crazy; he had never been crazy. He had only seen and heard the world as it always was: no boundaries, only transitions through all distances and time.[24]

From Tayo's point of view, all the stories—the old stories, the war stories, the story of destruction that was still being told—cohere, because they are all the story of the oppressor. Understanding this story as a master narrative allows Tayo to begin to recover his own stories (these are complicated because he is a half-breed) and, through this process, to find his way back to the communal ceremony that is necessary to his own healing. It hardly needs saying that his is a different project from that of either Myers or Rubenstein. Myers neither claims the story of the gathered pieces nor insinuates a story of her own. That is, she does not piece together the shards of china, reconstruct the tools, the gardens—or the lives of those who used and made these objects. Rubenstein presents as equal narratives of Los Alamos the stories of the woman who ran the tearoom, of her Indian companion, of the physicists, of their wives, of the Pueblos who served them dinner and with whom they worked side by side to build Edith Warner's house. The making of a house, even the making of a chocolate cake are set alongside the making of the bomb, or set against the unmaking that was the bomb's unfolding story: all these stories convey the "evidential force" of what was there.

Notes

1. John Berger and Jean Mohr, *Another Way of Telling* (New York: Pantheon, 1982), 279–80.
2. Roland Barthes, *Camera Lucida: Reflections on Photography,* trans. Richard Howard (New York: Hill and Wang, 1981), 88–89.
3. Marianne Hirsch, *Family Frames: Photography, Narrative, and Postmemory* (Cambridge, Mass.: Harvard University Press, 1997), 22.

4. Rebecca Solnit, "Meridel Rubenstein: 'Critical Mass,'" *Artspace* 16:4 (1992): 46.

5. Meridel Rubenstein and Ellen Zweig, "They Spoke to the Angels," *Conjunctions* (Spring 1993): 165–66.

6. Meridel Rubenstein and Ellen Zweig, with Steina Vaskula and Woody Vaskula, *Critical Mass* exhibition catalog (November 1993), 4.

7. Cited in Evelyn Fox Keller, "From Secrets of Life to Secrets of Death," in *Body/Politics: Women and the Discourses of Science*, ed. Mary Jacobus, Evelyn Fox Keller, and Sally Shuttleworth (New York: Routledge, 1990), 181–82.

8. Rubenstein and Zweig, "They Spoke to the Angels," 166. Material on Edith Warner and her interaction with Los Alamos physicists is drawn from Peggy Pone Church, *The House at Otowi Bridge: The Story of Edith Warner and Los Alamos* (Albuquerque: University of New Mexico Press, 1959).

9. Cited in Rubenstein and Zweig, "They Spoke to the Angels," 172.

10. See Peter Bacon Hales, *Atomic Spaces: Living on the Manhattan Project* (Urbana: University of Illinois Press, 1997).

11. See Rachel Fermi and Esther Samra, *Picturing the Bomb: Photographs from the Secret World of the Manhattan Project* (New York: Abrams, 1995).

12. Feynman and Szilard cited in Keller, "From Secrets," 178, 180.

13. Cited in Keller, "From Secrets," 178, 180; ibid., 181.

14. Edmund J. Ladd, Museum of Indian Arts and Culture, Santa Fe, New Mex., "The Big Shell," wall text and audio recitation for *Critical Mass* exhibit, June 1993.

15. Rubenstein and Zweig, "They Spoke to the Angels," 184–85.

16. Joan Myers, correspondence with the author, January 2, 2000.

17. Ansel Adams, *Born Free and Equal: The Story of Loyal Japanese-Americans* (New York: U.S. Camera, 1944), 112. See my analysis of the work of Lange, Adams, and Miyatake in *Women's Camera Work: Self/Body/Other in American Visual Culture* (Durham, N.C.: Duke University Press, 1988), 271–93.

18. Myers, correspondence with the author, January 2, 2000.

19. Edison Tomimaro Uno, introduction to Maisie Conrat and Richard Conrat, *Executive Order 9066: the Internment of 110,000 Japanese-Americans* (Cambridge, Mass.: MIT Press, 1972), 10–11.

20. Joan Myers and Gary Okihiro, *Whispered Silences: Japanese Americans and World War II* (Seattle: University of Washington Press, 1996), 94–95. Subsequent references are cited parenthetically in the text.

21. Elaine Scarry, *The Body in Pain: The Making and Unmaking of the World* (New York: Oxford University Press, 1985).

22. Edward J. Casey, "How to Get from Space to Place in a Fairly Short Time," in *Senses of Place*, ed. Steven Feld and Keith H. Basso (Santa Fe: School of American Research Press, 1996), 24.

23. Fermi, *Picturing the Bomb*, 23.

24. Leslie Marmon Silko, *Ceremony* (New York: Viking, 1977), 245–46.

Still Moving Images:
Photographs of the Disappeared in Films
about the "Dirty War" in Argentina

CATHERINE GRANT

I

> [I]n the cinema, no doubt, there is always a photographic referent, but this referent shifts, it does not make a claim in favor of its reality, it does not protest its former existence; it does not cling to me: it is not a specter.
>
> *Roland Barthes,* Camera Lucida

Motion pictures are usually composed of a series of photographically recorded, still images.[1] Very few narrative films, however, choose to foreground their photographic origins. Indeed, critics have maintained in accounts of the "basic"[2] differences between photography and film that the illusion of movement, created in large part by film's rapid, successive projection of its still frames, appears to "destroy," to a large extent, the potential power and action *as* photographs of these frames.[3] Although theorists such as Roland Barthes, Peter Wollen, Raymond Bellour, and Christian Metz have produced highly suggestive meditations on the ontological differences and similarities between film and photography,[4] I would argue that the spheres these writers circumscribe as "the photograph" and "film" are rendered so abstract in most of their accounts as to be of only limited practical use

to examinations of actual films and their relation to photography in particular contexts. To give one example of what I mean by this, the "power" of photographs is not always treated "destructively," or even irreverently, by films. In fact, the opposite is often the case. In ways that generally go unacknowledged by commentators, photographs make regular and *salient* on-screen appearances: they are important devices in film narration; they are frequently deferred to as *the* central objects in the frame; and they are even "imitated" by films through the use of freeze-frames and other aesthetic contrivances.[5]

In this chapter I explore some of the practices surrounding the diegetic interpolation of still photographs in narrative films, by examining a case in which both the photographs and the films are especially loaded with political and emotional significance. The case is that of the use of photographic portraits of the Disappeared (*los desaparecidos*), primarily in documentaries about acts of political resistance, "melancholic" memorializing, and mourning occurring in the aftermath of Argentina's "Dirty War," which took place between 1976 and 1983. I briefly examine aesthetic aspects of this narrative interpolation, such as the ways in which these portraits are framed by the films; their connection with forms of linguistic discourse, including captioning, dialogue, and voice-over; and the relationship between their (apparent) stillness and (emphasized) motion. But, more prominently, I consider how the films play, or opt not to play, on the capacity of the photo-images to move us *still*, after nearly two decades of changing film practice and reception and of changing narratives of national and international politics. Despite my determinedly *situated* interest in these particular films at this particular time,[6] then, this last thread of my discussion engages with aspects of ontological accounts of the "power and action" of photographs in the narrative medium of film.

II

In [these] photographs . . . , we see faces looking ahead towards a future they were never to have. The photograph's temporal irony elicits mourning and empathy.

Marianne Hirsch, Family Frames

The films that I focus on in this chapter are documentaries. The photographic portraits they incorporate, therefore, are usually of actual disappeared people. This raises questions pertaining to their index-

icality.[7] I would like to introduce my discussion, however, by examining a fictional film narrative, albeit one "based on a true story."

Some fifteen minutes into the harrowing feature *La noche de los lápices* (The Night of the Pencils; Héctor Olivera, Argentina, 1986), the film's high school protagonists achieve a joyous if temporary victory in their activist struggle for the right to discounted rates for public transport. The students, who soon will be shown being brutally abducted by forces acting for the military in the first days of the dictatorship, visit the city hall in La Plata to have their identity photographs and travel passes officially validated. In the next sequence, filmed outside in the main square and accompanied by an upbeat musical theme from the film score, Pablo (the only one of the group who will be released, after four years of captivity and torture, eventually to tell the story of their illegal arrest) takes snaphots of his fellow pupils, in group poses and on their own, as they triumphantly display their new identity cards. We see the shots Pablo takes of them from his optical point of view, supposedly through his camera lens. The striking testimonial significance of these filmed "photographs within photographs" is underlined at least twice more by the film's narration: once immediately, as the previously moving shots of the photographed individual students are shown again at the close of the sequence in a series of freeze-frame images; then once more, at the film's close, as the freeze-frame montage is repeated, this time in silence, in an elegiac, "roll call" gesture; or, as Alberto Ciria describes it, in "a brief commemoration" (*un breve recordatorio*).[8]

While this device may seem, on the surface, to run the risk of cliché, I would argue that the freeze-framing actually performs quite complex and paradoxical kinds of mourning and memory work in this fiction film, especially when viewed in the immediate context of the film's production. Both types of photographs represented in or suggested by the frames (public ID card and especially private snapshot) provide material evidence, at the end of the diegesis, to remind us of the Disappeared characters' preabduction appearance—the *vanitas* aspects of their unblemished youthfulness and their joy—as well as of the very fact of their *having been there* before the camera. Furthermore, along with the opening and closing credit sequences, both of which make truth-claims for the film-story, the self-consciously "evidential" photographic style of the freeze-frame sequences also potentially serves to remind the audience that *La noche de los lápices* is based on the *real* Pablo's account of the disappearance of his six high school friends, abducted along with an estimated Dirty War total of 232 adolescents.[9]

Each of these epistemic and aesthetic elements draws for their

legibility and much of their affective power on established social conventions for the viewing of photographs of people who have died. As Marianne Hirsch writes of certain art installations that employ photography to memorialize, directly and indirectly, the victims of the Holocaust, such aesthetics are "based on the identifications forged by familial looking [at photographs]."[10] In a similar way, the photographic "temporal ironies" presented to us by the freeze-frames potentially not only induce an individual *punctum* (a piercing, or poignancy), that small psychic trauma described by Barthes as the form of grief we experience, inter alia, when looking at certain photographic portraits and thinking *"He is dead and he is going to die . . ."*[11] They also provide a scene through which the audience may have access to collective forms of mourning and empathy: scenes typically occasioned by popular, public cultural forms such as cinema. This is especially the case with the kind of metonymic reference to large-scale tragedy and trauma—six youngsters standing for hundreds of others—that *La noche de los lápices* makes in these freeze-frames.[12]

But the film has an ambivalent relation at most to encouraging the audience actually to *mourn* its characters. In fact, it cannot explicitly memorialize them as *dead*, because what happened to them after the real Pablo was released was not known. There are the anguished words uttered by one of the characters to Pablo as he is being taken away: "We are already dead" (Nosotros estamos muertos). Crucially, however, the rest of the film's discourse (its story-events, dialogue, and credits) only acknowledges the six explicitly as *disappeared*. Just before the sound track goes silent to accompany the second montage of freeze-frames, the surviving character Pablo screams the final words of the film's dialogue to his friends as he is dragged away from their cells: "You're going to get out!" (¡Ustedes van a salir!). Nonetheless, the aesthetics of the freeze-frame photos immediately counteract his assertion: even as they testify to the life of their subjects, they must also, conventionally, make the audience contemplate their almost certain death.

III

Film gives back to the dead a semblance of life, a fragile semblance but one immediately strengthened by the wishful thinking of the viewer. Photography, on the contrary, by virtue of the objective suggestions of its signifier (stillness, again) maintains the memory of the dead as being dead.

Christian Metz, "Photography and Fetish"

La noche de los lápices was released in 1986, only three years after Argentina returned to democratic rule. This makes it an example, along with other films made in the immediate aftermath of the dictatorship, of what Ximena Triquell calls "testimonial cinema" (*cine testimonio*): that is to say, a cinema made in the heat of the moment, not in order to analyze, explain, or understand what happened but simply to tell; "to put the wounds of History into a story" (poner las heridas de la Historia en una historia).[13] Nonetheless, the film's "story," in particular its ambivalence about the conventional association of testimonial photography with death, was always already circumscribed by that particular History.

The year 1986 was when the Argentine democratic government, led by Radical Party president Raúl Alfonsín, under pressure from the prospect of repeated military coups, passed the "Full Stop" Law (Ley de Punto Final), a statute of limitations on further prosecutions of those responsible for abduction, torture, murder, and other human rights abuses perpetrated during the dictatorship. The following year, another piece of legislation allowed those convicted or under suspicion of such offenses to have recourse to the mitigating plea that they were only carrying out orders. These laws ensured that hundreds of people escaped trial or incarceration for their offenses. Many others were later released by the Peronist president Carlos Menem, who also pardoned the military leaders in 1990. Hundreds of thousands of people took to the streets in these years to defend their democracy and to protest against the Full Stop and Due Obedience legislation and later against the official pardons. There was great disappointment in particular that Alfonsín, who had swiftly set up a process of investigation into the crimes committed by the military and its supporters, which included the establishment of the National Commission on Disappeared People (CONADEP), with its well-known report *Nunca más* (Never Again), should seemingly have abandoned his society's quest for knowledge and justice, in favor of a much more limited version of "national reconciliation."

The context of the public protests in Argentina in the mid-1980s to mid-1990s, then, was that of unfinished business for many, especially for members of the most famous human rights organization, the Madres de Plaza de Mayo (Mothers of the May Square). The women-only organization had paraded around the square outside the government buildings almost every week since 1977, to demand the safe return (*aparición con vida*) of their sons and daughters presumed to be among the thousands of people disappeared at the hands of the military in their self-declared Dirty War against "subversion."

They wore white headscarves to identify themselves as a group and often carried individual snaphots, ID photos, and other mementos of their children. After the military regime finally announced democratic elections, very little if any information was forthcoming about what had happened to their loved ones. So the Mothers simply expanded their struggle, adopting new tactics to attract the attention of press and broadcasting organizations. As Diana Taylor has written of the campaigns they waged during and immediately after the dictatorship:

> Over the years, the Madres' notion of motherhood had gradually become political rather than biological. They came to consider themselves the mothers of all the disappeared, not just their own offspring. Their spectacles became larger and increasingly dramatic—they organised massive manifestations and marches, some of them involving up to 200,000 people: the March of Resistance in 1981, and again the following year; in 1982 the March of Life and the March for Democracy; in 1983, at the end of the last military Junta, they plastered Buenos Aires with the names and silhouettes of the disappeared. In 1986, when it became clear that Alfonsín's government would do nothing meaningful to punish those responsible for the atrocities, they staged the March for Human Rights as a procession of masks.[14]

Just as Taylor traces a motivational shift from biological motherhood to a more broadly based "political motherhood," she also sketches out a representational shift from the tactical use by the Mothers of personal, familial memorabilia toward, in addition, the strategic deployment of other, much less personal forms of metonymic illustration (silhouettes, masks, etc.). As for photographs, although the Mothers clearly used these initially for their testimonial and evidentiary status, as the physical scale of public demonstrations increased, the direct, personal associations of the photos became imbricated with their spectacular, memorializing effect. The aesthetic emphasis in the campaigns shifted, then, from the relatively straightforward indexical function of the photographs ("Here pinned to my body is a picture of *my* daughter who has been 'disappeared': where is she?") toward an ever greater *iconic* significance ("Here are *masses* of photos of all the disappeared children of our nation, criminally taken in the prime of their lives: where are they?"). Understandably, this representational shift was not entirely "comfortable": the function of the individual photograph *as index*

cannot just "disappear." As Taylor writes in another of her excellent studies of the Madres' theatrical tactics:

> The photos paraded by the Madres . . . are powerful evocations of their loved ones. . . . [L]ike magic fetishes, [they] keep the dead and brutalized bodies forever "alive." They tempt us to see them as "natural" and transparent manifestations of the "real." Thus it seems treasonous to resist that view by insisting on the iconic quality of these photographs. It is as if the recognition that the photo works as a powerful icon in the battle to establish meaning and set the record were somehow incompatible with the victims' humanness, undermining thus the very authenticity that supports political struggle. The political exigencies seem to beg for the uncritical acceptance of the object as the thing itself.[15]

Yet, while Taylor's analyses of the Mothers' "performances" have a great deal to recommend them, I would argue that something quite important is lost in her account of the changing materiality of the Mothers' long campaign. Her studies rely primarily on a mixture of historians' and witnesses' narratives, including her own, as someone who visited Buenos Aires in the aftermath of the dictatorship. Although she uses photographs of the Mothers' campaign activities very effectively to illustrate her work, she does not make such mediated "records" her object, preferring instead to offer her own and others' verbal evocations of the period as primary evidence. If, by contrast, attention is turned to the media rather than to the supposed content of "historical records" and narratives, I would argue that an even more complex account of the role of photographic representation at this time can emerge.

If, for example, we examine film documentaries containing footage of the Mothers' demonstrations produced from the early 1980s onward, it becomes clear that the kind of photographs that became preeminent in the "iconic" struggles for justice in human rights marches were formal portraits (passport and identity photos) rather than personal family snapshots. This is certainly shown to be the case with one of the most widely distributed documentaries, *Desembarcos/When Memory Speaks* (Argentina-West Germany, 1989), directed by the renowned German-Argentine filmmaker Jeanine Meerapfel and shot on location in Buenos Aires between 1986 and 1988.[16] This film follows the activities of a film workshop set up by the Goethe Institute and led by Meerapfel herself: a workshop that

provided space and facilities for three young directors to make their own short fiction films on topics connected to the Dirty War. In addition to showing sequences from the finished short films and of the process of their production, much of the documentary revolves around workshop discussions about political representation in an "amnesiac" society. It privileges discussions of the role of filmmaking as a tool to preserve the memory of the Disappeared and of the events of the dictatorship in the Argentine public consciousness. Yet the documentary's own production context coincided with events that meant it could not afford only to look *back* in time.

Desembarcos was made at the time of the campaign against the Full Stop Law by the Mothers and other groups and of further, ultimately failed military revolts against Alfonsín's government. Meerapfel responded to this atmosphere by filming two of the mass marches on May Square in December 1986, as well as a number of smaller rallies in the square. The first of the two march sequences, "The March of Resistance," takes place in daylight. Two camera positions predominate: a shot down on the demonstrators from on high as they pass by and shots from a hand-held camera up and down the front line of the march, where demonstrators are carrying a long horizontal banner that reads: "Safe Return [of our children]: The Mothers of May Square" (Aparición con vida: Las Madres de Plaza de Mayo). This camera also picks out in passing the small number of "photographs" of the Disappeared carried by the crowd near the front, some photocopied and blown up to cover a few large placards, others laminated and worn as necklace "pendants." The continuous chanting of the marchers is synchronously recorded but is accompanied by a matter-of-fact voice-over informing us that these marches were taking place at the same time as the film workshops. The voice-over is performed by Meerapfel in her role as the mediator of the film's events. The second of the two marches, again led by the Mothers but this time clearly directed against the Full Stop Law, takes place at night, with the same banner and similar displays of photos. Here, the documentary takes a more self-consciously dramatic, spectacular approach to its representation. There are a greater number and variety of high-angle shots, in addition to the two angles used to shoot the earlier march. The voice-over is absent, perhaps superfluous, and during the second half of the sequence, displacing the chanting, the film's principal, nondiegetic "theme" music strikes up, a tango-inflected waltz in which a range of urgent strings prevail. What these segments of the film orchestrate, with their sonoric and visual rhythms—the latter achieved by the movement of the crowd as well as by switches

between the proximity to the marchers of the hand-held shots and the dramatic distance of the crane shots—is accounted for by Elizabeth Cowie's concept of the "spectacle of actuality." Cowie argues that in nonfiction films "a greater conviction, and pleasure is achieved if the documentary can in some measure enable viewers to 'discover' [its] world for themselves, for . . . by taking the 'observing' camera's gaze as their own, viewers can feel that they are discovering the place and space of the documentary scene themselves."[17]

The film's "incidental," in situ photography of photographic material plays its own role in the creation of a convincing "reality" or "immediacy" effect, and I will come back to this later. But it also reveals that by 1986 the Mothers on these marches were using photographs for reasons other than, or in addition to, their symbolic valence as mementos. All of the photographs we see in this film are formal portraits (for passports or ID cards). Although they may be carried by relatives of the people represented in them, there is no sense that the film *requires* us to read them in this way: the camera simply picks them out fleetingly and moves on, not allowing the viewer time to read the legends (names, birth dates, dates of disappearance) that always seem to be inscribed on them. The effect of filming the photographs in this way is to foreground their spectacular value, at the expense of their *individual* testimonial significance: grainy black-and-white images of youthful people with 1970s hairstyles flash past the hand-held camera, while from the high-angle shot, the brief salience of photos held on high dissolves into the inexorable march of the crowd along the streets of the capital.

In Meerapfel's film, photos are only ever shown as part of an ongoing, collective struggle: personal or family photographs are never used to illustrate the numerous individual accounts the documentary represents about the past events of the Dirty War (stories of the disappearance of relatives of the filmmakers; the personal experience of torture of the sound engineer). Hence the aesthetics contrast with more conventional uses of photographs in documentaries. Furthermore, that these are exclusively ID photographs suggests that in the struggles for active memory and justice waged from the mid- to late 1980s onward, a preference was shown for the political currency furnished by a kind of "perpetrator image" used to represent the Disappeared.[18] Identity cards and passport photographs are precisely the generic images the state requires *of* its citizens, to prove their status *as* citizens (compare those held by the freeze-framed characters in *La noche de los lápices*). When Argentine citizens were "disappeared"—illegally arrested with no photo "mugshots" or fingerprints made available as evidence—

those responsible were setting aside the citizenship of a whole class of people. The deployment of identificatory visual material in the context of protest is thus a highly symbolic assertion of presence, in a public (and filmed) performance of active memory. And it articulates a striking, retrospective challenge to the military's pervasive suspension of habeas corpus during the Dirty War. The ironies staged by the incidental photographs in this film, then, are different from those "temporal ironies" described by Hirsch in the epigraph above. We are not allowed to contemplate the photos as "pathos-ridden" images of the Disappeared. Instead, we are forced to view them "on the move" and in the context, therefore, of another kind of narrative—that of the urgency of the collectivity to "re-member" the forgetting of their country's painful recent past.

IV

The compromise which normally concludes [the melancholic condition] consists in transforming the very nature of the feeling for the object, in learning progressively to love this object as dead, instead of continuing to desire a living presence and ignoring the verdict of reality, hence prolonging the intensity of suffering.

Christian Metz, "Photography and Fetish"

While Meerapfel's sophisticated solidarity film, made for Argentine and international audiences, seems to resist the "conventional" documentary temptation to deploy the representation of photographs to produce affect through what Jane Gaines has compellingly called "the pathos of the indexical (the 'tragically, *this happened*' effect),"[19] other international documentaries about the Dirty War, less concerned with solidarity and more concerned with other kinds of memorialization, have embraced it. For example, a "history" segment dealing with the dictatorship in *"New World, Old Order"* (United Kingdom–United States, 1992),[20] a film about Argentina from the founding of the Republic to the present, uses Rostrum camera shots of family photographs, as well as other footage of the same photos staged in situ in the family home of its "informants."

The film segment tells the story of two sisters. The younger was born in illegal custody, following the disappearance of her parents, but was reunited years later with her family after an investigation by her grandmother and a judge, both of whom are interviewed. Their

touching story is "illustrated" with lengthy close-ups of framed snap-shots of the parents, displayed on a side table. Interestingly, this attachment of particular photos to stories (told in absentia) of particular disappeared people, named and evoked by the voice-over, is echoed *inversely* in the rest of the film segment. Here we are shown contemporaneous footage of a 1992 rally held by the main breakaway group from the Mothers of May Square organization, the Madres de Plaza de Mayo, Línea Fundadora (Founding Line), alongside footage of a 1978 gathering in May Square of the original Mothers' group. Astonishingly, in neither piece of footage can any of the Mothers be seen to be carrying photos, as was and is their usual practice. This is significant because the film chooses to juxtapose found footage, which does not represent the customary (by the 1990s) public use of photographs of the Disappeared as *icons*, to its own filmed footage, which relies primarily on the *indexicality* of family photographs to produce its undoubted pathos.

I would argue that this is not "incidental": the film's clear asso-ciation with the Founding Line of Mothers alludes to the political and aesthetic choices involved in its own production context. In January 1986 (just before *Desembarcos* began filming), as Jo Fisher reported,

> ten of the original twenty Mothers who had formed the association in 1978 left the organisation to form a small break-away group known as *Las Madres de Plaza de Mayo, Línea Fundadora*. . . . It was a difficult and painful experience for all the women, the result of growing differences over leadership style and over the position the Mothers should take on government human rights policies. Members of the *Línea Fundadora* had grown increasingly uneasy about the Mothers' continued insistence, led by their spokeswoman Hebe de Bonafini, on *aparición con vida* [safe return of the Disappeared]. In their view, some government initiatives offered ways of dis-covering the fate of individuals that did not weaken the prin-ciple of the collective struggle, nor the demand for the trial and punishment of all those responsible for the disappearances.[21]

In the early 1990s, after pardoning the military junta leaders, the Menem administration began to offer financial reparation for fami-lies if they could prove that their relatives had been killed, through cooperation with forensic examination of the unnamed individual and mass graves discovered after the end of the dictatorship. In light of the amnesty, it is difficult to regard these initiatives as anything

other than an attempt to seek to subject to closure what had proved a highly damaging issue. By the time Menem launched his policy it was already possible, largely due to the Mothers' split, to distinguish at least two kinds of pro–human rights film *narratives* that had emerged from the mass struggles of the 1980s. There was the "old" narrative of those (epitomized by the main Mothers' organization) who, even after all this time, would not *publicly* recognize that their disappeared relatives and friends had perished. These groups *symbolically* refused to cooperate with the forensic investigation. They continued to demand knowledge, not about the whereabouts of the individual bones and bodies of the Disappeared, but about what had happened to these opponents of the Argentine military, along with other victims, *as a class of people.*

This was, for them, a form of knowledge that would be the prerequisite for proper justice. And then there was an alternative narrative, one now government sponsored, articulated on behalf of those (including the breakaway group of Mothers) who *did* want to achieve a form of closure and mourning, through burial and legal death certificates, rather than to continue with the publicly staged "melancholia," or refusal to acknowledge openly "the verdict of reality."[22]

In the 1992 documentary, *Terre d'Avellaneda/Tierra de Avellaneda* (Land/Earth of Avellaneda), a multinational coproduction directed by the Italian filmmaker Daniele Incalcaterra,[23] we can see further evidence of evolving narratives surrounding the iconic and indexical use of photos by groups and individuals caught up with the aftermath of the Dirty War. This film, like *Desembarcos*, was shot by its non-Argentine film crew around the time of contemporaneous events it attempts to "capture," between April and December 1992. The film's events take place after the amnesty of the military leaders, to which it refers in its opening credit sequence. It opts for the juxtaposition of "different" stories in what appears to be an attempt at representativeness: the spokeswoman of the main Mothers' group, representatives of the government, and an ex-Junta general are all given space to articulate their perspectives. The film focuses above all, though, on a pair of sisters, daughters of Disappeared parents they were too young to know, who were contacted by a team of official forensic specialists (Equipo Argentino de Forenses Antropológicos) investigating one of the "No names" grave sites at the time of filming. We see the sisters discussing their options, deciding to cooperate with the team, despite reservations (one is keener than the other to "lay the past to rest"). And we watch sequences of the scientists at work on the unmarked graves in the Avellaneda cemetery, interviewing the sisters and others

for information about the parents; taking their own photos of the remains; and sifting through the information in their headquarters.

The many photographs of the Disappeared shown in this film are always shot "incidentally" in situ, usually in the hands of those scrutinizing them, and are never obviously staged, as is the case of the family photo arrangement in *"New World, Old Order."* Each photograph shown is associated with a named disappeared person about whom we discover further information, and a number of photographs, almost exclusively family snapshots, are always presented for every case the scientists investigate. Ironically, the film reveals that for the purposes of identification of human remains, formal facial portraits (passport photographs, for instance) are not always the most up-to-date, most revealing form of evidence. In the sequences shot in forensic headquarters, photos are often scanned over (by scientists and the film camera) in the proximate presence of human remains. As Hirsch writes of the juxtaposition of family photographs of people who became Holocaust victims to photographs of atrocities from the Nazi concentration and extermination camps:

> [I]t is precisely the displacement of the bodies depicted in the pictures of horror from their domestic settings, along with their disfigurement, that brings home the enormity of Holocaust destruction. And it is precisely the utter conventionality of the domestic family picture that makes it impossible for us to comprehend how the person in the picture was, or could have been, annihilated. In both cases the viewer fills in what the picture leaves out: the horror of looking is not necessarily *in* the image but in the story the viewer provides to fill in what has been omitted.[24]

Like *"New World, Old Order,"* no photographs feature in any of *Terre d'Avellaneda*'s sequences containing footage of the Mothers' campaign. They appear only in the interwoven story strands the film privileges: the narrative of the sisters who were too young to know parents seen only in family photographs and who find out,[25] by lending photos, narratives, and other forms of knowledge to scientists, that these parents are dead; and the more general narrative of the forensic anthropologists. While close-ups of photographs and remains are rare in this film, and when used are only fleetingly held in the frame, it can be argued, nonetheless, that in making these juxtapositions (snapshots next to remains), the film is encouraging to a limited extent the kind of viewer response described by Hirsch. The film

also enables similar connections in its final sequence. The sisters (one of whom is more anguished than ever before by the greater knowledge she now has of her parents' fate) are movingly united with the remains of their parents at the cemetery. The earlier refusal to "milk" the photographs of the Disappeared for their pathos, or to exploit the human remains for their visual horror, all the while making subtler connections between both elements, seems indicative of the film's understated, reverent approach to its subject matter. There is no nondiegetic music to heighten expression and no narratorial voice-over: the documentary presents itself, instead, as a straightforward, respectful collage of events simply "taking place" during filming. The documentary ends somewhat regretfully and reverentially, with the memorial ceremony for the sisters' parents. This time they will be accorded a "proper" burial, with their names displayed.

It can be argued that the film chooses to present itself, along with the "real-life" struggles it records some ten years after the end of the Dirty War, as a sensitive "detective story," in which mourning is enabled by "science or investigation."[26] While it does not refer explicitly, in its "balanced" account, to the differing views of the Mothers' groups on the question of forensic investigation, there are already tensions in the uneasy narrative of partial solace presented by the key strands of the film. The questions about representativeness raised by political dissonances in *Terre d'Avellaneda* are habitual to debates about the fictional representation of horrific, real events, debates that are particularly well rehearsed in criticism of cultural texts about the Holocaust, for example. As Homi Bhabha writes in an essay on fictional representations of the people of a nation:

> [The people are] a complex rhetorical strategy of social reference where the claim to be representative provokes a crisis within the process of signification and discursive address. We have a contested cultural territory where the people must be thought of in double time.[27]

V

> As postmodern subjects is our generation not constructed, collectively, in relation to these ghosts and shadows, are we not shaped by their loss and by our own ambivalence in mourning them?
>
> *Marianne Hirsch*, Family Frames

In Argentina in the late 1990s, new campaigns for active memory (most notably, H.I.J.O.S, the organization for children of the Disappeared) joined their forces with those who had not ceased their fight for justice. After 1996, which marked the twentieth anniversary of the beginning of the dictatorship and during which enormous media interest was generated about the events commemorated by pro–human rights organizations, there was a discernible change in public opinion about the benefits of getting on with the future by leaving the past behind. During this period, former military collaborators in torture and disappearances began to come out of the woodwork and tell their stories. Under increasing pressure from campaign groups and the changing public mood, the courts began to move to investigate kinds of criminal activities that had not been included in all of the amnesty legislation: in particular, the abduction of children of the Disappeared who had been born in custody and sold to families sympathetic to the military juntas. Also, in a number of other countries whose citizens had been disappeared, or in which criminal acts had been performed against exiled opponents of the Argentine military regime (e.g., Spain), judges began to investigate the possibility of extraditing known individuals and commenced gathering evidence. It could be argued that the public, performed refusals to mourn, staged by the Mothers and other campaigns, were beginning to work.

Not surprisingly, given the level of media interest in the developments I have just described, documentaries about these events, produced inside and outside Argentina, began to proliferate. Here I compare the interpolation of photo-images of the Disappeared in a number of these more recent films. In them, questions of framing, of the relation of photograph to linguistic discourse, and of stillness and movement become increasingly significant. I also return to concerns I raised earlier about spectacles of actuality, to ask what happens to documentary spectacle when it endlessly recycles past images. In aesthetic terms, what seems to have happened is that just as documentaries on Argentina have proliferated, so too have the photos of the Disappeared within them. These iconic, grainy photos increasingly fill the screens. But what of the narratives these films tell?

In 1996 *Malajunta,* an Argentine film directed by Eduardo Aliverti, was released to commemorate the twentieth anniversary.[28] Aliverti's film mixes interviews and footage of present and past events with dramatic reconstructions, including a melodramatic reconstruction of paramilitaries invading houses to abduct residents. In general terms, the film's perceptual mode is consistently poetic rather than verisimilitudinous. Poems about loss, nostalgia, and mourning

are placed side by side with recordings of military speeches. This is a commemoration, a memorializing narrative of terrible events and people's response to them, rather than a "political" film about what ought to be done now. The film employs parallel editing to cut between three different pieces of footage of Mothers' marches in 1986: each piece of footage has a distinct kind of color saturation and grain, which communicates a sense of different archaeological strata, despite the fact that all were shot in the same year.

Almost everyone marching (unlike in the actuality footage shot in the same year for *Desembarcos*) is carrying a large placard adorned with a photographed face of a disappeared person. The sequences are linked by a postsynchronized recording of relentless chanting of the Mothers' slogan, "aparición con vida," in turn overlaid with nondiegetic music played to a slow drumbeat matching the rhythms of the marching and chanting. A later sequence shows a number of empty streets of Buenos Aires at the time of filming, adorned with triangular bunting on which are printed, in grainy black-and-white, hundreds of individual photographed faces of the Disappeared. At the beginning of the sequence, the film edits together the image of bunting hanging in May Square with an archival sound recording of the announcement in 1984 of sentences of life imprisonment for military leaders, following on from Alfonsín's human rights commission.

As the archival recording is faded out, the bunting is increasingly shown blowing about in a whistling wind, the noise enhanced by the sound track. Toward the end of the film, there is a photo montage sequence of full screen images of ID photographs of the Disappeared (again with different qualities of image grain, suggesting different "datelines"): each face is held on-screen for roughly one second and played out to the recital of a poem about the meaning of impunity by Juan Gelman, an Argentine forced into exile during the dictatorship. Many of the photos are cropped, seemingly taking us closer to the faces as the sequence progresses. The film closes immediately after this sequence with a cut to a black screen in the middle of which, in a smaller frame, appears a rapid succession of dissolves between different pieces of black-and-white footage depicting the streets in 1996 again, this time filled with demonstrators, surrounded by the bunting as before, and carrying cloth banners with yet more faces printed on them. This sequence is accompanied by mournful, contemplative, solo piano music. The frame in the center gradually increases in size, and the poem is reprised by the voice-over until the screen fades finally to black.

The excessiveness of the photographs in all of these sequences

is striking, though here they are clearly *photo-images* rather than photos: facsimiles of varied quality that have their new object status heightened by the film's presentation of them. There is no individual sense of indexicality: we are not allowed to contemplate any image for long, and in any case they simply defer onto the next generic 1970s face we know is coming, resulting in an iconicity of the mass, not of the individual. There is some written text at the bottom of the bunting triangles and the banners, but we can read no names. Instead we glimpse terrible words like "GENOCIDA" (genocide). Thus collectivized, the photo-images have become hauntingly re-reified, the uncanny objectification of an unfulfilled public wish for mass *aparición con vida* (the Spanish word *aparición* means "appearance," but also, as in English, "apparition" and "ghost").[29]

The remaining films I want to examine with *Malajunta* have a different context from that film but share a number of aesthetic aspects with it. All date from the late 1990s or from 2000. All are coproductions with Spain and are clearly directed (in part at least) at a Spanish audience, in the context of ongoing attempts to extradite "agents of international state terrorism and genocide." The films—*Argentina: punto y seguido* (Argentina: Full Stop, New Paragraph; Spain, 1998);[30] *Botín de guerra* (War Booty; Argentina–Spain, 1999);[31] and *Vivos en la memoria* (Alive in Our Memory; Spain [Catalonia], 2000)[32]—all contain interviews with Mothers' and Grandmothers' organizations in Argentina and their corresponding solidarity organizations in Spain. All inscribe direct, personal appeals to the camera for justice and solidarity. All use archival footage of past and present demonstrations, with photoplacards and banners. Interestingly, each film attaches individual stories of Disappeared relatives to *family* photos of those relatives (usually shown filling the frame in Rostrum camera shots).

These films seem to be presenting two narratives. The first is connected to a need in the new extradition context for *precision*. It is important to know detailed individual stories, aided by "illustration," because these are being used in legal evidence. For a similar reason, *Botín de guerra* provides a great deal of coverage of the campaigns of the Grandmothers of May Square and their continuing legal struggles to trace and reclaim their illegally "adopted" grandchildren. It might be expected, then, as is the case, that in these films there will be a greater reliance on attaching stories to photos by using voice-over narration or on matching the image with the sound recordings of interviews being carried out. But the second narrative presented is that which connects these "solidarity" documentaries with the poetic meditation on the Dirty War, *Malajunta*, and is the

narrative of genocide. Each of these Spanish films employs lengthy photomontages either of the sequential kind, like that of the penultimate sequence of *Malajunta*, or of a "photowall." The penultimate sequence of *Argentina: Punto y seguido* ends with a combination of these devices: some one hundred photo-images of the faces of the Disappeared are shown first in an establishing shot of the center of a wall or board covered with photos; next the film cuts to different, closer shots, then to a Rostrum tracking shot from left to right that picks out two of the rows; finally, in a very rapid succession of dissolves, the camera takes us close up to the wall, isolating single or paired images, all the while still moving from left to right along the wall. Once more the captions at the foot of each photo are impossible to read, either because they are too small or because the camera movement and dissolves are too fast. A sensation of speed is also conveyed by the breathy sound track, interspersing voice-over commentary on the continuing impunity of many of those responsible for atrocities with comments from interviewees.

These films are performing different kinds of memory and mourning work, but in all of them a privileged space is given over to this gesture of remembrance, always near or at the end of the narrative. Even in films in which the photo as individual index is privileged, there is an emphasis on the multiplicity of the images and on their interchangeability. In each of the films, the photo-images have continued to multiply: more than two hundred ID photos are shown in quick succession in *Argentina: Punto y seguido*, a metonymic representation of the close to seven hundred Spanish citizens thought to have been disappeared. These sequences are strikingly similar in conception and effect to the work of art installations that memorialize, directly and indirectly, the victims of the Holocaust, for example, those of Christian Boltanski. Like Boltanski's work, the Spanish films run risks with iconicity and indexicality. But these appear to be risks they are prepared to keep taking as efforts intensify to get people to "see" the crimes of the Dirty War as *genocide:* the intentional, systematic destruction of a class of people, those who, without any legal "evidence" offered, were implicitly accused by the fact of their abduction of being "subversives."

VI

Photographs promote forgetting.
Marguerite Duras, Practicalities

As Jacques Derrida writes in *Specters of Marx*,

> Mourning . . . consists always in attempting to ontologize remains, to make them present, in the first place by *identifying* the bodily remains and by localizing the dead. . . . Now, to know is to know *who* and *where*, to know whose body it really is and what place it occupies—for it must stay in its place.[33]

Played out in the film sequences discussed here is an iconic and indexical struggle over whether *or not* photographs should be deployed to attach identity stories, or particular bodies, to particular people (the two clearly delineated battle lines drawn by the Mothers, in the late 1980s and early 1990s at least). I have traced how certain films choose to personalize and individualize the stories they tell, through the display of family photographs, and to tell family stories around such photographs. But I have also examined the apparent refusal of a small number of other films to allow spectators access to such personalized photo-stories, by preventing them, in a variety of ways, from attaching names or other information to more generically portrayed disappeared people, even when this material is available on photographs for purposeful close-ups to capture.

In an article titled "Traumatic Memories of Remembering and Forgetting," Cowie examines what she argues is the unrepresentability of trauma, and therefore its unrememorability and inability to be forgotten, by addressing early silent documentary about shell-shocked, World War I soldiers, along with Alain Resnais's "false documentary" film, *Hiroshima mon amour,* of 1959. Of the latter Cowie writes: "The film imbricates a public history and a private memory, so that our relationship to the one becomes our relationship to the other."[34] She cites Marie Ropars-Wuilleumier's article on the same film: "Unless it is inscribed in bodies, History leads to the museum; the trace is at once an aid to readability and a sign of the unfamiliar; and if the reading still remains to be done, the writing-reading reminds us, by its surplus and its overflowing, of the loss of substance that the acquisition of meaning costs."[35] Cowie responds with the following remarks:

> It is the thing-in-itself of the memory/event as trauma, as affect, which the love affair represents, and it is this thing-in-itself which is the memory we can never have of Hiroshima, or of Auschwitz. Its very representation in "history" effaces

it as memory, becoming knowledge not affect. To remember trauma we make a detour through a woman's loss so that we arrive at memory as affect only to . . . lose this too. What had been trauma is now forgotten and therefore can be remembered.[36]

Just as Resnais's film stages this process,[37] so too, in different ways and at different times, do many of the documentary films I have examined. On the other hand, a small number of them consistently seem to privilege the public suspension or deferral of individual knowledge, or of a particular kind of personalized history, as if as soon as photo-images are publicly attached to the memory of particular bodies, or to the facticity of particular remains, the staging of an affective response will be drained of its symbolic power.

I began my chapter by evoking limitations intrinsic in accounts of the ontological differences between "film" and "the photograph." Roland Barthes's notion of *Ça-a-été*, the indexical "having-been-there" quality of the photographic referent, has proved crucial to such accounts. Hirsch writes of this concept:

> The "ça a été" of the photograph creates the scene of mourning shared by those who are left to look at the picture. . . . Photography's relation to loss and death is not to mediate the process of individual and collective memory but to bring the past back in the form of a ghostly revenant, emphasizing, at the same time, its immutable and irreversible pastness and irretrievability.[38]

From the phenomenological standpoint Barthes adopts in *Camera Lucida*, it is precisely these haunting qualities of the photographic referent that are disabled by the motion of film. In moving pictures, the image does not have the "completeness" it has in the still photograph: instead, it is "taken in flux, is impelled, ceaselessly drawn towards other views."[39] The photograph is "*without future* (this is its pathos, its melancholy)"; in it, there is no protensity, whereas "the cinema is protensive, hence in no way melancholic."[40] Cinema, therefore, cannot lend itself easily to the production of the *punctum*. Hirsch writes again: "On the one hand, the *punctum* disturbs the flat and immobile surface of the image, embedding it in an affective relationship of viewing and thus in a narrative; on the other, it arrests and interrupts the contextual and therefore narrative reading of the photograph that Barthes calls the *studium*."[41]

I would argue, though, that a historically contextualized aesthetic analysis of each of the films I have examined serves to complicate this account somewhat. When the films wish to move us emotionally, I have shown, they often choose to imitate the indexicality or stillness of photography, as far as this is possible in film. In addition, they may well compensate for the partial inability of film conventionally to achieve the same effects as photography—ultimately the film does have to "move on"—by employing other stylistic devices proper to a moving, audiovisual medium, such as dramatic framing, affecting music, and "personalizing" voice-overs recounting family stories. I have also examined how other films employ photographs in their mise-en-scène to "move" us in different ways, preferring to elicit collective "narrative" readings instead of or in addition to personalized affective responses. In any case, the most noticeable response evident in the most recent documentary films to the changing context of their national and international reception has been a gradual multiplication of photo-images. It may be argued that there will be a price to pay for this proliferation. Will the very ubiquity of these generic images and the ways in which they do, ultimately, keep moving— not just in the documentaries I have scrutinized but, more widely, in key practices of "communities of postmemory"[42]—lead to our increasing desensitization to the piercing affect of grief so eloquently articulated by Barthes? Will they promote our remembering or our forgetting? It will certainly be interesting to see where films about the Disappeared will go from here, if they are to "work" on us and to move us still.

Afterword

On April 6, 2001, while this essay was in the final stages of preparation, an Argentine judge, Gabriel Cavallo, declared the impunity laws (Punto Final and Obediencia Debida) to be unconstitutional and legally invalid, in response to a case brought to him by the Center for Legal and Social Studies (Centro de Estudios Legales y Sociales [CELS]). The declaration has opened up the possibility that hundreds of prosecutions for abduction, torture, and murder, suspended by the 1986 and 1987 legislation, will now be able to go ahead. Although Cavallo's decision is likely to be challenged in the Argentine Supreme Court, it nonetheless signals the continued success of human rights campaigners in keeping their struggle for justice in the public eye, both in Argentina and internationally.

Notes

Many thanks to the editors of this volume, as well as to the following people for their useful comments and suggestions after listening to earlier versions of this work: Roger Cardinal, Elizabeth Cowie, and Eirini Papadiki at the University of Kent; and Roy Boyne, Wendy Grossman, Marianne Hirsch, Andrea Noble, and Renée Vara at the Phototextualities workshop.

1. This is obviously not the case with audiovisual material recorded analogically or digitally on video. Only one of the films I consider in this chapter was recorded on video rather than on film.

2. See, e.g., Christian Metz, "Photography and Fetish," in *The Critical Image: Essays on Contemporary Photography*, ed. Carol Squiers (London: Laurence and Wishart, 1990, 1991), 155.

3. "[F]ilm is less a succession of photographs than, to a large extent, a destruction of the photograph, or more exactly of the photograph's power and action." Metz, "Photography and Fetish," 159.

4. See Roland Barthes, *Camera Lucida: Reflections on Photography,* trans. Richard Howard (London: Fontana, 1984); Peter Wollen, "Fire and Ice," *Photographies* 4 (1984); Metz, "Photography and Fetish"; Raymond Bellour, "The Film Stilled," *Camera Obscura* 24 (1990): 98–123.

5. In "The Film Stilled" Bellour does consider aspects of the freeze-frame at length. In particular, he asks: "What happens to film when the snapshot becomes both the pose and the pause of film?" (105).

6. This essay is one of a continuing series of mine on Argentine cinema of this period. See also "Camera Solidaria," *Screen* 38:4 (1997): 311–28; "Giving up Ghosts: Eliseo Subiela's *Hombre mirando al sudeste* and *No te mueras sin decirme a dónde vas*," in *Changing Reels: Latin American Cinema against the Odds*, ed. Rob Rix and Roberto Rodríguez-Saona (Leeds: Leeds Iberian Papers, 1997), 89–120; "Gender, Genre and the Social Imaginary in Some Films from Argentina's 'Cinema of Redemocratization' (1983–1993)," in *Cinema and Ideology*, ed. Eamonn Rodgers (Glasgow: Strathclyde Modern Language Studies, 1996), 17–33.

7. Notions of the photographic sign as index and icon are crucial to photography theory and derive from the narratological work of Charles Sanders Peirce. As Hirsch explains, the photograph is defined in the Peircean system "as both an icon, based on physical resemblance or similarity between the sign and the object it represents, and as an index, based on a relationship of contiguity, of cause and effect, like a trace or a footprint." Marianne Hirsch, *Family Frames: Photography, Narrative, and Postmemory* (Cambridge, Mass.: Harvard University Press, 1997), 6.

8. Alberto Ciria, *Más allá de la pantalla: Cine argentino, historia y política* (Buenos Aires: Ediciones de la Flor, 1995), 120.

9. Estimates of the total number of people who disappeared between 1976 and 1983 range between 9,000 and 30,000.

10. Hirsch, *Family Frames*, 267.

11. Caption of Alexander Gardner's "Portrait of Lewis Payne." See Barthes, *Camera Lucida*, 95.

12. While Barthes avoids basing his conceptualization of the *punctum* overtly on psychoanalytic precepts, Hirsch supports her argument about the identifications produced by familial looking at photographs with concepts heavily adapted from Lacanian psy-

choanalytic theory. See Hirsch, *Family Frames*, 11, 79–112. My own view, briefly, is that her very useful notion of the familial gaze need not be theorized solely from this perspective. For other, potentially useful frameworks for examining the formation of individual subjectivities under public and private "gazes," and of narratives of identity, that draw on phenomenological and symbolic interactionist sociologies, see George Herbert Mead, *Mind, Self, and Society* (Chicago: University of Chicago Press, 1934); J. H. Gagnon and W. Simon, *Sexual Conduct* (London: Hutchinson, 1974); W. Simon, *Postmodern Sexualities* (New York: Routledge, 1996); and Stevi Jackson, *Heterosexuality in Question* (London: Sage, 1999). Such frameworks are only now beginning to be adapted for film and cultural studies research.

13. Ximena Triquell, "Del cine-testimonio al cine testamento: El cine político argentino de los 1980 a los 1990," in Rix and Rodríguez-Saona, *Changing Reels,* 61.

14. Diana Taylor, "Performing Gender: Las Madres de Plaza de Mayo," in *Negotiating Performance: Gender, Sexuality and Theatricality in Latin America,* ed. Diana Taylor and Juan Villegas (Durham, N.C.: Duke University Press, 1994), 289.

15. Diana Taylor, *Disappearing Acts: Spectacles of Gender and Nationalism in Argentina's "Dirty War"* (Durham, N.C.: Duke University Press, 1997), 142.

16. First broadcast on Channel Four (U.K.), February 17, 1992, in the *Global Image* series.

17. Elizabeth Cowie, "The Spectacle of Actuality," in *Collecting Visible Evidence,* ed. Jane M. Gaines and Michael Renov (Minneapolis: University of Minnesota Press, 1999), 30.

18. This term is used compellingly by Marianne Hirsch in her contribution to this volume to invoke the way in which present-day memorializations of the victims of the Holocaust rely on and reemploy images taken by those responsible for atrocities. I am using it in a slightly altered sense to refer to a more symbolic than direct connection between "perpetrator" and "image": one that occurs in and follows on from a context in which the state ceased to observe the human rights of certain of its citizens.

19. Jane M. Gaines, "Political Mimesis," in Gaines and Renov, *Collecting Visible Evidence,* 99.

20. Produced and directed by David Ash. Coproduced by Central Independent Television and WGBH, Boston, and broadcast on British Channel Four in their *The "Other" Americas* series on October 26, 1992.

21. Jo Fisher, *Out of the Shadows: Women, Resistance and Politics in South America* (London: Latin America Bureau, 1993), 122.

22. Christian Metz's words on the differences between the psychic conditions of "mourning" and "melancholia," following the well-known account of Sigmund Freud. See Metz, "Photography and Fetish," 159.

23. Coproduced by LA Sept-Arte (France), ZDF (Germany), INA (France), in association with RAI3 (Italy) and Channel Four (U.K.).

24. Hirsch, *Family Frames*, 21.

25. Relevant here is Marianne Hirsch's concept "postmemory." "Postmemory characterizes the experience of those who grow up dominated by narratives that preceded their birth, whose own belated stories are evacuated by the stories of the previous generation shaped by traumatic events that can neither be understood or recreated." Hirsch, *Family Frames*, 22.

26. Françoise Davoine, cited by Ana Levstein, "La inscripción del duelo en el espacio público: Madres de Plaza de Mayo," in *Las marcas del género: Configuraciones de la diferencia en la cultura*, ed. Fabricio Forastelli and Ximena Triquell (Córdoba: Centro de Estudios Avanzados, Universidad de Córdoba, 1999), 98.

27. Homi K. Bhabha, "DissemiNation: Time, Narrative and the Margins of the Modern Nation," in *Nation and Narration*, ed. Homi K. Bhabha (London: Routledge, 1990), 297.

28. A highly resonant title, "Malajunta" signifies "Barren Ground" in Castilian Spanish but also suggests "Evil Junta"; and in Buenos Aires slang it means a "group of people up to no good."

29. A relationship suggests itself here with the most recent of the documentaries I have viewed in connection with this essay: *Invocación* (Spain, 2000). This examines various struggles in Argentina over active memory and mixes poetic "fiction" segments, a meditative autobiographical narrative, and interviews and actuality footage of demonstrations and memorial acts taking place in Argentina in 1999. The film, directed by Héctor Faver with Patricio Guzmán and Fred Kelemen, while containing much more verbal political discourse than *Malajunta* (it also attaches individual photos to individual stories, unlike the Argentine film, but very much like the other, more political films I examine shortly), nonetheless ends with a similar device: the camera zooms in slowly on a wall with hundreds of photo-images.

30. Directed by a Spaniard, Xan Leira for Canal + España. This film is shot on digital video.

31. Directed by an Argentine, David Blaustein.

32. Directed by two Spaniards (Catalans), Blanca de la Torre and Mireia Pigrou.

33. Jacques Derrida, *Specters of Marx*, trans. Peggy Kamuf (New York: Routledge, 1994), 9.

34. Elizabeth Cowie, "Traumatic Memories of Remembering and Forgetting," in *Between the Psyche and the Polis: Refiguring History in Literature and Theory*, ed. Michael Rossington and Anne Whitehead (London: Ashgate, 2000), 210. I am grateful to the author for sharing this important work with me in advance of publication.

35. Marie-Claire Ropars-Wuilleumier, "How History Begets Meaning: Alain Resnais's *Hiroshima mon amour* (1959)," in *French Film: Texts and Contexts*, ed. Susan Hayward and Ginette Vincendeau (London: Routledge, 1990), 183.

36. Cowie, "Traumatic Memories of Remembering and Forgetting," 202.

37. In her article Cowie is primarily interested in psychoanalytic questions concerning trauma and representation: "Trauma is a subjective, individual, but also unknown experience. How then can its unrepresentability be represented? How can we come to know trauma, and can we know the other's trauma?" ("Traumatic Memories of Remembering and Forgetting," 191). Related questions have been asked by researchers working in the context of postdictatorship Argentina (see, e.g., Antonius C. G. M. Robben, "The Assault on Basic Trust: Disappearance, Protest, and Reburial in Argentina," in *Cultures under Siege: Collective Violence and Trauma*, ed. Antonius C. G. M. Robben and Marcelo M. Suárez [Cambridge: Cambridge University Press, 2000], 70–101). Here I am simply borrowing the idea that certain texts "stage," or put in the frame and the duration of the film, particular narrative forms about traumatic events as opposed to others: my argument is that they do this in a particular sociocultural context. In the cases of *Hiroshima mon amour* and many of the films I have discussed, this has involved individualizing their narratives and drawing pathos from them in a variety of conventionalized ways (indeed, the screenwriter Marguerite Duras varied the formal elements employed in Resnais's film in a number of her other works). Although Cowie is content to examine the human experience of trauma in general and does not focus simply on film representation, I am not qualified to make a "psychological" case that extends beyond the observable aesthetic forms and conventions of use of the photographs and films that I have been discussing.

38. Hirsch, *Family Frames*, 20.

39. Barthes, *Camera Lucida*, 89.

40. Ibid., 90.

41. Hirsch, *Family Frames*, 4.

42. Ibid., 22.

PHOTOGRAPHY AND
NARRATIVE COMMEMORATION

Image—Memory—Text

NANCY M. SHAWCROSS

In the 1994 film *Smoke*—directed by Wayne Wang and written by Paul Auster—Auggie, a cigar store owner in Brooklyn, shares with a customer named Paul his hobby (or perhaps his obsession) of photographing the same scene at the same time each day, seven days a week, fifty-two weeks a year. The time is 8:00 A.M.; the scene is the intersection just outside his shop door, and he has been taking that shot for more than ten years. Not only does he faithfully set up his 35mm camera on a tripod each morning, but he also has the black-and-white film developed and then mounts the prints in typical black-page photograph albums, arranged chronologically. Paul cannot really understand the shopkeeper's mania: he haltingly suggests that the photographs are all the same. Auggie advises Paul to take his time, contending, "You'll never get it unless you slow down. . . . They're all the same, but each one is different from every other one." In his experiment-turned-adventure, Auggie has limited his variables to only one—time. The camera, the film, the printing, the photographer, and the camera's perspective never vary in any conceptually significant way. This photographic collection, Auggie says, represents "my project[,] . . . my life's work[,] . . . one little part of the world[,] . . . a record of my little spot."

Auggie's photograph albums serve as account books for the life

transpiring outside his shop door. They are organized and bound and await their readership. They offer, however, an uncommon form of narrative: one that complicates customary expectations and limits the use of text to captions consisting of dates. Rather than rely predominantly on a written narrative that is enhanced or augmented by photographs, Auggie's albums invert the pattern, making the text subservient to the image. Although this chapter focuses primarily on written narratives that include photographs, Auggie's albums signal that the manner in which we consider photography as a medium must be examined before any commentary on its use in written texts can be attempted.

In Western culture, the analog photograph has enjoyed a special relationship to time past. A mythology adheres that connects the photographic negative, for example, to the physicality of time past and not simply to the reconstruction of the past. Roland Barthes articulates this quality through the notion of "That-has-been." He writes, "In Photography I can never deny that *the thing has been there*. There is a superimposition here: of reality and of the past."[1] In what was considered by the photographic community an act in poor taste, Barthes failed in his 1980 publication, *La Chambre claire* (Camera Lucida), to consider at length—let alone praise—the photographer. He suggested instead that photography is capable of exceeding itself as a medium (and, implicitly, of exceeding the imprint of the photographer's hand and eye). The photographer and writer Wright Morris presages Barthes's point of view in an essay from 1978:

> If we were to choose a photographer to have been at Golgotha, or walking the streets of Rome during the sacking, who would it be? Numerous photographers have been trained to get the picture, and many leave their mark on the picture they get. For that moment of history, or any other, I would personally prefer that the photograph was stamped *Photographer Unknown*. This would assure me, rightly or wrongly, that I was seeing a fragment of life, a moment of time, as it was. The photographer who has no hand to hide will conceal it with the least difficulty. Rather than admiration for work well done, I will feel the awe of revelation. The lost found, the irretrievable retrieved.[2]

Aesthetic photography struggled throughout the nineteenth century for acceptance and respect. The Photo-Secession movement organized by Alfred Stieglitz in 1902 sought "the serious recognition of photography as an additional medium of pictorial expression."[3] The

movement tried to "erase the division between the way critics and the public viewed images made entirely by hand and those produced by a machine."[4] The concept of the photographer as auteur, promoted not only by a group of photographers themselves but also by an emerging critical community in the arts in the twentieth century, culminated in the 1960s with the acceptance of photography as a legitimate art form: an acceptance evidenced by the creation and growth of departments of photography at important art institutions, as well as by the establishment of museums devoted to photography and a plethora of photographic exhibitions. But the recognition of the photographer's centrality in the creation of the photographic image was gaining strength at a time when critical theory in the field of literature was questioning the notion of "author." In 1969 Michel Foucault not only asks "What is an Author?" he answers that "an author's name is not simply an element in a discourse. . . . [I]t performs a certain role with regard to narrative discourse, assuring a classificatory function."[5] And his conclusion regarding the classificatory function of "author" is as follows:

> The author is not an indefinite source of significations which fill a work; the author does not precede the works, he is a certain functional principle by which, in our culture, one limits, excludes, and chooses. . . . The author is therefore the ideological figure by which one marks the manner in which we fear the proliferation of meaning.[6]

The year before, in 1968, Barthes had argued for "the death of the author." He had worked to do away with the conceptual conceit that "the *explanation* of a work is always sought in the man or woman who produced it, as if it were always in the end, through the more or less transparent allegory of the fiction, the voice of a single person, the *author* 'confiding' in us."[7] It is no wonder, then, that he found it hard to embrace "Photography-according-to-the-photographer," to "accede to that notion which is so convenient when we want to talk history, culture, aesthetics—that notion known as an artist's style."[8] He suggests, in fact, that "Photography is an *uncertain* art,"[9] arguing instead that with a photograph one confronts "intractable reality."

As early as 1961 Barthes was struggling to understand the unique essence of the photographic medium and was puzzled by his conclusion that—at its root—the photograph represents a "message without code." At the same time, in the wake of the structuralist and semiotic speculations that emerged in the 1950s and 1960s, he and many others

exposed the discontinuity between writing and reality, causing history and historical memory to come under intense scrutiny. The conceptual concerns with which the work of Barthes and his peers engages—concerns that embrace issues of visual and narrative semiotics, authorship, and the writing of the real—traverse the exploration of literary texts proffered in what follows. This is not least because the scrutiny referred to above undoubtedly helped to empower certain kinds of writers and theorists who saw themselves as disenfranchised within the prevailing historical discourse. Some women authors, for example, did not recognize their lives, their ancestors' lives, or their ideologies in an academic canon too often presented as comprehensive and comprising what is culturally and artistically most important or worthwhile. Many sought redress through new critical approaches that valued the personal narrative and eschewed the tyranny of genre categorization. The memoir, for instance, as crafted by Maxine Hong Kingston in *The Woman Warrior* (1975), becomes the means not only to unbind her own Asian American voice but also to exhume and reanimate the lives of relatives silenced by society and family alike. Today this text sits ambiguously in the categories of nonfiction and literature, with some scholars even referring to it as a novel. In *The Stone Diaries* (1993), Carol Shields plays with the nonfictional genre of the diary to construct her novel and includes photographs to add an aura of authenticity to the deceit. And contemporary academics and theoreticians such as Alice Kaplan, Annette Kuhn, and Carolyn Kay Steedman have turned to autobiography and to the visual to recollect the past that shapes their present. The visual image is central to the work of all these writers: it suggests both the testimony of the analog photograph and the false or superficial construction of identity by others or even oneself. Sight emerges as a reconsidered source of information, knowledge, and self-awareness.

Maxine Hong Kingston's family "picture album" displays no photographs of an aunt who committed suicide in China. Until her mother mentions this aunt, in a cautionary tale about the shame of pre- and extramarital sex, Kingston had not been aware of her existence. The family attempted to obliterate all traces of the aunt's life, not only through the removal of physical evidence, but also through a bargain that tried to erase her mark in the minds and memories of those who knew her—a pact never to mention her name. In "No Name Woman," the first chapter of *The Woman Warrior*, the first line is "You must not tell anyone."[10] This conspiracy of silence represents a power play that seeks to "undo" past reality, to make the past "as if [the aunt] had never been born."[11] The authority of the word and of the transmis-

sion of history through language is forcibly conveyed to Kingston, who ultimately arms herself with a pen to assert her own being and to reinscribe the *actuality* of her aunt's existence in time. When neither image nor memory is preserved, a second death, a second crime is committed. Only text is left to Kingston to right the wrong. She cannot remember her aunt: she must re-create her through writing.

In her memoir *French Lessons* (1994), Alice Kaplan confronts a different but equally troubling effort to erase the particularity of the past. She reexamines the teachings of Paul de Man in the light of information disseminated after his death—information regarding collaboration with Nazis and his reinvention of himself in the United States after World War II. Through the tale of a fellow doctoral student who struggled with de Man's theory of deconstruction at Yale University in the 1970s and with her own story about choosing "to work on material that made history impossible to ignore,"[12] Kaplan argues that de Man's literary theory eliminated history: "deconstruction was about keeping person-ness away."[13] According to Kaplan, de Man focused so intently on wanting to know what literature was—"trim[ming] away anything that wasn't literature"[14]—that he removed not only history from his discourse but also himself from the analysis. Through her reconsideration of de Man's life story, the context of his experience and milieu during World War II, Kaplan discovers that the "blind spots"—the "places where language breaks down"—that she and her fellow students toiled to locate in their deconstructive critiques are just a metaphor for the blind spot in de Man's approach to literature and language. De Man's sleight of hand was to refute the ability of language to tell the truth—to *be* truth—without revealing his complicity in producing and promoting Fascist propaganda. While he acknowledged that "literature made a fool of his attempt to understand it,"[15] he maintained a fiction about his life that informed not simply who he was but also how he thought. Whether he meant to or not, Kaplan concludes, de Man made a fool of his students and others who attempted to understand and implement his ideas. His theory masked a need to deny truth as achievable and to eradicate individual human experience from the "reading" of a text. His reminder that one should not confuse theory with life becomes untenable for Kaplan. Not only does she find it "difficult, if not impossible, to think about deconstruction without thinking about de Man's collaborationist past,"[16] but she discovers that her posthumous assessment of de Man—his life and theory—forces her "to narrate [her] own intellectual history."[17] But autobiography, she states, in which de Man was interested, is "an impossible genre, a kind of emblem of deconstruction, where the more you try to confess, the

more you lie." Nevertheless, Kaplan argues, "the root of de Man's intellectual questions was in his own experience and pain."[18] The root, therefore, of her own intellectual integrity and clarity may well reside in understanding her own life history: "Now I'm helping my own Ph.D. students write their dissertations, and I don't want to fail them the way de Man failed me. How do I tell them who I am, why I read the way I do? What do students need to know about their teachers?"[19]

As indicated by the title of Kaplan's memoir, it is language, specifically the French language, that is the defining structuring factor of her life and its narrative recapitulation. Along the way, however, the photograph punctuates the narrative journey. Her recollection connects, for example, the death of her father when she was eight years old with the discovery of a cache of photographs in her father's desk drawer. In gray cardboard boxes "there were black and white photographs of dead bodies. . . . In several photographs hundreds of bony corpses were piled on top of one another in giant heaps."[20] Although aware that her father was a lawyer at the Nuremberg war crimes trials, Kaplan states that she "had never seen a dead body, not even in a photograph," until she uncovered these photographs taken by Mr. Newman, "a photographer for the Army when they liberated the concentration camps at the end of the war."[21] The photographs were used as evidence at the Nuremberg trials and confirmed for Kaplan not only the importance of her father's previous work but also the importance of, and her belief in, *facts*. For Barthes, as well, the photograph can testify to fact: a photograph he had cut out of a magazine that showed a slave market and which he had saved for many years "proves" the existence of slavery beyond a reasonable doubt, beyond the possibility of fiction inherent in written histories. He writes: "[T]he slavemaster, in a hat, standing; the slaves, in loincloths, sitting. I repeat: a photograph, not a drawing or engraving; for my horror and my fascination as a child came from this: that there was a *certainty* that such a thing had existed: not a question of exactitude, but of reality: the historian was no longer the mediator, slavery was given without mediation, the fact was established *without method*."[22] A well-known anecdote that concerns Susan Sontag and photography involves her account of viewing photographs taken at Bergen-Belsen and Dachau during World War II. Sontag states: "Nothing I have seen—in photographs or in real-life—ever cut me as sharply, deeply, instantaneously. Indeed, it seems plausible to me to divide my life into two parts, before I saw those photographs (I was twelve) and after, though it was several years before I understood fully what they were about."[23] Kaplan concludes in a similar vein: "That day when I was

eight, so powerful in my imagination that I often think it the basis of my entire sense of history, when I violated the privacy of my dead father's desk drawers and found the evidence from Nuremberg: photos from Auschwitz."[24]

As an adult, Kaplan can distinguish the difference between what the photograph provides and what it does not. When she interviews Maurice Bardèche, a Fascist intellectual and former tenured professor at the University of Lille, the memory of her dead father is palpable. She has a newspaper photograph of him, aged twenty-eight, "the young prosecutor at Nuremberg wearing his headphones, the man with the intense gaze. . . . He had earphones on to hear the testimony. He was listening, he was intensely focused, but I couldn't tell what he thought."[25] The photograph alone does not narrate; it does not explain; nor is it *precisely* a memory for Kaplan, in that she was not alive when the image was taken. She does not "remember" the trial and her father's participation: she has "learned" about the events in history, about what Barthes terms "that time when we were not born." Yet she realizes that "his image, silent and distant with headphones over his ears, [has been] a founding image for [her] own work."[26] Like the headphones that transmitted voices but absorbed testimony, the photograph of her father and the photographs of the death camps have no voice to give back but they can, nonetheless, *signify*.

Revisiting theory through autobiography is also a defining issue in Annette Kuhn's *Family Secrets: Acts of Memory and Imagination* (1995) and Carolyn Kay Steedman's *Landscape for a Good Woman: A Story of Two Lives* (1986). Like Barthes's *La Chambre claire*, these books were conceived or written shortly after the deaths of their authors' mothers. In her "biography" of her mother, Steedman challenges received ideas about theory and history and articulates the limitations of prevailing strategies for determining cultural and social meaning. Hers is "a book about stories; and it is a book about *things* (objects, entities, relationships, people), and the way in which we talk and write about them: about the difficulties of metaphor."[27] She understands that "memory alone cannot resurrect past time, because it is memory itself that shapes it, long after historical time has passed."[28] At times, therefore, she seeks out photographs to reconstruct the past: sometimes these images never existed or do not survive, but sometimes they do. Recalling her "first deception, the first lie," Steedman does not merely remember, that is, imagine, the day in June when she was young and smiled for the camera while feeling anger and depression over a preceding incident; instead she proclaims its authenticity and importance: "the world went wrong that afternoon: there is evidence: a photograph."[29] She concludes her

book with a rumination on the nature of writing history. The lifeblood of history is narrative—a connective discourse in which events, individuals, and things cohere and meaning is made possible, allowing entry "to a wider world of literary and cultural reference."[30] Yet she hesitates to release her working-class autobiography and her mother's life to the project:

> [T]o do this is to miss the irreducible nature of all our lost childhoods: what has been made out on the borderlands. I must make the final gesture of defiance, and refuse to let this be absorbed by the central story; must ask for a structure of political thought that will take all of this, all these secret and impossible stories, recognize what has been made out on the margins; and then, recognizing it, refuse to celebrate it; a politics that will, watching this past say "So what?"; and consign it to the dark.[31]

Like Barthes, Steedman fears the loss of the individual—particularly one whose life was lived in the margins of history—to the sweep of "the monolithic story of wage-labour and capital."[32] Both writers conjecture about a new approach to understanding human existence: one that partakes of *the impossible science of the unique being.*[33]

Kuhn echoes Steedman's reluctance and ultimate refusal to merge personal history into a comprehensive narrative—to subsume individual identity in a collective identity. Pivotal to her approach and methodology is the photograph, which serves as raw material for her exercise in "memory work [which] is a method and a practice of unearthing and making public untold stories, stories of 'lives lived out on the borderlands, lives for which the central interpretive devices of the culture don't quite work.'"[34] Kuhn, however, proffers a more comprehensive strategy regarding photographs than does Steedman. She evolves a methodology that seeks to combine the sociologist's recognition of the cultural rituals inherent in family pictures as well as in most public images with a reading of specific images that operates through the lens of the subject represented or the significance of the images for the author or her family. In discussing her baby picture, Kuhn writes:

> My photograph is in these respects no different from the thousands, the millions even, like it: it speaks volumes about the cultural meanings of infancy, the desires our culture invests in the figure of the newborn child. But while such meanings are certainly present in the specific contexts in which images

like this are produced and used, every image is special, too: gesturing towards particular pasts, towards memories experienced as personal, it assumes inflections that are all its own. My photograph, then, is the same, and yet it is different.[35]

She envisions a body of knowledge and a way of knowing that, rather than imposed from the outside, comes from "what is rooted within"—a blend of image, memory, and text that yields a new composite. She intuits a foundation and procedure for history that can accommodate difference when necessary and appreciates opposition between the dominant ways of knowing and "knowledge from below," common knowledge.

Memorializing a common life is the task the novelist Carol Shields pursues in *The Stone Diaries*. She chooses a metastructure that faithfully follows chronological time and organizes a unique existence into predictable, commonplace chapters: "Birth, 1905"; "Childhood, 1916"; "Marriage, 1927"; "Love, 1936"; "Motherhood, 1947"; "Work, 1955–1964"; "Sorrow, 1965"; "Ease, 1977"; "Illness and Decline, 1985"; and "Death." Her novel is a rumination on the ways in which human existence is remembered or even known. In the case of her mother, Mercy, who died in childbirth, Shields's protagonist, Daisy, has only a few small pieces of information. From these she weaves a tale of her mother's life, but it remains a fantasy or myth, for there were few if any witnesses to most of the defining moments of that life and few artifacts survive to carry a record of her thoughts and aspirations. No diary, for example, endures that keeps Mercy's voice alive to anyone who cares to read it. With this realization in mind, Daisy examines her own life and what will remain to mark its actuality. She then proceeds to fabricate a diary from the vantage point of old age. And in the process she reconstructs her life not only from her own memory but also from the personal artifacts that have accrued over the many decades. In addition to reproducing a family tree, a wedding announcement, letters from a lover, snippets of gossip, and the like, the text includes an eight-page section of photographs (bound approximately midway in the volume). The reader is exposed to most of the banalities of the afterlife of the common individual—bits and pieces that may include one-way correspondence (letters received but rarely copies of letters written), newspaper clippings, documents, mementos, photographs, and perhaps descendants. As she imagines her death, Daisy ends her diaries with a list of addresses (the places in which she has lived); her *unspoken* final words, "I am not at peace"; the closing benediction at her memorial service; and the conversation among unnamed

funeral guests (probably her children) regarding the fact that in the end they forgot her name.

In considering her past and in trying to assess how it should be conveyed or understood, Daisy struggles with the question of whether the story of a life should be "a chronicle of fact or a skillfully wrought impression."[36] On the one hand, Shields is as concerned as Kaplan, Steedman, and Kuhn that particularity should survive rather than simply be subsumed in a collective narrative. How does one craft a sincere, nonironic portrayal of someone whose life can so easily be summarized in a series of clichés? Shields embraces the tension between the conventionality of a middle-class, Canadian woman born in the first decade of the twentieth century and the personal saga and inner life of her unique character. But as a novelist, Shields undercuts the value of her artifactitious contributions to the book. This is best seen in the section of photographs. The first photograph is labeled *Cuyler and Mercy, 1902,* and does not correspond well with the written description of the couple in the first chapter. The visual information of weight, height, and age appear to contradict the written details. The second photograph, *Ladies Rhythm and Movement Club*, is also specifically referenced in the text. This time, however, the photograph seems to hold the power that Barthes's Winter Garden photograph of his mother holds for him: it testifies to Clementine Flett's existence: "A painting will lie, but the camera insists on the truth, he's heard this said. His beleaguered mate, her little bones and covering of soft flesh, occupied a place in the world in those days; no sane person, examining this photograph, would deny that fact."[37] Of course, Clementine's spouse is trying to convince himself that he was not a brutal husband and that his wife had been happy. Ultimately, however, his seemingly objective description of the photograph does not correspond well with a stranger's view. It is difficult for the reader to discern who the "slim, pretty, mischievous, cheeky" one is in the first row. The remainder of the photographs eschew any attempt at verisimilitude. In fact, they devolve into a group of images that appear to represent either one person or one family—a person or family remarkably similar to the author's image on the back cover (many of the photographs in the eight-page section are, in fact, pictures of Shields's children and family). As Daisy writes, "[T]he recounting of a life is a cheat, of course; I admit the truth of this; even our own stories are obscenely distorted; it is a wonder really that we keep faith with the simple container of our existence."[38] At the novel's end, it affirms the power of the individual to speak for and interpret her own life, yet finally repudiates the actual transmission of this testimony. Daisy's diaries are the

imagined work of a novelist. That a woman such as Daisy might actually record her deathbed recollections, Shields suggests, is unlikely, for we have no evidence as readers that Daisy shared in written or oral form the "diaries" that we have just read.

The purpose of the group of photographs incorporated in *The Stone Diaries* is hard to decipher. Are the photographs merely a stand-in for the sort of illustrations that would accompany a published biography or autobiography? Are they meant to represent a sample of a family photograph album? Are the obvious discrepancies between visual and written information meant to tell the reader that photographs cannot be understood accurately, that they become whatever the viewer chooses or needs to see in them? Are they intended to make manifest the evanescence of human existence, through an ironic mismatching of photographs with narrative? The attempt to combine photographs with fictional prose is rare and fraught with difficulties. Consider, for example, what may be the most ambitious and fully realized undertaking of this kind, *The Home Place* by Wright Morris, published in 1948. Each opening of the book contains a photographic image (shot and printed by Morris) on one full page and the continuation of the written narrative (authored by Morris) on the other. In an interview from the 1970s, Morris comments as follows on his conception and execution of the phototext, *The Home Place*:

> The photo-text confronted me with many [problems]. Chief among them is that some people are readers, some are lookers. The reader becomes a more and more refined reader, with less and less tolerance for distractions. In my own case, I cannot abide illustrations in a good novel. They interfere with my own impressions. The pictures I need are in my mind's eye. Now the relatively pure *looker* will subtly resent what he or she is urged to read. The looker wants all *that* in the picture. Each of these sophisticated specialists resents the parallel, competing attraction. . . . [T]he photograph requires a "reading," as well as a looking—its details scrutinized in a knowledgeable manner. In my case, this was a crisis. If the photograph overpowered the text, or if the reader treated the text lightly, I had defeated my original purpose. It was also crucial for my publishers, who considered me a novelist. *The Home Place* was well received, but pointed up this dilemma. I was losing readers, picking up lookers. Several reviewers asked why this ex-photographer was writing fiction. There was only one way to clear this up. Stop the photo-books. And so I did.[39]

A single photograph may inspire a novel, as Barthes exclaims in *Camera Lucida*, in a caption that appears under a 1931 André Kertész photograph titled "Ernest," a portrait of a schoolboy in Paris: "*'It is possible that Ernest is still alive today: but where? how? What a novel!'*"[40] In the 1985 novel *Three Farmers on Their Way to a Dance*, Richard Powers imagines a 352-page story based on the August Sander photograph of "young peasants on their way to a dance (Westerwald, 1914)."[41] And the German novelist E. G. Sebald has produced at least two works of fiction that include photographs, *Die Ausgewanderten* (The Emigrants; 1992) and *Die Ringe des Saturn, Eine englische Wallfahrt* (The Rings of Saturn: An English Pilgrimage; 1995). Both challenge and exploit the limits of realism in fiction. Yet the images in these novels continuously stop action, continuously disrupt narrative flow. Sebald does not attempt the text-and-image equality that Wright sought in *The Home Place*. Rather, he accepts that he will use photographs as historians and documentarians typically use them—as adjuncts to the text that are pointed to and explained. His use of them is no less "conventional" than Shields's placement of photographs in *The Stone Diaries*: a placement that represents the customary procedure for illustration in biography and autobiography. Photographs, in sum, assist these two authors in posing a novel in the trappings of nonfiction genres. As effective as photographs can be to the theorist or memoirist in attesting to and helping to recall *"That-has-been,"* they compete with rather than complement conventional storytelling, because the quality of certainty that the analog photograph may possess is a contradiction to the essence of fiction, a break in the tale being spun, a confrontation with intractable reality.

I began by invoking the image of Auggie and a set of photograph albums containing pictures of the same location (a Brooklyn street corner) captured at twenty-four-hour intervals. The frame never changes, yet the contents vary greatly from day to day: the people who are caught each morning at 8:00 A.M. are never the same or dressed the same; the weather alters from season to season, from forecast to forecast; and even the appearance of buildings can change, and the buildings eventually cease to exist. But Auggie asserts that his project is a mark of his existence—a physical token of his sight and his presence. And for Paul, the skeptic, one photograph at least reveals to him that these images are not all the same: his murdered wife emerges from the ream of album pages. Ironically, the film alters how this photograph would appear if taken to Auggie's specifications and routine. To underscore to the audience what Paul sees emotionally and

spiritually, the background is out of focus and the lighting and focal point is set on his wife. Perhaps this very need to heighten and enhance the memento, the private photograph, accounts for Barthes's refusal to publish in *Camera Lucida* the photograph that is most important for him: the Winter Garden photograph of his mother and her brother. Can others really see, let alone read, the evidence such artifacts possess? Can the individual survive the crush of historical narrative and its consuming hegemony?

Notes

1. Roland Barthes, *Camera Lucida: Reflections on Photography*, trans. Richard Howard (New York: Hill and Wang, 1981), 76.
2. Wright Morris, "In Our Image," in *Time Pieces: Photographs, Writing, and Memory* (New York: Aperture, 1989), 10.
3. Quoted in Naomi Rosenblum, *A World History of Photography* (New York: Abbeville Press, 1984), 325.
4. Ibid., 332.
5. Michel Foucault, "What Is an Author?" in *The Critical Tradition: Classic Texts and Contemporary Trends*, ed. David H. Richter (New York: St. Martin's Press, 1989), 981.
6. Ibid., 988.
7. Roland Barthes, "The Death of the Author," in *Image—Music—Text*, trans. Richard Howard (New York: Hill and Wang, 1977), 143. Emphasis in original.
8. Barthes, *Camera Lucida*, 18.
9. Ibid.
10. Maxine Hong Kingston, *The Woman Warrior: Memoirs of a Girlhood among Ghosts* (New York: Vintage International, 1989), 3.
11. Ibid.
12. Alice Kaplan, *French Lessons: A Memoir* (Chicago: University of Chicago Press, 1994), 160.
13. Ibid., 148.
14. Ibid., 153.
15. Ibid., 154.
16. Ibid., 169.
17. Ibid., 171.
18. Ibid., 173.
19. Ibid., 174.
20. Ibid., 29.
21. Ibid., 29–30.
22. Barthes, *Camera Lucida*, 80.
23. Susan Sontag, *On Photography* (New York: Farrar, Straus and Giroux, 1977), 17.
24. Kaplan, *French Lessons*, 197.
25. Ibid., 192–93.
26. Ibid., 197.
27. Carolyn Kay Steedman, *Landscape for a Good Woman: A Story of Two Lives* (New Brunswick, N.J.: Rutgers University Press, 1994), 23.

28. Ibid., 29.
29. Ibid., 51.
30. Ibid., 144.
31. Ibid.
32. Ibid., 14.
33. Barthes, *Camera Lucida*, 71. Emphasis in original.
34. Annette Kuhn, *Family Secrets: Acts of Memory and Imagination* (London: Verso, 1995), 8.
35. Ibid., 41–42.
36. Carol Shields, *The Stone Diaries* (New York: Penguin, 1994), 341.
37. Ibid., 97.
38. Ibid., 28.
39. Wright Morris, "Photography and Reality: A Conversation between Peter C. Bunnell and Wright Morris," in *Time Pieces*, 89.
40. Barthes, *Camera Lucida*, 83. Emphasis in original.
41. August Sander, *Men without Masks: Faces of Germany, 1910–1938* (Greenwich, Conn.: New York Graphic Society, 1973), [first foldout].

Nan Goldin: Bohemian Ballads

▮▮▮▮▮▮▮▮▮▮▮▮▮▮ ℵ FIVE

CHRIS TOWNSEND

The work of the American artist Nan Goldin, born in 1953, has often been cited as offering an authentic document of life in the bohemian cultures of Boston and New York in the 1970s and 1980s. Goldin is understood to be a member of the community she photographs rather than an apparently objective outsider. Goldin herself has commented: "People commonly think of the photographer as a voyeur, but this is my party, I'm not crashing."[1] One of her major works, *The Ballad of Sexual Dependency*, might in particular be understood as an artwork through which a subculture recounts its stories to itself. First presented as a slide show in clubs during the early 1980s and with a prehistory in the informal circulation of Goldin's early prints, *The Ballad* has subsequently been "recounted" in a wide variety of media, and for an increasingly disparate audience that is also increasingly distanced from the original community of reception that its narratives served. This apparent reification of bohemian creativity and community, predicated on the authenticity of the work's contents and sentiments, has become the object of a particular critical program, directed in part at Goldin's documentation of the deaths of friends from AIDS-related illnesses and in part at the degree to which Goldin's representations are authentic.[2] This discussion seeks to avoid the often personally inflected critiques that have characterized that program

and to avoid the polarized positions—eulogistic or demythifying—into which writing about Goldin's work seems to fall. It accepts the authenticity of Goldin's images, to the extent that one cannot deny the fact of presence in the photographs. To do so would be to ignore that essential characteristic of the photographic medium that Roland Barthes expresses as its encapsulation of "what has been": a characteristic dissected by a number of contributors to this volume. This essay suggests, however, that the "authenticity" that is ascribed to Goldin's images—an authenticity that refers not to presence but to the lives that those re-presented are apparently living—is fissured both by an imagination of what bohemia should look like and by an imagination of how bohemians should behave.

In a 1986 interview, invoking Walt Whitman, Goldin described *The Ballad of Sexual Dependency* as "my *Leaves of Grass* constantly updated and revised."[3] In its flexibility and historical contingency, the performance history of *The Ballad of Sexual Dependency* might be understood as reflecting subcultural shifts, so that a performance history is also a history of performance. In its successive mediations, I suggest, *The Ballad* is also a measure of the relation between a particular moment of bohemian history, the art world, and, to a more limited degree, mainstream culture. This relation is not simply one of reification into commodity forms, although certain mediations of *The Ballad of Sexual Dependency* doubtless represent a drive toward formats of mass consumption and fiscal rather than social value. Although, despite its nomination, its variable content, and the informal conditions of its early performance, *The Ballad* is clearly not figured as "a ballad," I have taken Goldin at her word, in her borrowing from Kurt Weill and her comparison of the work to Whitman's collection of verse. Without pressing too closely for historical parallels, I suggest that the history of *The Ballad of Sexual Dependency*'s mediation and its relationship to its primary audience—that is, the subjects who are represented in it—shares certain similarities with the fixing of the ballad as a literary genre. I further suggest that the values that are read, retrospectively, into the ballad by the consumers of its stabilized forms—immediacy, authenticity of experience, unselfconscious articulation of free subjectivity—are those that are projected onto *The Ballad of Sexual Dependency* by its wider audience. What these retrospective readings neglect, in privileging a certain naïveté, equivalent perhaps to the innocence ascribed to folkloric culture, is the consciousness of presence, the pose, of both subject and photographer, their awareness of their own identities and the historical circumstance in which they are formed.[4]

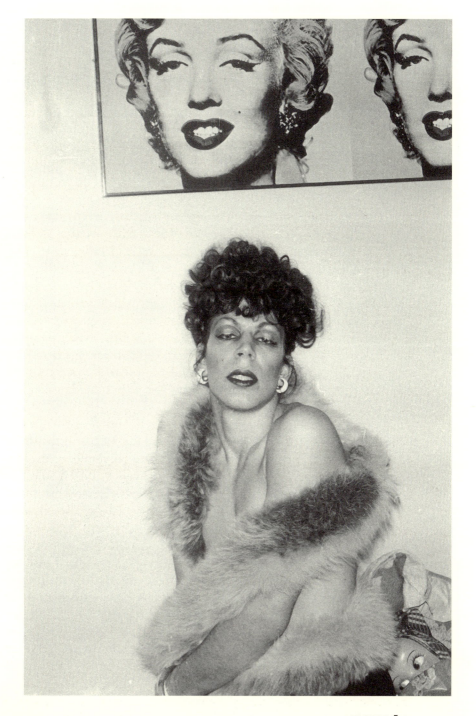

FIGURE 5.1.

Nan Goldin, *Ivy with Marilyn,* Boston, 1973

Goldin's photographic work began in Boston in the mid-1970s, when she was studying at the New England School of Photography under the tutelage of Henry Horenstein. It was here that she became influenced by Larry Clark's documentary style, in which the photographer was wholly complicit with his subjects, and discovered a subcultural milieu that provided an appreciative audience. Hers was a group that was, by its emphasis on its gay sexuality, drag, drug use, and self-consciously bohemian lifestyle, outside the norms of conventional behavior. As Goldin says in the film *I'll Be Your Mirror*: "It was as if we'd all escaped from America."[5] Goldin's early pictures are studies of her drag-queen friends and housemates in bars and nightclubs and portraits such as *Ivy with Marilyn, Boston, 1973* (fig. 5.1). The latter image overtly references Monroe as a hyperbolized icon of femininity. However, it also points toward Warhol's Factory as a role model for creative, "bohemian" behavior and endeavor.

Goldin's audience was also the community she photographed. Speaking of "exhibition practice" in mid-1970s Boston, David Armstrong remarked: "We'd bring the film to Phillips drugstore, and we'd get it back as packets of black and white snapshots. So that became a huge plastic bag full of pictures by the end of the summer, and the major activity that went on was taking the pictures, and everyone looking at them, and everyone stealing the ones that they liked of themselves."[6]

If this was the first means of disseminating her imagery, Goldin subsequently discovered a medium that enabled her to edit the material that had previously been jumbled in the plastic bag and to control the temporal relationship of image to audience. In 1977, unable to afford time or money to make prints, Goldin showed her work as slides. Goldin had also switched to working in color, reflecting the influence of then critically denigrated fashion photographers such as Helmut Newton and Guy Bourdin, whom she had encountered in the magazines read by her housemates. *Bruce bleaching his eyebrows, Pleasant St., Cambridge, 1975* (fig. 5.2) not only marks this stylistic shift externally but also establishes an internal, self-conscious reference to the prior sensibilities that have, to some extent, "produced" it. At the subject's feet are a *Harper's Bazaar* anthology and the collected poems of Frank O'Hara—representative of an earlier gay subculture.[7]

The slide show became Goldin's principal medium, and the format by which an expanding, though still resolutely bohemian, community recounted its histories to itself when Goldin entered the burgeoning punk scene around New York's East Village and Lower East Side. Goldin's performances became a central feature of a culture in which

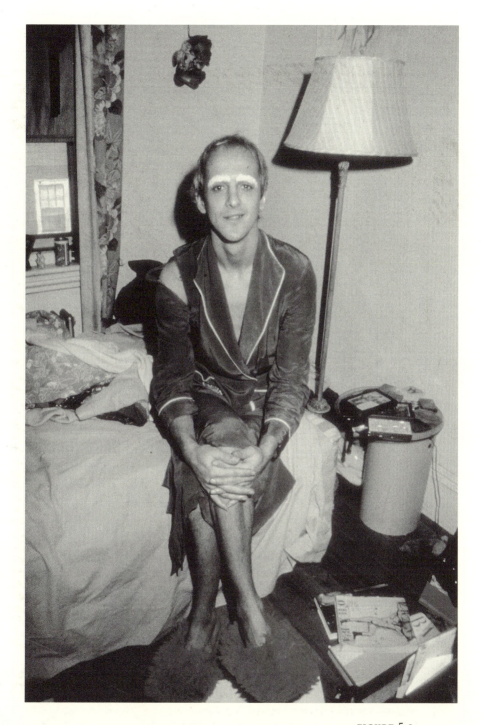

FIGURE 5.2.
Nan Goldin, *Bruce bleaching his eyebrows,* Pleasant St., Cambridge, 1975

personal identity was transient, often experimental, and above all "posed." Luc Sante comments of the period: "We were all finding our legs and moving shakily around on them, like baby giraffes. People were trying to decide on their names, their hair color, their sexual orientation, their purpose in life."[8] The slide shows addressed the community they depicted, functioned as a recollective focal point, and confirmed both individual presence and group cohesion. Goldin's first performance was at the Mudd Club in 1979, with the slides hand loaded. There was no conscious editing and no music. It was only when she showed slides at the Rock Lounge to accompany a band that Goldin saw the chance relations between images and music. Through 1980 and 1981, with her boyfriend acting as deejay, the slide shows became regular features at venues in the East Village. Goldin remarks: "The audience was the people who were in the slides. Cookie would be there, Sharon, Suzanne, David. People would yell and scream in relation to themselves on the screen. People would be mad at me because there would be some unflattering pictures or they'd be happy because there'd been a lot of beautiful pictures of them. One Thanksgiving, Jack Smith was there and did one of his endless slide shows."[9]

The screenings acquired titles: first *If My Body Shows Up*, a collaborative project using a written script and then *The Ballad of Sexual Dependency*. The live music accompaniment was abandoned in favor of prerecorded tapes and the visual material subjected to a controlled exposure, with each slide on-screen for four seconds in a performance lasting twenty to thirty minutes. What had been an ephemeral performance became a work with a distinct nomination, even if its content remained fluid, with Goldin editing the subject and order of slides between shows. In its sequenced flow of images *The Ballad of Sexual Dependency* aligned Goldin as closely with "no-wave" filmmakers such as Vivienne Dick and Lizzie Borden and older avant-garde practitioners such as Jack Smith as it did with photographic practice.

Defined as an autonomous entity, *The Ballad* began to reach audiences beyond the original context of its construction and reception. It remained, however, a highly mobile narrative work, with a different sound track accompanying every performance until 1987, and Goldin still edited and presented the images. In 1985 *The Ballad* appeared in book form, albeit, and of necessity, with significant differences from its performative mode. The publication contains 125 images in a sequence chosen by Goldin. In performance at this time, *The Ballad of Sexual Dependency* used about 700 slides and ran for forty-five minutes. The temporal relation of the spectator to the image was significantly transformed. Where, on-screen, the photograph was

a brief semifilmic flash in a flickering sequence, here it was reduced to an individual, static object of contemplation that could be considered for a protracted period, outside the context of the images that surrounded it and also outside the context of the audience that surrounded the spectator in live screenings. The public and transitory became established as private and extended. Publication also separated the images from the music that accompanied live performance.

The book of *The Ballad* presents a partially denatured version of bohemia, emphasizing "the pain" and addictive quality of heterosexual relationships—themes with which the larger audience the book required might more easily identify—and marginalizing those aspects of the lifestyle—homosexual difference and drug use—that might balk reception. An image such as *Greer and Robert on the bed, New York, 1982* (fig. 5.3), is ostensibly about a boy-girl relationship: one that, through the postures of its subjects and the hints of squalor in the crumpled bed and bare brick wall, solicits pathos in the same way that Picasso's sad clowns and acrobats, his Blue Period invocations of bohemia, seek our pity for their suffering. The masks on the wall behind the couple are perhaps the only hint that there is some degree of "masquerade" involved. While it conveys a certain inverted glamour of marginality and difference, *The Ballad* as book for a general audience succeeds in taming the content of *The Ballad* as slide show for its subjects. If in the early 1970s Goldin had documented her community as it escaped from America, the publication of *The Ballad of Sexual Dependency* seemed to reincorporate its marginality in mainstream culture. This process was to be repeated in the subsequent mediations of the work: a video in 1987 that guaranteed a fixed format, even if it included a sound track, and which meant the work could be "performed" in Goldin's absence, and the documentary film *I'll Be Your Mirror* that Goldin made in collaboration with the BBC in 1995.

While *I'll Be Your Mirror* has significant differences in form and narrative structure from *The Ballad of Sexual Dependency* (not least because of the editorial decisions of its codirector), in its continuous reference to *The Ballad*, its citation of sound track, and its self-conscious restaging of slide shows, we might well regard the film as a particular variant of *The Ballad*, albeit one in which the role of the work's original performer has been derogated against the retrospective "writing" of a history by others. Goldin's comments about the film, that she "wouldn't have made it so ploddingly narrative"[10] and that she could have made a thirteen-hour version, are illustrative of the artist's frame of reference within avant-garde filmmaking rather than television. They assume a spectator familiar with the durational

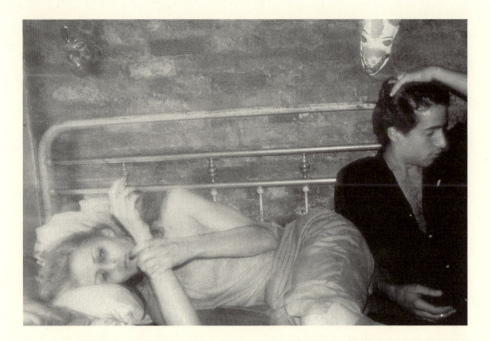

FIGURE 5.3.

Nan Goldin, *Greer and Robert on the bed,* New York City, 1982

exercises of Warhol's *Empire* rather than a general audience's expectations of narrative resolution produced within a tightly managed fifty-minute programming slot.

Goldin's evocation of *Leaves of Grass* as an equivalent for *The Ballad of Sexual Dependency* was perhaps more apt than she realized. With its instability of content over time, framed by a number of temporary inscriptions, *The Ballad of Sexual Dependency* parallels the evolving texts and contents of Whitman's numerous editions. Goldin's remark also points to other comparisons between her life and work and Whitman's. Whitman is the progenitor and reference point for a particular American bohemianism that can be traced throughout the twentieth century. Goldin's life and work are embedded in, and to some extent determined by, this milieu. Reading Goldin's photographic visual "texts" through Whitman's poetic forms highlights a distinctively lyrical appeal in her work: work rooted, as Goldin has commented, in the "subjective" and the "self-referential."[11] *Leaves of Grass* is a collection whose author's first "poetic" act is to represent himself on its flyleaf, posed as an idealized illustration of a bohemian. The contents are styled as personally observed fragments of the Real America.

Whitman's work is contingent on his life and, apparently, eschews conscious aestheticization. Like Goldin, always a participant but also always observing, Whitman experiences, suffers, is there: he witnesses, participates, and in particular announces himself as the representative of the marginalized and the abject.[12] For Goldin the act of representation is "a moment of clarity and emotional connection."[13] Whitman similarly erases distance to effect identification with his subjects.

Although *The Ballad of Sexual Dependency* is not posited as analogous to other performances and texts in the literary genre of the Ballad, its nomination nonetheless offers a point of entry to similarities with that archaic poetic mode. As genre, the ballad is a vernacular form that resists its transitive condition by mnemonic preservation; as individual text, it relies on performative reiteration for temporal and cultural continuity. The materiality of performance is reclaimed only through the memory of audience and performers. However, the ballad's repetition does not guarantee its fixity. The performed oral content changes according to historical context. As Susan Stewart pertinently writes, the ballad is "continually marked by immediacy—immediacy of voice, immediacy of action, immediacy of allusion."[14]

The ballad, as repeated, temporally and discursively variable performance, parallels Goldin's live screenings of *The Ballad of Sexual Dependency*, with constantly updated material reflecting immediate concerns within the community to whom the work is shown and who constitute its principal subjects. Goldin is that community's narrator, its registrar of couplings and separations, of marriages and deaths. The oral tradition of the ballad is similarly grounded in a community to which the performance is both wholly intelligible and of political and social import. The performer "voices" quotes and makes statements with the authority of an observer in context or witness.[15] This authority is bestowed by the interpretive community within which the performer speaks.

The Ballad is often posited as a mode of production below the level of conscious literary art. Goldin's work, especially in the context of reflexive gestures that emphasize art's status as art, is similarly posed in terms of innocence. Liz Kotz cites an essay on Goldin's contemporary Mark Morrisroe, in which Peter Schjeldahl remarks: "The Bostonians reacted authentically to a situation dominated, in '80's art culture, by the theoretical prattle of 'postmodernism' and brittle pictorial mediating of . . . mediated media mediations. Rather than brainily distance signs of signs and images of images they sought bedrock in ferociously honed exposure of their first person, bodily, sex-saturated, fantasy-realizing, determinedly reckless experience."[16] As

Kotz observes, "[A] return to a prior model of photographic practice (a model of autobiographic self-display with roots well into the early twentieth century) is posed as the 'authentic' in order to allow the critic to deny, it would seem, the very historicity of photographic images."[17] The feral innocence that Schjeldahl ascribes to "The Bostonians" is a critical illusion. Goldin, as she shows from her earliest images, is wholly aware of her precedents. Naïveté of self-representation might be understood as equally "postmodern": a commentary on the pursuit of "authenticity" as much as authenticity's depiction. As Stewart points out, the very nomination of the Ballad as below the level of conscious art is not an internal condition of the form but rather an external, and retrospective, categorization that as much defines what "literature"— or "high art"—is not as it tells us what a folk art might be. "Materiality, the collected form, invents an ephemerality that legitimates its own sense of temporality and subjectivity."[18]

We might here consider Elizabeth Sussmann's reference to the handcrafted aesthetic of the early versions of *The Ballad*[19] and contrast this to the polished, industrial productions of the book and the television film—even though the latter, in its editing strategies and use of a visually imperfect medium (Hi-8), seeks to efface that sophistication in favor of a rough-hewn effect. The Ballad is often described as a genre that "emerges at the point of transition between a feudal and a capitalist/industrial order."[20] There is, of course, a certain circularity in this argument, since it is only the emergence of the capitalist-industrial order, with its own modes of literary production, that forces the recognition of cultural modalities inherent to precapitalism. However, we might see the poverty of materiality that characterized punk as reflecting a liminal cultural positioning that parallels the liminality so often ascribed to folkloric culture.

A profound tension exists between the ballad as oral form and the Ballad as literary genre. The latter is constituted not by the continual iteration of performances but by the inscription of one or several performances into a single, authoritative version. Cultural recognition is contingent on the conversion of speech into writing. This materialization fixes the absent text of transitory performance, reclaiming it from the oblivion threatened by its ephemerality and guaranteeing its continued signification. However, the act of signification and what is signified address a different audience: that of the fine-art or literary collector. Stewart suggests that the historic "rescue" of the ballad through its written form only validated the vernacular condition by instituting its newly universalized texts as objects of curiosity and collection. The re-presentation of *The Ballad of Sexual Dependency* as a

stable collection of representations—whether in book or on video or film—may be seen as a similar gesture of preservation. In the early 1980s *The Ballad* had no materiality. Its images existed as momentary projections for its audience. Publication conferred status and authority on the performative by fixing signification as durable and establishing presence through privileging print over projection. *The Ballad of Sexual Dependency* can be seen as a souvenir of a past culture in the same moment as it finally articulates the concerns of that culture within a wider discourse. The book places Goldin simultaneously within East Village bohemia, as authentic representative, and outside its purlieus, as narrator and commentator. Stewart remarks that one motivation for the artifactual collection of verbal art was "to place such 'specimens' as curiosities, characterized by fragmentation and exoticism, against the contemporary and so use them to establish the parameters of the present."[21] One might argue that a similar motivation underpins the film *I'll Be Your Mirror* with its narrative watershed of post- and pre-AIDS. Here the separation between history and its moment of collection is compressed into a few years—a symptom perhaps of an accelerated nostalgia for a distanced and short-lived culture. We might see *The Ballad* in particular as fulfilling that role which Stewart perceives for the Ballad as tocsin of nostalgia. "Such a separation of speech from its particular moment may result in a singular text, but this text goes on to become symptomatic. It is a fragment of a larger whole that is a matter not only of other versions, but of the entire aura of the oral world—such a world's immediacy, organicism, and authenticity."[22]

As an object of consumption, *The Ballad of Sexual Dependency* was addressed not to a community represented in the pages of a book or in prints but to the art market. Success in that field was contingent on the effect of those images, on identifications other than those facilitated by immediate recognition and transparency of meaning in a communal environment. The materialization of signification ensured that it signified with different effects, told a different story. In this context *The Ballad of Sexual Dependency* comes to resemble nothing so much as a souvenir, an objectival trace of authenticity. As Stewart remarks: "The souvenir distinguishes experiences. We do not need or desire souvenirs of events that are repeatable. Rather we need and desire souvenirs of events that are reportable, events whose materiality has escaped us, events that thereby exist only through the invention of narrative. Through narrative the souvenir substitutes a context of perpetual consumption for its context of origin. It represents not the lived experience of its maker but the 'second-hand' experience of its possessor/owner."[23]

We might conclude that in its successive mediations *The Ballad of Sexual Dependency* "behaves" much like a Ballad. Progressively fixed as an object of collection and souvenir of experience, it becomes increasingly remote from the community to which its political and social specificity was addressed. Its mediations, as they diversify their contexts of reception, increasingly rely on a spectacularization of and nostalgic investment in the original material. We need, however, to temper this conflict between an originary bohemia and a late-capitalist reification of bohemia's cultural difference through appeals to the authenticity of the lives depicted. There is no originary bohemian community here but rather one that constitutes itself in knowing reference to previous manifestations and to a previous moment of collection—whether that moment is encapsulated in Whitman and his subsequent invocation by the Beat Generation; Picasso's Blue Period; Ed van der Elsken's vision of Love on the Left Bank from the early 1950s; Warhol's circle in the 1960s; or the underground cinema of Jack Smith and Ron Rice. In its constitution and its points of reference, *The Ballad of Sexual Dependency* is a knowing constitution of what a bohemian document should look like: one that engages in the self-referentiality of high art, which Schjeldahl sees it as evading. Goldin's work, even as it documents bohemia, is imbued with an artistic strategy that, rather than comment overtly on the mediation of bohemia, effaces its status in favor of authenticity. In such a reading, Goldin is not only complicit with her subjects, she assumes a certain poverty of form as the appropriately bohemian mode of representation. What we have, then, is not the originary "Ballad" but rather a version of that narrative read through a century and a half of thought about what the bohemian life should look like. *The Ballad of Sexual Dependency* is simultaneously a document of feral immediacy and a retrospective meditation on how such immediacy is figured.

Notes

1. Nan Goldin and Edmund Coulthard, *I'll Be Your Mirror* (London: Blast!Films/BBC, 1995). I refer here to the unpaginated transcription of all the material shot for the film *I'll Be Your Mirror*, on which I consulted in 1996 and is not generally now available for scrutiny. I should like to thank Blast!Films for their cooperation with my work on Goldin and this essay.
2. See, e.g., David Deitcher, "Death and the Marketplace," *frieze* 29 (1996): 40–45; Liz Kotz, "The Aesthetics of Intimacy," in *The Passionate Camera: Photography and Bodies of Desire*, ed. Deborah Bright (London: Routledge: 1998), 204–15.
3. Mark Holborn, "Nan Goldin's Ballad of Sexual Dependency," *Aperture* 103 (1986): 45.

4. I am thinking here of the subject as "posed" in the sense outlined by Craig Owens as neither wholly fixed by the camera nor controlling its representation, and equally as neither free in its subjectivity nor wholly determined, but rather in a condition of diathesis—between terms. See Craig Owens, *Beyond Recognition: Representation, Power and Culture* (Berkeley: University of California Press, 1992), 201–17.

5. This is articulated in the Blast!Films, Goldin and Coulthard transcript. Goldin's remark is resonant of that much earlier declaration of bohemian independence, voiced by John Sloan in 1916, when he announces Greenwich Village as a "Free Republic, independent of Uptown." See Fred McDarrah, *Greenwich Village* (New York: Corinth Books, 1963), 30–32.

6. Goldin and Coulthard, *I'll Be Your Mirror*.

7. I am grateful to Renée Vara for identifying the O'Hara volume.

8. Luc Sante, "All Yesterday's Parties," in Nan Goldin, David Armstrong, and Hans-Werther Holzwarth, *I'll Be Your Mirror* (Zürich: Scalo, 1996), 99. I refer here to the paginated catalog of a 1996 touring exhibition titled *I'll Be Your Mirror*, published by Scalo.

9. Nan Goldin and Jay Hoberman, "My Number One Medium All My Life," in Goldin, Armstrong, and Holzwarth, *I'll Be Your Mirror*, 140.

10. Conversation with the author, July 1996.

11. Holborn, "Goldin's Ballad," 38.

12. See, e.g., Walt Whitman, "A Song of Myself" (lines 509–12, 518–20), in *Collected Poems* (London: Penguin Books, 1975).

13. Nan Goldin, *The Ballad of Sexual Dependency* (New York: Aperture, 1986), 6.

14. Susan Stewart, *Crimes of Writing* (New York: Oxford University Press, 1994), 125.

15. Ibid., 124–25.

16. Peter Schjeldahl, "Beantown Babylon," *Village Voice,* April 9, 1996, 81.

17. Kotz, "Aesthetics of Intimacy," 215 n.7.

18. Stewart, *Crimes,* 104–5.

19. Elizabeth Sussman, "In/Of Her Time: Nan Goldin's Photographs," in Goldin, Armstrong, and Holzwarth, *I'll Be Your Mirror*, 34.

20. Stewart, *Crimes,* 109.

21. Ibid., 103.

22. Ibid., 104.

23. Susan Stewart, On Longing: Narratives of the Miniature, the Gigantic, the Souvenir, the Collection (Durham, N.C.: Duke University Press, 1993), 135.

| *Part Three* |

PHOTOGRAPHY AND
NARRATIVES OF DIFFERENCE

(Con)text and Image:
Reframing Man Ray's *Noire et blanche*

██████████████████████████ ≋ SIX

WENDY GROSSMAN

For more than half a century, the appropriation and provocative transformation of objects was a hallmark of Man Ray's multifaceted artistic career. Even his approach to photographing the African masks and statues flooding Parisian markets in the 1920s reflected this impulse. At the apogee of an era in which the avant-garde was looking to the arts of Africa, Oceania, and the Americas to reinvigorate what it perceived as a decadent and moribund Western culture, he created his now iconic photograph, *Noire et blanche* (fig. 6.1). By appropriating an African mask for his photographic tableau, Man Ray focused attention on the recently elevated field of African art through the lens of this still marginal medium, constructing an image that challenged conventions and hierarchies of Western artistic tradition both in content and in form.

Man Ray's translation of African objects into his photographic idiom added a provocative new dimension to the modernist phenomenon of "primitivism."[1] With such pioneering photographs, he defied assumed boundaries of a medium perceived as merely reproducing transparent and unmediated representations of reality, creating a quintessentially modernist image. In the contemporary cultural milieu in which appropriations of African and Oceanic objects by painters and sculptors remained shrouded in a mystique of artistic

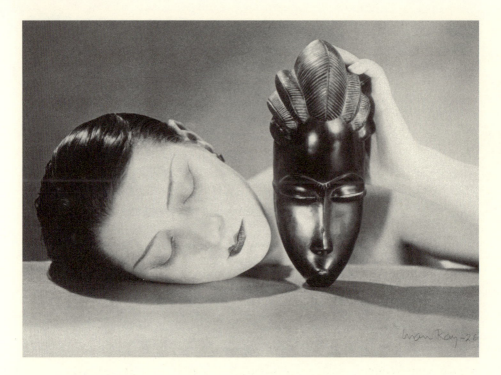

autonomy, Man Ray's photographic practice exposed the fictitious
posturing behind such statements as Picasso's notorious 1920 quip,
"African art? Never heard of it!" (L'Art nègre? connais pas!).[2]

Thus, by virtue of photography's mimetic nature and its ambigu-
ous status as an art form, images such as *Noire et blanche* have per-
formed and continue to perform contradictory functions in a variety
of modernist discourses. Indeed, since its original publication in Paris
Vogue in May 1926, Man Ray's photograph has functioned in a manner
distinct from similar appropriations in other media. As I indicate here,
context and narrative have played key roles in inflecting the way in
which viewers have come to understand Man Ray's image. This essay
considers how both the context of its reproduction and extravisual lin-
guistic elements such as title and associated texts have infused *Noire
et blanche* with meaning and mediated its reception. Equally, it illus-
trates the often contradictory and overlooked mechanisms through
which this photograph has achieved the status of a modernist icon. In

the context of this reading framework, I examine the multilayered texts inscribed in Man Ray's enigmatic picture and dissect the questions they posed at a crucial historical juncture in postwar France. Relocating Man Ray's photographs of African art in both this critical context and the artist's unique body of work facilitates the construction of a far more complex interpretation of *Noire et blanche* and the vision behind it than has been heretofore proposed.

Noire et blanche posits as dialectical embodiments of the "ultra-modern" and the "ultra-primitive" the disembodied white-painted face of Man Ray's lover and muse, the chanteuse Kiki de Montparnasse, and the darkly stained Baule portrait mask.[3] Almost as if it were a direct cast, the vertical mask, with its shiny black patina, is a negative mirror image of the reclining model's ovoid face, with her pursed lips, closed eyes, and tautly styled coiffure. Parallel symmetrical shadows extend beneath the two perpendicular forms, coupling face and mask in a tightly framed, shallow, and austere space. The vitality of the erect mask is contrasted with Kiki's passivity, manipulating gender stereotypes to suffuse the image with erotic tension. In characteristic vein, Man Ray exploits the erotic potential of the female mask as human surrogate by imbuing it with a visual tumescence, evoking a sexual inversion that undermines notions of clearly defined identities. These devices invoke a formal and psychological dialogue between differentiation and parity, underscored by the binary polarization indicated by the title.

As a number of scholars have noted, the context of reproduction rather than necessarily the style of Man Ray's photographs was instrumental in transforming their reception.[4] Unlike so many of Man Ray's other images featured in avant-garde publications, however, *Noire et blanche* never appeared on the pages of *Minotaure, La Révolution Surréaliste,* or any other contemporary vanguard journal. Rather, two years after its publication in *Vogue, Noire et blanche* was reproduced in the illustrated monthlies *Variétés* and *Art et Décoration,* straddling boundaries between high and low culture, art and fashion, and vanguard and popular attitudes toward African art in the 1920s.[5] Man Ray's choice of a highly refined, polished, and stylized Baule mask from the Ivory Coast would in fact appear far more attuned with a fashion aesthetic than with that of the surrealists who were promoting—rather than African art—Oceanic objects as an avenue through which to shock, unsettle, or violate European sensibilities.[6] Despite Man Ray's intimate relationship with the surrealist movement and its leading proponents, he felt no more compelled to allow their aesthetic preferences to guide his own creative production than he did to identify himself

with any single artistic philosophy. Indeed, while his photograph was about beauty, it was certainly not about the type of "convulsive beauty" proposed by André Breton. It was perhaps thus inevitable that in defying surrealist taste, *Noire et blanche* would find its audience through fashion and popular publications rather than through vanguard venues. The photograph would, in fact, remain virtually absent in conventional modernist narratives and exhibitions on surrealism until it was resurrected in the wake of renewed critical interest in the primitivist phenomenon in the 1980s.[7]

The context of reproduction was indeed significant for *Noire et blanche*. When it first appeared in *Vogue,* the isolated photograph filled the upper half of the page, arbitrarily inserted between pages featuring leading Parisian fashions and an eclectic assortment of unrelated articles and images. A rather curious editorial caption, inflected with social Darwinism and pseudoscientific racial theories, accompanied the image in a small block of italicized type reproduced below:

Face of a woman, calm transparent egg straining to shake off the thick head of hair through which it remains bound to primitive nature! It is through women that the ultimate evolution of the species, its past full of mystery, will be accomplished. Sometimes plaintive, mankind returns with a feeling of curiosity and dread to one of the stages through which, perhaps, before becoming what she is for us today, the evolved white creature passed.

Visage de la femme, doux oeuf transparent tendant à se débarasser de la toison par où il tenait encore à une nature primitive! C'est par les femmes que s'accomplira l'évolution qui portera à son suprême degré l'espèce au passé plein de mystère. Dolente parfois, elle revient avec un sentiment de curiosité et d'effroi à l'un des stades par où passa, peut-être, avant de parvenir jusque'à nous, la blanche créature évoluée.[8]

Embedded in this loaded commentary are notions of a gendered "primitive" otherness and attitudes toward the female body inherent in patriarchal modernist discourse: phenomena that have been addressed in recent scholarship by a number of critics.[9] As Marianna Torgovnick notes, "[G]ender issues always inhabit Western versions of the primitive. Sooner or later those familiar tropes for primitives become the tropes conventionally used for women."[10] Verbiage such as the *Vogue* caption and the complexity of the various narratives that Man Ray's photograph engages exemplify Victor Burgin's concept of

the "photographic text" as "the site of a complex 'intertextuality,' an overlapping series of previous texts 'taken for granted' at a particular cultural and historical juncture."[11]

One of *Noire et blanche's* most crucial texts that is consistently "taken for granted" is the title of the photograph itself. Although it first appeared in *Vogue* as *Visage de nacre et masque d'ébène* (Mother-of-pearl face and ebony mask), the photograph was reproduced in subsequent publications accompanied by its streamlined title. "For Man Ray," the critic Janus notes, "words were a profoundly ironic instrument, a way of manifesting the idea that is always behind every thought and of emphasizing the uncertainty of things that delude themselves into believing that they belong to a well-defined category. . . . [W]ords (the titles of works) serve the same purpose that shadows do in many other works by Man Ray."[12] This observation is nowhere more apt than with respect to *Noire et blanche*.

Man Ray was profoundly aware of the subtleties of language—with regard to both his native English and the French of his adopted city. Indeed, his "accented" wit was noted in the 1928 article, "Les Photographies de Man Ray," contained in the issue of *Art et Décoration* that featured *Noire et blanche*: "This is the American artist Man Ray, well known for his humor in a café of the boulevard Montparnasse, where the French language is colored by the most diverse accents" (C'est Man Ray artiste américain, bien connu pour son humour dans certain café du boulevard Montparnasse où la langue française se colore des accents les plus divers).[13] As the Russian philosopher and theorist Mikhail Bakhtin observed, "[A] deeply involved participation in alien cultures and languages . . . inevitably leads to an awareness of the disassociation between language and intentions, language and thought, language and expression."[14] Man Ray's work over the course of his career, *Noire et blanche* included, is testimony from one of the twentieth century's most astute commentators on the disjunction to which Bakhtin refers.[15]

Man Ray's wit and delight in linguistic play, encouraged by his lifelong friendship with Marcel Duchamp, were legendary in the circles in which he traveled. He reveled in the provocative ambiguities his titles and linguistic games added to his work. This is exemplified in such classics as the 1920 airbrush on glass, *Danger/Dancer*; the 1930 assemblage, *Trompe l'oeuf* (the egg that fools the eye); and the 1950 plaster cast, *Pain Peint* (literally, "painted bread"), translated by Man Ray as *Blue Bred* and subtitled *Favourite Food for Blue Birds*.[16] One of his most famous verbal and visual puns is the 1924 *Le Violon d'Ingres,* an ironic commentary appropriating the subject and pose of the French master's

Baigneuse de Valpinçon and—in the title—plays on French slang for "hobby."[17] Whether in the form of witty puns, double entendres, or in more complex naming endeavors, Man Ray conceived his titles as an integral component of his creative effort. *Noire et blanche* is no exception. Thus this photograph needs to be read not only for its visual clues but also for those embedded in the title the artist chose to apply.

The simplicity of the title *Noire et blanche* is remarkably deceptive. How, then, are we to understand it as a self-consciously employed textual element in Man Ray's elegantly composed and multilayered interplay of animate with inanimate forms, black with white, light with shadow, and European with African? The most obvious reading—a reading that takes it as a simple and formal reference both to Man Ray's photographic medium and to the "objects" depicted—is the interpretation that is conventionally adopted. On further consideration, however, such a reading proves insufficient. Why, for instance, are the key lexical elements of the title specifically feminine, and to what exactly do they refer? Face in French (*le visage*) is masculine, as is mask (*le masque*), so the feminine form of the signifiers *noire* and *blanche*, taken as adjectives, is confusing. If the feminized words simply denote the feminine subject and/or the photographic medium, then why does Man Ray give the title *Blanc et noir* to a photographic series created several years later, in which a seminude white female model, her body crisscrossed by black bands and garters, emerges as fragmented forms from a black backdrop? Moreover, if the title *Noire et blanche* were merely descriptive, why do the color references fail to correspond—left to right—with the objects to which they allegedly refer? Playing with language just as he played with images and ideas, Man Ray undermines any simple correspondence between signifiers and signifieds, thus calling into question the arbitrary manner in which representations acquire meaning.

The complexity of the categories designated in the title *Noire et blanche* is illustrated further with a negative version of the same photograph (fig. 6.2) produced—although not published—in the same year. In this rendition, Man Ray not only reverses the polarity of black and white in the two ghostly forms but also, in flipping the image, inverts the positions of the mask and the model. As Sidra Stich observes about this photographic pair:

> [D]ifference inverts to similitude as the Black African mask and the Caucasian head establish a relationship of correspondence and reciprocity. The photographs set forth new parities that go beyond standard classifications or Eurocentric ideals.

Nevertheless, they refuse to define new boundaries, resting instead within the zone of disruption and contradiction. They also call attention to the issue of difference, rejecting a vision of unity that reduces everything to a homogeneity and obliterates the realities and exoticism of otherness.[18]

"Reading" the negative version left to right, the *noire* of the title corresponds to the mask—which is now white—while *blanche* corresponds to the model—whose face is now rendered in deep black tones. This manipulation of form and language, image and text, is similar to the manner in which Man Ray transformed *Man* and *Woman,* 1918 photographic renditions of his earliest Dada readymades, into *Femme* and *Homme,* interjecting not only a linguistic translation but transposing gender identities as well. In titling his composition *Noire et blanche,* Man Ray called attention to disjunctures between language

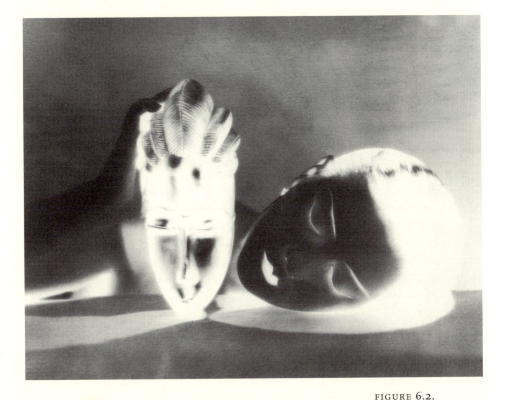

FIGURE 6.2.
Man Ray, *Noire et blanche* negative, 1926. © 2002 Man Ray Trust/ Artists Rights Society (ARS), New York/ADAGP, Paris.

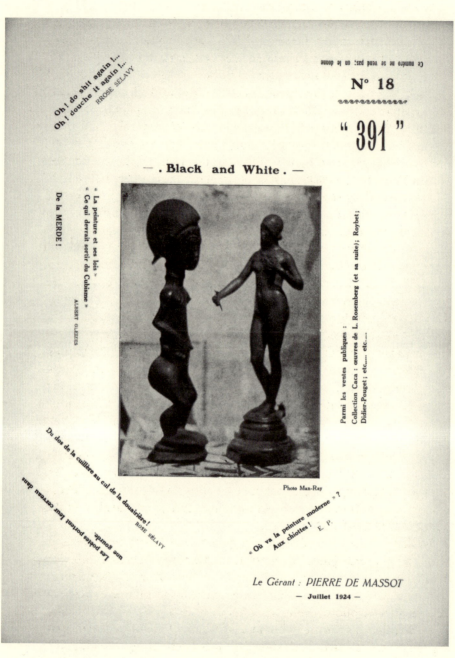

FIGURE 6.3.
Man Ray, *Black and White*, 1924. © 2002 Man Ray Trust/
Artists Rights Society (ARS), New York/ADAGP, Paris.

and intentions and language and expression, inflecting his image with irony and multivalent meaning.

Noire et blanche was not, however, Man Ray's first endeavor in this vein. Two years earlier, he created *Black and White* (fig. 6.3), a relatively obscure photograph known only in reproduction, which provides clues to understanding the evolution of and meanings behind his later image. In its juxtaposition of traditional African and Greco-Roman female forms, *Black and White* invokes African art as a literal and figurative challenge to the hegemony of Western classical traditions, much in the vanguard manner that had prevailed for two decades. The gendered nature of this proposition, which would later surface in *Noire et blanche,* first appears then in this 1924 photograph.

Corresponding sequentially with the objects to which it refers, the title attached to *Black and White* would seem a straightforward text describing the Baule and classical figures directly below it. However, even this delineation incorporates an ambiguity, for although the surface of the African figure is indeed black, the Western figure is not represented by a clearly contrasting white plaster cast. Rather, the statuette is neither black nor white but apparently bronze, blurring the categories designated by the title. What *is* black and white in the photograph, however, is the geometric pattern of the African textile on which the two female figures stand and which conveys the impression that the statuettes are two oversized queens facing off on a chessboard. Seizing on the opportunity to employ an African statue as a black board game queen, Man Ray manipulates the object in a quintessentially modernist gambit. Several years later, when *Black and White* was conceptually and literally translated into its French counterpart, *Noire et blanche,* it was grammatically invoked in specifically feminine form. Man Ray's consciously gendered translation could perhaps in part be explained as yet another allusion to the game of chess, wherein the individual piece—*la pièce noire* or *la pièce blanche*—is also referred to in the feminine.

With the exception of Duchamp, no other artist was more obsessed with the cerebral game of chess than Man Ray: chess symbolism infused his work throughout his career in many forms.[19] The association of chess symbolism with African objects would become most evident in several photographs from his 1937 *Mode au Congo* series (fig. 6.4), in which his Caribbean model, Adrienne Fidelin, is posed leaning on a chessboard and sporting a beaded Congo headdress.[20] Conversely, African references appear in the use of Egyptian-inspired pyramidal forms for the king pieces in his 1920 chess set, one of many such constructions he would design over the years.[21] Against this

backdrop, the words "black and white" would certainly have elicited connotations of the game that occupied so much of his creative and intellectual activity. It is perhaps no coincidence that in 1926 he was executing a commission by an Indian prince for three sets in silver of his earlier chess design.[22]

Similar chess allusions surface in another untitled and undated contemporaneous photograph (fig. 6.5), in which Man Ray juxtaposes two contrasting African objects—a Pende ivory pendant and a darkly patinated Chokwe whistle—as if they were opposing game pieces. Distorted through the camera's lens and floating in the picture plane against a pattern of interwoven shadows, these objects become literal and figurative "pawns" in the artist's visual vocabulary. The self-consciously aestheticized composition—the extreme close-up, oblique camera angle, and play of light and shadow—bear witness to Man Ray's efforts to blur the boundaries between document and art in his photographs of African objects. By thus exploring the multivalent meanings of the black and white leitmotiv and linking this theme to his fascination with chess, the artist developed an idiosyncratic approach to photographing African sculpture that would culminate in the creation of *Noire et blanche*. The conflation of woman, object, and toy would indeed be quite consistent both with his own creative vision and with the deeply embedded gender attitudes of the early-twentieth-century avant-garde. That said, it is clear that—whether in French or English—the words "black and white" carried far more signification for Man Ray than they have previously been accorded.

Against this backdrop, it is informative to consider both the context in which *Black and White*—Man Ray's first known effort to incorporate African art in his photography—emerged and the texts that accompanied it. When first published on the cover of the July 1924 issue of Francis Picabia's avant-garde journal *391*, the photograph was flooded by text. With the title *Black and White* looming boldly above, the image was surrounded by a field of iconoclastic aphorisms strewn at arbitrary angles in characteristic dada fashion. These included provocative statements such as "'Where is modern art going?' To the crapper!" ("Où va la peinture moderne?" Aux chiottes!) and "Amongst the public sales: Collection Crap: work from L. Rosemberg (and his followers) . . ." (Parmi les ventes publiques: Collection Caca: oeuvres de L. Rosemberg [et sa suite] . . .).[23]

This strategic pairing of image with texts situated Man Ray's photographic appropriation of a Baule figural statue at the heart of contemporary political and aesthetic meditations over the nature of

FIGURE 6.4.
Man Ray, *La Mode au Congo,* 1937. © 2002 Man Ray Trust/
Artists Rights Society (ARS), New York/ADAGP, Paris.

the modernist enterprise. In the increasingly conservative and nationalistic climate of postwar France, the inventive celebration of African arts manifest in Man Ray's photographic tableaus would serve a function distinct from that served by predecessors in other media a generation earlier. "In the teens, and continuing into the twenties," Jody Blake notes, "Americanism was thought to have assumed a rejuvenating role comparable to the one that Africanism had played during the previous decade. . . . In the postwar period, however, this celebration of machine-age dynamism, like the cult of 'primitive' vitalism, was increasingly tempered by doubts and anxieties."[24] In an era of entrenched reaction to perceived excesses of the *avant-guerre* and resentment against foreign "perversions" of classical French cultural traditions, the juxtaposition of Man Ray's photograph and Picabia's irreverent texts constituted a radical indictment of recidivist cultural forces: forces that called for a return to the values of clarity in the peacetime "Call to Order." Indeed, this collaborative celebration of African art by the

FIGURE 6.5.
Man Ray, Untitled
(Pende pendant
and Chokwe
whistle), ca. 1933.
© 2002 Man Ray
Trust/Artists
Rights Society
(ARS), New York/
ADAGP, Paris.

American photographer Man Ray and by Picabia, the progenitor of the machine aesthetic, epitomized everything against which conservative critics were rallying in their promotion of a classical revival in the arts.

"In a period no longer tolerant of 'foreign outrages,'" Blake argues, "the French attacked other blatant violators of their sensibilities: African sculpture, African American music and dance, and the modernist works they had engendered."[25] As Blake signals, the threat posed by such alien influences was manifested most vociferously in the reaction to African American music and entertainment, particularly the *Revue Nègre* when it opened in Paris in 1925 at the illustrious Théâtre des Champs-Elysées. Contemporary critics perceived this "invasion" by Josephine Baker and her troupe of a monument to French artistic traditions—with its architecture by Auguste Perret, marble reliefs by Antoine Bourdelle, and murals by Maurice Denis— as "the theatrical equivalent of savage fetishes' ousting the marble gods from the classical temple."[26] The racist and xenophobic undertones of such responses could not have escaped Man Ray, an avid devotee of the *Revue Nègre* and other venues of black entertainment. Moreover, as an American, he was undoubtedly aware of the disjuncture between the exoticized performance by African Americans and fictitious European notions of a polymorphous black culture being promoted on stage.

Critics today—most notably, James Clifford and Whitney Chadwick—convincingly argue that modernists' appropriations of African art must be understood in the context of the enthusiasm for all things related to black culture to which they responded.[27] What has yet to be considered in discussions of *Noire et blanche*, however, is how factors particular to interwar France such as escalating xenophobia and Man Ray's own marginal position within France's xenophobic climate would have informed his attitudes toward African art and his artistic vision.[28] Moreover, strife over French colonial activities in Africa was rampant in this period, and anticolonial sentiment in surrealist circles was resolute. While their manifestos and pamphlets protesting the idea of "colonialist banditry" excluded signatures of foreign surrealists for their own protection, and Man Ray himself was characteristically oblique in expressing his political sympathies, he was undoubtedly aware of and affected by these controversies.[29]

Despite such mitigating factors, Chadwick is unequivocal in her critique of *Noire et blanche*. She argues that "as a white male American artist living in Paris in the 1920s, Man Ray could hardly be expected to be exempt from the dominant social and cultural ideologies of his

day. . . . In the end, [his] photographs reproduce ideological formations that reduce sexual and cultural difference to signs within a cultural system of exchange."[30] This characterization not only oversimplifies an artist whose work arguably enjoyed a far more complex relation to the universalizing and deterministic matrix Chadwick invokes than she is willing to allow. It also demonstrates how *Noire et blanche* has evolved to become the paragon of primitivism in the photographic medium. The photograph appeared in the catalog of the Museum of Modern Art's controversial 1984 exhibition *"Primitivism" in Twentieth-Century Art: Affinity of the Tribal and the Modern* and in subsequent publications on this topic, similarly employed in a manner that implied it was merely a transparent reflection of its time.[31] Featured on the cover of Marianna Torgovnick's 1990 text, *Gone Primitive,* its fate was sealed. Ironically, despite its visual prominence in these books, the image is accorded only passing commentary, its meaning assumed to be self-evident.[32]

A totally different interpretation emerges, however, when *Noire et blanche* is reframed within the critical perspective proposed here. Within the metanarrative this perspective engenders, *Noire et blanche* stakes its turf as a decidedly oppositional, textually complex statement, articulated in Man Ray's characteristically enigmatic and idiosyncratic manner. The reading adumbrated in this essay casts *Noire et blanche* as an image that provocatively employs an African mask in a supremely classical composition: an image produced in a controversial medium and reproduced in an unconventional forum. My exegesis argues that, inflected with irony and ambiguity, the photograph undermines facile constructions and understandings of categories of difference assigned by polar oppositions: categories such as the black and white designated in its title. And my interpretation affirms that what is most remarkable is that no matter how implicated it is in issues of its time, this photograph still retains its power to fulfill Man Ray's artistic goal "to amuse, bewilder, annoy or to inspire reflection."[33]

Noire et blanche was from its inception an enterprise defying simple categorization. A hybrid image crossing boundaries between high art and popular culture, it was addressed in form and content not to a self-consciously artistic community but to a sophisticated fashion audience. And while in today's market *Noire et blanche* has transmogrified into a canonical modernist art object in and of itself—a positive and negative diptych having recently sold at auction for a record-breaking $607,500—its place in art historical narratives over the past century has not always been so enthusiastically acknowledged. Interpreted alternately as an extension of the early modernist impulse to universalize and neutralize difference, as a reflection of contemporary

attitudes toward race and gender, or simply as formalist interplay, the image represents a paradigm of intertextuality in photographic discourse as it unfolds around representations of African art.

African art clearly held many possibilities for Man Ray beyond the considerations by which *Noire et blanche* is conventionally weighed. Complex issues are at play in this iconic tableau, emblematic of the dislocations and oscillating meanings underlying the modernist ethos. If nothing else, *Noire et blanche* demonstrates that, for Man Ray, these concerns could not be considered simply black or white.

Notes

This essay is adapted from my dissertation, "Modernist Gambits and Primitivist Discourse: Reframing Man Ray's Photographs of African and Oceanic Art" (University of Maryland, 2002). For their comments, encouragement, and support in the preparation of this essay, I am greatly indebted to Merry Foresta, Johnnie Gratton, and Kirsten Powell. Additional thanks go to Mary Jo Aagerstoun, Judy Freeman, and John Greathouse for their diligent reading of the text and editorial suggestions.

1. "Primitivism" is the admittedly problematic terminology used here to refer to the phenomenon of modernist interpretations of "tribal" objects initiated by Western artists at the turn of the century and reaching its apogee between the wars.

2. Cited in Guillaume Apollinaire, "Opinions sur l'art negre," *Action* 3 (April 1920): 25.

3. Masks from the Baule peoples of the Ivory Coast entered France before 1900 as a result of colonial activities. Because of their relative naturalism and refined carving, Baule objects were avidly collected and absorbed into the Western canon of African art. See Jean-Louis Paudrat, "From Africa," in *"Primitivism" in Twentieth-Century Art: Affinity of the Tribal and the Modern,* 2 vols, ed. William Rubin (New York: MOMA, 1984), 125–75; and Susan Vogel, *Baule: African Art, Western Eyes* (New Haven: Yale University Press, 1997). Ironically, the "ultra-primitive" mask in *Noire et blanche* was probably made for commercial trade rather than ritual use and was probably no older than Kiki. See Evan Maurer, "Dada and Surrealism," in Rubin, *"Primitivism,"* 539.

4. See Merry Foresta, "Perpetual Motif," in *Perpetual Motif: The Art of Man Ray,* ed. Merry Foresta (Washington, D.C.: National Museum of American Art, 1988), 34; Sandra S. Phillips, "Themes and Variations," in Foresta, *Perpetual Motif,* 193. On the intersection of photography and text in the "age of mechanical reproduction," see also Rosalind Krauss, "The Photographic Conditions of Surrealism," in *The Originality of the Avant-Garde and Other Modernist Myths* (Cambridge, Mass.: MIT Press, 1985), 87–118.

5. *Noire et blanche* was published in July 1928 in the Belgian journal *Variétés* among several pages of photographs by a number of photographers and with an essay by Paul Fierens, "Des Rues et des Carrefours." It appeared in November 1928 in the Parisian monthly *Art et Décoration* as a half-page header to a seven-page illustrated essay by Pierre Migennes titled "Les Photographies de Man Ray." Although the photograph was displayed at the *Exposition Minotaure* in Brussels in 1934, it never actually appeared in that journal.

6. On the surrealist predilection for Oceanic art, see Elizabeth Cowling, "Another Culture," in *Dada and Surrealism Reviewed,* ed. Dawn Ades (London: Arts Council of Great Britain, 1979), 451–68; Maurer, "Dada and Surrealism," 535–54; Louise Tythacott, "A 'Convulsive Beauty': Surrealism, Oceania and African Art," *Journal of Museum Ethnography* 11 (1999): 43–54. Man Ray's photographic moonscape, *La Lune brille sur l'Ile Nias,* with an Oceanic object from Breton's collection, better reflected surrealist ideals; it was featured on the catalog cover for the Galérie Surréaliste's 1926 opening exhibition, *Les Tableaux de Man Ray et objets des Iles.*

7. See Rosalind Krauss and Jane Livingston, eds., *L'Amour fou: Surrealism and Photography* (New York: Abbeville Press, 1985); and Sidra Stich, *Anxious Visions: Surrealist Art* (Berkeley: University Art Museum, 1990), 58–61. These two publications were among the first retroactively to insert *Noire et blanche* into the surrealist canon.

8. *Vogue* 7:5 (1926): 37.

9. On feminist critiques of modernist attitudes to the female body, see Carol Duncan, "Virility and Domination in Early Twentieth-Century Vanguard Painting," in *Feminism and Art History: Questioning the Litany,* ed. Norma Broude and Mary D. Garrard (New York: Harper and Row, 1982), 293–313; Mary Ann Caws, "Ladies Shot and Painted: Female Embodiment in Surrealist Art," in *The Expanding Discourse: Feminism and Art History,* ed. Norma Broude and Mary D. Garrard (New York: HarperCollins, 1992), 381–96. On *Noire et blanche* specifically, see Marianne Torgovnick, *Gone Primitive* (Chicago: University of Chicago Press, 1990); Whitney Chadwick, "Fetishizing Fashion/Fetishizing Culture: Man Ray's *Noire et blanche,*" *Oxford Art Journal* 18:2 (1995): 3–17.

10. Torgovnick, *Gone Primitive,* 17.

11. Victor Burgin, "Looking at Photographs," in *Thinking Photography,* ed. Victor Burgin (London: Macmillan, 1982), 144.

12. Janus, *Man Ray: The Photographic Image,* trans. Murtha Baca (London: Gordon Fraser, 1980), 13.

13. Pierre Migennes, "Les Photographies de Man Ray," *Art et Décoration* (November 1928): 155.

14. Mikhail Bakhtin, *Dialogic Imagination,* ed. and trans. Michael Holquist (Austin: University of Texas Press, 1981), 36.

15. Jane Livingston's assertion that Man Ray was "stubbornly unproficient in languages other than English" is, in fact, ill founded. See Livingston, "Man Ray and Surrealist Photography," in Krauss and Livingston, *L'Amour fou,* 120. As relayed by Lucien Treillard, Man Ray's longtime assistant, he was not only quite fluent in French but was known to carry around both English-French and French dictionaries.

16. See Arturo Schwarz, *Man Ray: The Rigour of Imagination* (London: Thames and Hudson, 1977), 199.

17. See Kirsten Hoving Powell, "*Le Violon d'Ingres:* Man Ray's Variations on Ingres, Deformation, Desire, and Sade," *Art History* 23, 5(2000): 772–79.

18. Stich, *Anxious Visions,* 58.

19. On Man Ray and chess, see Peggy Schrock, "With 'Homage and Outrage': Man Ray and the Dangerous Woman" (Ph.D. dissertation, University of Illinois at Urbana-Champaign, 1992) and Wendy Grossman, "Man Ray's Endgame and other Modernist Gambits," in *The Art of the Project: Projects and Experiments in Modern French Culture,* ed. Johnnie Gratton and Michael Sheringham (London: Berghahn Books, forthcoming).

20. See Wendy Grossman, "Das Faszinosum Afrikas in den Photographien Man Rays,"

in *Man Ray 1890–1976 Photographien*, ed. Rudolf Kickcn (Munich: Hirmer Verlag, 1996), 15–28.

21. The pyramidal form used for the king in Man Ray's 1920 chess design was, according to the artist, intended "as a symbolic evocation. Taking the Egyptian symbol of kingship as the pyramid, this was used for the King." Man Ray, *Chessmen by Man Ray*, cited in Schwarz, *Man Ray*, 203. The leap from African symbolism in his constructed chess pieces to chess symbolism in this photograph was not difficult to make, especially given the association of Egypt with the African continent in Western thought of the period. Although distinctions were still made between Egyptian and "Negro" art, Egypt still retained its African association at this time.

22. See Scharz, *Man Ray*, 203.

23. Begun after World War I by Picabia in Barcelona as a tribute to Stieglitz's defunct journal *291*, *391* was directed initially at the exile community and was intermittently produced in Barcelona, New York, Zurich, and Paris, where the final six issues were published. Man Ray's work appeared regularly, although the exact relationship between him and Picabia in the production of *Black and White* for the penultimate issue is unknown. See Michel Sanouillet, *391*, 2 vols. (Paris: Le Terrain Vague, 1960).

24. Jody Blake, *Le Tumulte noir* (University Park: Pennsylvania State University Press, 1999), 58. On the political and cultural conservativism of the interwar period, see Kenneth E. Silver, *Esprit de Corps: The Art of the Parisian Avant-Garde and the First World War, 1914–1925* (Princeton: Princeton University Press, 1989); and Romy Golan, *Modernity and Nostalgia: Art and Politics in France between the Wars* (New Haven: Yale University Press, 1995).

25. Blake, *Le Tumulte noir*, 84.

26. Ibid., 96.

27. See James Clifford, "On Ethnographic Surrealism," in *The Predicament of Culture* (Cambridge, Mass.: Harvard University Press, 1988); Chadwick, "Fetishizing Fashion."

28. In the increasingly anti-Semitic, xenophobic, and politically polarized atmosphere of Paris in the two decades before the outbreak of World War II, Man Ray's own marginal existence as foreigner, a photographer, and a Jew is certainly worth considering. See Golan, *Modernity and Nostalgia*, 137–54; Golan, "The Debate about the Status of Jewish Artists in Paris between the War," in *The Circle of Montparnasse: Jewish Artists in Paris 1905–1945*, ed. Kenneth Silver (New York: Jewish Museum, 1985), 81–87.

29. See Helena Lewis, *The Politics of Surrealism* (New York: Paragon House, 1988), 95; Dawn Ades, "Surrealism: Fetishism's Job," in *Fetishism: Visualising Power and Desire*, ed. Anthony Shelton (London: South Bank Centre, 1995), 67–87. Discussing the surrealists' anticolonial campaign, Ades states: "Recent critiques of the Surrealists' attitudes to non-Western cultures are a useful corrective to a romanticisation of their position, but do not necessarily take into account the full complexity of this position historically" (68).

30. Chadwick, "Fetishizing Fashion," 17.

31. See Maurer, "Dada and Surrealism," 539; Cecil Rhodes, *Primitivism in Modern Art* (London: Thames and Hudson, 1994), 140–41.

32. This use of *Noire et blanche* as visual shorthand is repeated in the discourse on photography and sculpture where it appears as cover illustration and is ignored in the text. See Michel Frizot and Dominique Paini, eds., *Sculpter-Photographier/Photographie-Sculpture* (Paris: Louvre, 1991).

33. Man Ray, "It Has Never Been My Object . . . ," 1945, reprinted in *Man Ray 1890–1976* (Ghent: Ludion Press, 1995), 11.

Gender in the Archive: *María Zavala* and the Drama of (not) Looking

SEVEN ▨ ▬▬▬▬▬▬▬▬▬▬▬▬▬▬▬▬

ANDREA NOBLE

The Woman Detective

The case: *María Zavala, "La destroyer," ayudó a bien morir a los sol-dados.* This curious photograph (fig. 7.1)—one of some six hundred thousand photographs that constitute the Casasola Archive—has intrigued me for many years. Who was María Zavala? What was her "profession"? Was she some kind of nurse of death, since she "helped soldiers to die well"? What might it mean to help someone "die well"? What is the significance of her nom de guerre—*"La destroyer"*—which seems sinisterly at odds with her nurselike qualities? What, moreover, of the objects that she appears to be proffering for display in the image? When and where exactly was this image made, given that the caption that accompanies it contains no information concerning either the date or the place of its making? Beyond these more tangible elements that offer themselves up for scrutiny from within the photographic frame, on a more affective level, I also find myself captivated by María Zavala's compelling gaze. This is a gaze that meets my own, in an oblique way, but that nevertheless provides me with no clue as to how to interpret it.

With a compulsion to insert the photograph into a context, to investigate María Zavala's story, I set about the task of finding out

more. My first line of inquiry took me to the photograph's archival source, the Casasola Archive that documents the Mexican Revolution and its aftermath. Named after its founder Agustín Víctor Casasola, the archive started out as the Agencia de Información Gráfica (the Graphic Information Agency), which was established in about 1912, some two years after the outbreak of the revolution. Casasola's agency served as a repository for images made by a range of photographers whose depiction of the violent social and political upheavals of the revolution were sold to the foreign and national press. In time, once the violent phase of the civil war was over and the events photographed had become less instantly newsworthy, the agency was transformed into an archive. Images from the archive formed the basis of a visual history of the revolution, an event that was to determine the course of Mexican history in the twentieth century. Published as the *Historia gráfica de la Revolución Mexicana*, in 1960, this photographic history charts the revolution from its inception during the thirty-four-year dictatorship of Porfirio Díaz through the armed struggle and the period of the revolution's institutionalization to the first years of the presidency of Luis Echeverría. In 1976 the archive was purchased by the state and is now administered by the prestigious

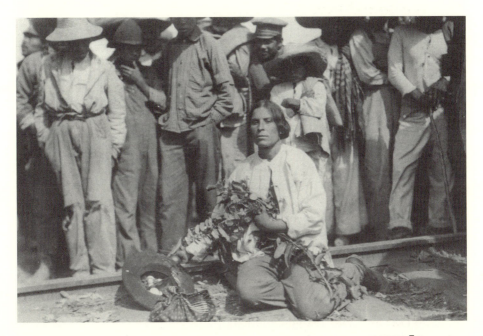

FIGURE 7.1.

María Zavala, *"La destroyer," ayudó a bien morir a los soladados*

Instituto Nacional de Antropología e Historia (National Institute of Anthropology and History). It has furthermore started to generate a body of critical literature dedicated to historicizing and interpreting its images: a corpus that was to provide my next port of call in my search for clues in the case of the mysterious *María Zavala*.[1]

But, with the exception of a brief reference by the photo-historian John Mraz, María Zavala appeared to have left no trace in the critical literature in question.[2] Nevertheless, any mention, however passing, was worth pursuing. In an essay titled "Más allá de la decoración: Hacia una historia gráfica de las mujeres en México" (Beyond Decoration: Toward a Graphic History of Women in Mexico), Mraz has the following to say of María Zavala:

> It could be argued that the questions that photographs [of women in Mexico] suggest are as important as what they show. There are one or two of those published that serve to open up the panorama of the different roles played by women in the revolution. For example, that of María Zavala, "the Destroyer," whom we find sitting on a rail track. The foot of the photo makes us think that she must have blown up trains during the de la Huerta rebellion.

> Ahora bien, se podría argumentar que las preguntas que las fotos [de las mujeres en México] sugieren son tan importantes como lo que muestran. Hay una que otra de las publicadas que sirve para abrir el panorama de los diferentes papeles de la mujer en la Revolución. Por ejemplo, la de María Zavala, "La destroyer," a quien encontramos sentada en una vía ferroviaria. El pie de la foto nos hace pensar que debe haber sido una dinamitera de trenes durante la rebelión delahuertista.[3]

This brief reference was not much to go on. Nevertheless, Mraz's conjecture helped me to locate the photograph within a more or less precise historical frame. The image was made some three to four years after the end of the violent phase of the revolution, during the period in which the protagonists of the triumphant faction—the so-called *familia revolucionaria* (revolutionary family), Adolfo de la Huerta, Alvaro Obregón, and Plutarco Elías Calles—jockeyed for power. As its name suggests, the de la Huerta uprising was led by Adolfo de la Huerta and was triggered, in part, by Obregón's backing of Elías Calles as his presidential successor in 1923. With a clearer historical frame in mind, I came upon a slim volume by Enrique Arriola, *La*

rebelión delahuertista, in the illustrated Secretaría de Educación Pública series Memoria y olvido: Imágenes de México (Memory and Forgetting: Images of Mexico). Arriola situates the delahuertista uprising as

> a significant moment in the process of consolidation of the new State and the institutionalization of the armed force. . . . The rebellion can be considered a decisive moment in the formation of the army as defender of that abstract entity, above and beyond class, that is the nation, and as the safeguard of the interests of all the members or interests of this entity.

> un momento significativo en el proceso de consolidación del nuevo Estado y de institucionalización de las fuerzas armadas. . . . La rebelión puede plantearse como un momento decisivo en la formación del ejército como defensor de esa entidad abstracta, por encima de las clases, que es la nación, y como salvaguarda de los intereses de todos los miembros o intereses de la misma.[4]

The de la Huerta rebellion can be understood as an end point in the revolution, when it was purged of its dissident voices and retrospectively constructed as a coherent project of social and political progress. Much like the Casasola photographs themselves, which passed from forming part of an agency to part of an archive, at this stage the revolution passed into cultural memory, now to be invoked in official discourses of state and nationhood that would serve to authorize and legitimize political regimes and their "revolutionary policies."[5]

On the basis of Arriola's evidence, it was possible to prove that the photograph of María Zavala was made at a historically poignant moment: a moment at which the postrevolutionary Mexican state started to consolidate itself as the revolution and entered its main phase of institutionalization (1920–40). However, among the images in Arriola's book, including photographs of railways, locomotives, and military men, I was hard pressed to find many women, let alone a reproduction of the explosive María Zavala. Indeed, the more I delved into the photographic and historical sources that intersect in this image, the more I seemed to lose from sight those elements that most fascinated me about María Zavala: namely, her status as woman warrior and that piercing gaze. At this point, then, I turned to feminist theory: surely this was a more appropriate reading tool for the woman detective.

The Woman Warrior

If *María Zavala* captivates the viewer-detective's gaze, compelling her to search for answers to questions that traverse both historical and photographic narratives, the realignment of the discursive and the visual is ultimately more problematic than productive. As Griselda Pollock states:

> Never simply a matter of shifting existing methods and theories to other subjects: women, feminist cultural studies and histories disturb the very frameworks that have been established for cultural analysis. Sexual difference, what it means, how it is produced, lived, negotiated, how it shapes and is shaped by cultural practices, is . . . the compelling perplexity for an academic adventure that demands realignments of both the forms and the contents of knowledge.[6]

To attempt to reinsert *María Zavala* into the thrust of the historiography of the Mexican Revolution is to neglect to tackle the conflicts and tensions that relate to issues of gender: conflicts and tensions that inhere in both the historical and the photographic narratives into which I had attempted to insert the image. That this is so is exemplified in a recent collection of photographic images of women combatants and camp followers (*soldaderas*) that is preceded by an introduction by one of Mexico's foremost literary figures, Elena Poniatowska.[7] Without the *soldaderas*, claims Poniatowska, seemingly without a trace of irony,

> there is no Mexican Revolution: they kept it alive and fecund, like the earth. They were sent on ahead to collect firewood and to start the fires, and they fed the revolution throughout the war years. Without the *soldaderas*, the men taken by levy would have deserted.

> no hay Revolución Mexicana: ellas la mantuvieron viva y fecunda, como a la tierra. Las enviaban por delante a recoger leña y a prender la lumbre, y la alimentaron a lo largo de los años de guerra. Sin las soldaderas, los hombres llevados de leva hubieran desertado.[8]

On some level, Poniatowska is undoubtedly right in her claim that without these women, who have certainly been excluded from the

masculinist historiography of the revolution, there can be no revolution as we know it. And the images of feisty women warriors that follow her celebratory introduction attest precisely the *soldaderas'* role as protagonists of the historical narrative. "Look!" these images proclaim, women were there, not only in domestic, sexual, and supportive roles. "Look!" they cry, these women also carried guns and they knew how to use them. There are, however, problems associated with reading such images as evidence of women's participation in the revolution: problems that turn, in part, on their status as photographic images. That is, the imperative "look" of the images, their evidential force, is predicated on photography's privileged purchase on the real, on its indexical status. The notion of photographic indexicality, as other contributors to this volume testify, has most famously been articulated by Roland Barthes in *Camera Lucida:*

> Show your photographs to someone—he will immediately show you his: "Look, this is my brother; this is me as a child," etc.; the Photograph is never anything but an antiphon of "Look," "See," "Here it is"; it points a finger at certain vis-à-vis, and cannot escape this pure deictic language.[9]

Put to work in the name of a quasi-feminist effort to celebrate the woman warrior, however, the indexicality of photographic representation ultimately, I suggest, does this feminist project a disservice. This is because the Barthesian *"That-has-been"* of the photographic image ends up producing nothing more than the well-worn "power of women topos."[10] Viewed from a celebratory feminist optic as a form of reversal—"Look, women are powerful too!"—these images of feisty women come "inevitably [to] signify the mechanism of reversal itself, constituting themselves as aberrations whose acknowledgement simply reinforces the dominant system of aligning sexual difference with a subject/object dichotomy."[11] Or, to return to *María Zavala, "La destroyer,"* the message "Look, she blew up trains!" does nothing to disturb the established frameworks for analysis that have accumulated around this image as a historical photo-document and which are blind to the workings of sexual difference.

If we are to embark on the adventure of disturbing these frameworks, we must find a more sophisticated way of reading the relationship between sexual difference and its attendant historical and photographic narratives. As it is, disregarding the "compelling perplexity" of sexual difference, these latter narratives are of themselves

areas of cultural practice that have enjoyed an uneasy relationship with one another:

> It is confusion over the way photographs carry their meaning, and suspicion over their teasing ambiguity, that makes scholars wary of the evidence photographs embody. At worst images and particularly photographs are ignored; at best they are used merely in illustration of other histories.[12]

When we look at photographs as illustrative, when we privilege the historical over the photographic, as so often happens with photographic images (and as was my own immediate impulse with *María Zavala*), we are not, I suggest, really looking at all. We are looking and not looking. But, I argue in what follows, the double drama of looking and not looking provides us with a clue to help us see—not more clearly or transparently, but certainly more critically—the gender dynamics at play in *María Zavala*.[13]

The Double Drama of (not) Looking

In the introduction to *Family Frames*, Marianne Hirsch argues that "multiple looks circulate in the photograph's production, reading, and description." Later, she states that "between the viewer and the recorded object, the viewer encounters, and/or projects, a screen made up of dominant mythologies and preconceptions that shapes the representation."[14] Photography is a mode of representation that when taken at face value seems to offer an objective, unmediated transcription of "reality" that is somehow free of the workings of ideology. Hirsch's account, however, alerts us to photography's status as a highly mediated cultural product, whose meanings are framed by the complex discourses that operate in the production and reception of a photograph. It is this notion of the multiple looks that circulate around any given photographic image and the ideologically inscribed screen that exists between viewer and image that I wish now to bring into focus in my analysis of *María Zavala*.

We can identify (at least) four different, yet interconnected, looks in circulation around this particular photograph, which I propose in this essay to set up as a chain of looking that will serve as a defining nexus in my exploration of the relationship among photograph, historical narrative, and sexual difference. The first look that I identify is a contextualizing look that has so far been invisible in my discussion

of the historical and archival contexts to which the photograph belongs. It pertains to the editor—Pablo Ortiz Monasterio—of the volume of images from the Casasola Archive where I first encountered the image of "La destroyer": a volume titled *Jefes, héroes y caudillos* (Chiefs, Heroes, and Caudillos) and originally published in 1986 by the Fondo de Cultura Económica.[15] A well-known photographer, Ortiz Monasterio was to select and edit the images. Hence he was responsible, among other things, for the order in which the photographs appear in the collection. With the first image of the volume dating from 1903 and depicting Porfirio Díaz before the revolution that swept aside his dictatorship, *Jefes, héroes y caudillos* takes the viewer through a more or less chronological photographic narrative: through the rise and fall of Franciso I. Madero; *La decena trágica* ("The Tragic Ten Days," when Madero was assassinated in Mexico City); the interim presidency of Victoriano Huerta; the *caudillos*, Francisco Villa and Emiliano Zapata; the triumphant constitutionalist *jefes*, Alvaro Obregón and Venustiano Carranza; to the de la Huerta rebellion, where *María Zavala* is the final image to appear in the selection. In this sense, *María Zavala* is literally the ultimate image in Ortiz Monasterio's collection.

I have already mentioned the second look I wish to identify: namely, that of the subject of the photograph, María Zavala, who holds our gaze so insistently. This look, in turn, takes us to the third and fourth looks engaged by the photograph: the look of the viewer and the gaze that mirrors it in the photograph, the gaze of the row of male onlookers who stand on the other side of the rail track and for whom María Zavala is also clearly the object of scrutiny. Or is she? If the notion of a chain of looks implies continuity, then here the constitutive optical relations that link viewing subject to viewed object break down. An element that fascinates me about this row of onlookers is that, without exception, their gaze is occluded from the viewer outside the frame through cropping, the shadows cast by the onlookers' hats, or the lighting effects produced in the image that serve to render their eyes invisible. What, then, are the implications of this occluded look? Or, to rephrase the question, what is it that this row of male onlookers gaze upon, which, according to the logic of looking set up in and around the image, is signaled to the viewer as that which cannot be looked at?

Let us move back to the look of the editor whose task it was to collate and organize the photographs of *Jefes, héroes y caudillos*, and who places alongside *María Zavala* another image (fig. 7.2): *Jefe revolucionario muerto en los combates de Palo Verde. Jalisco, 1924* (Revolutionary chief dead in the battle of Palo Verde. Jalisco, 1924).

When we take into consideration the position of this pair of images, it is important to note the wide format of *Jefes, héroes y caudillos*—a format that obliges the viewer to see the two photographs side by side. Beyond the book format that positions these photographs contiguously, there are further formal and thematic correspondences between *María Zavala* and *Jefe revolucionario* that merit our attention. If the central focus of *María Zavala* is (of course) María Zavala herself, as both caption and image inform us, then there is also a thematic relationship with the adjacent image. That is, if one of Zavala's roles in the armed conflict—a role that, at the outset, I allied with her "nurselike" quality—was to "help soldiers die well," then the viewer cannot help but surmise that the *Jefe revolucionario* may well have been one of Zavala's "victims." In other words, read in tandem with *María Zavala*, *Jefe revolucionario* performs an illustrative function. There is, however, another correspondence between the two photographs. The row of onlookers in the first image is echoed in the second by a similarly faceless group of federal soldiers whose posture suggests to us that they are looking at the dead man but whose gaze again is uncannily occluded. Here, once more, the viewer is presented with, indeed implicated in, the double drama of looking and not looking.

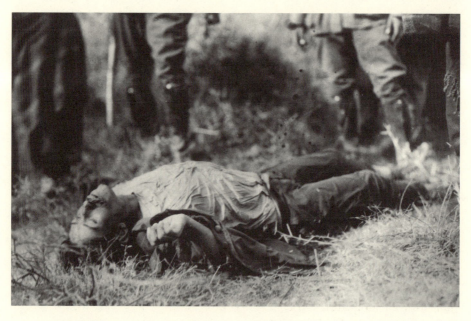

FIGURE 7.2.
Jefe revolucionario muerto en los combates de Palo Verde, Jalisco, 1924

Before moving to a conclusion, there is one final correspondence between the two photographs that I wish to outline. This third parallel functions at the level of the trope and again engages the viewer's gaze. As we look at these contiguously located images, our gaze slips from *María Zavala* to the unnamed *Jefe revolucionario*. Or, to put it another way, our gaze slides between femininity and death: between figures that, as Elisabeth Bronfen has argued in *Over Her Dead Body*, are linked as "superlative sites of alterity." The focus of Bronfen's analysis is the ubiquity in Western culture of images of the death of women. The pair of images that are the focus of this essay would appear to fall outside the remit of the insights offered by Bronfen, in that the death they depict is male death. Her analysis is nevertheless relevant to the present discussion precisely because death and femininity are conflated in the two images, via their alignment. Positioned alongside *Jefe revolucionario* and linked to it via caption and formal elements within the frame, the photographic subject María Zavala comes to embody death. As feminine death embodied, following Bronfen's analysis, María Zavala is burdened with further connotations: "Femininity and death cause a disorder to stability, mark moments of ambivalence, disruption or duplicity and their eradication produces a recuperation of order, a return to stability."[16] What then is at stake in the position of these two photographic images, placed side by side *and* located as the final images in a photo-story of the Mexican Revolution? I wish to signal two points about their tropic interrelationship.

The first is concerned with the chronological photonarrative that *Jefes, héroes y caudillos* constructs. The collection provides, primarily, a linear narrative of progress about the revolution and its protagonists. The de la Huerta uprising of 1924 that is depicted in the final section of the collection marks, as Arriola states, a significant moment in the consolidation of power that was to give birth to the modern Mexican (party of) state as we know/knew it.[17] As stated earlier, the revolution and its association with narratives of progress were to play an important role in the legitimation of postrevolutionary political regimes. As a mode of representation loaded with the power of objective transcription, photographs from the Casasola Archive came to play an important role in embedding the revolution and its ideological underpinnings in cultural memory. Located in the context of such a photonarrative, however, *María Zavala* becomes charged with meanings that resonate on quite another scale. That is, following Bronfen, if the sight of death and femininity "cause a disorder to stability," if they are the scene of disruption and ambivalence, then *María Zavala* and

Jefe revolucionario, as the ultimate images in *Jefes, héroes y caudillos*, can be seen to represent a subversive visual gesture: one that has the potential to call into question the narrative progress constructed by the collection as a whole. In the wider context of postrevolutionary cultural memory, to subject the linear progress of the revolution to scrutiny is tantamount to calling the whole official postrevolutionary project into question.

But herein lies a problem. To return to Hirsch's notion of the encountered or projected screen between viewer and photographic image, one of the dominant mythologies writ large on that screen is "Woman" as site of alterity: as that which, like death, is the site of fear and anxiety. And as long as "Woman" is reduced to a telos of alterity, it will be impossible to offer an account of her agency. This agency is, I believe, visualized in photographic artifacts such as the images that appear in Poniatowska's collection *Las soldaderas*: it is there in the indexical "look" I have pointed to in the photographs that comprise this parade of woman warriors. However, as Philippe Dubois asserts in his 1983 essay *L'Acte photographique* (The Photographic Act), we must not allow the index—a term that has accrued much critical currency in theories of photography—to become photography's "new epistemological obstacle."[18] As I have argued, we cannot take the evidential force of such photographs of female subjects of the revolution at face value, as images that simply document female participation and therefore affirm female agency. To do so is to overlook precisely the screen of representation that determines looking. Photographic images are much more complex than their apparent transparency would have us believe. For me, this is, perhaps, the ultimate fascination of the photograph *María Zavala*. In the double drama of looking and not looking that the photograph enacts in its depiction of the occluded gaze of the onlookers, do we come closer to deciphering María Zavala's mysterious gaze? Could the ultimate enigma of her gaze that meets the viewer's so insistently be a challenge to look at a culturally prohibited sight? By following through the chain of looks I have traced in this essay, this photograph urges us to look differently. And by learning to look differently, do we not begin to disturb the frameworks of cultural analysis that have long clouded our vision of Others?

Notes

1. For a useful source of the critical literature on Mexican photography, see Ariel Arnal, "Mexican Photography: A Bibliography," *History of Photography* 20:3 (1996):

250–54. This indispensable issue of *History of Photography* is guest edited by John Mraz and devoted to Mexican photography.

2. Much of the work on the Casasola Archive tends to offer overviews of its images rather than detailed readings of individual photographs. Those images that have been the subject of closer scrutiny tend to be the overtly iconic ones, such as that of Pancho Villa on the presidential throne, accompanied by Emiliano Zapata. The thrust of my own work on the archive has been oriented precisely toward such close and detailed readings. See my "Photography and Vision in Porfirian Mexico," *Estudios Interdisciplinarios de América Latina y el Caribe* 9:1 (1998): 122–31; and "Casasola's *Zapatistas en Sanborns* (1914): Women at the Bar," *History of Photography* 22:4 (1998): 366–70.

3. John Mraz, "Más allá de la decoración: Hacia una historia gráfica de las mujeres en México," *Política y cultura* 1 (1992): 160. The translation here, as elsewhere in the chapter, is mine.

4. Enrique Arriola, *La rebelión delahuertista* (Mexico: Martín Casillas/SEP, 1983), 7.

5. See Thomas Benjamin, *La Revolución: Mexico's Great Revolution as Memory, Myth and History* (Austin: University of Texas Press, 2000). It is important to emphasize that the iconography of the revolution has not only been appropriated by a hegemonic project of state. The 1994 Zapatista uprising in the southern state of Chiapas, in its adoption of the iconography associated with Emiliano Zapata, is an example of a reappropriation of revolutionary icons put to contestatory ends.

6. Griselda Pollock, "Killing Men and Dying Women: Gesture and Sexual Difference," in *The Practice of Cultural Analysis: Exposing Interdisciplinary Interpretation*, ed. Mieke Bal (Stanford: Stanford University Press, 1999), 75.

7. See Elizabeth Salas, *Soldaderas in the Mexican Military: Myth and History* (Austin: University of Texas Press, 1990), xii. Salas traces the etymology of the word *soldadera* back to the time of the Spanish conquest of Mexico: "Both domestic and foreign troops after the Spanish Conquest in 1519 used women as servants (*soldaderas*). Soldiers used their pay (*soldada*) to employ women as paid servants (*soldaderas*)." Ibid. By the time of the 1910 revolution, the term had come to designate a variety of roles played by women, ranging from camp followers, to frontline combatants.

8. Elena Poniatowska, *Las soldaderas* (Mexico: Era/INAH, 1999), 14.

9. Roland Barthes, *Camera Lucida: Reflections of Photography*, trans. Richard Howard (London: Fontana, 1984), 5.

10. See Nanette Salomon, "Vermeer's Women: Shifting Paradigms in Midcareer," in Bal, *The Practice of Cultural Analysis*, 352.

11. Mary Anne Doane, "Film and the Masquerade: Theorising the Female Spectator," *Screen* 23:3–4 (1982): 77.

12. Caroline Brothers, *War and Photography* (London: Routledge, 1997), 14.

13. I am borrowing the notion of the "drama of looking" from Johnnie Gratton's extremely stimulating discussion of the photography of Sophie Calle.

14. Marianne Hirsch, *Family Frames: Photography, Narrative, and Postmemory* (Cambridge, Mass.: Harvard University Press, 1997), 1, 7. The photograph to which Hirsch is referring in the first section of my selective quotation is Barthes's famous "Winter Garden" photograph, an image that haunts the pages of this and other volumes devoted to the discussion of photography.

15. Flora Lara Klahr, *Jefes, héroes y caudillos* (Mexico: INAH/Fondo Cultura Económica, 1986). Klahr's contribution to the book is a contextualizing essay.

16. Elisabeth Bronfen, *Over Her Dead Body: Death, Femininity and the Aesthetic* (Manchester: Manchester University Press, 1992), xxii.

17. As I write, the ruling party in Mexico, the Partido Revolucionario Institucional (PRI), which came to power in the wake of the revolution, has just lost the national elections for the first time in more than seven decades to the Partido de Acción Nacional (PAN). It will be interesting to see how the iconography of the revolution is reappropriated in the wake of this historic event.

18. Philippe Dubois, *L'Acte photographique* (Paris: Nathan, 1983), 80–81.

Humanism Reimagined: Spain as a Photographic Subject in W. Eugene Smith's "Spanish Village" (1951) and Cristina García Rodero's *España oculta* (1989)

■■■■■■■■■■■■■■■■■■■■■■■■■■■■■ ⊠ EIGHT

JOHN D. PERIVOLARIS

This chapter focuses on the current problematization of long-standing assumptions about photography as a humanist endeavor. Humanism is understood as a belief in the commonality of humankind's experience and aspirations: a commonality that transcends cultural, economic, geographic, social, and ideological differences. The responsibility for one's fellow "man" implied by a humanist perspective has never been shouldered with greater commitment than by the legendary photojournalist W. Eugene Smith (1918–78). By setting his photography of rural Spain next to Cristina García Rodero's much more recent, less solemn coverage of the same subject, I highlight not only the elisions and assumptions of the photographic tradition represented by Smith but also how García Rodero's interrogation of humanist images of the nation and individuality, as well as of Francoist propaganda, ultimately also appeals to universal values such as freedom and democratic representation that are humanism's avowed raison d'être. I further argue that García Rodero's complex relationship of sympathetic opposition to Smith's approach is traced by her photographs' lack of narrative coherence. This situates them in a very different photographic place from that occupied by the work of Smith. At the same time, her images exist in the narrative and photographic contexts of post-Francoist Spain, against which they articulate their meaning. The sense of simultaneous

detachment from and dependence on established loci of meaning has been identified as one of the principal features of the grotesque in art and literature.[1] Consequently, I claim that García Rodero's photography may be inserted into a well-established tradition of grotesque art in Spain.

In 1950 Smith completed what is considered among the finest photographic essays, "Spanish Village," which he shot in Deleitosa, Extremadura, and which was published by *Life* magazine the following year (fig. 8.1). His comments about his photographs are revealing. Reflecting on the significance of one of the images in the series, he attacks Francoist propaganda and repression and asserts his Republican sympathies: "Away from the publicized historical attractions, away from the unrepresentative disproportion of the main cities, away from the tourist landmarks, Spain is to be found. Spain is of its villages, simple down to the poverty line, its people unlazy in slow-paced striving to earn a frugal living from the ungenerous soil. Centuries of the blight of neglect, of exploitation, of the present intense domination weigh heavily; yet the people are not defeated. Believing in life, they reluctantly relinquish their dead."[2] And about another photograph in the series he comments: "The Spaniards are a people who are not easily defeated. They work the day and sleep the night, struggle for and bake their bread—and believe in life." Throughout his life he focused passionately and compassionately on concerns such as "the blight of neglect, of exploitation," and the life-and-death struggle in harsh environments. Another statement reveals that for him photography was a means of triggering universal recognition of a common human spirit, righteous anger in its defense: "And each time I pressed the shutter release it was a shouted condemnation hurled with the hope that the picture might survive through the years, with the hope that they [*sic*] might echo through the minds of men in the future—causing them caution and remembrance and realization."[3]

In 1955 Smith joined Magnum, the photographers' cooperative set up in New York in 1947 to pursue projects promoting the humanistic values that he championed and that were espoused by the socialist views of the agency's founding members.[4] Magnum's first commission, for the mass-circulation *Ladies Home Journal*, was a project titled "People Are People the World Over," which recorded the lives of farmers and their families around the world.[5] At the same time, one of Magnum's founding members, David Seymour, was documenting the situation of impoverished children and orphans in postwar Europe for UNESCO. In the same year Smith also contributed photographs (though none from "Spanish Village") to *The Family of*

FIGURE 8.1.
W. Eugene Smith, *Spanish Wake*, from "Spanish Village," 1951.

Man exhibition, held at the Museum of Modern Art in New York, one of the key exhibitions of the medium's history. The 503 photographs selected from more than two million submitted from around the world—14 percent were taken by Magnum photographers—are distinguished by their emblematically classic, at times monumental composition. The viewer was to be inspired by the human spirit portrayed by images that, in the words of the exhibition's organizer, the photography pioneer Edward Steichen, were "conceived as a mirror of the universal elements and emotions in the everydayness of life—as a mirror of the essential oneness of mankind throughout the world."[6] The enterprise was aided by captions citing great men; the classics of world literature, from the Bible to the Bhagavad Gita; and proverbs and verse from nonmetropolitan ethnicities, specifically those of the Sioux, Pueblo, Kwakiutl, and Navajo Indians, as well as the Maori. All such texts underline what are presented as universally recognizable ideals and themes related to humanity's cycle of birth and death: justice, love, childlike purity, parenthood, industry, fortitude, and, above all, hope, represented by the last photograph of the exhibition, a 1946 photograph by Smith. Showing his children walking into the brilliant light of a forest, it is titled *The Walk to*

Paradise Garden (fig. 8.2). Captioned in the exhibition catalog with a line by St. John Perse, "A world to be born under your footsteps," Smith's photograph faces the catalog's inside back cover image by Cedric Wright, a photograph of waves breaking. The exhibition thus served as a photographic "mirror" of "Mankind," uniting all nations under a humanism that makes them immediately legible, so that the strong photographic compositions undergird the assurance of the exhibition's themes and sentiment. It was this confident period of postwar American photography that Marshall McLuhan had in mind when, in his 1964 *Understanding Media: The Extensions of Man*, he wrote: "[The photograph] wipes out our national frontiers and cultural barriers and involves us in *The Family of Man*, regardless of any particular point of view."[7]

It is no accident that the exhibition's location was the same as that of the headquarters of the United Nations, the organization that emblematized its values, optimism, and concerns. A photograph of the UN General Assembly appears on page 184 of the exhibition catalog, along with a passage from the United Nations Charter referring to its mission to "reaffirm faith in fundamental human rights, in the dignity and worth of the human person, in the equal rights of men and women and of nations large and small." *The Family of Man* took place at the end of the first decade of the United Nations, with both projects indisputably necessitated by the horrors of the recent world war and the threat of global holocaust unleashed by the nuclear arms race.[8] The dangers and benefits of the nuclear age are debated through the juxtaposition of a Sioux passage urging the responsible ("sacred") use of fire and a quotation from the U.S. Atomic Energy Commission urging the same responsibility with regard to nuclear energy, both running down the center of a two-page spread displaying a photograph of an office building, each of whose windows is illuminated by abundant electricity, and nuclear scientists and engineers at work.[9] Meanwhile, on page 178 there is a photograph of a young Nagasaki victim of radiation burns, opposite a condemnation of the nuclear arms race by Bertrand Russell.[10] The assumed internationalism, ease, accessibility, and immediacy of the ideals represented by *The Family of Man* are directly related to its location in the immediately postwar United States and are reliant on a reception based on a liberal consensus of values only conceivable before the late and postindustrial age of globalized travel, transnational media distribution, youth and sexual revolutions, Vietnam, and ethnic separatism in the United States. But the ultimate foundation of such confident universalism is the superpower status the United States enjoyed in

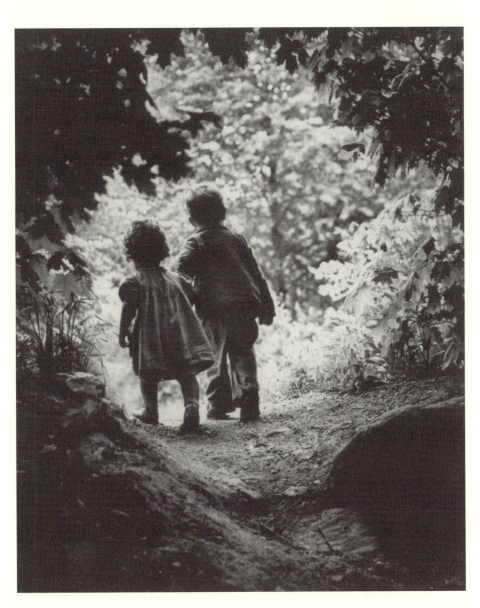

FIGURE 8.2.
W. Eugene Smith, *The Walk to Paradise Garden*, 1946

the 1950s, represented by its domination to the present day of the UN Security Council, as well as by its coming of cultural age, manifest in the culmination of modernism in abstract expressionism and in New York's displacement of Paris as the cultural capital of the cold war world.[11] This is a universalism that asserted, to use Marianne Hirsch's term, a "monocular" perspective that subordinates the word *family* to the patriarchal authority of self-assured, self-assuring knowledge of and familiarity with the lives of foreigners that it fixes with its gaze.[12]

Smith's portrayal of Spain, the detail of which I revisit below, needs to be read against the particular, midcentury photographic context profiled in the preceding paragraphs: a context possessed of a marked—and, as Hirsch signals, contested—ideological hue. The contrast between his "Spanish Village" and the work of Cristina García Rodero, made almost forty years later, in 1989, is startling. That contrast indicates a new age of photographic representation, a crisis of the Oedipal domestication of national identities, marked within Magnum itself by the divisive admission to full membership, in 1994, of the British photographer Martin Parr, whose hostile and grotesque color photographs of working-class life in Britain and mass tourism have led to accusations of his "ridiculing mankind in his work."[13] García Rodero's stark compositions of events inaccessibly rooted in local ritual and unaided by textual captions accompanying each photograph make her images difficult to assimilate not only by foreign viewers but also by Spaniards not from the locations photographed. The sense of disorientation is dramatized by the fact that the images are those of a Spanish photographer, whose exploration of her country promises the ethnographic depiction of a "dark continent," suggested by the title of her book, *España oculta* (Hidden Spain). But there is no recourse to the ethnographer's reassuring narrative-scientific categories or to *National Geographic*'s attractive exoticism. Her photographs are, in this sense, antihumanist, since the authority of universal values is undermined.

In the context of Spanish photographic history, as outlined by Spain's foremost historian of the medium, Publio López Mondéjar, in his authoritative 1997 *Historia de la fotografía en España* (History of Photography in Spain), I would also consider these photographs anti-Nationalist. This is because they disallow the pictorialist celebration of an eternal, epic Spain contrived by photographers favored by the Francoist regime's propaganda apparatus, particularly the Dirección General de Prensa y Propaganda. One such photographer was José Ortiz Echagüe, who traveled the length and breadth of Spain to

produce emblematic pictures, often with a religious theme, of Spanishness and Spanish types, which he published in a tetralogy of books: *España, tipos y trajes* (1933; Spain, Types and Costumes); *España, pueblos y paisajes* (1938; Spain, Villages and Landscapes); *España mística* (1943; Mystical Spain); and *Castillos y alcázares* (1956; Castles and Fortresses).[14] The probability that García Rodero's own *España oculta* might be read as an intertextual parody of the third title in the series is increased by the bathetic distance her photographs evince from the values attributed to Ortiz Echagüe's work by Friar Justo Pérez de Urbel, writing in 1948:

> Throughout his work we witness filing past men from every province and also every period, those who have made that colossal history that exceeds the maddest distortions of epic poetry. Thus we can see the heroes of Numancia and the conquistador of America, the anonymous settler of the Reconquest, Don Quixote, Hernán Cortés.

> A través de su obra vemos desfilar al hombre de todas las provincias y también de todos los tiempos, el que ha hecho esa historia descomunal que supera los más locos extravíos de la poesía épica. Así vemos al héroe de Numancia y al conquistador americano, al repoblador anónimo de la Reconquista, a don Quijote, a Hernán Cortés.[15]

Less bombastically, we might note that, to a certain degree, a photograph is an optical reproduction as well as a re-creation of reality. It is pre–digital photography's necessarily empirical encounter with the phenomenological world that allows García Rodero to coincide with the aesthetic project of Gilbert and George, English artists who work with photographic installations and who have illuminated the optimism of their work by declaring, "We want to create a reality that doesn't exist in art. . . . It's not usual to show the human person. Normally what is shown is a human condition."[16] Her photography coincides, too, with that of one of Magnum's founding members, Robert Capa, whose 1936 photograph of a Republican soldier shot on the Córdoba Front is perhaps the most famous war photograph ever taken. Of Capa, another Magnumite, Eve Arnold, says the following, countering the impression that his pictures "were not consistently well designed"[17] by highlighting their immediacy: "He was aware that it is the essence of a picture, not necessarily its form, which is important."[18]

It is to the documentary quiddity of Capa's photographs, taken before and at the outset of Magnum, prior to Smith's membership and to *The Family of Man*, to which García Rodero's work harks back. Her images move beyond the conspicuous equilibrium of Smith's compositions, whose interpretive intention as messages is underlined by his declaration, at the beginning of his career, "I want them to be symbolic of something."[19] The inherent immediacy of the medium—the pre-digital photographer's obligation to be, in Smith's words, "physically present"—unsettles the detachment of aesthetics, a designed view of reality, or ideas of self-expression and social responsibility.[20] Smith resolutely brought the latter to bear on his work, through a narrative essay form of photography that involved flawless composition, sometimes directed or even posed; strictly controlled chiaroscuro; and copious captions.[21] In this, he reminds us of Henri Cartier-Bresson, one of the original Magnum founders, who was trained as a painter and could master the world he photographed through his cultivated virtuosity and an intellectual's sense of photography as a tool for discovering "significance" in the world. In his landmark 1952 book, *The Decisive Moment*, Cartier-Bresson set forth thus his philosophy of the medium:

> To me, photography is the simultaneous *recognition*, in a fraction of a second, of the *significance* of an event as well as of a *precise organization* of forms which give the event its *proper expression.* . . . But this takes care only of the content of the picture. For me, content cannot be separated from form. By form, I mean a *rigorous organization* of the interplay of surfaces, lines and values. It is in this organization alone that our conceptions and emotions become concrete and communicable. In photography, visual organization can stem only from a *developed* instinct. . . . Photography must seize upon this moment and hold immobile the *equilibrium* of it.[22]

Of course, the artless candidness of many of García Rodero's photographs (fig. 8.3) is no less contrived than and involves as many aesthetic decisions as Smith's more rhetorical approach. In the Spanish photographer's case, the frequent choice of wide-angle lenses enables her to accentuate the length of lines, vanishing point, and angles; to introduce distortion in the foreground of the frame; and to include a large number of figures in the same shot, most of whom vie for our attention by being kept in focus by the enhanced depth of field. Moreover, the initial chaotic impression created by many of her images

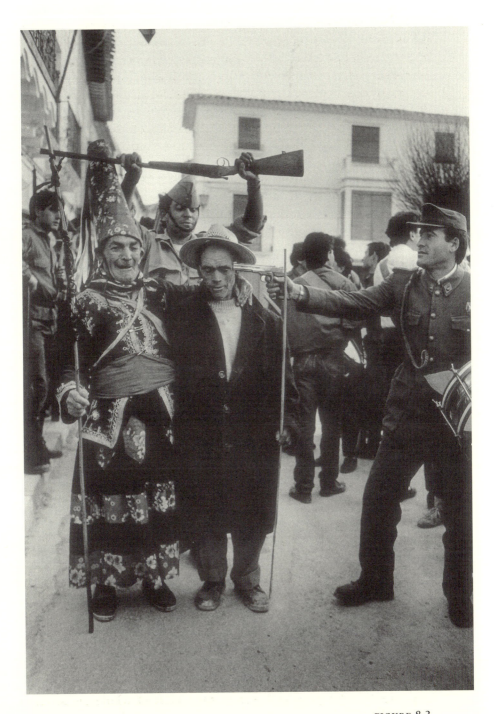

FIGURE 8.3.
Cristina García Rodero, *El Cascaborras*, from *España oculta*, 1989.

reveals finally her strong, geometric sense of photographic design. The most striking irony allied to the two photographers' differing approaches is that a veteran photojournalist such as Smith should have striven to validate his rhetorical gravity in terms of "art." He once likened the symbolism of his photographs to that inherent in "many of the Old Masters of the Paints."[23] Meanwhile, García Rodero, who trained as a painter and has been a professor of photography at the Complutense University in Madrid, avoids the archetypal resonances of high art.

García Rodero works in the wake of a resurrected interest in documentary realism, a genre largely dormant since the Republican period but revived by Spanish photographers such as Jordi Olivé and Manuel Ferrol. Her work was also enabled by the emergence, toward the end of the Franco period, of art photography, oppositional photojournalism, and formerly prohibited genres such as the nude, as well as by a boom in iconoclastic experimentation exemplified by the Nueva Lente group of the 1970s, of which García Rodero and her sister, Marigrá, were members.[24] García Rodero presents post-Franco Spain in the form of a series of discontinuous moments, empty of historical significance. If folklore is the repository of national identity, then the images she creates are vacant and disarticulated. If Catholicism was the mainstay of Francoism, religion merely provides, in her photography, the stage set for absurdist drama. Eschewing, however, the nihilism of that dramatic genre, García Rodero's photography undertakes a scrupulous representational voiding of the homeland and Spanish history, by pushing the search for decentralized regional identity to its extreme. Her book proposes a quest for an "España oculta," an invisible Spain beyond the misrepresentations of propaganda and tradition, and challenges the preservationism of regional cultural patrimony enshrined by the devolutionary direction that Spanish politics adopted after Franco. The Spain she seeks has been made invisible, overshadowed by the epic masculinity of *conquistadores* and Catholicism promoted by the Francoist vision of history and projected during the dictatorship by photographic pictorialism. Her willful unintelligibility confounds the traditional fetishization of Spanishness, tapping the same vein as that mined by Goya—another artist of post-Enlightenment historical upheavals—in his use of the grotesque, particularly in his print series, *Caprichos* (1799) and *Los proverbios* (1820–24), and in paintings such as *El conjuro* (1797–98) and *El pelele* (1791–92). Many of her photographs manifestly recall such paintings, through their gravitation toward the distorted or excessive over the harmonious; through their privileging of incongruous detail over emblematic unity, vulgarity over

refinement, comedy over solemnity, and mystification over knowledge (fig. 8.4).[25] Of course, Mikhail Bakhtin, in his study of Rabelais, has demonstrated that the grotesque involves the renovation of customary representation. On the other hand, Jo Labanyi writes that monsters "challenge the laws of form that enable representation to take place."[26] García Rodero's antiauthoritarianism uncannily disturbs the familiarity of universalism, makes the homeland unhomely for a moment, and is literally monstrous according to the etymology of the word, given that monstrosity signals "that which reveals" renegade possibilities of perception and identity.[27] That her iconoclasm paradoxically follows a tradition of the grotesque in art is confirmed by Wolfgang Kayser's important study, *The Grotesque in Art and Literature*, which identifies major elements of the grotesque as "estrangement," "suddenness," and "surprise."[28] These features, along with a "strong affinity with the physically abnormal," associate García Rodero's work with grotesque art and writing, particularly in their Spanish and Latin American modes[29]—modes in evidence in the painting of Goya and Velázquez; in the picaresque novel and the more modern literary genre that is the *esperpento*; and in the cinematic work of Buñuel.[30] Her photography, like a number of Hispanic narrative works that have recourse to the grotesque, interrogates established conceptions of national identity.[31] Its engagement with the grotesque is unsurprising, insofar as photography is an ideal vehicle for the identifying features of the grotesque that Kayser isolates, by virtue of its inherent candidness and immediacy, or at least its appeal to these phenomena.

García Rodero's jagged moments at the sidelines of events we know little about give nothing away. The paternalistic compositions of family groupings undertaken by Smith, as photographer, and by Steichen, as curator—compositions that in their "precise organization of forms . . . give the [family] event its proper expression" (Cartier-Bresson's words)—are overwhelmed in her overpopulated images, whose numerous subjects (often involved in simultaneous and various activities) and numerous details (such as limbs at curious angles and grotesquely distorted or inappropriate facial expressions) divert our attention from a familiarizing thematic reading, as do the mystifying circumstances of each photograph. Often shot flat-on, García Rodero's photographs assume an artless perspective, giving equally impassive attention to every feature within the frame. Smith's use of light and shadow, a chiaroscuro painstakingly refined in the darkroom, strove conversely to focus the eye on the essence of the picture, excluding distractions through careful framing and cloaking shadows. Unlike Smith, whose compassionately narrative photographic essays

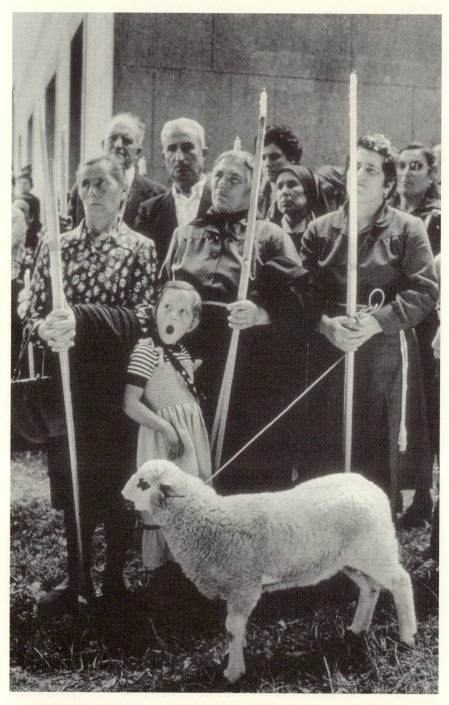

FIGURE 8.4.
Cristina García Rodero, *El ofertorio*, from *España oculta*, 1989

championed the resilience of the human spirit, its grace under the pressure of inhumane situations, García Rodero defies narrative intelligibility in her "monstrifying" images. She does so in the spirit of the (suitably Transylvanian) philosopher E. M. Cioran, who exhorts us to give ourselves up to "the philosophy of *unique moments*, the only philosophy."[32] Her work recalls Cioran's conviction that we should "live face to face with being, and not with the mind,"[33] and his belief (surprising in an archnihilist, given the optimism of rebirth that it evinces) that we should "let the moment do its work, let it reabsorb [our] dreams."[34] And García Rodero's photography causes us to reflect on the intricacies of photographic temporality, invoked both by Barthes as he reflected on how photography produced in him a "longing" that was "fantasmatic, deriving from a kind of second sight which seems to bear [him] forward to a utopian time, or to carry [him] back to somewhere in [himself],"[35] and by Christian Metz in his dissections of the "timelessness" of photography, its "instantaneous abduction of the object out of the world into another world, into another kind of time."[36] Photographic temporality unbinds time from a sense of inevitable causality, from a mortal teleology, and is consequently, says Metz, comparable to "the timelessness of the unconscious and of memory," indeed of possibility.[37]

García Rodero's Calibanesque work is driven by an apparent nihilism that is actually utopian in its pursuit of a freedom of the split second; a type of revitalizing death promising an unprecedented rite of passage; an interruption in time best invoked by the complexity of the photographic moment, whose irresolution mortally unsettles the narrative composure of Smith and *The Family of Man*. At the same time, her work releases those photographed, and their viewers, from the ahistoricism of Steichen's exhibition, by attacking the sense of perpetuity suggested by its universalism.[38] But we are still left haunted by the necessity of the project of advocacy pursued by Steichen and the United Nations, and left haunted, too, by the necessary integrity and compassion of a photograph that has been described as "the pietà of the century"[39]: Smith's photograph of a fifteen-year-old girl from Minamata, Japan, Tomoko Uemura, being bathed by her mother. The photograph of a girl crippled by mercury poisoning from eating fish contaminated by effluent from a local chemical plant was part of Smith's last photographic essay, undertaken between 1971 and 1975 as a personal crusade by a photographer who was shortly to die with eighteen dollars in the bank, considered virtually unemployable by the magazines of his day because of his commitment to unpalatable causes.

Images of humanity in inhuman situations, of war, struggle, poverty, and environmental disaster, fuel our voracious media at the beginning of a new millennium and evince a need for common narratives. This need is confirmed by the second republication, in 1996, of the original catalog to *The Family of Man*, amid heated international debates about the role of the United Nations, in the wake of the fiftieth anniversary of that organization in 1995 and in the aftermath of Rwanda, war in the Balkans, and the Pinochet case. García Rodero's greatest challenge to and greatest affinity with the humanism represented by Smith and the UN, her redemption of a Goyesque pessimism regarding human action, lies in her often teeming photographs' deferral to the multiple looks of specific men, women, and children who contest their framing—photographic, familial, and national. Hence, perhaps, the title of her monograph: the part of Spain in danger of being hidden most by humanism, artistic or political, is precisely the contesting look of humanity, a look that should be guaranteed by Spain's newly born institutions and with which she aligns herself as a Spanish woman photographer. It is a contesting look registered distractingly through the looking glass of a photography whose focus elicits humanism's mortality: a renewable history, continually displaced by its subjects, who will not be fixed by the shutter's click but demand to see and be seen. By seeing, García Rodero dramatizes the undeterminable contingency of humanism, nationalism, and the institutions of community and family. These are reconstituted through their reframing by anonymous subjects who locally re-present their Spanishness in front of her lens by registering physical discomfort with their current roles through their grotesque poses. She recompenses the hitherto invisible ("occult") "dependence of the visible [Spain] on that which places us under the eye of the seer," in an encounter of solidarity with her compatriots that makes the photographer answerable to them in her deflection of custom and authority.[40] For, if the photographic gaze is an inquiry into who people are, then, in their turn, those who look back at the photographer and viewer interrogate the position and assumptions of that gaze. And, by focusing the split between invisibility and visibility, seer and seen, to a point of convergence on the photographic plane, the drama she stages emerges out of the momentary release/capture of photographic time; the continual reassertion of freedom within the validating enclosure of responsive photographic framing; and subsequent narratives of national history, institutional representation, and photographic tradition rewritten by responsible humanist critics.

Notes

I should like to thank Thomas Doubliez at Agence VU for permission to reproduce Cristina García's photographic work, credited to Cristina García Rodero, Agence VU. I should also like to thank Magnum for their permission to reproduce Smith's photographs, which are credited to W. Eugene Smith (Magnum Photos).

1. See Arthur Clayborough, *The Grotesque in English Literature* (Oxford: Clarendon, 1965), 70; Lee Byron Jennings, *The Ludicrous Demon: Aspects of the Grotesque in German Post-Romantic Prose*, Publications in Modern Philology, vol. 71 (Berkeley: University of California Press, 1963), 26.
2. W. Eugene Smith, *W. Eugene Smith* (New York: Aperture, 1969), n.p.
3. Cornell Capa, ed., *The Concerned Photographer 2* (London: Thames and Hudson, 1972), n.p.
4. Russell Miller, *Magnum: Fifty Years at the Front Line of History* (London: Pimlico, 1999), 19–73.
5. See Miller, *Magnum*, 56–57, 62.
6. Edward Steichen, ed., Catalog to *The Family of Man* exhibition, 1955, with a prologue by Carl Sandburg (New York: MOMA, 1996), 4.
7. Marshall McLuhan, *Understanding Media: The Extensions of Man* (New York: Mentor, 1964), 177.
8. Marianne Hirsch, *Family Frames: Photography, Narrative, and Postmemory* (Cambridge, Mass.: Harvard University Press, 1997), 50.
9. Steichen, *Family of Man*, 82–83.
10. Ibid., 179.
11. On the CIA's campaign to promote American culture, especially abstract impressionism, over that of Europe, as part of U.S. cold war policy, see Frances Stonour Saunders, *Who Paid the Piper: The CIA and the Cultural Cold War* (London: Granta, 2000).
12. See Hirsch, *Family Frames*, 52, 41–77, 101–4.
13. See Miller, *Magnum*, 295.
14. Publio López Mondéjar, *Historia de la fotografía en España* (Barcelona: Lunwerg, 1997), 100–114, 178–83.
15. Ibid., 179.
16. Gilbert and George, "Blood, Toil, Tears and Sweat," Interview with Wolf Jahn, *The Independent on Sunday*, October 3, 1999, 21.
17. Miller, *Magnum*, 82
18. Ibid., 83.
19. Ben Maddow, *Let Truth Be the Prejudice: W. Eugene Smith, His Life and Photographs* (New York: Aperture, 1985), 12 n. 66.
20. Smith, cited in Henning Hansen, *Myth and Vision: On "The Walk to Paradise Garden" and the Photography of W. Eugene Smith* (Lund: Aris, 1987), 69.
21. Glenn G. Willumson, *W. Eugene Smith and the Photographic Essay* (Cambridge: Cambridge University Press, 1992), 242–48.
22. Miller, *Magnum*, 102; my emphasis.
23. Jim Hughes, *W. Eugene Smith: Shadow and Substance: The Life and Work of an American Photographer* (New York: McGraw Hill, 1989), 36.
24. López Mondéjar, *Historia*, 126–37, 160–264.
25. See Jennings, *The Ludicrous Demon*, 8, 18.

26. Jo Labanyi, "Representing the Unrepresentable: Monsters, Mystics, and Feminine Men in Galdos's *Nazarín*," *Journal of Hispanic Research* 1:2 (1993): 226.

27. Jeffrey Jerome Cohen, "Monster Culture (Seven Theses)," in *Monster Theory: Reading Culture*, ed. Jeffrey Jerome Cohen (Minneapolis: University of Minnesota Press, 1996), 4.

28. Wolfgang Kayser, *The Grotesque in Art and Literature* (Bloomington: Indiana University Press, 1963), 184.

29. Philip Thomson, *The Grotesque* (London: Methuen, 1972), 9.

30. Though I cite some pictorial manifestations of the grotesque, this literary mode of representation is particularly prominent in the imagery employed by writers. See Jennings, *The Ludicrous Demon*, 21–22; James Iffland, *Quevedo and the Grotesque* (London: Támesis, 1978), 35–39.

31. Two twentieth-century examples from literature might be cited here: Juan Goytisolo's novel *Reivindicación del Conde don Julián* (1970; Count Julian) and Severo Sarduy's *De donde son los cantantes* (1957; From Cuba with a Song).

32. Emile M. Cioran, *The Temptation to Exist* (Chicago: University of Chicago Press, 1998), 164. Emphasis in original.

33. Emile M. Cioran, *The Trouble with Being Born* (London: Quartet, 1993), 43.

34. See Cioran, *Temptation*, 181. The view he expresses in this statement is quite consistent with his upbringing as the son of a Greek Orthodox priest. The Orthodox conception of liturgical time is synchronic, not historical, and views the body and blood of Christ, his Crucifixion and Resurrection, as transcendent realities experienced daily by worshipers. Of more relevance to García Rodero's liberation of history, through her focus on transcendent moments of daily life, is the Orthodox liturgy's simultaneous synchonicity and diachronicity: "It is synchronic since it shares in the eternal liturgy, but it is also (of necessity) historical, since it is through the daily repetition of the liturgy that the mystery of salvation is made present within time." Anthony Lappin, in conversation with the author.

35. Roland Barthes, *Camera Lucida: Reflections on Photography*, trans. Richard Howard (London: Fontana, 1984), 40.

36. Christian Metz, "Photography and Fetish," in *Overexposed: Essays on Contemporary Photography*, ed. Carol Squiers (New York: New Press, 1999), 213–14.

37. Ibid., 213.

38. See Hirsch, *Family Frames*, 57

39. Maddow, *Let Truth Be the Prejudice*, 34

40. Relevant to this is Jacques Lacan, "The Split between the Eye and the Gaze," in *Four Fundamental Concepts of Psychoanalysis*, trans. Alan Sheridan (Harmondsworth: Penguin, 1994), 72.

| *Part Four* |

PHOTOGRAPHY AND NARRATIVES
OF IDENTITY

Hervé Guibert's Photographic Autobiography: Self-Portraiture in *L'Image fantôme*

NINE

ALEX HUGHES

What (or how) do photographs mean in the context of an auto-biography? Do they come to the rescue of autobiographical ref-erentiality through the presentation of the author's body in the world, or do they undermine the integrity of referentiality through multiple or posed presentations? Did the invention of photography transform the way we picture ourselves?

Linda Haverty Rugg, Picturing Ourselves

As a number of analysts of life-writing, notably Paul John Eakin, have affirmed, readers of autobiography invariably succumb to the Romance of the Real.[1] Well aware that (self-)fiction(alization) inflects and infiltrates the life-writing endeavor, aware too that contemporary theory has deconstructed autobiographical reference, readers rarely nonetheless divest themselves of their "will to believe."[2] Rather they cleave to the (mis)conception that the autobiographical space is one in which a complete, self-knowing, extralinguistic subject expresses himself or herself transparently, in a discursive medium that surren-ders the stuff of being.[3]

Even in the age of poststructuralist skepticism, then, the consumers of autobiographical discourse persist in preserving their faith in its referential reach.[4] But are practitioners of autobiography any more

167

willing to accept or expose the autobiographical opus as one that cannot absolutely refer to, or proffer "true," total knowledge of, or display the "essence" of the subject outside the text: a subject we must recognize as decentered and dispersed? In the field of writing that concerns me here, French autobiography, it is certainly the case that twentieth-century life-writers such as Roland Barthes and Serge Doubrovsky have worked to contest the myth of the autobiographer as a "'full,' authorial, expressive self"; a "referentially given and self-giving subject."[5] Yet, critics contend, these contemporary, postmodern "anti-autobiographers" have effected discursive shifts that suggest they came belatedly to reaccredit more conventional, not to say credulous, views of autobiography, reference, and narrative (self-)enunciation.[6] Their writing, in sum, has been taken likewise to cede to that Romance of the Real Eakin invokes as a cipher for the reading response autobiographical narrative activates.

Among the younger generation of French autobiographers, the author, journalist, and photographer Hervé Guibert (1955–91) occupies a significant place. Articulated not simply through writerly practice but also in the form of photography and video, Guibert's self-portraiture is a key component of his corpus. Unlike Barthes and Doubrovsky, however, Guibert cannot be taken to follow an autobiographical trajectory marked by a tardy move toward referentiality, a turn from postmodernist self-textualization. Rather Guibert's engagement with self-representation, across its variant forms, may be considered to testify to a more enduringly equivocal relation to (self-)reference. The engagement in question is pursued in Guibertian *autofictions* such as *A l'ami qui ne m'a pas sauvé la vie* (To the Friend Who Did Not Save My Life), the 1990 novel in which Guibert addressed his experience of AIDS via a fictional narrator named "Hervé Guibert";[7] in *Mes parents* (My Parents; 1986), an *autobiographie de jeunesse* in which novelistic and autobiographical narrative modes compete for primacy;[8] in Guibert's self-occlusive photographic self-portraits;[9] and in his AIDS video-diary, *La Pudeur ou l'impudeur* (Modesty or Immodesty), shown on French television in January 1992 and seen by critics as a "reality show" haunted by a nostalgia for (self-)fiction(alization).[10] Readers and viewers familiar with these artifacts unfailingly sense that in effecting the self-inscriptive gesture, Guibert oscillates between a deconstructive desire to problematize the possibility of narrative referentiality; an (oppositional, "regressive") impulse to believe and operate in an autobiographical mode grounded in transparent self-revelation;[11] and a mischievous will to turn the autobiographical, "truth-telling" enterprise against itself by playing with deceit, fakery, and disguise.[12]

As an autobiographer, in sum, Guibert would seem to waver between an effort at elaborating a self-referential *écriture de soi* aimed at narrative self-communication and a (stronger) need to subvert (no longer) standard suppositions about self-expression: suppositions that see autobiography as providing an unmediated purchase on a realm of existential reality, extant beyond the text. His ambiguous stance is dramatized in *L'Image fantôme* (Ghost Image; 1981),[13] a narrative that offers a Guibertian self-portrait mediated through photo-analysis and invokes issues of autobiographical and photographic representation in such a way as to foreground the question of referentiality, posed by autobiography and photography alike.[14] In the rest of this chapter, I focus on the detail of Guibert's auto/phototext. Examining the narrative fragments that compose it—fragments that are both autobiographically and photographically oriented—I work to dissect what, in particular, his "attempt at biography through photography" (*GI* 138) ("tentative de biographie par la photographie," *IF* 124) reveals about his relation to narrative self-reference.

Constituted out of a series of reflections on photography and photographs (many of the latter being latent, unrealized, or unreadable) (*GI* 137/*IF* 124), *L'Image fantôme* belongs in some respects to the photo-essay genre, for all that it is unaccompanied by any photo-images. However, its thematically organized bricolage of self-focused narrative segments allies it equally with that autobiographical construct qualified by Michel Beaujour as the literary self-portrait.[15] The hybrid status of Guibert's *photobiographie*, predicated on an effort to "integrate into the fragmented narrative of his life a collection of intimate photo-images" (intégrer au récit fragmenté de sa vie une collection de photos intimes),[16] is flagged in the incipit of *L'Image fantôme*. Divided into two parts, this (meta)narrative threshold likewise announces the contradictory autobiographical impulses nourishing the text it introduces.

In the first, brief, untitled section of *L'Image fantôme*'s incipit, Guibert's self-projective narrator has the following to say:

> I used to dream about an amazing invention I saw in one of my *Bibi Fricotin*: eyeglasses that can read our thoughts. But I grew frightened when I realized that they could be used against me. Later on, in some slightly lurid advertisements, I discovered the existence of eyeglasses that can see through clothing, that can expose us. I pictured photography as having the ability to combine these two powers. I was tempted to do a self-portrait. (*GI* 7)

Il y avait, dans un de mes Bibi Fricotin, une invention fabuleuse qui me faisait rêver, et qui me faisait très peur en même temps si j'imaginais qu'on pouvait les retourner contre moi: les lunettes à lire la pensée. Depuis, j'ai trouvé dans des réclames plus ou moins salaces l'existence de lunettes qui transpercent les vêtements, qui déshabillent. Et j'ai imaginé que la photographie pouvait conjuguer ces deux pouvoirs, j'ai eu la tentation d'un autoportrait. (*IF* 9)

In these remarks, Guibert conveys the self-illustrative scope of the photo-focused narrative they initiate, establishing its autobiographical ambit ("j'ai eu la tentation d'un autoportrait"). Equally, he suggests that the written self-portrait he is drawn to offer in *L'Image fantôme* will resemble the essential, "ontological" (self-)image he (provisionally) imagines photography can engender. The kind of photo-portrait invoked here, allusively, is one whose subject's being is pierced, read, and revealed within it, by virtue of the invasive potency of the photographic act. It resembles that hyperreferential, singularity-seizing photo-image celebrated by Barthes in his famous account of the Winter Garden image of his mother as a girl,[17] deemed to accomplish and articulate *"the impossible science of the unique being"* (*CL* 71) (*la science impossible de l'être unique, CC* 110).[18] It is an image that, like Barthes's Winter Garden image, is conceived as providing its receiver not with a mere simulacrum but with intimate perceptual access to its referent.[19] And it is used by Guibert, metanarratively, in the first section of *L'Image fantôme*'s incipit, as a metaphor for the narrative, autobiographical self-rendition he (initially) desires to elaborate in his auto/phototext.

In section two of his incipit, however, Guibert changes autobiographical tack. In this longer, titled fragment, which shares its title with the volume that contains it, Guibert proffers a parable of photographic stillbirth. The story he tells signals that the type of photo-image adumbrated in part one of his incipit—an image used to emblematize the sort of written self-portrait he is first tempted to create—is difficult if not impossible to achieve and is, moreover, undesirable. Concomitantly, Guibert's story signals that between the first and second movements of his metanarrative introit, his self-inscriptive intentions evolve.

In "L'Image fantôme," section two of his incipit, in Barthesian vein, Guibert addresses a photo-image of his mother: an image that he himself, as an eighteen-year old youth, sought to create. This image, he explains (*GI* 9–13/*IF* 12–15), was intended to proffer a subversive representation of his genetrix: one that, like the maternal "just image"

(*image juste*) Barthes discovers in the Winter Garden photograph, would denude, capture, and disclose the mother's essential identity and truth (*CL* 103/*CC* 160).[20] Once again, then, Guibert invokes an "ontological," forcefully referential image of the kind he has just meta-narratively/metaphorically employed as an autobiographical cipher. Equally, he tells of how this hyperconstative, superrevelatory maternal image failed to come into being. He recounts how his Oedipalized photo session,[21] rendered infecund by a fault in his camera, produced nothing more than an absent image, a piece of blank film (*GI* 14, 16/*IF* 16, 17). And, eventually, he conveys his ultimate relief at the photographic miscarriage to which the session gave rise. He suggests that had his essential, hyperreferential, truth-telling maternal image come to exist, had it not morphed into a "ghost image" (*GI* 16), an "amorce de pellicule vierge" (*IF* 17), it would have proved reifying, destructive, even death-dealing. It would have been finally falsificatory, for all its intimate, mimetic ambition:

> The picture would be in front of me, probably framed, perfect and false, even more unreal than a photograph from childhood—the proof, the evidence of an almost diabolical practice. More than a bit of sleight-of-hand or prestidigitation—a machine to stop time. (*GI* 16)

> L'image serait là devant moi, probablement encadrée, parfaite et fausse, irréelle, plus encore qu'une photo de jeunesse: la preuve, le délit d'une pratique presque diabolique. Plus qu'un tour de passe-passe ou de prestidigitation: une machine à arrêter le temps. (*IF* 17–18)

In the closing paragraph of "L'Image fantôme," the phantom image discussed in it—the image that was supposed to be but did not succeed in being penetrative and encapsulative of its referent's core—is situated by Guibert as the central stimulus behind the self-representative *autoportrait* proffered in *L'Image fantôme*:

> For the text would not have existed if the picture had been taken. . . . For this text is the despair of the image, and worse than a blurred or fogged image—a ghost image. (*GI* 16)

> Et le texte n'aurait pas été si l'image avait été prise. . . . Car ce texte est le désespoir de l'image, et pire qu'une image floue ou voilée: une image fantôme. (*IF* 17–18)

Now, superficially, all Guibert is saying in this final paragraph is that the self-inscriptive narrative constructed in *L'Image fantôme* ultimately owes its genesis, as a written artifact, to a stroke of mischance, cast by Alain Buisine as the "irremediable loss" (*perte irrémédiable*) of Guibert's desired snapshot of his mother.[22] More profoundly, however, in locating his written *autoportrait* as "le désespoir de l'image," and in likening it, finally, to an "image fantôme" rather than that ontological, captative image evoked earlier in his incipit, Guibert is letting us know what kind of self-image he comes eventually to want to fabricate in *L'Image fantôme*. For Buisine, the above extract constitutes a narrative locus where Guibert addresses an emblematic instance of the failure of mimetic representation ("une désolante défaillance de l'inscription mimétique").[23] But it is no less possible to view it as a metanarrative site where Guibert indicates that the self-image evolved in *L'Image fantôme* will not be the analog but the antithesis of the essential, revelatory, indelibly referential photo-image proposed as a (provisional) symbol for his self-transcriptive practice in *L'Image fantôme*'s opening fragment *and* evoked in Guibert's account of his unrealized image of his mother. In the sentences that bring "L'Image fantôme" to its conclusion, Guibert is hinting that the self-image engineered in *L'Image fantôme* will be self-related but will nonetheless not be a construct that affords the "perceptual access" to him invoked in part one of his incipit. Equally, he is letting us know why he ultimately opts not to produce a narrative self-portrait analogous to the "essential," revelatory photo-image he and Barthes both address. By flagging the latter type of image as "perfect and false," as "unreal," and allied to noxious representational practices, he is intimating that if he elects not to pursue the creation of a superreferential, self-exposing self-portrait that would work as its textual corollary, this is because he understands the obstacles and dangers that self-expressive, mimetic portraiture (an autobiographical mode he does not dismiss here as wholly unachievable) entails.

In sum, the bipartite incipit of *L'Image fantôme* is not just a textual environment where Guibert begins his dissection of photography's capacities and tells of an experience of photographic frustration. It is also the site of a metanarrative explication of the autobiographical, self-textualizing project pursued in *L'Image fantôme* as a whole: a project Guibert situates as central to his photo-essay in its opening paragraph. *L'Image fantôme*'s incipit constitutes, moreover, a space in which different autobiographical desires compete. And it is a locus where Guibert's initial desire for an autobiographical practice grounded in an intense referentiality enduringly associated with photography[24] cedes

to a desire for a mode of "phantom" self-portraiture that, its self-focused aspect notwithstanding, does not pretend or seek to provide access to its author's "unique being."

In Guibert's incipit, the figure of the penetrative, essence-encapsulating *photo/autoportrait* is used to convey the hyperreferential, self-displaying autobiographical practice he moves to refute. Cast as "parfaite et fausse," the same image-symbol is employed to frame that practice as flawed, undesirable, and somehow dangerous.[25] On the other hand, the cipher of the "image fantôme" serves to communicate the (nonmimetic) narrative self-image Guibert comes to want to develop.[26] In the remaining fragments of *L'Image fantôme*, avatars of these emblematic photo-images—images that function as metanarrative autobiographical indicators—abound, transmuting Guibert's photo-essay into one in which metatextual clues to its autobiographical pretensions constellate its narrative weave.

"Ghost" images—images that fail to afford their viewer a sense that she or he can use them to achieve a possessive, penetrating grip on the real of the referent—are regularly referred to in *L'Image fantôme*. In a crucial discussion of his fondness for such images, contained in a segment titled "Inventaire du carton à photos" (*GI* 35–48/*IF* 34–44), Guibert's dissection of the representational mode they emblematize is couched in terms that persuade us to see that he is talking here about more than just *le photographique*; that the autobiographical aesthetic subtending his auto/phototext is no less his concern:

> But the photographs I like are always the ones that didn't come out well, the ones out of focus or badly framed, or taken by one of the children, and thus unintentionally connected with the vitiated code of a photographic esthetic out of synch with reality. (*GI* 43)

> Mais les photos que je trouve bonnes, moi, sont toujours les photos loupées, floues ou mal cadrées, prises par les enfants, et qui rejoignent ainsi, malgré elles, le code vicié d'une esthétique photographique décalée du réel. (*IF* 40)

Unexpectedly, in a fragment titled "La Radiographie" (*GI* 74/*IF* 68), the intimate, singularity-seizing visual image the "image fantôme" displaces at the beginning of *L'Image fantôme* (and, by extension, the self-transcriptive practice that image metaphorizes) is briefly revalorized by Guibert, reminding us of the autobiographical impulse that inspired *L'Image fantôme* at its inception:

Several years ago, in the flap of a portfolio, I came upon an x-ray of the left side of my torso taken April 20, 1972, when I was seventeen. I stuck it onto the glass of the French window opposite my desk. . . . I was displaying the most intimate image of myself—much more intimate than any nude, one that contained an enigma, and that a medical student could easily decipher. (*GI* 74)

Il y a quelques années, j'ai fixé sur la vitre de la porte-fenêtre qui fait face à ma table de travail une radiographie, retrouvée par hasard dans la chemise d'un carton à dessin, d'un profil gauche de mon torse pris le 20 avril 1972, à l'âge de dix-sept ans. . . . je placarde l'image la plus intime de moi-même, bien plus qu'un nu, celle qui renferme l'énigme, et qu'un étudiant en médecine pourrait facilement déchiffrer. (*IF* 68)

But in an earlier fragment, "L'Image parfaite" (*GI* 20–23/*IF* 22–24), focused on a photograph Guibert failed to take of youths on a beach on Elba, the figure of the purely transcriptive, hyperreferential image ("la photo fidèle") is critically cast, like Guibert's nonrealized, "perfect" image of his mother, as somehow obliterating its referent and the Guibertian emotions attached to that referent.[27] Equally, it is posited as finally alien to Guibert's representational desires:

Looking at that scene, I already see the picture that will represent it and the abstraction that will automatically result, setting off the four boys in a kind of fictive space beneath the foaming waves. (*GI* 21)

En regardant cette scène, il faut dire que je vois déjà la photo qui la représenterait, et l'abstraction qui automatiquement s'effectuerait, détachant ces quatre garçons dans une espèce d'irréalité sous leur bloc écumeux. (*IF* 23)

Concomitantly, in the closing paragraph of "L'Image parfaite," the metanarrative status of the referentially captative, mimetic photo-image invoked within it—its status as a pointer to the kind of autobiographical self-portrait Guibert comes to mistrust as self-falsificatory and comes *not* to want to evolve in *L'Image fantôme*—is mooted quite explicitly:

[A]nd the image [of the boys] would have been "returned" to

me as a photograph, as an estranged object that would bear my name and that I could take credit for, but that would always remain foreign to me. (*GI* 23)

[E]t la vision m'aurait été "retournée" sous forme de photographie, comme un objet égaré qui pourrait porter mon nom, que je pourrais m'attribuer mais qui me resterait à jamais étranger. (*IF* 24)

Once we acknowledge that the Guibertian "ghost" image functions as a metaphor for the autobiographical mode embraced in *L'Image fantôme*, we clearly need to scrutinize the kind of referential sign it represents. The first of *L'Image fantôme*'s spectral images, Guibert's unactualized maternal image, is evanescent, refusing to surrender its referent to the reading gaze:

[T]hat image didn't exist. Looking through the film against the bluish light of the bathroom, we saw that the entire film was unexposed, blank from one end to the other. (*GI* 14)

[L'image] n'existait pas: nous vîmes en transparence, contre la lumière bleutée de la salle de bain, le film entier non impressionné, blanc de part en part. (*IF* 15–16)

Likewise, the final "image fantôme" of Guibert's *photobiographie* is one that works to thwart the viewer's penetrating look. The image in question is qualified by Guibert as "cancerous" and is celebrated as such. It is a photograph whose reproduced subject—an adolescent intuited by Guibert as his own double/brother (*GI* 192/*IF* 169)[29]—succumbs to a process of chemical degradation that means his image comes to be barely imprinted on the photographic material that sought to capture his being (*GI* 187–92/*IF* 165–69). It is a photo-image whose referentiality is (or, more precisely, becomes) almost negligible; whose readability is minimal.[29] It is an image that proffers not a reproduction of its referent, ultimately, but a "trace fantomatique,"[30] an "image blanche" (*GI* 192/*IF* 169).

Unlike the essence-yielding images invoked in *L'Image fantôme*'s opening pages, and the Winter Garden image they recall, we can liken the "ghost" images that Guibert profiles, prizes, and posits as autobiographical "clues" to the indexical photo-image anatomized by Philippe Dubois in *L'Acte photographique*. The indexical image, in Dubois's photographic typology, is understood not as unreferential,

by virtue of its "contiguous," metonymic connection to its referent, but as an artifact that offers a shadowy, spectral trace of the referent: an imprint that is in no way a faithful reproduction, an iconic "image mimétique."[31] If, though, the self-representational practice Guibert opts finally to evolve in *L'Image fantôme*, emblematized in the "image fantôme," is of the order of photographic indexicality—if it works to offer not a mimetic rendering of its Guibertian referent but one that functions like a shadow, a footprint—then what sort of self-portrait does that practice engender? What figuration of selfhood does Guibert's auto/phototext, composed largely of prose representations of photo-images, of image-texts, elaborate? What type of autobiographical image does *L'Image fantôme*, conceived by Guibert as a "négatif de photographie" (*GI* 137/*IF* 123) and as a site of "photographic writing" (*GI* 79–84/*IF* 73–77), furnish, as it strives to engineer an *image de soi* analogous to the indexical "image fantôme"?

As it pursues its voyage around photography and engages with self/life-writing, Guibert's phototext treats of its autobiographical referent in a manner that is never more than elliptical. *L'Image fantôme* begins by conveying, in classic vein, the kind of biographical data we expect to find in the canonical autobiographical *récit*, only to abandon the autobiographical orthodoxy it seems initially to embrace in favor of a storytelling practice in which the peripeteia of Guibert's existence are chronicled only discontinuously, insubstantially. It is an episodic artifact that illuminates key aspects of its narrator's personality/subjectivity—notably, his sexuality and friendships—yet witholds the contextualizing, elaborative detail the reader craves. It provides a tale whose autobiographical "I" is only intermittently present, disappearing from or peripheral to a number of its tableaus. It offers a narrative that, not least by virtue of its reluctance to name its diverse personae, refuses to allow the reader to take its central narratorial figure as identifiable, transparent, "scrutable."

The Guibertian depiction that *L'Image fantôme* presents, as it lights fleetingly on moments of being and elements of selfhood, firmly resists providing us with an "image intime": an image we can receive as absolute, essential, a conduit to the real Hervé Guibert. As a narrative (self-)portrait, it is referential but only in the sense that it leaves us with the feeling that all it offers up is a vestige of Guibertian substance. The self-image that Guibert's auto/phototext evolves is one that thwarts our will to exploit it to "decipher" its subject, or to take the narrative it features in as a hyperreferential locus of textual self-revelation. Indubitably, then, Guibert's written *autoportrait* impresses us as a "ghost" image, emanating from an "esthetic out of synch with

[the real]"; an "esthétique décalée du réel." It strikes us as a self-image haunted by an ontological absence that Guibert, in a narrative fragment titled "L'Autoportrait" (*GI* 67–71/*IF* 62–65), associates with the posthumous image he wishes to leave behind (*GI* 71/*IF* 65). The Guibertian self-image of *L'Image fantôme*, Donna Wilkerson suggests, is fashioned in a narrative in which "the narrator as subject is effaced," resembling a "mere simulacrum."[32] For Raymond Bellour, it constitutes a "phantom double" (*double fantomatique*) of its creator, engendered in a text in which Guibert's identity is blurred, fragmented.[33] Finally, the phototextual *autoportrait* elaborated in *L'Image fantôme* can be understood as a corollary of Guibert's actual photographic self-portraits: images in which, Buisine argues, Guibert's bodily reality is absented, removed from our gaze ("sa propre corporéité s'absente"), so that mere remnants *("restes")* of being remain.[34] And it can be conceived as not unlike the unreproduced photographs that underpin *L'Image fantôme*: photographs that, Ross Chambers affirms, have "'died' into writing," surviving in textual space solely as "absent presence."[35]

Our sense of the shadowy, "indexical" nature of the Guibertian self-image evolved in *L'Image fantôme* is reinforced by its exclusion of photographs. When we find photographs in autobiography, our faith in narrative reference is firmed up, even though, as reference is no more total in photo-images than in autobiographical discourse, our belief that the integration of photographs into life-writing "comes to the rescue" of autobiographical referentiality is misplaced.[36] Photographic presence in autobiographical narrative, to plunder Guibert's terminology, affords a "palliative against absence" (*palliatif de l'absence*): a (phony) guarantee that the autobiographical referent is *in* the text, enshrined in a visual frame we can use to identificatory, deciphering ends, as we might use an "instrument de surveillance policière."[37] The photographic *absence* peculiar to Guibert's auto/phototext encourages us to divest ourselves of our desire to see it as a vehicle for a superreferential, ontological self-portrait, whose emblem is the "truthful," essence-rendering photo-image evoked at *L'Image fantôme*'s inception.[38]

My argument has been that *L'Image fantôme* functions as a narrative in which "strong" or "pure" self-reference is eschewed. Yet despite everything I have said hitherto, I cannot help, "credulous" autobiographical consumer that I am, but take *L'Image fantôme* as an artifact that gives up an (if not the) essence of its Guibertian referent. Guibert's auto/phototext surrenders, for me, an emanation not of the subject Guibert "is" in/by the early 1980s but of the autobiographical

practitioner he *will become*. *L'Image fantôme* strikes me not as the site of a (self-)representation whose message, like that afforded to Barthes by images such as the *photographie du Jardin d'Hiver*, is "*That-has-been*" (*ça-a-été*) (*CL* 77/*CC* 120), but as a locus of self-portraiture that announces "ce qui sera": what "will [autobiographically] be."

Guibert's phototext incorporates recounted episodes (including that involving his unrealized maternal "image parfaite") that subsequently figure, in revised form, in *Mes parents*, his most conventionally autobiographical opus. It is brought to a close by a dissection of a "cancerous" ghost image that, as Chambers contends, works prophetically as a *mise-en-abyme* of the confrontation with moribund deliquescence, the dynamics of survival through "transfer," staged in Guibert's autobiographical AIDS video, *La Pudeur ou l'impudeur*.[39] In its play of photographically oriented tableaus, it establishes the central thematic concerns of Guibert's autobiographical/autofictional corpus: homosexuality; family relations; the subject's relationship to the body, identity, and identification; friendship; betrayal; the possibilities and limits of the representational act; the interactions between different representational media. By virtue of these different features of it, *L'Image fantôme* evinces, for this reader at least, a curiously predictive, metanarrative referentiality, the object of which is the life-writing trajectory Guibert will follow. It exerts a singularity-seizing impact we cannot ascribe to the indexical "ghost" images Guibert deploys as metanarrative pointers to the autobiographical ambitions subtending his *récit photographique*. In "L'Image parfaite," Guibert seems to propose that writing, a "pratique mélancolique," enjoys a more intimate relation to or capacity for reference than the "forgetful" (*oublieuse*), "enveloping" (*englobeuse*) practice that is photographic representation (*GI* 23/*IF* 24). As my concluding remarks have sought to demonstrate, *L'Image fantôme* confirms in some ways Guibert's (by no means stable) sense of the referential reach of the written text, even as it operates, globally, as an *autoportrait* whose referentiality impresses us as mitigated.

Notes

1. Paul John Eakin, *Touching the World: Reference in Autobiography* (Princeton, N.J.: Princeton University Press, 1992), 52.
2. Ibid., 30.
3. Ibid., 29–53, for a comprehensive discussion of this phenomenon.
4. Linda Haverty Rugg, *Picturing Ourselves: Photography and Autobiography* (Chicago: University of Chicago Press, 1997), 11.

5. Johnnie Gratton, "Roland Barthes par Roland Barthes: Autobiography and the Notion of Expression," *Romance Studies* 8 (1986): 57.

6. See Eakin, *Touching the World*, 3–28, esp. 16, 20, 22; Gratton, "Roland Barthes par Roland Barthes," 58; Haverty Rugg, *Picturing Ourselves*, 13–14; Alex Hughes, "Autobiographical Desires: Repetition and Rectification in Serge Doubrovsky's *Laissé pour conte*," *French Studies* 40 (2001): 179–93.

7. On the ambiguous, complex generic status of *autofiction* and the status of *A l'ami* as an *autofiction*, see Alex Hughes, *Heterographies: Sexual Difference in French Autobiography* (Oxford: Berg, 1999), 3–4, 111–15. On Guibert's writing as fiction "contaminated" by the "real," see Donna Wilkerson, "Hervé Guibert: Writing the Spectral Image," *Studies in Twentieth-Century Literature* 19:2 (1995): 273.

8. Marie Darrieussecq, "De l'autobiographie à l'autofiction: *Mes parents*, roman?" in *Le Corps textuel de Hervé Guibert*, ed. Ralph Sarkonak (Paris: Minard, 1997), 115–30.

9. Alain Buisine, "Le Photographique plutôt que la photographie," *Nottingham French Studies* 34:1 (1995): 40.

10. Darrieussecq, "De l'autobiographie," 132; Wilkerson, "Writing the Spectral Image," 271, 283–84.

11. Jean-Pierre Boulé, "Guibert ou la radicalisation du projet sartrien d'écriture existentielle," in Sarkonak, *Le Corps textuel de Hervé Guibert*, 30–31; Jean-Pierre Boulé, *Hervé Guibert: Voices of the Self* (Liverpool: Liverpool University Press, 1999), 65.

12. Boulé, *Hervé Guibert*, 3, 9–11; Wilkerson, "Writing the Spectral Image," 271, 283; Raymond Bellour, "Vérités et mensonges," *Magazine Littéraire* (February 1993): 68–70.

13. Hervé Guibert, *L'Image fantôme* (Paris: Minuit, 1981); *Ghost Image*, trans. Robert Bononno (Copenhagen: Green Integer, 1998). On occasion, the English translation is less than felicitous; however, I have opted not to modify it here. Subsequent references are given in the texts: *GI*, English translation; *IF*, French edition.

14. Haverty Rugg, *Picturing Ourselves*, 1–27; Timothy Dow-Adams, *Light Writing and Life Writing* (Chapel Hill: University of North Carolina Press, 2000), xi–xxi.

15. Michel Beaujour, *Miroirs d'encre* (Paris: Seuil, 1980), 2; *Poetics of the Literary Self-Portrait*, trans. Yara Milos (New York: New York University Press, 1991), 8. On *L'Image fantôme*'s generic status, see Boulé, *Hervé Guibert*, 60–62; Hughes, *Heterographies*, 47–48.

16. Pierre Saint-Amand, "Mort à blanc: Guibert et la photographie," in Sarkonak, *Le Corps textuel de Hervé Guibert*, 82.

17. Roland Barthes, *La Chambre claire: Note sur la photographie* (Paris: Cahiers du cinéma/Gallimard/Seuil, 1980), 105–15; *Camera Lucida: Reflections on Photography*, trans. Richard Howard (London: Fontana, 1984), 67–73. Subsequent references are given parenthetically in the text.

18. On the Winter Garden photo as an image Barthes viewed as capturing the core of, and offering the essential, whole truth of, its referent—a truth deeper than similarity—see Marianne Hirsch, *Family Frames: Photography, Narrative, and Postmemory* (Cambridge, Mass.: Harvard University Press, 1997), 2; Clive Scott, *The Spoken Image* (London: Reaktion Books, 1999), 236.

19. The notion of the photograph as an artifact that provides perceptual access to its referent, rather than just a representation of it, is mooted by the philosopher Kendell L. Walton and invoked by Dow-Adams in *Light Writing and Life Writing*, in a discussion of the work of Wright Morris (*Light Writing*, 196). It illuminates the kind of photograph, and vision of photography, that Guibert addresses at the start of *L'Image fantôme*, as well as Barthes's account of the Winter Garden image.

20. The photo-image Guibert discusses here is cast as revelatory of his mother's "essence" by virtue of its erasure of falsifying identity layers imposed on Mme Guibert by the passage of time, the aging process, and his father's husbandly manipulations-dictats. Guibert's account of the preparations that preceded his photo-session emphasizes his efforts to strip these layers away.

21. Saint-Amand, "Mort à blanc," 83–84.

22. Buisine, "Le Photographique," 37.

23. Ibid.

24. On the evolution of conceptions of reference in photography and photographic signification, see Philippe Dubois, *L'Acte photographique* (Paris: Nathan, 1983), 19–108. In his analysis of the photographic sign, Dubois engages richly with Charles Sanders Peirce's definition of the sign as symbol, icon, and index. I shall return to the notion of the photo–image as indexical sign, as it chimes with Guibert's discussions of the ghost image.

25. There are various moments in *L'Image fantôme* when Guibert denounces the "perfect image." We can read these as simply indicative of his dislike of the overposed *photo d'art*; however, "L'Image fantôme" encourages us to understand his wariness of the "image parfaite" as a wariness of the hyperreferential photo-image.

26. Ralph Sarkonak comments that "the photograph in Guibert's books is always askew in relation to the text that might 'explain' it." Ralph Sarkonak, "Traces and Shadows: Fragments of Hervé Guibert," *Yale French Studies* 90 (1996): 178. In *L'Image fantôme*, a narrative whose autobiographical complexities are "explained" through the photo-images it profiles, matters are more complex.

27. Buisine, "Le Photographique," 39. My sense that in "L'Image parfaite" Guibert is addressing a hyperreferential image of the kind invoked earlier in "L'Image fantôme" is fueled by the fact that both (unactualized) photos are presented as "perfect" images.

28. That the referent of the "image cancéreuse" is viewed by Guibert as his "second frère," whose fading image eventually gets transferred to Guibert's own body, after he sticks the damaged photograph to his skin, intensifies our awareness that the "cancerous image" dissected at *L'Image fantôme*'s conclusion, like its other ghost images, enjoys a symbolic connection with Guibert's autobiographical practice.

29. On (sexual) readability in *L'Image fantôme*, see Hughes, *Heterographies*, 47–56.

30. Dubois, *L'Acte photographique*, 67.

31. Ibid., 67; see also, more generally, 40–108. Useful here (49–50) is the distinction Dubois anatomizes between notions of the photo-image as (i) icon, or mirror of the real, and (ii) index, or trace of the real. As Hirsch observes (*Family Frames*, 6), in his account of the Winter Garden photograph and his understanding of the photograph as a material emanation of reality, Barthes goes beyond, or intensifies, the conception of the photograph as indexical sign that Dubois borrows from Peirce. Likewise, while Guibert's accounts of "ghost images" mesh with Dubois's discussions of the photograph as index, his vision of truth-telling, penetrative photographs, manifest in the earliest parts of *L'Image fantôme*, sits uneasily with them.

32. Wilkerson, "Writing the Spectral Image," 274.

33. Raymond Bellour, "Entre les images et les mots," *Magazine Littéraire* (January 1982): 56.

34. Buisine, "Le Photographique," 40.

35. Ross Chambers, *Facing It: AIDS Diaries and the Death of the Author* (Ann Arbor: University of Michigan Press, 1998), 35.

36. Dow-Adams, *Light Writing and Life Writing*, 20; Haverty Rugg, *Picturing Ourselves*, 1, 14.

37. Hervé Guibert, "Susan Sontag: Des mots contre l'image," in *La Photo, inéluctablement* (Paris: Gallimard, 1999), 124. This volume comprises Guibert's photojournalistic writings, some of which nourish *L'Image fantôme*. If the guarantee of referential presence afforded by the inclusion of photographs in autobiography must be recognized as "phony," this is not least because photo-images are themselves representational loci wherein the referent is already, inevitably, absent.

38. Buisine, "Le Photographique," 39.

39. Chambers, *Facing It*, 35–38.

Sophie Calle's *Des histoires vraies*: Irony and Beyond

TEN ◼ ▬▬▬▬▬▬▬▬▬▬▬▬▬▬▬

JOHNNIE GRATTON

In a quotation originally circulated by the editors of this volume as a way of kick-starting the whole notion of phototextuality, Victor Burgin states that "the intelligibility of the photograph is no simple thing."[1] While I am more than happy to support such a contention, I must admit to having serious reservations about endorsing his follow-up assertion that "photographs are texts," for this seems to me precisely a simplification: one of many thrown up by the heady mix of intellectual forces that produced 1970s textualism. As I propose to understand it here, the analytics of "phototextuality" assume a bifocal perspective. This perspective embraces, on the one hand, photographs, or at the very least the idea of photography, as something textually under consideration and, on the other hand, a text or texts, or at the very least a possibility of text, as something triggered in or by a photo. The term "phototextualities," again as I understand it, further implies a study of the different kinds and degrees of relation that hold between image and language across a wide range of contexts.

In the context of contemporary French art, few artists would seem to lend themselves more fittingly to a phototextual approach than Sophie Calle. Calle is both a writer and a photographer, only rarely one without the other.[2] This double focus is accommodated in two

main forms. The first, and the one that usually appears first, is the installation exhibited in an art gallery or museum, where photos hung at eye level or sometimes, if large enough, simply left leaning against a wall are juxtaposed with framed printed texts. But Calle has also found a rewarding outlet in the form of book publications based on the same kind of text/photo juxtaposition. By virtue of being compactly redistributed across the sequenced pages of a book, the published work tends all the more strongly to bear out the description of herself that Calle is said to favor—that of "narrative artist" (which neatly sidesteps, even while it echoes, the more frequently bestowed label "conceptual artist").[3] Calle's work has become renowned for the stimulating and often controversial ways in which it crosses the boundary lines between self and other, public and private, detachment and involvement, art and life.

Calle remains best known for installations that are records of experimental projects in which photos were taken and words tape-recorded or written at the same time, that is, over the real time of the project in question. The project requires and ensures a contemporaneity (if not absolute simultaneity) of text, image, and referent.[4] Rather differently, the two phototextual sequences contained in *Des histoires vraies* (1994; True Stories) take as their antecedent aspects of the global project we call a "life," in this case Calle's own life. To invoke another composite word, whose French variant was first coined by Gilles Mora in the early 1980s, *Des histories vraies* is an experiment in "photobiography."[5] Accordingly, the play of time and tense will be such as to make it very unlikely for a contemporaneity of text, image, and referent to come about.

Of the two text-image sequences contained in this volume, the first, *Des histoires vraies*, gives its title to the book, and consists of sixteen chronologically organized photobiographical units narrating episodes dispersed across at least twenty-seven years of Calle's life (*DHV* 9–41). The second sequence (*DHV* 43–63), titled *Le Mari: 10 récits* (The Husband: Ten Tales), consists of ten photobiographically represented episodes spread over a much shorter time span: the few years it takes Calle to meet, marry, divorce, and forget her American lover, Greg Shephard. In each case, what I am calling a "photobiographical" unit consists of a photo and a short text headed by a title. The text does not necessarily refer directly to the photo but tends rather to narrativize the object or objects represented in the photo. Photo and text are juxtaposed in a variety of patterns, most often on facing pages but occasionally with the text set beneath a photo spread across two pages. On three occasions in the first sequence and once in

the second, the image element is missing from the unit, though the unit arguably remains both "phototextual" and "photobiographical," insofar as a space is left where a photo might have featured. Thus the blank page invites the reader to ponder the reasons for and significance of the absent image. For the purposes of this discussion, I shall concentrate primarily on the first sequence.

Is it possible in this postmodernist day and age to take a title such as "True Stories" without a pinch of salt? The image of a closed eyelid featured on both the front and back covers of the 1994 Actes Sud edition of Calle's book might well be taken to represent a wink of complicity encouraging healthy skepticism about the capacity of either photographic or autobiographical representation to pin down anything as definitive as "the" truth, or even "a" truth, of the represented subject. In fact, I strongly suspect that Calle's title is a quotation from Serge Doubrovsky's *Le Livre brisé* (1989; The Broken Book), where Doubrovsky's narrator himself quotes at one point from the diary of Antoine Roquentin, the hero of Jean-Paul Sartre's famous novel *La Nausée* (Nausea) of 1939:

> When you tell your own story it's always storytelling. People talk about true stories. As if there could be such a thing as true stories; events occur in one direction and we recount them in the opposite direction. Autobiography, novel, it's all the same. The same thing, the same trickery.

> Quand on se raconte, ce sont toujours des racontars. On parle d'histoires vraies.Comme s'il pouvait y avoir des histoires vraies; les événements se produisent dans un sens et nous les racontons en sens inverse. Autobiographie, roman, pareil. Le même truc, le même truquage.[6]

Doubrovsky, of course, is best known as the inventor of the term "autofiction," which can be taken to describe one of the forms assumed by autobiographical writing at a time of severely diminished faith in the power of memory and language to access definitive truths about the past or the self. Merging two of the composite, crossover terms that have appeared in this chapter so far, one might say that Calle, through her borrowed title, is signaling her intention to produce an essay in photobiographical autofiction.

This same intention is signaled all the more clearly in the two texts that appear on the inside leaves of the front and back covers of *Des histoires vraies*. Where we would normally expect some kind

of biographical note about the author, we are in fact given two quotations from Paul Auster's 1992 novel, *Leviathan*:

> [*She*] was an artist, but the work she did had nothing to do with creating objects commonly defined as art. Some people called her a photographer, others referred to her as a conceptualist, still others considered her a writer, but none of these descriptions was accurate, and in the end I don't think she can be pigeonholed in any way.[7]

> Her subject was the eye, the drama of watching and being watched, and her pieces exhibited the same qualities one found in [*her*]: meticulous attention to detail, a reliance on arbitrary structures, patience bordering on the unendurable.[8]

These passages do in fact describe Sophie Calle but via a fictionalized version of her, a character called Maria Turner, who is to be found in Auster's novel. Indeed, the eagle-eyed reader of the novel may chance upon a sentence on the publication details page of *Leviathan*, according to which "the author extends his special thanks to Sophie Calle for permission to mingle fact with fiction."[9] To what extent, then, does Calle's photobiographical essay mingle fact and fiction, and to what extent does such mingling produce, or contribute to, a conceptualist or postmodernist ironization of photobiography?

Fact and fiction clearly "mingle" in the eighth text-image unit of *Des histoires vraies*. Here, alongside a photo showing the pages of a handwritten letter, a short text relates how, some years previously, Calle had paid a professional letter writer one hundred francs to send her a love letter, something she had never yet received in reality (fig. 10.1). The result, she says, was a beautiful seven-page letter, penwritten and in verse (*DHV* 25). The photo, in which one can make out the pages of the letter and even the two lines Calle quotes from it, authenticates the story. The evidential force of the photo is ironized, however, to the extent that the story reveals what the letter on its own, and the photo of the letter on its own, cannot indicate: namely, that this is a bogus love letter, a pure fiction. Is the point of this irony to critique or deride the autobiographical impulse? Only in small part, for the letter as fiction is shown to have been both needed and appreciated. Thus the letter as fiction enters into one of the recurrent thematic clusters informing Calle's work, that of loss and substitution, which can take narrative forms that are as quietly poignant as they are sharply ironic.

The mingling of fact and fiction takes a different form in the ninth text-image unit of *Des histoires vraies* (fig. 10.2). Here, a text—"Les chats" (*DHV* 26)—briefly explains how the three pet cats Calle has owned in her life came to die. The corresponding photograph shows three dead cats, or, to be more precise, three identical images of the same dead cat. Furthermore, one cannot be sure at the level of the referent whether these are the desiccated, possibly even mummified remains of a real cat or some kind of sculpted simulation of such a state. In this instance, fiction comes into play, insofar as the cats mentioned in the text and those displayed in the photo cannot be co-referential. Once more, however, the irony articulated by this nonconnection does not necessarily override a sense in which the photo, by virtue of its

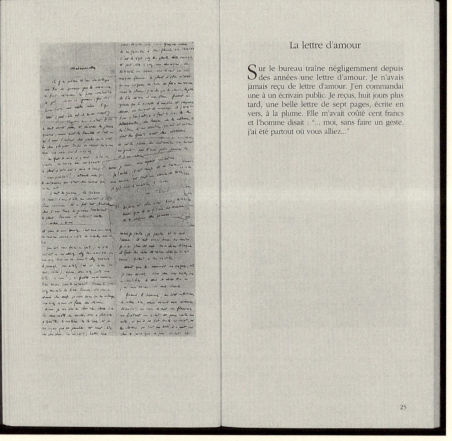

FIGURE 10.1.

Sophie Calle, *La lettre d'amour*, from *Des histoires vraies*, 1994

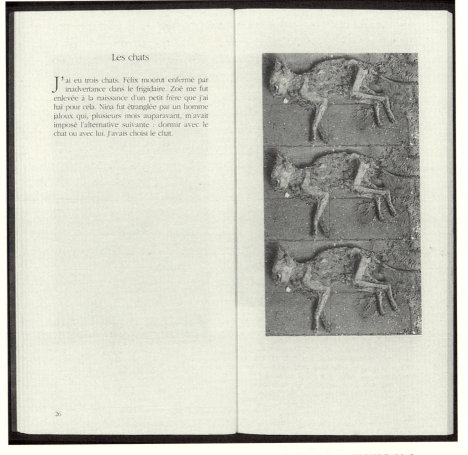

Les chats

J'ai eu trois chats. Félix mourut enfermé par
inadvertance dans le frigidaire. Zoé me fut
enlevée à la naissance d'un petit frère que j'ai
haï pour cela. Nina fut étranglée par un homme
jaloux qui, plusieurs mois auparavant, m'avait
imposé l'alternative suivante : dormir avec le
chat ou avec lui. J'avais choisi le chat.

26

FIGURE 10.2.

Sophie Calle, *Les chats*, from *Des histoires vraies*, 1994

contrived structure and stony texture, constitutes a kind of monument
to the three dead cats. The thematics of loss and substitution contin-
ues to tease and touch in equal measure.

A similar irony of impossible co-referentiality characterizes the
third text-image unit of *Des histoires vraies* (fig. 10.3). The text accom-
panying and narrativizing this all too evident symbol of the male gen-
italia deserves to be quoted in its entirety:

At fifteen years of age I was afraid of men. One day, at the
restaurant, I chose a dessert for its name: "A Girl's Dream." I
asked the waiter what it meant. He replied that he was going
to keep it a surprise. A few minutes later, the man set down

before me a plate containing a peeled banana and two scoops of vanilla ice-cream. Then, amid general silence, he wished me *bon appétit* with a smile on his lips. I held back my tears and closed my eyes, as I was to do years later when, for the first time, a man stripped naked before me.

A quinze ans j'avais peur des hommes. Un jour, au restaurant, je choisis un dessert pour son nom: "rêve de jeune fille." Je demandai au serveur de quoi il s'agissait. Il répondait qu'il me réservait la surprise. Quelques minutes plus tard, l'homme posa devant moi une assiette qui contenait une banane épluchée et deux boules de glace à la vanille. Puis, dans le silence général, il me souhaita bon appétit, sourire aux lèvres. J'ai retenu mes larmes et fermé les yeux ainsi que je le fis des années plus tard, lorsque, pour la première fois, un homme se mit nu devant moi. (*DHV* 14)

Irony, the impossibility of "straight" autobiography, subsists here as a minor rather than determining factor. The dessert depicted in the photo obviously cannot be the "same" dessert as that referred to in the short narrative text. The photo offers a reconstruction or illustration. As so often in her work, Calle uses photography to stage substitute images or scenarios. With this act of substitution, however, Calle triggers a disturbing effect of *mise-en-abyme* whereby the depicted referent, in all its obscenity, seems to be claiming strong affinities with the depicting photograph. Both the referent and the photo are visual displays taking the form of images, defined by Patrick Maynard in his recent book, *The Engine of Visualization,* as "units of marks and surfaces, including unmarked bits of surface."[10] In other words, just as the photo frames, centers, and frontally registers the dessert as visual display set off against a neutral background, so the oval plate, whose shape recalls a classic frame model in the history of portraiture, performs the same pictorial service for its lewdly configured contents. That a similar parallel might be said to exist between the photographer's act and the waiter's act is neatly if rather unwittingly suggested by Maynard when, writing about depictive technologies generally, he observes that "photography provides methods of marking surfaces that *entice imagining.*"[11] Is that which is staged to be seen through a window of representation always to some degree pornographic? And, if so, what are we to make of this disturbing affinity?

The narrativization of this photo resolves the *particular* problem of its own difference from what it depicts but seems to me to continue to

acknowledge the *general* problem, especially as it affects the woman artist, of the complicity of the photographic with the pornographic. The particular problem is resolved because the narrative text helps us to understand that the point of the photo as a form of display is *forensic* rather than *pornographic*. This visual reconstruction takes us back to the scene of a crime: to a sick joke that turned something assumed through the male gaze to be a girl's "dream" into something more akin to a blind spot, a visual trauma or phobia. The unexpected turn taken by the last sentence of Calle's narrative powerfully conveys this transformation of a tasteless episode into a kind of scopic primal scene, situated well beyond the reach of irony.

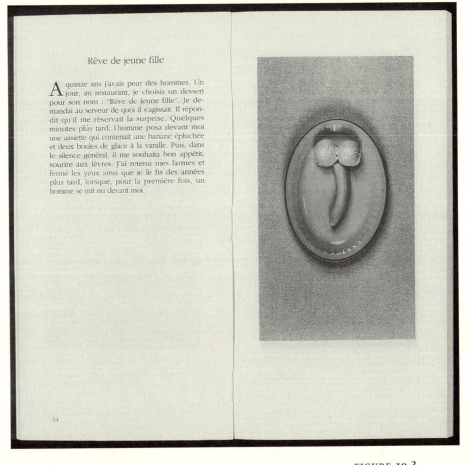

FIGURE 10.3.

Sophie Calle, *Rêve de jeune fille*, from *Des histoires vraies*, 1994

As for the *general* problem of the complicity of the photographic with the pornographic, this is an issue kept alive precisely as the upshot of the primal scene described in the third of Calle's *histoires vraies*. This upshot can be tracked, for example, through a theater of visuality that stages not only the "drama of watching and being watched" (as Auster puts it) but also that of looking and not looking. This double drama unfolds most notably through a thematics of dress and undress, modesty and immodesty. For reasons that are at least partly explained in the episode titled "Rêve de jeune fille," Calle's sensibilities as an adolescent and young woman contained a strong element of modesty, of *pudeur*. Enlisted in her work both textually and photographically as a key autobiographeme, Calle's *pudeur*, itself part of a broader fragmentary portrait of an innocent or naive subject, manifests itself most notably through past experiences involving preference for forms of dress over shows of nudity. Such experiences are never bluntly ironized by Calle, never simply attributed to an embarrassing past self long since superseded by an enlightened present self. Her past fear of male nudity is foregrounded notably in the photobiographical unit titled "Le peignoir" (The Dressing Gown), which directly follows "A Girl's Dream." The garment in question, photographed hanging phantomlike from a hook on a bare wall, is narrativized as that regularly worn by the eighteen-year-old Calle's first lover over the twelve-month period of their relationship, not because of any wish on his part, but because the young Sophie insisted he wear it whenever there was a risk of his genitals being exposed to view.

The turn to *im*modesty is demonstrated in the sequence of photobiographical units immediately following "Le peignoir," where Calle shows how, in what amounts to a willful inversion of the terms of her phobia, she came to display her own body to various publics. We see the twenty-seven-year-old Calle performing as a striptease artist in a Pigalle strip joint, sporting a blond wig and 1950s-style hat with veil, in an act of self-exposure attenuated by the recurring incidence of modesty and disguise. Finally, following two text-image units dealing with Calle the stripper, a third unit homes in on a two-week period Calle spent as a model in a life-drawing class. The photo here (fig. 10.4) is of a drawing of her posing nude, left behind by one of the male students in the class after he had slashed it with a razor blade. What remains, writes Calle, are "pieces of herself," "morceaux de moi-même" (*DHV* 23). The violence of the male gaze, it would seem, echoes the fetishistic take of photography as, to echo the words of Christian Metz, it cuts "into the referent . . . cuts off a piece of it, a fragment, a part object, for a long motionless journey of no

return."[12] A case could be made for believing that, when she was producing *Des histoires vraies*, Calle not only was familiar with this famous essay, but was dialoguing with it. Metz himself mentions that psychoanalysis offers a description of the subject in which "the male features are often dominant, mixed with (and as) general features,"[13] but does not consider how resistance to such a generalization might affect his analysis of the fetishistic nature of the photograph. Calle clearly wishes to examine her own position as a woman photographer in relation to this modeling of the photographic *fascinum* on fetishistic male desire. Evoking Freud's analysis of the fetish, Metz argues that the "compromise" of providing a substitute penis for the one the woman is deprived of, the "compromise" that is specifically designed to allay male anxiety about castration, "consists in making the seen retrospectively unseen by a disavowal of the perception, and in *stopping the look*, once and for all, on an object, the fetish . . . which was . . . near, just prior to, the place of the terrifying absence."[14] By contrast, to go back to "Rêve de jeune fille," Calle offers us an episode in which disavowal (or refusal?) of a violently displayed iconic/symbolic representation of the penis as fetish-god "stops the look" not by fixing it on an adjacent object but, far more intransitively, by the act of closing one's eyes altogether. Does this result in a "feminizing" of the fetish, instanced, too, in Calle's obsession with clothes (the dressing gown, a wedding dress, and even a tie, sent to an acquaintance as the first step toward realizing the "dream" of the perfectly dressed man), masks, and multiple identities?[15]

The double drama of watching and being watched, of looking and not looking, that traverses *Des histoires vraies* is of course intimately bound up with a series of essential questions posed by photography and photographs. Inter alia, it poses the question of how, as a woman, Calle herself happened to become a photographer. Thus, beyond its ironic distancing from the conventions of standard autobiography, Calle's book, in its own compelling way, takes up and confirms a central preoccupation of autobiographical writing by photographers: a preoccupation described by Clive Scott as "the exploration of the ambiguities and contradictions which surround [the writer-photographer's] relationship to [her] medium."[16] We are now in a position, I would suggest, to evaluate rather differently the significance of the closed eye depicted on the front and back of Calle's book. Calle in fact ensures that the reader of *Des histoires vraies* cannot leave its confines possessed of the impression that this image serves merely to mark the instance of an ironic *clin d'œil*, for, in the very last photobiographical unit of the book (that is, the last episode of the sequence titled *Le Mari: 10 récits*),

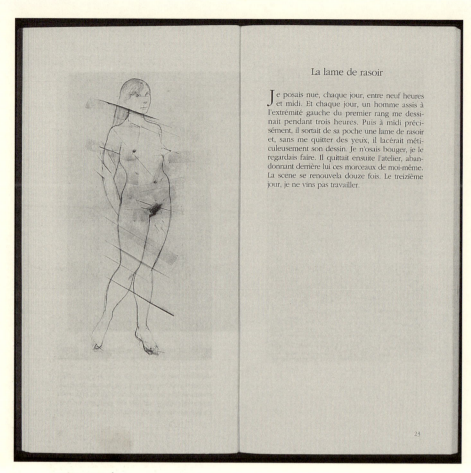

La lame de rasoir

Je posais nue, chaque jour, entre neuf heures
et midi. Et chaque jour, un homme assis à
l'extrémité gauche du premier rang me dessi-
nait pendant trois heures. Puis à midi préci-
sément, il sortait de sa poche une lame de rasoir
et, sans me quitter des yeux, il lacérait méti-
culeusement son dessin. Je n'osais bouger, je le
regardais faire. Il quittait ensuite l'atelier, aban-
donnant derrière lui ces morceaux de moi-même.
La scene se renouvela douze fois. Le treizième
jour, je ne vins pas travailler.

23

FIGURE 10.4.
Sophie Calle, *La lame de rasoir*, from *Des histoires vraies*, 1994

she reproduces that image alongside a narrative concerning the first
man she slept with after breaking up with her American husband, Greg
Shephard. Here (fig. 10.5), the image corresponds to a moment in the
story where Calle, spending her first night with her new lover but
believing she still loved Greg, preferred to shut her eyes, for fear that
she would see her husband's "ghost" and be invaded by the idea
that this new man was not the "right" man (*DHV* 62). Not unlike the
moment at which the camera shutter cuts off the light being received
by the negative, the moment when Calle shuts her eyes conforms to a
temporality suspended between loss and substitution.

I have tried to point out how a number of Calle's photobiographical
units contain, but are not ultimately contained by, irony. In various

ways, these units steer a course beyond irony, opening the way for more pathic/empathic forms of self-exploration and self-representation. I want now to suggest that this push beyond irony is embodied also in the structure of *Des histoires vraies* as a sequence of photobiographical units. Just as the final sentence of the primal scene narrative lifts us clear of ironism, with unexpected power and poignancy, so too does the final unit in relation to the series of units composing *Des histoires vraies* (*DHV* 40–41). The text (fig. 10.6) begins by explaining how Calle's great-aunt strove for six days to fight off the moment of her death until February 4, 1988, her hundredth birthday. She thus achieved her ambition of reaching the age of one hundred years. The object depicted in the adjacent photo is introduced in the second part of the text:

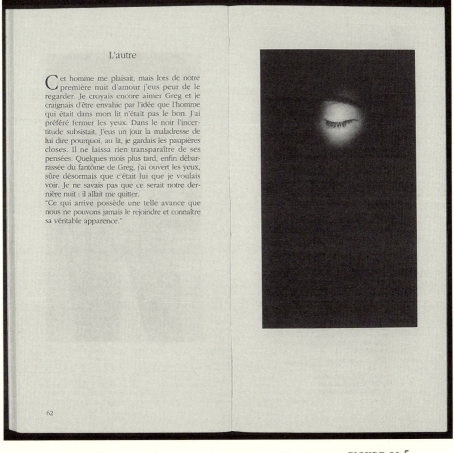

FIGURE 10.5.

Sophie Calle, *L'autre*, from *Des histoires vraies*, 1994

Before dying, she had embroidered a sheet with my initials. I offered it to my friend Hervé, gravely ill at the time, in memory of that already far-off night when he had refused to share my bed. In this way I invited him to sleep with me just a little. Also, I liked to believe that, having been embroidered by a woman who had reached the age of one hundred through a fierce act of willpower, this sheet, aglow with faith, would transmit her strength to him.

Avant de mourir elle avait brodé un drap à mes initiales. Je l'offris à mon ami Hervé, alors gravement malade, en souvenir de cette nuit, lointaine déjà, où il avait refusé de partager mon lit. Je l'invitai ainsi à dormir un peu avec moi. Et puis, j'aimais à croire qu'ayant été brodé par une femme devenue centenaire grâce à une volonté farouche, ce drap, auréolé de foi, lui transmettrait sa force. (*DHV* 40)

Reproduced in color, not black-and-white, and presented as a close-up of Calle's embroidered initials on the sheet, the photo has a warmth and intimacy that distinguishes it from most of the others in the sequence it concludes. Despite the context of the great-aunt's death, the sheet in the photograph escapes the necrographic, shroud-like connotations attached to previous images of items of clothing. The sheet of the image is presented as fully co-referential with the sheet in the text. The force of the photograph is evidential: the image is there to authenticate the story told about the sheet, as is the text of the great-aunt's death notice, positioned directly beneath the story text. Furthermore, many readers familiar with contemporary French culture will recognize in the name "Hervé" a reference to the French writer and photographer, Hervé Guibert, who died of AIDS in 1991. Powerfully and tenderly, all these pointers combine to utter a Barthesian "*That-has-been*" (*ça-a-été*).

We are nowhere farther from ironism, perhaps, than in the final sentence of the text, where Calle explains how she succumbed to the belief that, through the passing-on of the sheet first given to her, her great-aunt's strength might be transmitted to her dying friend. (Here, it seems to me, Calle's wanting-to-believe bears strong affinities with the "fantasy of rescue" invoked by Marianne Hirsch elsewhere in this volume in her examination of responses to Holocaust photographs.) Moreover, as an object aglow with faith, the sheet clearly alludes to the powers regularly attributed to photographs by virtue of their indexicality: their status as physical traces and not just visual representations of per-

sons or objects from the past. It is indexicality, Philippe Dubois observes, that explains certain personal, sentimental, and superstitious uses of photos: "uses always caught up in games of desire and death and which all tend to attribute to photography a particular *force*, something that makes of it a veritable *object of belief*, beyond all rationality, beyond any reality principle, beyond any question of aesthetic value."[17] To place the photograph between hurting and healing, to promote the possibility of what Linda Haverty Rugg calls a "superstitious reading" of the photograph,[18] is to rewrite the book of irony as a book of pathos and, thereby, to restore to these "true stories" something of their truth. Not Truth with a capital *T,* not necessarily a great deal of truth. Only as much truth, perhaps, as the amount of sleep Calle felt she might share

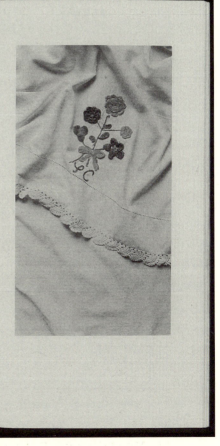

FIGURE 10.6. Sophie Calle, *Le drap,* from *Des histoires vraies,* 1994

with Hervé Guibert via the offer of her precious sheet (that is, via the implementation of her "fantasy of rescue"): "just a little."[19]

Finally, is it not possible to make a similar point here about identity? According to Clive Scott, the projects of many modern and contemporary women photographers have been close to the notion of "phototherapy," insofar as their aim has been "to escape identification through self-multiplication, which itself becomes a route back to identity."[20] That Calle is among those who have sought to escape identification by multiplying, deterritorializing, and reinventing themselves photobiographically is beyond dispute. However, I am not at all sure that the "route back to identity" is as easily tracked in Calle's work as it might be in the projects of certain other women photographers. That said, a minimal claim to identity does seem to be made in the last text-image unit of *Des histoires vraies*, alongside its minimal claim to truth. The identity in question is itself minimal because it is *relational*—and therefore arguably provisional. For the "I" of Calle is here delicately positioned between an act of receiving and an act of giving. She is the transmitter of a "strength" that is not hers. Incongruously, she finds herself mediating between a great-aunt who represents familiality, domesticity, and tradition and a male friend who represents the marginality of the artist and the homosexual. Together, the text and the photo say that this is a position that Calle feels privileged to have been in, to have *found herself* in. Why else would she bring her essay to a close not with the authority of her signature, or even with her "own" initials qua micro-signature, but, more minimally still and more delicately still, with a photo of her initials as embroidered by the dying yet loving hand of another?

Notes

1. Victor Burgin, "Looking at Photographs," in Burgin, ed., *Thinking Photography* (London: Macmillan, 1982), 144.

2. Variations on (rather than exceptions to) this rule include Calle's video film *No Sex Last Night* (1992), about a car journey she made across the United States with her boyfriend Greg Shephard, "un film sur notre vie de couple" as she puts it in *Des histoires vraies*. See Sophie Calle, *Des histoires vraies* (Arles: Actes Sud, 1994), 58. We should note, too, that, since turning to color photography, Calle has become more involved in the conception and design of image sequences than in the actual taking of photographs. Furthermore, the textual elements in many of her most recent projects are often edited and translated versions of taped interviews with third parties. See, in particular, *L'EROUV de Jérusalem* (Arles: Actes Sud, 1996); *Souvenirs de Berlin-Est* (Arles: Actes Sud, 1999); *Disparitions* (Arles: Actes Sud, 2000); and *Fantômes*

(Arles: Actes Sud, 2000). Subsequent references to *Des histoires vraies*, my key focus here, are given parenthetically in the text (*DHV*), and translations are mine.

3. For Calle's self-definition as "narrative artist," see the text to be found at http://www.cnp-photographie.com/expo/atelier/archive/sophie/index.html (no author named).

4. While many of Calle's postproject installations or books do not always contain the "original" texts or photos, an *effect* of contemporaneity is usually preserved.

5. See Gilles Mora, "La Photobiographie: Une forme autobiographique?" *Cahiers RITM* 20 (1999): 183–89.

6. Serge Doubrovsky, *Le Livre brisé* (Paris: Grasset, 1989), 91. The translation is mine.

7. Paul Auster, *Leviathan* (London: Faber and Faber, 1993), 60.

8. Ibid., 63.

9. Calle's fascinating response to Auster's fictionalization of her is recorded in the exhibition titled *Doubles-jeux* and in the boxed set of seven books bearing the same name (Arles: Actes Sud, 1998). This is translated as the single-volume *Double Game*, trans. Dany Borash, Danny Hatfield, and Charles Penwarden (London: Violette Editions, 1999).

10. Patrick Maynard, *The Engine of Visualization: Thinking through Photography* (Ithaca: Cornell University Press, 1997), 33.

11. Ibid., 114; my emphasis.

12. Christian Metz, "Photography and Fetishism," in *The Critical Image: Essays on Contemporary Photography*, ed. Carol Squiers (London: Lawrence and Wishart, 1991), 158; translation amended.

13. Ibid., 163.

14. Ibid., 160.

15. On the different forms of fetishistic satisfaction derived by women, see Emily Apter, *Feminizing the Fetish: Psychoanalysis and Narrative Obsession in Turn-of-the-Century France* (Ithaca: Cornell University Press, 1991).

16. Clive Scott, *The Spoken Image: Photography and Language* (London: Reaktion Books, 1999), 96.

17. Philippe Dubois, *L'Acte photographique* (Paris: Nathan, 1983), 77; my translation. The original reads "usages toujours pris dans les jeux du désir et de la mort et qui tendent tous à attribuer à la photo une *force* particulière, quelque chose qui fasse d'elle un véritable *objet de croyance*, par-delà toute rationalité, tout principe de réalité ou tout esthétisme."

18. Linda Haverty Rugg, *Picturing Ourselves: Photography and Autobiography* (Chicago: University of Chicago Press, 1997), 26–27.

19. On "deflationist" theories of "minimal truth" in contemporary philosophy, see Pascal Engel, *La Vérité: Réflexions sur quelques truismes* (Paris: Hatier, 1998).

20. Scott, *The Spoken Image*, 238.

PHOTOTEXTUAL MOMENTUM

"Neither an Odyssey nor a Testament": Drifting with Jacques Derrida and Catherine Malabou

■■■■■■■■■■■■ ❧ ELEVEN

MARIE-CLAIRE BARNET

> Then I tell myself that, after all, I write in a bedroom only to avoid the camera, cinema, television, and photography.
>
> Je me dis alors que j'écris en chambre, au fond, pour éviter la caméra, le cinéma, la télévision et la photographie.
>
> *Jacques Derrida, from Derrida and Safaa Fathy,*
> Tourner les mots

According to Hervé Guibert's *L'Image fantôme* (Ghost Image; 1981), a travel picture has very particular qualities. Guibert tells us, "For me a travel photo is a kind of drive, a form of hysteria that is quickly dissipated" (Pour moi la photo de voyage est une espèce de dynamique, d'hystérie qui se dégonfle très vite), and that it is at odds with reflection: "If I think, I can't take the picture" (si je réfléchis, je ne peux pas prendre la photo).[1] But what sorts of hysteria, paralyses, impulses, or other processes of mental momentum are we given to see, read, and embark on in *La Contre-Allée* (The Side Path; 1999), an unusual "travel book" coauthored by Jacques Derrida and Catherine Malabou, and one that resists classification, despite its inclusion in a series titled "Travelling with . . ."?[2] As a contributor to this series, Derrida has (to abide by) a given

201

structure: his volume must be a collection of photographs, with accompanying texts about travel. We shall see, however, that the textual and visual strategy that Derrida adopts in *La Contre-Allée* is in fact highly subversive. The aim of this chapter is to show how the Derridean phototextual constructions of *La Contre-Allée* offer a compelling example of the uneasy, complex relationship between photo-images and written narratives. It seeks to do so by demonstrating that these constructions question both the subject (Derrida or Malabou?) and the object of the text and images (Derrida's private album or his witty collection of stereotypes?) they juxtapose, and play with, or undermine, referentiality. In other words, my chapter works to signal that despite belonging to a series with a set format, *La Contre-Allée* defies readerly expectations in a number of ways.

How does one start to write about a trip? Derrida's response to this question conveys a certain panic if not a (guibertian) hysteria:

> As for me, I wonder what I would do if I had not only to "think" travel, the "concept" of travel, but also to remember and speak about travel, which is something I've never known how to do or wanted to do. I would be perfectly incapable of relating this first stay in Turkey, overwhelmed by the conviction I have that it would require hundreds of volumes and the invention of another language.

> De mon côté, je me demande ce que je ferais si j'avais non seulement à "penser" le voyage, le "concept" de voyage, mais à me rappeler, et à raconter, ce que je n'ai jamais su ni voulu faire. Je serais bien incapable de raconter ce premier séjour en Turquie, écrasé par le certitude qu'il y faudrait des centaines de volumes et l'invention d'une autre langue. (*CA* 29)

In what sense is the book his statement refers to not credible? That it is not is hinted at in the warning or apparent confession that Derrida articulates in it: "No, I exaggerate a little, as usual . . ." (Non, j'exagère un peu, comme toujours . . . ; *CA* 29). How does its truth relate to the truth of *"That-has-been"* found in pictures: a truth famously expressed by Roland Barthes but subsequently interrogated by Christian Boltanski, Guibert, and Cindy Sherman, among others? Photography evinces strong reference but also objectification, voyeurism, alienation: it invokes distortion, manipulation, and distrust. And photographs are "potentially dangerous," as Linda

Haverty Rugg observes. But for whom? Haverty Rugg reminds us that writers, especially autobiographers, may manipulate their texts with pictures in their hands, consciously or not, working with but also against photographic representation:

> All autobiographers of the photographic age must in some way reckon with photography when they take account of themselves; in this way they move to reclaim the control of self-image inherent in the autobiographical act and threatened by the advent of photography.[3]

Photographs may of course reassure the (autobiographical) writer. In his comments on a friend's pictures of him, Guibert suggests that he learns to read signs from photographs taken by someone else and to re-cognize and rediscover himself in Hans Georg Berger's revealing portraits.[4] So what is Derrida looking at/looking for when he scrutinizes Malabou's text, her quotations from his own texts, or the series of portraits of himself included in *La Contre-Allée*?

La Contre-Allée has a complex structure, even including two, contradictory tables of contents. It has three "voies," or tracks: "Le Renversement" (Overturning); "La Traversée" (Crossing); "La Version ou le non-arrivé" (Version, the "not arrived"). It has subsections, "Tropiques" (Tropics) and "Envoyage et Mise en chemin" (To Be Traveling and Setting in Motion), that point at different themes or tracks and a three-track conclusion ("à trois voies"). Its title opens up a series of meanings: the sidepath to the royal or main path; the parallel but deviant track; but also the verb underlined by Derrida: *contre-aller/aller contre*, the reluctance to go, the will to go despite, or the risk of going against (*CA* 274). The objective of the book is clear and unclear: "Therefore I follow/I am you" (Donc je vous suis; *CA* 29), warns Derrida, in a Cartesian pun, thanking Malabou for accepting the "risks" of the "traveling with" process. She is certainly an unusual "traveling companion." From Paris, she will travel mentally and textually with Derrida, searching through his previous texts and present letters, "drifting" in a virtuoso, intertextual encounter, while he will literally cross countries (Turkey, the United States, Italy, Japan, Poland), and read along/across the texts she sends him. Are these texts hers, or his own? To which author do they belong? These are questions the authors will not answer. But both embark on a journey "without truth," a "voyage sans vérité":

> "I'd like, in my own way, to name . . . the journey, but a

journey with no coming back, without any circle or world tour in any case, or, if you like, a return to life which would not be a resurrection. . . . Neither an Odyssey nor a Testament."

"je voudrais dire à ma manière, nommer . . . le voyage mais un voyage sans retour, sans cercle ni tour du monde en tout cas, ou, si vous préférez, un retour à la vie qui ne soit pas une résurrection. . . . Ni une Odyssée, ni un Testament."[5]

Does the (multiply) dual text that is *La Contre-Allée* make us want to reread Derrida? Do its pictures give us an illusion of fluidity, displacement? Do they metaphorically transport us beyond the "banality" of images of travel?[6] Do they make us dream of packing our suitcases, or of opening more books? Drifting along the tracks of the double "non-Odyssey, non-Testament" that Malabou and Derrida offer us, we cannot help but reflect on the tactics *La Contre-Allée* employs to keep the authors and the readers on board. In what follows, I shall do precisely that. I start by examining the dynamics of the pictures the text includes: pictures that inscribe identity and memory, as well as places and time zones. Subsequently, I underline how the (Barthesian) motif of death, notably authorial death, and the return of the repressed (image) feature in *La Contre-Allée*. Finally, my conclusion looks at the uses of trauma in the text, at its last picture, and at its apparent rejection of travel.

Picturing Oneself in Motion: Photography, Autobiography, Geography

Flipping through the collection of pictures included in *La Contre-Allée*, we see that these are obviously not instant snapshots, taken in front of tourist venues. But what sort of distortion of this particular photographic genre do they offer? All of the images, except a few (there is, for example, a picture of seabirds, to which I shall return), represent Derrida, abroad. We might therefore ask ourselves who is the subject who, in relation to the photo-images and/or their referents, is "hysterically" driven by curiosity, by voyeurism? Who controls the pictures, the texts, that are exchanged between Derrida and Malabou and between them and us?

In perusing *La Contre-Allée*, we may respect the disorder that seems to govern it, reading the Japanese section before the Algerian

section and then returning to the Californian section. We may flip through the texts, as if we are scrutinizing a family album, or drift along the quoted texts, sometimes familiar, highlighted by Malabou. We may read the new postcards and correspondence featured in *La Contre-Allée*, and, when we see the photograph of the postcard rack (*CA* 175), we may think of the series of postcards previously invoked in Derrida's *La Carte postale* of 1980. Perhaps we recognize themes, a style, that we associate with Derrida. And we recognize the pictures—or do we? Does *La Contre-Allée* consolidate the image we have of the philosopher/traveler, or does it succeed in creating a fluid portrait, in the style of Francis Bacon? In an interview with François Ewald, asked if he wanted not to have an identity, Derrida says the following:

> Of course not, I do, as everyone else. But beating about an impossible bush, that I probably resist too, the "I" constitutes the essence of resistance.

> Si, comme tout le monde. Mais en tournant autour d'une chose impossible et à laquelle sans doute je résiste aussi, le " je" constitue la forme même de la résistance.[7]

What *La Contre-Allée* is not about is "introducing Derrida," offering a *Derrida for Beginners*. Its purpose is not to simplify, to clarify, to reveal: a project pursued in *Le Magazine Littéraire's* "Dossier Jacques Derrida: La déconstruction de la philosophie" of 1991. At the same time, *La Contre-Allée's* pictures are not caricatures, exaggerated images created for cartoon books. But Derrida seems himself to overdo, to parody the photograph album format, by exhibiting a multiplicity of images and playing endlessly with their meanings, until a "breaking point" of (over)signification is reached. Photographs, as Régis Durand points out, are not tragically static. Rather they have an inner tension, they can create hallucinations, they can explode, from within. They are, in sum, visual time bombs:

> It could be said, of course, that photography lacks the mobility necessary to represent the dynamism of a passage, of a transformation—that it can, at best, only suggest a moment when the viewer shifts from the apparent image to something else, a metaphoric or metonymic displacement. That is true. But the essential dynamism of photographs lies in their implosive character.[8]

Caught up in an encounter with a book that multiplies and desta-bilizes meanings, texts, and authors(hip), we may wonder how Derrida could—and does—use or misuse the photographs chosen for inclusion in the "travelogue" created in *La Contre-Allée*. Equally, we may ask our-selves how Derrida might rearrange and re-present himself and/or his trips differently. I would suggest that in *La Contre-Allée* Derrida beats us at the old voyeurism game beloved of readers of photographs and autobiographies, showing himself but hiding in the pictures of the pho-totextual narrative, and, in fact, revealing more disturbing memories or dreams in its texts. In short, I would say, he visually gives us, liter-ally, and with a certain panache of irony, so many clichés.[9]

The "Examples of Travel Pictures" that *La Contre-Allée* provides invoke, inter alia, the following stereotypes: the old man and the sea (*CA* 30); the young man and the sea (a young man who is hopeful, aboard the liner *Liberty* (*CA* 33); the little boy posed before ominous railings (*CA* 39); the invisible prisoner trapped behind railings or walls in Prague (*CA* 39); palm trees in California (*CA* 272); the "pop philoso-pher" (here, a term borrowed from Gilles Deleuze is played with and parodied) (*CA* 101); Marlon Brando in *The Wild One* (*CA* 116); the moody poet in the Poets' Lane, Central Park (*CA* 103); the art of using chopsticks in Japan (*CA* 243). They effect visual puns, for instance in the photographs of Heidegger's heirs (his son and Derrida), which comment implicitly on Heidegger's much-discussed anti-Semitism and his retreat into the mountains. Their organization makes us smile: after the sunshine in Algeria (*CA* 83), the Muscovite snow we are given to see (*CA* 96) strikes us as extreme, not least because we view it by virtue of the acrobatics of the photographer, who has to lie on his back to take a picture of Derrida, posing (fig. 11.1). The banana skin/slip joke narratively staged here seems to be not just on the photographer but also on Derrida and on us, as we voyeuristically watch a watcher (Derrida) being (photographically) watched. When did the smile start? Even before the preface: in the image we are presented with, Catherine Malabou and Derrida are radiant (*CA* 4). The end of the idols is shown above this picture: the statue of Gertrude Stein and the stat-uesque pose of Derrida next to it belong to everyone and could be "everybody's autobiography." When some of Derrida's personal images reemerge in *Tourner les mots, Au bord d'un film*, the effect is ambivalent. We recognize the "universal" subject depicted but also wonder whether everyone wants to be Tarzan (fig. 11.2).

What are the side alleys left to us, as reader-interpreters, as we look at this personal/impersonal collection? And when do I, as an individ-ual viewer/consumer, stop smiling? When the picture seems reflective,

FIGURE 11.1. *Photographié à Moscou,* 1994, from *La Contre-Allée*

particularly targeted at me: when it acts as a mirror of my own self and past. My nostalgia for California is, for instance, unsettlingly reflected back to me by the image-text of the University of California, Irvine (*CA* 228). Although they seem to unify *lieux de mémoire* (realms of memory), to cite the title of Pierre Nora's seminal multivolume collaborative cultural history of France,[10] consigning them to the "no-man's land" of the obvious cliché, the pictures of *La Contre-Allée* also constitute a kaleidoscope of geographic and temporal references, destabilizing and fragmenting the identity of the subject who inhabits them. Emily Apter has affirmed that Pierre Nora's privileged spaces of French cultural memory curiously or symptomatically censor Algiers and Montreal: "Even the most recent volumes of Pierre Nora's richly textured *Les Lieux de mémoire*, with their New Historical attention to the mystificatory components of national identity, clumsily justify their choice not to include Algiers or Montreal as *hauts lieux*, or psychotopographies worthy of revisionist nostalgia."[11] In contrast, Derrida includes numerous, predictable images of Algeria, but he occludes secret traumas behind the postcard picture of the port of Algiers (*CA* 82) and in the

FIGURE 11.2.

Jacques Derrida à 15 ans, El Biar, Algérie (Profil de l'artefacteur en jeune singe), from *Tourner les mots, Au bord d'un film*

lines of the text. "Look and Read: Now you see them, now you don't," Derrida seems to say. But who or what is he invoking? The answer to this question, I would argue, is Barthes, the Father, and metropolitan France: figures with a tragic aura.

The Deaths of the Author

Derrida's reading of *Droit de regards* (Right of Inspection), Marie-Françoise Plissart's 1985 photonovel, was haunted by Barthes, the father of photography analysis and self-analysis through photography.[12] In "Les Morts de Roland Barthes" (The Deaths of Roland Barthes), Derrida also paid eloquent homage to his mentor-friend, famously weaving hallucinations around the ghosts of Barthes or Barthes's mother, forever looking for signs of their approval.[13] In *La Contre-Allée*, Derrida does not comment explicitly on his photographs. And he does not allude explicitly to Barthes, because he does not need to. The ghost of death, inscribed in the pictures of *La Contre-Allée*, in

Barthesian frames or in Derridean drifts along these frames, is omnipresent in the narrative, allying *La Contre-Allée* intertextually to Barthes's photoexegetical project.

Derrida's texts in *La Contre-Allée*, like those of Barthes's *La Chambre claire*, converge to point at death, or, rather, to a plurality of deaths: Derrida's own, his brother Norbert's (*CA* 29), his father's, and that of his friend, the philosopher Jean-François Lyotard (*CA* 271). Ghost texts and images haunt the drifting notes of his non-Odyssey/non-Testament. Death warnings and threats are echoed visually—the picture of a photographer saturated by Greek sunlight or sleep presents itself as a figure of death, announced by ruins and the Poe-esque or Hitchcockian black bird in the corner (*CA* 108)—*and* textually: the Californian seagulls or "cormorans" (*CA* 273) become "le corps mort/mourant" (the dying and dead body). Hallucinations, produced by the content/inspection of pictures, are verbalized and transformed into text: the page (*CA* 273) that presents the "cormoran/corps mourant" on Laguna Beach (fig. 11.3) also features a narrative, textual allusion to Derrida's near-fatal accident in a helicopter in Brittany, on the Isle of Groix.

A lighter mood runs parallel to the morbid text that *La Contre-Allée* incorporates. The comic relief of self-derision is always present but is always counteracted and transitory. From *La Contre-Allée*'s preface, in the margins of the narrative, Derrida insists: "I'm scared of this 'Traveling with' collection" (ce voyager avec me fait peur; *CA* 29 n. 5). He is, we are told, "the only 'living' author, so the first one to still be alive" (le seul 'vivant,' donc le premier vivant; *CA* 29). His fear is not a simple function of blind superstition. Publishing, perishing, and traveling all subtend the project that is *La Contre-Allée*, producing a "bizarre connection" that generates an irrepressible anxiety:

> Every time I publish a book or I leave for a trip (this bizarre connection must mean some kind of finitude), besides the perpetual anxiety about "my" family (but I just have to leave Ris Orangis to go to Paris for that sort of anxiety), only one question prevails above all the rest: will I pull through? Translate: will I come back alive? And what if I happen to die while I'm away, what will "my" family do with my body?

> chaque fois que je publie un livre ou que je pars en voyage (ce rapprochement bizarre doit bien signifier quelque échéance), outre l'angoisse de chaque instant pour les "miens" (mais il suffit, pour cette angoisse-là, que j'aille de Ris-Orangis à Paris),

une seule interrogation domine toutes les autres : m'en sorti-rai-je ? Traduisez: en reviendrai-je vivant ? Et si je meurs en voyage, qu'est-ce que les "miens" feront de mon corps? (*CA* 29)

When someone announces his (virtual) death on the Web, Derrida is not amused. Why should he be? Coincidences are eerie and reveal-ing: "[a so-called Clifford Duffy] finds it clever and desirable . . . to announce my death . . . on the Web" ([un certain Clifford Duffy] croit malin, et désirable . . . d'annoncer sur le Web . . . la nouvelle de ma mort; *CA* 274). Panic spreads among friends and relatives, and when

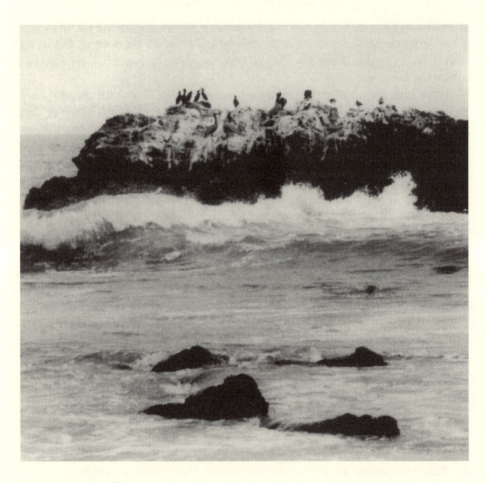

FIGURE 11.3.
'Nos amis les oiseaux' sur leur rocher blanc. J'en ai fait faire des photos pour votre livre, from *La Contre-Allée*

it reaches Derrida himself, he suffers from a less than desirable distance from the self, a total loss of belief in or sense of reality: "I pinch myself: what if it was for real?" (Je me tâte . . . et si c'était vrai? *CA* 274). The following night produces a dream of his father's death (the father is already dead), a real nightmare, with intense suffering and tears. What surfaces and upsets Derrida in his dream (in his body and in the text) is dual: he is traumatized by his inability to get rid of his guilt (he has not cried enough, just as his father did not cry enough over Derrida's younger brother's death [CA 29]), and by the impossibility of communicating (he cannot share emotion with his sister and brother on the phone). Is having no words to share trauma, we wonder, worse than the images of the nightmare?

What is the origin of this haunting suffering, this fear and fixation on the dead/deadly father figure? Derrida investigates and questions language, interrogates his memory. Tentative explanations are offered:

"Travel" means, in my primitive French, work, slavery, slave trade. And a certain shame, even, the origin of social shame. Consequence and rule: never mix travel with leisure, doing nothing, or active tourism, visiting, curiosity.

Voyage égale, dans mon français primitif, travail, asservissement, traite. Et une certaine honte, même, l'origine de la honte sociale. Conséquence et règle: ne jamais associer le voyage au loisir, à l'oisiveté, ni même au tourisme actif, à la visite, à la curiosité. (*CA* 40)

The business trips his father made are associated with an intense suffering, and a sense of an absurd repetition that Derrida now shares:

Am I perchance doing just the same as him, after protesting all my life against his slavery? Are my academic trips for conferences a theatrical, distinguished, sublimated version of a humiliated father?

Est-ce que je ferais comme lui, par hasard, après avoir protesté toute ma vie contre son esclavage? Est-ce que mes tournées de conférences seraient la version théâtrale, distinguée, sublimée d'un père humilié? (*CA* 40)

Many other controversial or puzzling points are highlighted in the

text of *La Contre-Allée*, with an irony that is echoed by the manner in which its photos are manipulated. We witness Derrida's (self-directed) irony, for example, when we encounter a narrative section (*CA* 218) titled "La déconstruction, c'est l'Amérique?" (Is Deconstruction America or in America?) and look at the accompanying picture, which could be labeled "Double exposure/The End of Legends or Sitting on Great Men at Johns Hopkins" (fig. 11.4). After giving up on his right of authorship (for this is what he does in *La Contre-Allée*), Derrida gives up on the (philosophical) paternity inscribed in the "ism" of Deconstructionism. There is, we sense, a safe distance in irony:

> I don't know, by the way, whether or how you will tackle the question of my relationship to America/my "American ques-tion." There's more than one, obviously (the first voyage, the first long stay abroad, 1956–57, so many universities where I taught, so many translations, so many friends and enemies, etc. and I wrote many translations myself, but really not enough). But if I were in your shoes, if I had to tackle the so-called American question, I would first be tempted to use satire. All that's being said, mainly in France, about this "American con-nection," I've always found it, really, comical.

> Je ne sais pas si ou comment, à propos, vous allez aborder ma "question américaine." Il y en a plus d'une, bien sûr (premier long voyage, premier séjour de longue durée à l'étranger, 1956–57, tant d'universités où j'ai enseigné, tant de traductions, d'amis et d'ennemis, etc. et j'en ai moi-même beaucoup écrit, quoique très insuffisamment). Mais si je devais traiter, moi, à votre place, ladite "question américaine," je serais d'abord tenté par le genre satirique. Ce qui est dit, surtout en France, de cette "connexion américaine," je l'ai toujours trouvé, au fond, comique. (*CA* 35)

Derrida intervenes in and "resists," here, the fierce debate over deconstruction, showing how that debate, and how he himself, is framed by different, "national" currents of ideology and showing too how others invent not only his "self" but also a strict "script" for that self. We may read his move, which works to "intervene" in and (re)direct a narrative of himself, as somehow ironical, given Derrida's repeated claim that identity can only be accorded by the Other. Equally, we may read his move as a "political" intervention, given that, as Marianne Hirsch pertinently affirms:

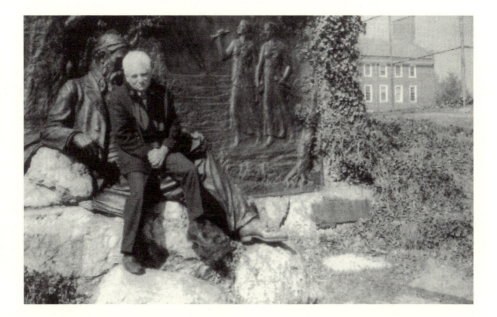

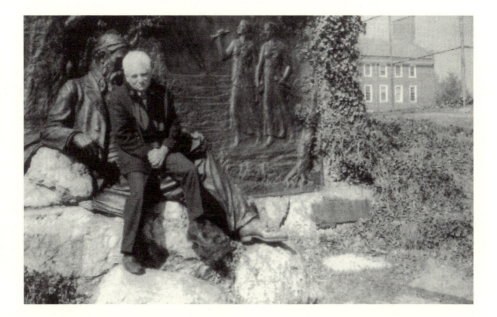

FIGURE II.4.

A l'université Johns Hopkins de Baltimore, 1996, from *La Contre-Allée*

When we intervene in the ideological scripts determining our own lives, I would like to maintain, we are also intervening politically.[14]

Conclusion. A Traveler's Traumas: To Trick or to Treat?

La Contre-Allée ends with temporary stops, labeled "Haltes" (*CA* 283–88). These are confessions of momentary breakdowns, refusals to move again and again, and they form part of the "curriculum" section of the narrative. "Curriculum" is itself a term that is made subject to interrogation/destabilization in *La Contre-Allée*. Derrida refuses to offer us a "proper" travelogue/CV: an equivalent of a conventional index, listing dates and places. If a CV of some sort has to be provided to help us follow his movements over the years, it will be a CP, a *Curriculum peregrinationis*, linked to a marathon rather than to his pursuit of a successful (traveling) career. Does Derrida really/always hate travel? We are reminded, in reflecting on this question, of a similar, violent rejection by Gilles Deleuze: a rejection that is paradoxical and comical, even for

the founder of nomadism himself, and draws support from Samuel Beckett's statement: "We're stupid but not to the point that we travel for pleasure" (On est con, mais pas au point de voyager pour le plaisir).[15] As for Derrida's take on the subject:

> Someone in me, I swear, has never liked to travel, even insists on not going, on never having gone even. Oh, if only I could never travel, at least not far away from home—where I find myself, and probably more than necessary, in a rather "agitated" state, if I may say so, thanks to all that happens to me. And thanks to what does not happen, to me, to one or the other.

> Quelqu'un en moi, je le jure, n'ai jamais aimé voyager, qui insiste même pour ne pas le faire, ni même l'avoir jamais fait. Ah, si je pouvais ne jamais voyager, en tout cas loin de chez moi—où je me trouve assez, plus qu'il ne faut sans doute, *mouvementé* si je puis dire, par ce qui m'arrive. Et par ce qui n'arrive pas, à moi, à l'un ou à l'autre. (*CA* 283–84)

We should note that the (ironic, paradoxical) juxtaposition of this passage of text with the photograph of a young, dynamic Derrida in motion, running in the sun in Algeria, counteracts any pathos intrinsic in the regrets or denials that the passage conveys. The visual image underscores what is clearly articulated below (*CA* 283): that is, "the sadly comic effect" (l'effet tristement comique) of the CV/CP that Derrida, on his computer, designates as his "travel agency" (*agence de voyage*). The tone of *La Contre-Allée*, here, strikes us as bittersweet: the humor proves to be sweeter, as "jubilant" as the reluctant trips it invokes:

> Yes, all these trips have been like a jubilant commotion for me, of which I'm guilty, and from which I suffer.

> Oui, tous ces voyages furent pour moi une commotion jubilatoire dont je m'accuse et dont je souffre. (*CA* 283)

Paradoxes are exposed: Derrida does love his trips to Greece, for example, but relationships between places and time are uneasy; time and space can fall out of synch. An awareness of time can replace an unambivalent relation to space. The question "Why, why did I wait for so long to go to Greece" (Pourquoi ai-je attendu si longtemps pour

me rendre à la Grèce; *CA* 105) ultimately becomes a substitute for a description of the Greek picture. The malaise of feeling "Out of Place" and "Out of Time" that it communicates binds *La Contre-Allée* to Edward Said's autobiography, *Out of Place* (1999). This malaise traverses the following excerpt from "Haltes," between the lines and beyond the dates of which we need to read carefully:

1957–1959 Military service in Algeria. I've taught for two years, in civvies and upon my request, in a school for the children of the troops in Kolea, 30 kilometres from Algiers. Some summer trips to Paris and Charente. 1959: Cerisy-la-Salle.

1957–1959 Service militaire en Algérie: j'enseigne pendant deux ans à ma demande et en civil dans une école d'enfants de troupes à Koléa, à 30 kilomètres d'Alger. Quelques voyages, l'été, à Paris et en Charente; en 1959 à Cerisy-la-Salle. (*CA* 285)

Does this excerpt offer another, perhaps unavoidable justification for Derrida's activities during the Algerian war: activities that are also covered in the more detailed CV provided in "Actes (La loi du genre)" of 1991?[16] Or, rather, does its memorializing impact serve to underscore, once again, the paradoxical, self-ironizing tenor of *La Contre-Allée*, the (autobiographical) creation of an author famously disillusioned by "nostalgeria"? Tiny pictures and CV entries follow. Are they biographical anecdotes, or relevant traces of a life? We see pictures of a ski resort; of a walk Derrida takes with his young son near Prague; of Derrida as an older professor at Yale. These juxtaposed pictures seem to affirm that there might be no hierarchy in time, place, or activity, and no such thing as superfluous or ridiculed "biographical anecdotes."

Let us consider the penultimate photograph of *La Contre-Allée*: a photograph of a young student. It shows us a youthful Derrida in Paris, wearing a wool scarf, his hands in his pockets, next to a street tree, that unavoidable concomitant of Parisian scenes (*CA* 288). The lacy frame of this old picture stands out as fragile, situating the photograph as an endangered species. It elicits nostalgia. But what saves us from the trap of nostalgia—and from further readerly, visual drifts—is another visual enigma, or pun, or challenge. When we turn to the last picture of *La Contre-Allée*, a more recent photograph (September 1998), we see Derrida with a cap that recalls Rembrandt's (Derrida's multiple portraits recall the more famous serial self-portraits of the Dutch artist), in South Street Port, New York (*CA* 292). There are many big boats but we

remember the first "Liberty" ship and feel that we are no longer going/drifting anywhere, except perhaps in Baudelaire's harbor, invoked in the prose poem "Le Port." The kind of visual "Invitation au Voyage" that *La Contre-Allée*'s final image proffers stops us in our tracks. That invitation is too obvious to be refused, but also to be trusted. And if fascination draws us into the picture for too long and the associations the picture communicates seem innumerable or engulfing, then we might remember that Régis Durand, in "How to see (photographically)," also suggests how photographs can stop us looking, and why:

> Photographic images, then, whatever their apparent subject, are images *in crisis*. Something in them is always trying to turn off, to vanish.[17]

Let us close our scrutiny of *La Contre-Allée*, then, on a note of suspense, or suspension. Derrida might have wanted to add to our traversal of and dialogue with his phototext the quality of silence: "You should speak of these photographs as of thinking, as a pensiveness without a voice, whose only voice remains suspended" (Vous devriez parler des ces photographies comme de la pensée, d'une pensivité sans voix, sans autre voix que suspendue).[18] But, as Denis Roche wonders as he muses over a collection of photos, how do you leave someone in the middle of a picture?[19]

Notes

All translations in this chapter are my own, except for the final one and those from Hervé Guibert's *L'Image fantôme*. The illustrations are reproduced by kind permission of Jacques Derrida.

1. Hervé Guibert, *L'Image fantôme* (Paris: Minuit, 1981), 71, 72; *Ghost Image*, trans. Robert Bononno (Copenhagen: Green Integer, 1998), 77, 78.
2. Jacques Derrida and Catherine Malabou, *Jacques Derrida: La Contre-Allée* (Paris: La Quinzaine Littéraire, Louis Vuitton, Collection "Voyager avec . . . ," 1999). Subsequent references to this work generally use the abbreviation *CA* and, unless otherwise stated, refer to the "Correspondance" section by Derrida.
3. Linda Haverty Rugg, *Picturing Ourselves: Photography and Autobiography* (Chicago: University of Chicago Press, 1977), 231.
4. Hervé Guibert, *L'Image de soi* (Bordeaux: William Blake and Co, 1988), n.p.
5. C. Malabou, "L'écartement des voies," *CA* 36. Malabou cites here Derrida, "Un ver à soie," *Contretemps* 2:3 (1997): 10–51. This text is reprinted in Hélène Cixous and Jacques Derrida, *Voiles* (Paris: Galilée, 1998): 23–85.
6. This is discussed by Georges Van Den Abbeele. See Emily Apter, *Continental Drift:*

From National Characters to Virtual Subjects (Chicago: University of Chicago Press, 1999), 200.

7. Jacques Derrida, "Entretien avec François Ewald," *Magazine littéraire* 286 (1991): 18.

8. Régis Durand, "How to see (photographically)," in *Fugitive Images: From Photography to Video*, ed. Patrice Petro (Bloomington: Indiana University Press, 1995), 150.

9. See Jean-Philippe Toussaint, *Autoportrait (à l'étranger)* (Paris: Minuit, 2000), on Derrida's play with our expectations, with his own and our portable stereotypes.

10. Pierre Nora, *Les Lieux de mémoire* (Paris: Gallimard, 1984–92).

11. Apter, *Continental Drift*, 2.

12. Marie-Françoise Plissart, *Droit de regards, suivi d'une lecture par Jacques Derrida* (Paris: Minuit, 1985).

13. See Laurent Milesi, "Between Barthes, Blanchot, and Mallarmé: Skia(Photo)-Graphies of Derrida," in *The French Connections of Jacques Derrida*, ed. Julian Wolfreys, John Brannigan and Ruth Robbins (Albany: State University of New York Press, 1999), 175–209.

14. Marianne Hirsch, *Family Frames: Photography, Narrative, and Postmemory* (Cambridge, Mass.: Harvard University Press, 1997), 215.

15. See Gilles Deleuze and Claire Parnet, "V comme Voyage," in *L'Abécédaire de Gilles Deleuze* (Paris: Éditions Montparnasse, 1996).

16. See Geoffrey Bennington and Jacques Derrida, *Jacques Derrida* (Paris: Seuil, 1991), 303.

17. Durand, "How to see (photographically)," 147.

18. Jacques Derrida, *Right of Inspection*, photographs by Marie-Françoise Plissart, trans. David Wills (New York: Monacelli Press, 1998), n.p.; Marie-Françoise Plissart, *Droit de regards, suivi d'une lecture par Jacques Derrida*, XXV.

19. Denis Roche, *Le Boîtier de mélancolie* (Paris: Hazan, 1999), 208.

In the Spiral of Time: Memory, Temporality, and Subjectivity in Chris Marker's *La Jetée*

TWELVE ▧

JON KEAR

That face that he had seen was to be the only peacetime image to survive the war. Had he really seen it? Or had he invented that tender moment to prop up the madness to come?

Ce visage qui devait être la seule image du temps de paix à traverser le temps de guerre, il se demanda longtemps s'il l'avait vraiment vu, ou s'il avait crée ce moment de douceur pour étayer le moment de folie qui allait venir?

Chris Marker, La Jetée

As a key figure in the origination of the Nouvelle Vague (New Wave) movement, Chris Marker's films have established him as one of the most uncompromising and original filmmakers of his generation. Over the course of his long career, his work has provided a distinctive model of ideologically engaged filmmaking that has developed the legacy of early experimental Soviet cinema, revising its conventions of montage in relation to new technologies such as video and multimedia. *La Jetée* is Marker's most famous film but in some ways an untypical one, as it is his only purely fictional work.[1] It is to the genre of documentary filmmaking that he has devoted most of his energies, although, since the 1970s, he has pioneered a form of docu-fiction. Films such as

Sunless (1982) and *Level Five* (1996), for instance, deconstruct the boundaries between actual and fictional events, interweaving historical and invented materials into a seamless whole, where, for the most part, it no longer makes sense to make a clear separation between reality and fiction, between past events and the memories and representations we make of them.[2]

From first to last, Marker's filmmaking has explored the themes of time, memory, and the passage of history, presenting eloquent filmic essays that have probed the political dilemmas of our age.[3] The examination of these themes has gone hand in hand with a self-reflexive investigation of the cinematic medium. Marker finds in film's capacity to interweave moments of past and present into a seamless whole a poignant metaphor for the nature of memory. Indeed, one might call Marker's cinema a machine for time travel, and in this respect *La Jetée*, in reflecting on the complexities attendant on the accessibility and perception we have of past events, is typical of his oeuvre.[4] What I wish to discuss in this chapter is the form in which Marker's film thematizes a cluster of questions about time, memory, and perception; how these issues are embedded in the narrative structure of his film; and the way in which Marker's inquiry into questions of temporality—questions that in turn lead on to others about power, freedom, and the limits of free will—becomes inextricable from an examination of the nature of the cinematic apparatus itself.

Since its first showing in 1964, *La Jetée* has held a privileged place in the discussion of the modern postwar cinema. On a formal level, its originality lies in the fact that it is composed of a series of photograms, edited together to give the suggestion of movement.[5] The film operates in the mode of a generalized "freeze-frame," reimagining cinematic movement by returning it to its origins.[6] The editing of these "photo-stills" (duplicated at a rate of twenty-four times per second) into a set of sequences juxtaposed using straight cuts, dissolves, fades, and even, at the beginning, a simulated panning shot, enables each individual still to become associated with others and thereby to establish a sense of duration and progression.[7] With the exception of one unique moment of actual motion, movement is not reproduced but represented, induced by a kind of gestalt, animated by the viewer's willingness to intuit it from the sequence of the photograms. The spectator is thus required to fill in the gaps in transition and defrost the freeze-frame effect, to add to these "stills" the illusion of motion. In this way it is the viewer who projects the film by imagining movement, something enhanced by the acceleration and deceleration of the cuts, dissolves, and fades. However, as we

shall see, it is not the supplanting of stillness by movement but the relationship between movement and the still image that matters in the film: a relationship that this discussion will return to at various intervals.

Marker's "photo-stills" are the raw material out of which an intricate dystopian narrative of time travel is woven: the story of a death—the same death—that happens twice, to the same man. In the postnuclear world of the aftermath of World War III, space has become off-limits.[8] From the depths of a subterranean prisoner of war camp, captives are subjected to a series of painful thought experiments, conducted with the aim of sending emissaries into time to summon the past and future to the aid of the present.[9] The protagonist is chosen for these experiments because of an obsessive attachment to an image from his childhood. The story narrated by the extradiegetic narrator revolves around this visual image, which is indelibly imprinted on the protagonist's memory, an image of the frozen sun, the setting at the end of a jetty at Orly airport where his parents had taken him as a child to watch the departing planes, and of a woman's face (fig. 12.1). It is to the moment in time that the image figures that *La Jetée*'s protagonist will be inexorably drawn, in a return that leads him back to the moment of his own death. Whether his final return to the world constitutes an act of free will, whether he is driven by a compulsion to repeat (a death wish), or whether this return is simply the final act of a plot orchestrated by the camp police, whose assassin trails him back in time, is left as a matter of some ambiguity. While the protagonist seems to acquire free will in the course of the story, ultimately choosing to make one final return to the past, the conclusion casts a question mark over the limits of his perception and actions.[10]

This story of a man marked by an image of his past is thus a film about memory and time, perception and misrecognition, about the recollection of a past that has become condensed into a single image: a half-remembered moment that, like a screen memory, veils the experience of trauma. It is the image of a woman's face on the jetty that becomes the lure that will eventually lead Marker's character to return again to that moment that will reenact his death. The protagonist's memory is the passageway through which the journey, whether actual or purely mental, is undertaken, and it is the rhythms of memory that organize the momentum of the film's image and sound track. *La Jetée* is composed around the operations of memory, its fractured time, elisions, blurring of tenses, and ellipses conveying the mutability of recollection, that Marker constantly returns to in his films.[11]

Temporality in *La Jetée* is thus made subject to the processes and "distortions" of thought. Marker's montage of photo-stills is integral to communicating this, in its editing of images in juxtapositions that not only break down the rational order of chronology but also unravel the conventional demarcations of time and establish instead "irrational" divisions and probabilistic connections that present an image of time as a heterogeneous duration.[12] The presentation of snapshots that refer back to the past but are equally detached from it compresses time, condensing it within the image. These photo-stills, arranged in alternately continuous and discontinuous sequences, thus constitute evocative fragments of the protagonist's reimagined past, forming a montage whose associational rhythms allude to the thought processes of memory itself. Indeed, the use of still images leaves us with the impression that we have watched edited highlights of a larger film. And, as I go on to argue, this is no accident.

The state of "pure" becoming in which time is wrapped also prevails on the representation of subjectivity offered in *La Jetée*.[13] In place of a unified subject is substituted a subject in process, the nature

of whose subjectivity is in question throughout. This alienation of the subject is demarcated most obviously at the temporal and spatial levels of the film's plot: a plot that presents a man who witnesses his own death from two perspectives in two moments in time, from the viewpoint of the man who will die on the jetty and from that of the child who uncomprehendingly watches the fate that always already lies in store for him. As a subject who exists simultaneously on different planes, Marker's hero resembles a character in a Borges tale: he is both dreamer and dreamed, both inside the story his reveries unfold and outside of them. Subjugated to the will of the experimenters, he exists in a state of pure affectivity: he suffers and is periodically relieved from suffering.

The identity of this unnamed protagonist, who has no history and no biography outside of the memory he is so obsessively attached to, and whose subjectivity is nothing other than the relay of the fractured image-memories he projects, is also, like time in *La Jetée*, continually subject to a kind of fragmentation and fading. In the course of the film, the boundaries that normally demarcate bodies in space become contingent; the representation of the body is consistent with the same logic of fragmentation that prevails in the sequence of montaged photo-stills. Marker's oblique juxtaposition of imagery, indebted to conventions of organic montage pioneered by Eisenstein and other Soviet *monteurs*, serves to elide the distinctions between mind and body, interiority and exteriority. Through discreet serial juxtapositions of images, linked mainly through sharp cuts or dissolves, a set of liminal connections are made that reflect back on the portrayal of the protagonist's existence. Our first shot of him is immediately followed by one of a broken statue: the same statue that is juxtaposed to the image of a previous experimentee who, we are informed, had been driven insane by the experiment. In a sequence presented shortly afterward, four stills appear of damaged statuary—archaic monuments whose faces have been worn away by time, mutilated relics that provide a poignant image of the ruins of time and memory. By way of contiguity and association, these statues are linked at once to the image of the woman from the protagonist's childhood, to his desire (via the mutilated statue of an embracing couple), and to his own identity, by way of a slow dissolve from the damaged visage of a statue to his own masked and distressed face. The abject condition of the subject, whose trauma is almost imperceptible, suggested only obliquely by the bandage on his right hand, is covertly revealed via the associational relationships this procession of images conveys.[14] The ultimate significance of this sequence, however, is already itself anticipated in

an earlier *amorce* where an abrupt cut is made between a still of a graveyard and an image of the jetty.

It is montage sequences such as these that point to the particular force of signification given over to the role of the photo-still in *La Jetée*, both in relaying the story and in opening up other implicit lines of association. This force of visual communication is such that it is never entirely contained by the narration: if image and sound track possess a certain degree of autonomy, while referring to each other, they are never entirely absorbed into a totalizing whole. The simplest example of this phenomenon occurs in a sequence in which the narrator describes the jetty as empty, while in the photo-still that "illustrates" these words, two shadows are clearly evident. And the issue here is not that of the reliability of the narrator but rests rather on Marker's mode of editing.

We must turn, in scrutinizing that practice, to the intervals in Marker's film and to two forms of interval in particular: first, the cessation of the narrator's voice, and, second, the periodic fading of the visual imagery into blankness. These are formal features that seem to carry much weight in *La Jetée*.[15] In the first respect, though the commentary of the narrator binds the images into a story, it also serves to place question marks over the truth, status, and meaning of events. The narrator's tone remains probing rather than authoritative. Moreover, for long periods, narration is absent and the procession of photo-stills continues in silence, occasionally accompanied by heightened sound effects (whispers, the sound of a heartbeat, a crescendo of birdsong). In the second respect, these intervals simultaneously connect and disconnect images and segments and are thus integral to the impression of the film's "indeterminate continuum," by turns conjoining and fracturing the flow of isotopic images.[16] What makes these blanks that arrest the narrative so notable is their length and frequency. While they are initially accompanied by the reflections of the narrator, gradually they acquire an independence as mediating signs between the actual and virtual worlds of *La Jetée*. In the duration of the film, these intervals create what Christian Metz, in another context, has termed "instants of non-vision": sequences that dissolve perception. As such, they may be considered on one level devices of "estrangement" that distract and distance the spectator.[17] These moments of "nonrepresentation" are also integral components of the relaying of the thematics of time, memory, and subjectivity in *La Jetée*: they become signifiers in their own right. In a film that presents so many signs of fracture, arrested movement, mutilation, and death, they produce yet another, one that comes through a series of dissolves to be associated with the

state of the damaged and fragmented postnuclear world of the story. Ultimately, as Réda Bensmaïa has suggested, such moments serve to stand for everything that cannot be represented: the affectivity of the subject, its fading, and its finitude.[18] Hence the film ends with a fade into blackness and silence, without succeeding credits.

It is through the recognition of this implicit play of forces in the film that we begin to approach the way that the symmetry of the plot is overwritten by the heterogeneity of the image track; the mutable nature of the images as a signifying system and more particularly the discreet ways in which the photo-stills transmit the theme of memory, embedding it in the semantic structure of *La Jetée*'s formal components.[19] Yet there is another memory that is embedded in the film's imagery and which extends its examination of temporality into an investigation of the cinematic medium itself. For the film presents us with an intricate subtextual inquiry into the nature of the cinematic signifier that anticipates theorizations of the ideological effects of the cinematic apparatus associated with Jean-Louis Baudry and Christian Metz.[20] (It is of no little relevance here that the Palais de Chaillot, whose mazelike tunnels are the subterranean setting where the thought experiments of *La Jetée* are enacted, is where Henri Langlois established the important Cinémathèque Française in 1935.)

Baudry and Metz have in recent years been critiqued for the essentialist and totalizing nature of their accounts of the cinematic subject, from critical perspectives that have rightly stressed that spectator positions are multiform, fissured, and discontinuous.[21] Particular features of their individual descriptions of the conditions of cinematic spectatorship, however, offer striking parallels with *La Jetée*'s portrayal of subjectivity and are relevant in several broader respects to a discussion of the operations of the film. The writings of Baudry and Metz naturally have their own distinctive features and reference points. They converge, however, on a certain characteristic state of fascination and illusory mastery that is induced by the specular image projected on the cinematic screen. Building on the notion of total cinema that André Bazin, a close associate of Marker, developed, Baudry and Metz both emphasize the importance of immobility and darkness to the positioning of the cinematic spectator. Equally, they stress the way in which the enunciatory mechanisms of the image (camera, optical projections, monocular perspective) have particular consequences, inducing the subject's identification with and projection of himself or herself into the representation. This phenomenon, their work suggests, proceeds through either primary or secondary identification—that is, either through an identification with the apparatus as pure disembod-

ied perception or through a morphological identification with what is filmically represented (an identification with one or more of a film's characters, for instance).[22]

Initially, in "The Ideological Effects of the Basic Cinematic Apparatus," Baudry argued that the apparatus not only created an illusion of reality but also stimulated subject-effects, evoking infantile narcissism in the way it established the illusion of the spectator as a transcendental subject, the unitary center and origin of meaning. The fact that film is mobile and involves successive frames, Baudry suggested, complements rather than disrupts this delusion. The spectator is blinded to the ideological operations of film, its frame-by-frame construction of what passes for reality, for the succession of frames is effaced by the illusion of continuous vision. The cuts from one image to another, the passage from segment to segment, are similar to the operations of the eye "no longer fettered by the body, by the laws of matter and time."[23] Given this homology between the apparatus and the activity of vision, edits, shifts in time and space, and framing devices are perceived as acts of synthesis and constitution. Those textual operations that might seem to rupture the spectator's self-identification as a transcendental subject thus paradoxically serve to confirm it.

In his later article, "The Apparatus," Baudry drew an analogy between the nature of cinematic projection and the scene of Plato's cave, regarding cinema as the realization of the perfect simulacrum.[24] However, it was less the film's mimeticism and the spectator's corresponding disavowal of the nature of the illusion that was his object than the way its conditions of viewing fostered an artificial state of regression: one that parallels a basic psychic structure of desire dependent on lack. The darkness of the auditorium, the immobility of the spectator, the womblike sealing off from ambient noises and quotidian pressures, elicit, he argued, a false consciousness of essential solitude, all contributing to a state of narcissistic self-absorption and the re-creation of "archaic moments of fusion": stimulating, that is to say, a regressive desire to return to an earlier state in which the boundaries of one's own body and the exterior world are ill defined.[25] In addition, Baudry argued that the strong visual and auditory stimuli of cinema lead to a form of "hyperperception," passivity, and disembodiment comparable to the experience of dreaming in which repressed desires find expression in hallucinated images. The fades, dissolves, and abrupt shifts in scenario mime the condensations and displacements through which the primary-process logic of dreams works over its fantasized objects.[26] In film, as in the dream, thoughts

find expression in images, and words are often transposed into thing presentations. In this way Baudry, drawing on Lacan, argued that the forms of identification that pervade the deluded cinematic subject's experience of viewing result in a state in which he or she misrecognizes the desire of the Other for his or her own.

In these respects, the situation of the protagonist of *La Jetée* closely resembles the particular delusional conditions of the cinematic subject described by Baudry and Metz. The film's subject is wired up for daydreaming and placed in a condition of sensory deprivation (the darkness imposed by the blindfold). Although in the presence of others, he experiences an essential solitude: he is projected into the relay of images that he imagines himself to be the center and origin of but yet experiences passively (as if the events of these reveries were happening to him). While the protagonist imagines that his desire is unitary and autonomous, he is ultimately in a situation in which it is impossible to distinguish between free will and coercion, or for that matter between the flow of fantasized images and that of actuality. The condition he finds himself in is one in which he is continually shifting across different registers of perception.

While the depiction of the protagonist allegorizes the condition of the cinematic subject as a state of reverie, fascination, and rapture, other components of the film serve to extend this meditation on the nature of filmic spectatorship in a more questioning and even contesting fashion, opening up alternative spaces of resistance to the spectator's rapt absorption in the image. The first set of these elements of *La Jetée* ironically revolves around the image that is the very lure for the protagonist: the woman from his childhood. First, a covert reference to the cinematic gaze occurs in the episode when the protagonist is trailing the woman through the shopping mall. At the moment when their eyes make contact, significantly via a mirror reflection, she places her hand in front of her face, looking at the reflective screen through outstretched fingers, in a gesture that unmistakably imitates Man Ray's mechanism of distanced spectatorship, whereby the lure of and identification with the image is supposedly mediated and dispelled (fig. 12.2).[27] Second, in the only passage of actual cinematic motion in the film, we are confronted with a gaze that looks back out at us as spectators (the only direct look to the camera in the film): a moment that breaks the stillness of *La Jetée* but also ruptures the fictional frame by acknowledging the presence of an anterior space, thus raising the viewer's self-consciousness of the mechanism of filmic illusionism.

One further factor seems pertinent here, which takes us back full circle to the question of the movement through the montage. Though

I spoke earlier of its simulation of motion, produced through diverse edits, any account of *La Jetée* that deals solely with movement leaves aside the equally important effect of stillness and interruption, the apparent resistance of the photographic still to movement or its sudden arrest, the evident fragmentation of the image-track. *La Jetée*'s use of the photo-still ensures that the effect of movement produced within it is never complete, and its inclusion of an actual instance of motion serves only to make this more plain. (Rather than this moment constituting a culminating point, it appears merely as a temporary aberration.) Just as the protagonist struggles painfully to have the world of his imagined past become realized, so that he might move within that world without pain and anxiety (his first movements in the world of the past are restricted), so the viewer will constantly be aware of the effort to bring the body of the film to life and of the impossibility of sustaining this illusion. Despite the affective quality of *La Jetée*'s images, perhaps precisely on account of it, the film's "perceptual transfer of reality" is too fragile, too spectral, for the spectator fully to sustain the kind of voyeuristic gaze Metz and Baudry describe.[28] Like the protagonist whose wanderings within the projected world of his imagination are

FIGURE 12.2.
Photo-still from *La Jetée*, Zone Books, 1992

constantly interrupted, who is constantly withheld from, as well as projected into, that world, we too experience the fracturing of time and space, and we too are constantly drawn back from this embryonic secondary realm by the absence of the reproduction of movement. At any moment the film threatens to freeze over and become associated with the many signs of death it puts in play.[29] The use of photo-stills in the film thus has a significant role to play in the way it presents two types of cinematic subject: a subject who is inextricably enmeshed in the illusionary mechanisms of cinema (a position associated with that of *La Jetée*'s protagonist); and a subject whose position, mediated by the form of the montage, remains delicately poised between being drawn into the fictive world of the ensuing narrative and being conscious at every stage of the framing operations of the film. It is in this way that Marker's film thematizes the power of the illusionism of the cinematic apparatus while simultaneously countering that illusionism through its mode of representation.

That the position of the protagonist corresponds to that of the cinematic subject is no coincidence, for if on one level, that of the diegesis, this is the story of the memory of a moment from the past lived twice, on a metafilmic level it is the memory of another film, replayed in another genre. In short, *La Jetée* offers an astute commentary on a movie that has long obsessed Marker. During one of their many aimless strolls through the Jardin des Plantes, the lovers pause by a cross section of a sequoia tree whose concentric lines are covered by historical dates marking out the passage of history. At this moment the narrator states: "She pronounces an English name he doesn't understand" (Elle prononce un nom étranger qu'il ne comprend pas). This is followed by a shot of the protagonist gesturing to a point that lies outside of the time scale demarcated by the tree: "As in a dream he shows her a point beyond the tree and hears himself say, 'This is where I come from . . .'" (Comme en rêve, il lui montre un point hors de l'arbre. Il s'entend dire: "Je viens de là . . .") (fig. 12.3). The deixical gesture in this sequence will recur many times in the film and indeed will reappear time and time again in later Marker films. Most immediately, it is a gesture that unites the two lovers in front of the sequoia tree, as the woman imitates the protagonist's action. Its meanings here are, however, manifold. In respect of the film's temporal-spatial poetics, this deixis connects up to the acute single point perspective of the initial shot of the jetty at Orly, where *La Jetée*'s hero will eventually be projected back in time and space. In terms of the montage, it is a gesture that enacts a transition, via a sharp cut, between the spaces of the camp and the past. On a more general thematic level, however, it points to a

desire for transcendence and is thus associated with the various images of actual or suspended flight (photo-stills of planes and birds) that recur throughout the film. Beyond this, though, the gesture intertextually refers to a scene in Hitchcock's masterpiece *Vertigo*, filmed four years earlier, in 1958, where the ostensibly possessed Madelene halts in front of a similar cross section of a tree and points to two moments in time: the moment of her birth and that of her death.[30]

This is not the only instance of intertextuality in the film. The arched arm of the dying protagonist as he falls to the ground refers to the emblematic photograph of the death of a Spanish Republican during the Spanish Civil War created by Robert Capa, itself purportedly a staged death. More discreetly, the culminating image of the one actual moment of movement, where the woman looks back at the spectator, refers to a similarly emblematic image: the gaze of Venus in Titian's *Venus of Urbino*, who, in returning the spectator's gaze, implicitly thematizes the interface between the fictive space of representation and the actual space of spectating. One should not underestimate the significance of these reference points, which poignantly condenses a cluster of residual ideological meanings: Marker's cinema has been

FIGURE 12.3.
Photo-still from *La Jetée*, Zone Books, 1992

nothing if not an archive of such resonant imagery.[31] It is, however, the relationship to *Vertigo* that is most important here.[32] Gradually through a web of traces, replays, and faint echoes, references to *Vertigo* build up in *La Jetée*, creating poignant parallels that establish a structure analogous to Hitchcock's film. In the final meeting in the museum, for instance, the protagonist becomes spellbound by the trailing coils of the woman's hair that drape across the nape of her neck (fig. 12.4). This closely echoes a similar scene in a museum in *Vertigo*, where the detective, Scottie, likewise becomes fascinated by the coiffure of Madelene with its spiral knot at the back of her head, noticing an exact match with a portrait of the late Carlotta Valdes. Later, in the aforementioned scene in the park, the spiral pattern of Madelene's hairstyle is identified visually with the circles that demarcate the trajectory of history in the cross-section of the tree, becoming in this way a metaphor for the passage of time itself.

As Marker has commented, while *Vertigo* is on a literal level an obsessive love story, it may be read allegorically as an astutely skeptical meditation on the way the perception of the past is perpetually subject to misprision.[33] The detective Scottie is hired to follow the trail of

FIGURE 12.4
Photo-still from *La Jetée*, Zone Books, 1992

Madelene, the wife of an old friend, who believes she is possessed by the spirit of Carlotta Valdes, a woman who committed suicide after a doomed love affair many years before Madelene's birth. As the plot gradually unfolds, Scottie's ability to unravel the tangled web of illusions and events becomes more and more tenuous. Appearances are not what they seem. Eventually, by a strange twist of fate, he will find himself unwittingly complicit in Madelene's death, on two occasions. Hitchcock's "all-seeing" detective is, in reality, blind to the actual course of ensuing events and unaware that he has become enmeshed in a complex web of deceit, masquerade, and murder. Deluded into believing himself responsible for Madelene's death, he attempts to re-create the memory of her in the present by refashioning in exact detail the appearance of his new lover to match that of his past. Only later will he realize this simulacrum is actually the same woman he had fallen for in the first place. At the point when he believes that he has finally mastered the situation, he will ironically find himself helpless to prevent a "repetition" of her death. At each stage in the narrative, therefore, Scottie will unknowingly be the catalyst through which events, which are ultimately beyond his control, unfold.

Like *Vertigo*, Marker's film is permeated by imagery of perception and blindness. Blindfolds, dark glasses, and optical instruments of various kinds figure heavily throughout. In the underworld where the masked protagonist is subject to mind experiments, sight itself is damaged, hence the strange stereoscopic spectacles that so many of the inhabitants of the tunnels wear. The two other places in time the protagonist visits develop this theme further. The interior world of the past, a world exclusively illuminated by daylight, at first presented as blinding and blurred (many of the photographic images are overexposed or ill defined), is a world that the protagonist travels to only via mechanisms of sense deprivation (he is blindfolded and his mind stimulated by electrodes). And in the Neoplatonic world of the future (a rebuilt labyrinthine Paris composed of ten thousand incomprehensible avenues), the protagonist has to protect his vision by wearing dark glasses. These glasses seem as much a metaphor for the inability to envision the future as a protection against it. The same dark glasses will be worn by the protagonist on his final return to the world of his past and death. As in the case of Hitchcock's detective, the protagonist of *La Jetée* will also be blind to the course of unfolding events, inexorably lured back to the scene where his death always already awaits him. Gradually, a trap builds itself around him, and later we recognize that in that final meeting with the woman in the museum, a site that is itself a poignant metaphor for time travel, they

too are like the petrified natural specimens in the display cases—a point the camera implies by the way in which the progression of the sequences of images frames the lovers as though they were trapped in the glass cages they gaze at.

La Jetée is therefore like an ill-remembered memory of Hitchcock's film, which subjects the latter's plot to a series of displacements and condensations. The photo-stills that constitute its formal idiom present redolent images that refer back to salient moments of its source in a structure of repetition with difference. In narrative terms, *Vertigo* constitutes what Gérard Genette has called a "hypotext": an anterior text that is modified, transformed, and reelaborated by a later one (here, *La Jetée*).[34] In reworking Hitchcock's film, Marker brings to the surface a deeper underlying problem of perspective within his source: the limits attendant on our perception of past and present events. It is to this subtext of *Vertigo* that Marker will return twenty years later, in *Sunless*, where, in a vignette, he stages a reconstruction of the plot of Hitchcock's complex film. This passage is dominated by the motif of the spiral, "the spiral of time," which in the original film source is evident in the opening titles and recurs as a leitmotiv at various intervals. In this sequence, Marker makes explicit the links between *La Jetée* and *Vertigo*, re-presenting the plot of Hitchcock's original crucially translated into the idiom of photo-stills of *La Jetée*. This reenactment of the narrative of *Vertigo* takes the form of a return to the locations where Hitchcock had shot his film: a return that serves to elaborate the passing of time (many of the sites have been destroyed or transformed) and at the same time to present an allegorical reading of *Vertigo*, through which Marker characterizes Scottie as "time's fool of love."

> In the spiral of the titles he saw time covering a field ever wider as it moved away, a cyclone whose present moment contains motionless; the eye. In San Francisco he made his pilgrimage to all the film's locations. The florist . . . where James Stewart spies on Kim Novak, he the hunter, she the prey, or was it the other way round? . . . He had driven up and down the hills in San Francisco where Jimmy Stewart's Scottie follows Kim Novak's Madelene. It seems to be a question of trailing, of enigma, of murder, but in truth it's a question of power and freedom, of melancholy and dazzlement, so carefully coded in the spiral that you could miss it, and not discover immediately that this vertigo in space in reality stands for the vertigo in time.[35]

The thematics of temporality that structure *La Jetée* thus expresses itself as a melancholy reflection on perception and power, the desire for omniscience, and the limits of perspective. It is history as a site of loss and ruin that prevails in the film. As in *Vertigo*, this wistful representation of time will center on the emblematic image of a woman's face: a face presented as a riddle that contains within it all that is sorrowful, enigmatic, and imperceptible about the past. The history encoded in Marker's own spiral of time is one that speaks ultimately to the complexities of deciphering the image as a fragment of time detached from its past but which remains imbued with the residual traces of that lost past.

Notes

1. Chris Marker, *La Jetée* (London: Zone Books, 1996), n.p.
2. For a fuller discussion of this aspect of Marker's work, see, e.g., Jon Kear, *Sunless* (Wiltshire: Flicks Books, 1998), 30–42.
3. On Marker's involvement with militant filmmaking, see Jean-Paul Farguier, "Pour le dépérissement du cinéma militant," *Cahiers du Cinéma* 284 (1978): 47–51.
4. Paul Coates, "Chris Marker and the Cinema as Time Machine," *Science Fiction Studies* 14 (1987): 307–8. See also Raymond Bellour, "Le Livre, aller; retour," in *Qu'est-ce qu'une Madeleine?* ed. Yves Gevaert (Paris: Centre Pompidou, 1997), 65–103.
5. Réda Bensmaïa, "From Photogram to Pictogram: On Chris Marker's *La Jetée*," *Camera Obscura* 24 (1990): 139.
6. See Bensmaïa, "From Photogram to Pictogram." On the use of photo-stills in films, see Raymond Bellour, "The Film Stilled," *Camera Obscura* 24 (1990): 99–123.
7. Roger Odin, "Le film de fiction menacé par la photographie et sauvé par la bande-son (à propos de *La Jetée* de Chris Marker)," in *Cinémas de la modernité, films, théories*, ed. Dominique Château, André Gardiès, and François Jost (Paris: Cerisy, 1981), 141, 149.
8. For a discussion of the way the film engages with conventions of the time travel genre, see Coates, "Chris Marker and the Cinema as Time Machine," 307–15.
9. As Jean-Louis Schefer has argued, there are allusions here to the medical experiments conducted in the German death camps during World War II (at certain intervals the camp police whisper among themselves in German). But one should also remember that the scenes of torture had an added significance at the time, given the revelations about the employment of Gestapo-style torture against Algerians and left-wing sympathizers during the Algerian war. Jean-Louis Schefer, *The Enigmatic Body*, ed. and trans. Paul Smith (Cambridge: Cambridge University press, 1996), 141–44. See also Patrick Markham, *The Death of Jean Moulin* (London: John Murray, 2000), 17–18.
10. For a psychoanalytic account of *La Jetée* as an enactment of a compulsion to repeat, see Constance Penley, *The Future of an Illusion: Film, Feminism and Psychoanalysis* (Minneapolis: University of Minnesota Press, 1989), 136–39.
11. See Kear, *Sunless*, 20–45.
12. The key reference point in Marker's exploration of time in his films is of course

Bergson's notion of duration. See Henri Bergson, *Matière et mémoire; essai sur la relation du corps avec l'esprit*, in *Oeuvres* (Paris: Presses Universitaires de France, 1959); and *Essai sur les données immédiates de la conscience*, also in *Oeuvres*. See also Francis Moore, *Bergson: Thinking Backwards* (Cambridge: Cambridge University Press, 1996); John Mullarkey, ed., *The New Bergson* (Manchester: Manchester University Press, 1999). On the application of Bergson's thought to cinema, see Gilles Deleuze, *Cinema 1: the Movement Image*, trans. Hugh Tomlinson and Barbara Habberjam (London: Athlone, 1989), and *Cinema 2: The Time Image*, trans. Hugh Tomlinson and Robert Galeta (London: Athlone, 1989). See also Gilles Deleuze, "Bergson's Conception of Difference," in Mullarkey, *The New Bergson*, 42–66.

13. Here again Bergson's thought, particularly his discussion of personality, seems a useful starting point in thinking about the conception of subjectivity in *La Jetée*. See Bergson, *Matière et mémoire* and *La Pensée et le mouvant,* in *Oeuvres*.

14. On the relationship between trauma and memory, see Nicola King, *Memory, Narrative and Identity: Remembering the Self* (Edinburgh: Edinburgh University Press, 2000), 1–32.

15. Marker's use of intervals clearly emerges out of the ideas of Soviet *monteurs* such as Eisenstein and Vertov. See, e.g, Eisenstein's comments in Sergei Eisenstein, "Film Form," in *Essays in Film Theory*, ed. Jay Leyda (New York: Harcourt, Brace and World, 1949), 32, 47, 62; and those of Dziga Vertov, in Annette Michelson, ed., *Kino Eye: The Writings of Dziga Vertov* (Berkeley: University of California Press, 1984), 7–9. See also Annette Michelson, "The Wings of Hypothesis: On Montage and the Theory of the Interval," in *Montage and Modern Life*, ed. Michael Teitelbaum (Cambridge, Mass.: MIT Press, 1992), 60–81.

16. See Odin, "Le film de fiction menacé par la photographie," 150–51.

17. On the use of notions of estrangement in avant-garde cinema, see Jean-Louis Baudry, "Ecriture/Fiction/Idéologie," in *Tel Quel* 31 (1967), reprinted in *Afterimage* 5 (1974): 22–39. See also Peter Wollen, *Signs and Meanings in the Cinema* (Bloomington: Indiana University Press, 1969); Peter Wollen, *Readings and Writings: Semiotic Counter Strategies* (London: Verso, 1982).

18. Bensmaïa, "From Photogram to Pictogram," 142–57.

19. Ibid., 143.

20. See Jean-Louis Baudry, "The Ideological Effects of the Basic Cinematic Apparatus," *Film Quarterly* 27:2 (1974–75): 39–47; Jean-Louis Baudry, "The Apparatus: Metapsychological Approaches to the Impression of Reality in the Cinema," *Camera Obscura* 1 (1976): 104–26; Christian Metz, *Essais sur la signification au Cinéma*, 2 vols. (Paris: Klinkssieck, 1971–72); Christian Metz, *Language and Cinema*, trans. Donna Jean (The Hague: Mouton, 1974); Christian Metz, "The Imaginary Signifier," *Screen* 16:2 (1975): 14–76.

21. For critiques of Baudry and Metz, see, e.g., Penley, *The Future of an Illusion,* 57–82; Joan Copjec, "The Orthopsychic Subject: Film Theory and the Reception of Lacan," *October* 49 (1989): 53–71; Stephen Heath and Teresa de Lauretis, eds., *The Cinematic Apparatus: Problems in Current Theory* (London: Macmillan, 1980).

22. Baudry, "The Ideological Effects of the Basic Cinematic Apparatus," 39–47. Baudry was returning to Bazin's notion of "the myth of total cinema," presenting a more negative and psychoanalytic account of it. See André Bazin, *What is Cinema?* ed. and trans. Hugh Gray (Berkeley: University of California Press, 1967), 20.

23. Baudry, "The Ideological Effects of the Basic Cinematic Apparatus," 43.

24. Baudry, "The Apparatus," 104–26.

25. bid., 122.

26. On the analogies and disanalogies between dreaming and the experience of cinematic spectatorship, see Christian Metz, *The Imaginary Signifier, Psychoanalysis and Cinema*, trans. Ben Brewster, Celia Britton, Alfred Guzzetti, and Annwyl Williams (Bloomington: Indiana University Press, 1982), 99–142. For other earlier accounts that explore the relationship between film and dream, see Hans Mauerhofer, *The Psychology of Cinematic Experience* (New York: Scribner, 1949); Suzanne Langer, *Feeling and Form* (New York: Scribner, 1953).

27. See Robert Stam, *Film Theory* (London: Blackwell, 2000), 57; Paul Hammond, ed., *The Shadow and Its Shadow: Surrealist Writings on Cinema* (London: British Film Institute, 1978).

28. See Odin, "Le film de fiction menacé par la photographie," 149–50; Bensmaïa, "From Photogram to Pictogram," 140–43.

29. See Bellour, "The Film Stilled."

30. For a useful discussion of alternative ways of thinking about intertexts, see Michael Worton and Judith Still, eds., *Intertextuality* (Manchester: Manchester University Press, 1990), 1–44.

31. On the significance Marker attributes to Titian's *Venus of Urbino* as a work that thematizes representation, see Chris Marker, *Immemory* (Paris: Centre Pompidou, 1997).

32. For earlier comparisons of Marker's work with Hitchcock's *Vertigo*, see Ronco Yaobling Liem, "Chris Marker and *La Jetée*" (Ph.D. dissertation, Columbia University, 1983), 104–5. This dissertation usefully situates *La Jetée* in the context of modern postwar cinema and its theorizations.

33. Chris Marker, "A Free Replay (notes on *Vertigo*)," *Positif* 400 (1994): 83. There is of course a play here on the name "Madelene" in Hitchcock's *Vertigo* and the involuntary reveries evoked by "une Madeleine" in Proust's *A la recherche du temps perdu*.

34. Gerard Genette, *Palimpsestes* (Paris: Seuil, 1982), 7–14, 448–51.

35. Chris Marker, *Sunless* (1982).

PHOTOTEXTUAL CONSTRUCTIONS

Talking through the "Fotygraft Album"

■■■■■■■■■■■■ ❧ THIRTEEN

ELIZABETH SIEGEL

In a humorous send-up of the family album, written in 1915, Rebecca Sparks Peters, age eleven, walks a new neighbor through her family's "Fotygraft Album." The unsuspecting Mrs. Miggs has paid a visit while Rebecca's mother is out, and the girl entertains her as she has seen adults do. "Let's see," she says. "S'pose we set on th' sofa and I'll show yuh th' album, so's yuh'll kinda begin t' know some of our folks." A typical exposition of her "folks" goes like this, as they look at a cabinet card portrait of two boys (fig. 13.1): "Them's Willie and Freddie Sparks. They was cute little fellers but it's awful t' think th' way they turned out, pa says. Willie's an editor and Freddie's a lawyer, and they work together jist fine. Willie gets into trouble, and Freddie, he gits him out."[1] Here we have a scene familiar to all owners of family albums and to all obliging visitors that stages the talking through of the stories that accompany family pictures. However, Rebecca ends up spilling all the family secrets that she has obviously overheard from her parents and relatives but that are supposed to be kept from outsiders. Hers is the very private version of the more public family history that the album displays, and it surely scandalized Mrs. Miggs.

Parodies are often illuminating, and Rebecca's prattling reveals much about the function and structure of the narratives that knit together early photographs and created meaning for viewers of albums.

FIGURE 13.1.

Freddie and Willie Sparks, from Frank Wing, *"The Fotygraft Album"*:
Shown to the New Neighbor by Rebecca Sparks Peters Aged Eleven

The young heroine of *"The Fotygraft Album"* is play-acting what she has seen her parents do, and her mishap highlights the dual function of the family album: first, to construct a visual and historical past for ourselves, a narrative of identity cemented by its retelling; second, to entertain others and explain to them who we are. The structure of this chronicle is one of show-and-tell. It points to sitters and explains something about their past, as well as how they relate to (and perhaps illuminate) the teller. Each page in this book ends with Rebecca telling her new neighbor, "Turn Over!"—turn the page, continue the story. The act of exposition invokes two parallel narratives, which the girl comically confuses: one public, largely photographic, displayed as evidence for all to see; and the other more intimate and reserved for family, a narrative of an oral or textual nature that fills in photographic gaps with stories.

What is perhaps most striking about this scene from *"The Fotygraft Album"* is that the album being caricatured is not the familiar snapshot album of birthday parties and family outings but rather a cabinet card album from the 1880s, one of the earliest family albums. The cabinet card album and the *carte-de-visite* album before it (a product of the 1860s) have largely been neglected in the literature on family photography. They have been dismissed because the pictures within are professional productions, posed in the studio instead of captured by an intimate, and are relatively removed from the sphere of the domestic and the everyday.[2] Yet by overlooking the first family albums, scholars have missed a key transitional moment in the way our memories and stories have been formed. It was in the pages of these albums that families first collected images of relatives, friends, and public figures and first created the kinds of narratives that would cement them into a cohesive history. The earliest photograph albums made a transition from a text-based genealogy of family trees and Bible entries into a photographic record that would draw on entirely new kinds of information to construct its histories. The performative conventions of family albums were established before the advent of the Kodak, in Victorian parlors and sitting rooms, for family edification and visitors' amusement. If we are to understand—and perhaps, as many have been doing recently, to resist—the ideologies scripted by family narratives and encoded in photograph albums, then we need to examine the origins, structures, and functions of the family stories made visible for the first time in these early portrait albums. How did the accumulation of anecdotes and identifications elicited by the photograph album add up to a larger family narrative? How did these first photographic narratives draw on or break from earlier, textual histories, and how did a visual

genealogy shape the way a family told its stories? This chapter explores processes of telling and retelling in America's first photograph albums, addressing the "talking through" of pictures within families and from family to outsiders. The practices of viewing and narrating photograph albums fundamentally altered the way our family histories were told in two critical ways: by making a familial past visible in the first place and by linking our private narratives with public ones.

The photograph album, as we know it, began with the *carte-de-visite*. From about 1860 up to almost the end of the nineteenth century, this small, initially full-length photograph on cardboard was the overwhelming choice for portraiture. Sold by the dozen, the card picture surpassed the daguerreotype and ambrotype by virtue of its massive reproducibility and overtook the silhouette and painted miniature because of its faithfulness to reality and comparative cheapness. For the first time in history, a visual genealogy became accessible to nearly all classes; it was no longer the domain of commissioned oil portraits in ancestral homes. With the *carte-de-visite*, images of national notables as well as family members were readily available, affordable, and abundant. They were exchanged in huge quantities, quickly overflowing card baskets and requiring a suitable means for collection and display. As early as 1861, American photography journals and popular magazines urged their readers to participate in the new and worthwhile trend of assembling their multiplying images in albums produced especially for that purpose. In the United States, the timing of the first family albums was particularly poignant, with death and distance effected by the Civil War and westward migration dividing families on an unprecedented scale. Thus it fell to albums, new repositories of family history and memory, diligently to record the existence and appearance of family members in the face of their dispersal.

The emergence of photograph albums marked a radical shift from earlier American methods of family record keeping. Extensive genealogies had previously been exclusive to the upper classes, possessed of distinguished ancestry and properties. But as the young nation matured there was a growing interest in genealogy, on the familial and national levels. Even relatively humble families might record births, deaths, and marriages in the pages of the family Bible, creating their own chronicle of Abraham begat Isaac. These inscriptions could serve as legally valid documents. The practice became formalized in the midnineteenth century, when Bible manufacturers inserted preprinted pages for that purpose. More elaborate "Family Registers," also on the market at the midcentury moment, provided space for additional infor-

mation, such as physical and health-related characteristics, education, occupation, and religious milestones. Whereas Bible records gave only the barest of pertinent facts, family registers might furnish more information about the life and history of an ancestor or family member than would even a photograph. The accompanying oral narrative would still have to fill in the personal stories behind the readable facts, but the record of names was more a static document than the performative object the photograph album would become.

When photographs began to be included in these compilations, an entirely different kind of record ensued. A look at American family Bibles of the 1860s and later (fig. 13.2) illustrates this critical transition point. Enterprising publishers began inserting cardboard pages with slots for *cartes-de-visite* along with the written family record, and the list of family names was transformed into a series of family portraits. And it is here that this particularly modern shift from an oral or textual tradition to a visible one is most apparent: the family record had now become a history of appearances and physiognomies, feeding a positivistic desire to see and verify—and thus to *know*—the person pictured there.

The most striking emblem of this transitional moment is an 1864

FIGURE 13.2.
Pages from Bible published by William W. Harding, Philadelphia, 1868

genealogical album, which combines photographic documentation with a near-obsessive practice of textual record (fig. 13.3). Published with a lengthy introduction by a Dr. A. H. Platt, this album came with slots for *cartes-de-visite* and ample room for physical and personal data.[3] In the midst of the Civil War, Dr. Platt worried that the widows and orphans of those who gave their lives in battle would be unable to prove their relationship to the deceased and would lose the lands and pensions due to them from the government: a comprehensive family record would provide proof of one's heritage and claims. The album's full title, as written on the opening page, reveals the scope of Platt's project:

The Photograph Family Record,
OF
HUSBAND, WIFE, AND CHILDREN;
ADAPTED TO
RECORDING IN A PLAIN, BRIEF AND INTELLIGENT MANNER,
The Name, Birth-place, Date of Nativity, Descent, Names of Parents,
Number of Brothers and Sisters, Education, Occupation, Politics,
Religion, Marriage, Stature, Weight, Habit, Complexion, Color of Eyes
and Hair, Health, Time and Place of Death, Disease, Age and Place of
Interment of Each Member of Any Family,
With Album Leaves for the Insertion of Photographs of the Same.

The album has separate pages for the father, mother, and up to eleven children. On the right side of each page spread is room for two *cartes*, presumably intended to record loved ones' appearances at different stages in life. On the left is the designation of the family member, space

FIGURE 13.3.
"Second Child," page from A. H. Platt, *The Photograph Family Record*, 1865

for his or her authenticating autograph, and lines for the various characteristics to be filled in. Platt viewed this photograph album as part family history, part legal document. It had to function as a certificate of authenticity, with the text and images corroborating one another.

This album invokes loss and absence, even as it presents itself as their antidote, in its sentimental calling to mind of the memories of deceased family members. The photographs placed carefully in the slotted pages would recall the features of dear ones, returning them to life for the viewer. At the end of the book, blank pages are supplied for recording memories, and Dr. Platt suggested that such pages could serve two ends. They could abet the memory of a mother who had lost a child in infancy and wanted to record the events of the baby's brief life, or they might hold a record of military service, thus linking a family history (and, in many cases, a family death) with a national event.

Perhaps the most important function of this kind of album was its ability to reconstruct families' genealogies, to serve at once as a monument to the past and a legacy for the future. Platt sensed a deficiency throughout the families of America as heritages and histories stood to perish entirely. With his book, he intended to provide the many families who wanted records of their past with a useful recording system. What individual would not rejoice, he argued, at obtaining an accurate genealogical history of his father's family and of his father before him? The problem was that up to now (read: before the publication of Platt's album) there had never been a proper *vehicle* for its recording. There is little of the traditional Old World genealogy here: what Platt was interested in—and what he believed everyday Americans were interested in as well—was a limited record of a few generations back (more, if possible) that supplied some details about what these people were like. "The Photograph Family Record" represents a break with previous notions of lineage and descent, allowing even the most humble of households to obtain and maintain a visual past.

Platt envisioned the collection and narration of this material as a national project—an infinite number of private genealogies adding up to a nation's history, a permanent record of a country's past. Records of other branches of the family could be obtained by sending additional copies of the album to relatives all over the world, to be filled up and returned. Furthermore, not only the head of each family, but each child therein, could have his own chronicle of the whole family, which could be handed down and retold to future generations. In its circulation and repetition through children and extended family, the album expanded its scope beyond the cell of the household. Each individual family, by filling up the record and telling its stories, acted as a link in this chain.

In this kind of genealogy, physical peculiarities take center stage. At a moment when outward appearance was linked so closely with inner character, it was important to learn not only the deeds and social standing of one's ancestors (a textual or oral history) but also the way they *looked*. The photograph was uniquely capable of providing this information and was the most appropriate vehicle to furnish a large number of homes with the kind of genealogy all families, not just the most prestigious, could possess. The *carte-de-visite*, in particular, was well suited for this purpose as it was comparatively inexpensive, massively reproducible, and was easily inserted in books alongside text. There seemed to be a strong sense, even this early, that our personal memories would from this point on be constructed through photographs and, furthermore, that our individual, private histories would intersect more with national, public ones, which were also beginning to take shape in photographs. The form of the genealogical album marks a new kind of record keeping and a new kind of knowledge, one in which the images and text justify each other and one which would influence the shape of family histories in years to come.

But it was the typical *carte-de-visite* album, without the genealogical text, that sparked a full-fledged craze in the 1860s (fig. 13.4). It became the dominant form of picturing the family, eventually giving rise to cabinet card and snapshot albums. The ritual leafing-through of the photograph album provided the occasion for the reenactment of old stories. As images replaced text and visible facts took the place of historical facts, the narrative of a family's past also altered. The descriptive photographs in the first family albums more easily provoked recollections, but at the same time more oral information was required to fill in the gaps caused by a lack of text. If, previously, the reader or listener could learn the dates of major life events or even pertinent physical and personal characteristics, now the viewer could see a shared visible heredity, along with discernible proof of character. Unlike their counterparts of the post-Kodak era, nineteenth-century albums contained individual studio portraits instead of personal snapshots of group *events*, and although for the first time middle-class sitters could pose for the camera more than once in a lifetime, sitting for a picture was still an unusual and important affair. Thus the portrait had to represent not a moment of a person's life but the *person herself*. Looking at a *carte-de-visite*, for example, one could accurately remark: "*That is* Aunt Edith, a very good likeness," but not "That is Aunt Edith at Cousin John's wedding—remember how she danced?" The narrative contained in or suggested by a

nineteenth-century family photograph album had to fill in substantial blanks about the lives and personalities of the people pictured there, weaving portraits of individuals into a story of a group.

Moreover, the very apparatus that made photographs so accessible to the masses in the first place—the repeated props, mass-produced backgrounds, and formulaic poses—conventionalized the small pictures, leveling status and individuality in a way remarked on even at the time. Albums were also very much products of a commercialized industry, factory-made in massive warehouses, with standardized slots to hold standard-sized pictures. Reflecting America's increasing industrialization, these repositories of family pictures would come to appear very much the same. Viewers of albums needed to individualize the otherwise unexceptional pictures and distinguish album collections from the many others that graced parlor tables in homes across the nation. They basically had to transform a rather commercial production into a personal family history. The narrative would become the means of this personalization: the event in which the unique was acted out. Each family's story was different, even though the receptacle was the same and the telling was structured by an ordered sequence of pictures.

FIGURE 13.4.
Carte-de-visite album, ca. 1870s

Once assembled together in an album, photographs seemed to take the form of a narrative by the sheer fact of their being sequential. A viewer might "read" the pictures one after another, turning the pages like a book, linking the pictures into a cohesive story (recall Rebecca's command, "Turn Over!"). This "reading" took the form of a demonstrative pointing and telling, marking the person pictured in a way that simply listing names could not. The sitter's very visibility suggested a kind of proof and presence, rendering his existence and appearance a fact. As Roland Barthes has put it: "The photograph is never anything but an antiphon of 'Look,' 'See,' 'Here it is.'"[4] A story called "The Awful Photographic Album," found in a nineteenth-century book of American humor, shows the typical form this kind of narrating of the first photo albums might take. A man paging through a family album proudly declares:

> I am a man accustomed to family photograph albums. . . . I have sat up with them from Halifax to Denver, and I know them by name and sight. Pa and ma and that's grandpa and that's grandma, and here's Uncle George, and this is an aunt of pa's, she's very wealthy and has no children and pa is her favourite nephew; and this is a young lady I went to school with, and this is his [sic] brother Henry, and this is cousin Sue, and this is Aunt Hattie's baby and this is a young man Henry went to school with . . . oh, my son, you can't strand me on photograph albums. I know just where the family ends and the strangers file in.[5]

He continues on and on in this vein, getting everybody "right" except for himself, comically not recognizing his own picture. Even in parody, the declarative mode of the photograph album is tied up in its performance with other viewers, a public identifying of who's who on the page.

The photograph album enabled a new kind of self-presentation to others, and a new excuse for that display. Sitters presented a public face to the camera, posing in an endless series of respectable interiors. And albums occupied a relatively public place in the home, on the center table of the parlor, where visitors would be received. Etiquette manuals and home decorating guides classed albums with games, stereoscopes, new music, and other objects of amusement for entertaining guests in those awkward intervals after dinner or simply during usual visits.[6] Photography journals and women's magazines extolled the value of the photograph album as a form of entertainment to visitors,

in no small part because it relieved the guest from having to make witty conversation or supply original verses in a ladies' album. One article suggested that everyone could find at least something to remark about a collection of photographs and the sitters pictured therein, whether complimentary or quietly malicious.[7] Another stated, "Their great beauty is that they provoke conversation." Invoking the problem of a tardy cook and waiting diners, it went on, "A photographic album is the most amusing anteprandial friend that a lady could have in her establishment."[8] The photograph album actually *supplied* text, or conversation, where there was a danger of embarrassing silence. Entertaining gossip or edifying genealogy, public chatter or private family history, talk flowed from its pages to fill the void.

Of course, there was always the danger that the private and public tales would mix, as when Rebecca Sparks Peters spills the family secrets. This danger was often allied to class differences, as is evident in a cartoon in which a servant has lost herself in "her" (in reality, her employer's) family album, leafing through the private pictures for her own amusement and blurring the boundaries of family (fig. 13.5). A British editorial reprinted in an American journal, titled "Keep Your Albums Locked," urged families to guard their precious collections of portraits from the "dirty fingers of the domestics and their friends, who are never tired of thumbing the family album." The article imagined the scene that might take place in the album owner's absence, as the house servants paged through the portraits, violating the sanctity of the family unit inside. In a cheaper imitation of the oral retelling of family history that accompanied the family album, the domestics point to the pictures and tell their own version of the story:

"This is missis, in that new yellow gown of hers; and this is missis again when she was a young 'un.—This is a picture of that gent, what comes here very often, wearing a red tie, and a short pipe; you know, him as gave me a half-a-crown one Sunday, that I bought a parasol with.—Oh! ain't I grand? Here's master in his long ulster, smoking a cigar. And this," etc. One can well imagine the conversation that goes on as the leaves of one's album are turned over.[9]

The servants in this imaginary scene imitate what they have seen their betters do, inserting themselves into the stories, distorting the narrative even as they mimic it. This article suggests, perhaps unwittingly, that the retelling of album stories instructed the working

classes in the keeping of family histories, a process of assimilation whereby they could enter a larger community of family pasts and begin to participate in a collective narration of history.

Indeed, the family album embraced more than just immediate family. *Cartes-de-visite* of far-off relatives could be sent through the mails, shrinking the distance that divided extended families in an era of increasing mobility. Friends, local personages, and even national figures might enter the pages of the nineteenth-century family album. Some writers on albums advocated keeping two separate collections of photographs: one of celebrity *cartes* and views for visitors' entertainment and another of "family beauties" for private purposes.[10] But celebrities such as Civil War generals, actresses, and P. T. Barnum's famous curiosities might still make their way into the family album, mingling intimately among the portraits of loved ones. It was as if Abraham Lincoln were not only the father of the nation, but the patriarch of the family pictured in the album's pages. The narratives linking family pictures expanded to include these public figures, creating a sense of a national family. Patricia Holland has noted that the personal histories snapshots record are always part of the larger, public narratives of community, religion, ethnicity, and nation.[11] This is perhaps even more true of *carte-de-visite* albums, which expanded to accommodate distant relatives and national notables, whereas snapshot albums have more often than not constricted to showcase close family. The inclusion of a celebrity portrait in a family album might suggest cosmopolitanism, connections to the worlds of art and literature, or an alliance with a certain political viewpoint. But more than that, it indicated that our private narratives were inextricably linked with public ones and that all these people, made visible in photographs and assembled together for the first time, were part of the same history.

The public and private narratives occasioned by photograph albums would intertwine and blend in innumerable ways. On the one hand, stories for public consumption were made visible in the album's pages. These include the heroism of a soldier in his uniform; the joy of a new addition to the family; the displayed status of a celebrity portrait; and the sheer middle-class respectability of presenting oneself to the camera in the first place. Viewing such pictures was acceptable Victorian entertainment. On the other hand, those things that were generally absent from the album's many photographs—servants, pregnancy or disease, the workplace, or even parts of the house that were simply not parlors—were rendered invisible, stricken from the visual narrative. It would be up to the accompanying oral narrative, now so

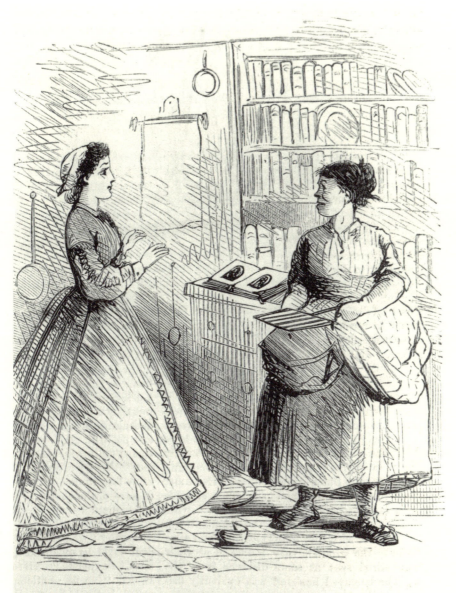

A REASONABLE EXCUSE.

Mrs. Brown.—"Why, how is this, Bridget? Nine o'clock, and the fire not made yet!"

Bridget.—"Oh, ma'am, I was looking at my Photographic Album, an' forgot meself entirely!"

FIGURE 13.5. "A Reasonable Excuse," from *Harper's Monthly* 30, no. 177 (February 1865): 406.

readily occasioned by the presence of photograph albums, to fill in those gaps—or perhaps to perpetuate them. There had always, certainly, been private narratives reserved for the family, but now for the first time there was also a visible one to display for others.

The rise of the first photograph albums marks a crucial transition between an essentially biblical way of telling family histories and an unprecedented visual showing of a familial past and present. From their inception, our memories of family would be shaped as much by how someone *looked* in a photograph as by what he *did*. Visible character would parallel remembered stories, and when the stories were forgotten, the photographs would remain as testimony. Albums became the occasion and the means to tell and retell these stories, but they also changed their narrative by adding a public dimension to them. By the time the Kodak appeared on the scene toward the end of the century, the photograph had long since become the way that information about families was transmitted, constituting evidence of a past in the manner that textual genealogy had previously done. Scholars who seek to understand the creation and reinforcement of normative ideologies in family snapshots will need to examine these earliest practices of displaying and narrating collections of family photographs. These first family albums must be explored and historicized, in order for us fully to understand contemporary avatars of Rebecca's "Fotygraft Album"—today's equally codified snapshot album and home video. The conventions of telling a family past established at that critical moment when albums came into being lay the foundations for the ways we still view family pictures—and thus families—today.

Notes

1. Frank Wing, *"The Fotygraft Album": Shown to the New Neighbor by Rebecca Sparks Peters Aged Eleven* (Chicago: Reilly & Britton Co., 1915), n.p.
2. In the recent and extensive literature on family photography, the emphasis is almost exclusively on snapshots. See Julia Hirsch, *Family Photographs: Content, Meaning, and Effect* (New York: Oxford University Press, 1981); Jo Spence and Patricia Holland, eds., *Family Snaps: The Meaning of Domestic Photography* (London: Virago, 1991); Annette Kuhn, *Family Secrets: Acts of Memory and Imagination* (London: Verso, 1995); Marianne Hirsch, *Family Frames: Photography, Narrative, and Postmemory* (Cambridge, Mass.: Harvard University Press, 1997); Marianne Hirsch, ed., *The Familial Gaze* (Hanover, N.H.: University Press of New England, 1999).
3. I have seen two examples of this particular album, one in the collection of the Smithsonian Institution National Museum of American History (1864) and another, which contains slight revisions, in the International Museum of Photography and Film

at George Eastman House (1865). My citations are from the revised Eastman House copy. As the reader can see in the page for the "second child" (fig. 13.3), the family chose to leave the fields blank and insert different photographs; this can perhaps be ascribed to a (surprisingly early) resistance to the conventions imposed by albums. For more on this album and album conventions, see my article "Miss Domestic and Miss Enterprise—Or, How to Keep a Photo Album," in *Layered Memories: Essays on the Commonplace Book, the Scrapbook, and the Album,* ed. Susan Tucker and Patricia Buckler (Washington, D.C.: Smithsonian Institution Press, forthcoming).

4. Roland Barthes, *Camera Lucida: Reflections on Photography,* trans. Richard Howard (New York: Noonday Press, 1981), 5.

5. *Tit-Bits of American Humour, Collected from Various Sources* (New York: White and Allen, n.d. [ca. 1870s]). Shannon Thompson Perich at the Smithsonian's National Museum of American History kindly brought this piece to my attention.

6. In a chapter titled "Dinner Company," S. Annie Frost suggests: "The ladies upon leaving the dining room, retire to the drawing-room, and occupy themselves until the gentlemen again join them. It is well for the hostess to have a reserve force for this interval, of photographic albums, stereoscopes, annuals, new music, in fact, all the ammunition she can provide to make this often tedious interval pass pleasantly." S. Annie Frost, *Frost's Laws and By-Laws of American Society* (New York: Dick and Fitzgerald, 1869), 61. Advice, in a home-keeping guide, for entertainment in the parlor includes the following: "Place boxes of games, scrap-books and portfolios filled with pictures, photograph albums and objects of amusement, such as the stereoscope, kaleidoscope, and microscope, in appropriate places, and place chairs near them." Henry T. Williams and Mrs. C. S. Jones, *Beautiful Homes, or Hints in House Furnishing* (New York: Henry T. Williams, Publisher, 1878), 112.

7. "Editor's Table: Photography as an Art," *Godey's Lady's Book* 65 (July 1862): 97.

8. "The Great Beauty of Photographs," *American Journal of Photography* 6:15 (February 1864): 348–49.

9. "Keep Your Albums Locked," *Anthony's Photographic Bulletin* 7:2 (February 1876): 42–43.

10. Nod Patterson, "Two Kinds of Album Pictures," *Photographer's Friend/Almanac and American Yearbook of Photography* (1872): 45–47.

11. Patricia Holland, Introduction, in Spence and Holland, *Family Snaps*, 3.

The "Eyes of Affection" and Fashionable Femininity: Representations of Photography in Nineteenth-Century Magazines and Victorian "Society" Albums

FOURTEEN �W ▬▬▬▬▬▬▬▬▬▬▬▬▬▬▬

PATRIZIA DI BELLO

In "On the Invention of Photographic Meaning," Allan Sekula argues that photographs cannot be separated from what they are asked to do by photographic discourse, the "system within which the culture harnesses photographs to various representational tasks."[1] With his statement in mind, this chapter contributes to an investigation of the emergence of photographic sign systems in the feminine culture of Victorian England. Recognizing that, as Sekula affirms, "photographs are used" and "photographic literacy is learned,"[2] it seeks to examine how women learned to use and read photographs, at a time when, a few years after the invention of photography, photographic literacy was being invented as much as acquired.

The Ninteenth-Century Album as (Feminine) Photonarrative Form

Marina Warner notes that "many of the women who used the camera [in the nineteenth century] are well known, but the contribution of women to the reception of images has not been explored."[3] Such an exploration is no simple task. The nineteenth-century women who helped to circulate photographic images by taking, commissioning,

and collecting them did not in the main see themselves as professional photographers, or committed collectors, and operated outside the network of photographic clubs and the specialist press. This discussion thus considers representations of photography in the general press—in literary magazines, advice manuals, and women's magazines—and compares them with those found in or generated by photographic albums compiled by Victorian women. As collections glued together, arranged in a specific sequence and narrative by the collector, albums offer insights into how photographs were looked at and used. That they do so, however, raises the question of how we are to understand the role of the collector. Is she a consumer of new forms of mass-produced visual culture, or a reader of images whose meaning is already encoded in them by the photographic industry and concomitant discourses? Or is she an author, imposing on the photographs a new meaning, contrived through their selection, sequence, and arrangement on the page? Alan Thomas, one of the few historians of nineteenth-century photography to dedicate a sustained analysis to albums compiled by women who were not photographers, argues that these women should be seen as authors.

> It is no wonder that the modern reader examining these albums feels the hovering presence of Victorian novelists. . . . Documents half shaped into narrative, Victorian albums . . . come down to us as objects halfway between the life and the literature of the age; in this they reflect again the median position which photography frequently occupies between actuality and art.[4]

Thomas is partly dealing here with the more general question of photographic meaning. Does that meaning come from the referents being photographed, realistically represented by a medium presumed to be transparent, or is it created by the formal and technical choices of the photographer, however commonplace and "invisible"? Or does it, as Sekula's argument would suggest, result from the ways in which photographs are used? Of course, the issue of how a photograph "means" and of how its "meaning" is invented is pertinent to the photograph album too. Do albums have a "meaning" given by the collector that differs from that of the individual photographs? Or do we, as viewers and readers, create their significance? And how, exactly, does sociocultural context influence, or modify, the "meaning" the album conveys?

Literary studies and studies of the social production of art have decentered the figure of the author, "now understood as constructed

in language, ideology and social relations,"[5] and have emphasized instead the function of the reader as "the space on which all the quotations that make up a writing are inscribed without any of them being lost."[6] Viewed in light of this phenomenon, albums are particularly interesting. This is because they are poised between constituting a reading practice (because they evince the fact that photographs are looked at in a particular environment) and a writing practice (because, like all texts, they represent "not a line of words"—or images—"but a multi- dimensional space in which a variety of writings . . . blend and clash").[7] Put together from heterogeneous sources, albums seem to emphasize the multidimensionality of narrative signification, by virtue of their nature as "a tissue of quotations drawn from the innumerable centres of culture."[8]

Nineteenth-Century Discourses on Photography: Questions of Gender and Social Allegiance

Some of the earliest responses to the invention of photography comment on its uses in the personal sphere. In an article of 1843, David Brewster places the development of photography in a grand narrative of progress, in which "drawing by the agency of light," as a representation of God's creations, can contribute to scientific, artistic, and historic knowledge. He adds:

> But even in the narrower . . . sphere of the affections, where the magic names of kindred and home are inscribed, what a deep interest do the realities of photography excite! . . . They are instinct with associations . . . vivid and endearing. The picture is connected with its prototype by sensibilities peculiarly touching. It was the very light which radiated from his brow—the identical gleam which lighted up his eye—the pallid hue which hung upon his cheek—that pencilled the cherished image, and fixed themselves for ever there.[9]

By the 1840s Western middle-class domestic ideology had identified the sphere of the affections and the home as a feminine province, to which photography appealed not because of its scientific realism, or its aesthetic potential, but by virtue of its indexicality: its direct physical connection with its referent.[10] This perspective is echoed in Elizabeth Eastlake's "Photography," published in 1857. Here, Eastlake discusses the merits of photography

as a mass communication medium, assessing them against its claims as an art form:

> What indeed are nine tenths of those facial maps called photographic portraits, but accurate landmarks and measurements for loving eyes and memories to deck with beauty and animate with expression, in perfect certainty, that the ground-plan is founded upon fact?[11]

The implication seems to be that a painted portrait would be animated with beauty and expression by the skill and vision of the artist, while a photographic portrait, animated by the viewer's loving eyes, is valuable as a "facial map," serving to retrace our experience of the person loved, through the landscape of memory.

For both Brewster and Eastlake, then, the encounter with the photographic portrait is one that privileges the relationship between sitter and viewer, at the expense of the author. The affective response to photography that their writings evoke was often characterized, in writings of the nineteenth century, as a particularly feminine way of relating to portraits in general. Sarah Ellis's *Daughters of England*, a popular book of advice to young middle-class women, recommends drawing as a feminine accomplishment, not simply because it can be practiced without much skill or artistic talent but because it is "the art which preserves to us the features of the loved and lost, . . . [a] magic skill which has such power over the past, as to call up buried images, and clothe them again in youth."[12]

In the nineteenth century, in short, women were encouraged to look at portraits for sentimental purposes, as gendered subjects charged with the construction and maintenance of familial memories. The (assumed male) connoisseur, on the other hand, was taught to recognize and value "the stamp of excellence," without which a portrait "would cease to have value in any eyes when those of affection could no longer contemplate it."[13]

Review magazines and advice manuals of the time suggest that women's relationship with portraiture is dominated by sentimental values. Yet these values are rarely represented in references to photography found in women's magazines.[14] Such references emphasize, rather, the uses made of photography in a culture of celebrities, novelties, and fashions. The front page of nineteenth-century women's magazines was regularly illustrated with a large engraved portrait, usually of a worthy woman, accompanied by her biography. Occasionally during the 1850s and regularly by the mid-1860s, such

portraits were described in their captions as being from a photograph (fig. 14.1). This may have been for copyright reasons; however, the prominence of the caption suggests that the fact that the engraving derived from a photograph, rather than from a painting or a sketch from life, added a positive connotation to the page. The photographic origin of the engraving appeared to guarantee not only accuracy but also the fashionable status of the sitter. And readers may have been familiar with the photograph, as photo-images of celebrities became available for viewing and purchase in high-street photographers' studios. Magazines seemed aware of the growing interest in photographic portraits among their readers. Mayall's "Royal Portraits" (a series of *cartes-de-visite* of the Royal Family) were selling well, and *The Lady's Newspaper* reported on a planned "new and extended series of Royal Photographs" in 1861.[15] In the same year, the magazine also reviewed the annual exhibition of the Photographic Society, noting that "the portraits are far more numerous than heretofore."[16] The use of photographs as a source for engraved portraits was encouraged by competition from the flourishing market in photographs of famous people and was facilitated by a shift in the magazines away from an interest in prominent people from the past (who would not have been photographed) to a concern with famous contemporaries.

It seems that during the 1860s women's magazines became keen to harness the indexicality of photography in order to give mass-produced images a "connection to their prototype." This connection, however, was socially aspirational rather than grounded in sentiment. When photographic exhibitions were reviewed, it tended to be because royals were attending, or because titled ladies were exhibiting. *The Lady's Newspaper* reports in 1861:

> [L]ast week Her Majesty and Prince Albert honored the Photographic Exhibition with a visit, and stayed for nearly an hour beyond the time fixed for their departure. It is well known that the august personages take great interest in the art of photography, and that they even practice it themselves.[17]

Exhibitions of the Photographic Society were reviewed again in 1863, when both Lady Jocelyn and Lady Hawarden exhibited, respectively, "Studies from Life" and landscapes, works declared by their reviewer "charming" and "deserving of praise."[18]

In *The Lady's Own Paper* of 1869, in the section "London & Paris Fashions, Toilet etc.," we can read specifically about the photo album:

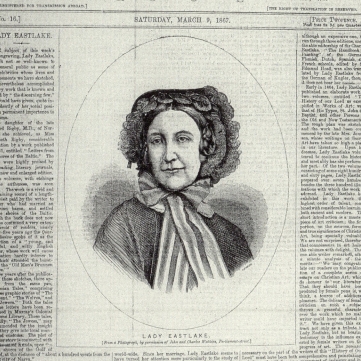

FIGURE 14.1.

Front page of *The Lady's Own Paper,* with a portrait of Lady Eastlake (from a photograph by permission of John and Charles Watkins, Parliament Street), Saturday, March 9, 1867. By permission of The British Library, shelfmark 1867.

Biographical Family Album.—Though not strictly coming under the head of "Toilet" we cannot but notice, among these novelties, the latest introduction in albums. . . . The first page is destined to receive the names, dates of birth, and marriage of parents, with reserved places for their photographs, taken at various periods.

The description goes on to speak of grandparents and, of course, children, each allotted album space for "five portraits executed at various periods."[19] By 1873 the illustrated volumes that featured regularly in the plates illustrating the latest "Home Costumes" (fig. 14.2) may be taken by the viewer to be photographic albums: a fashionable form of visual pleasure presented as a novelty in a context that at the same time emphasized traditional skills such as embroidery, an activity historically associated with the aristocracy. The various "Work Table" and "Lessons for Ladies" pages, which gave embroidery patterns and instructions for decorative works, sought clearly to accommodate aristocratic practices within the domestic, introducing new media, like photography, as a surface for hand decoration.[20] It seems, then, that nineteenth-century feminine photographic culture—and particularly women's photograph albums—can be read through a network of representations and constructions of gender, class, and fashionable social practice. To elaborate on my examination of this aspect of Victorian visual culture, I turn now to *Lady Filmer in Her Drawing Room* (fig. 14.3), a page from an aristocratic woman's album dated circa 1860 featuring collaged albumen prints and watercolor.

Lady Filmer's Album

Most contemporary discussions of nineteenth-century albums compiled by women emphasize the importance of understanding women's amateur photographic practices in the context of the ideology of separate spheres.[21] A dominant ideal of Victorian society, this ideology prescribed that men should act in the public domain of paid work and political life and that women, as guardians of domestic morality, should keep within the private space of home and family, to make the home into a sanctuary from the dehumanizing influences of the world of work. It is in this sense that Lady Filmer's collection of photographs and other such collections have been defined as family albums, regardless of their subject matter. Because they are made by

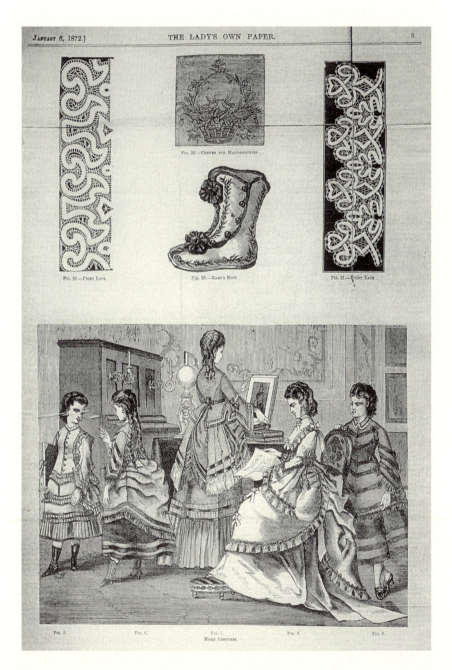

FIGURE 14.2.
"Home Costumes" illustration on page 9 of *The Lady's Own Paper,* January 6, 1872. By permission of The British Library, shelfmark 5o.

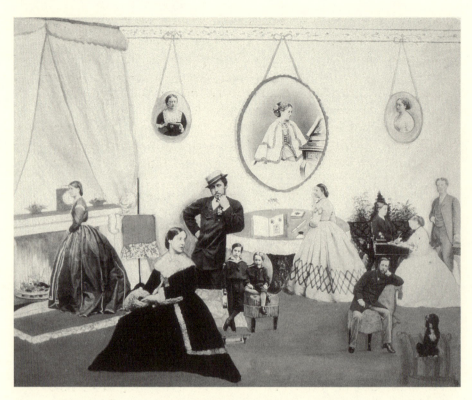

FIGURE 14.3.

Lady Filmer, *Lady Filmer in Her Drawing Room*, mid-1860s. Albumen prints and watercolor. By kind permission of Paul F. Walter.

women, they are assumed to have been created and exhibited within the confines of the domestic, understood both as an environment and as an ideology.[22]

As a genre, the family album is usually taken as a celebration of successful domesticity and of the cohesiveness of the family unit, united by dynastic continuity and bonds of affection.[23] Even more imaginative, mixed media works such as Lady Filmer's tend to be construed as never quite exceeding or disrupting domesticity, however humorous or resistant to the realism of photography they may have been. Naomi Rosenblum, for example, in a discussion of albums by aristocratic Victorian women, claims that such albums were "decorative objects, without the political or social intent of the photocollages made during the 1920s," even if they did "prefigure the Dada disdain for spatial and temporal clarity."[24] I wish here to question the notion that all Victorian women's albums must be interpreted through the optic of domestic ide-

ology. To do so, I want to reinstate albums such as Lady Filmer's in the aristocratic environment in which they were created and to read her collection not as a family but as a "Society" album. This is not only because Society people featured among its favored subjects but also because Society provided one of the actual and ideological contexts in which the album would have been exhibited.

Lady Filmer, granddaughter of Mary Baroness Sandys, was born Mary Georgiana Hill[25] in London in the late 1830s. She married Sir Edmund Filmer in 1858, just before the beginning of his political career as member of Parliament for East Sutton. The 1861 census finds them living at East Sutton Place, the Filmer country house, with six guests and sixteen servants.[26] As Kim Reynolds argues, nineteenth-century aristocratic women were less restricted by prescriptive feminine ideals than middle-class women and never expected to confine their lives to the care of husband and children.[27] The country house, especially of a political family, could not be withdrawn from Society and isolated from the world of work and politics, because of its role as a place of management and political corporate entertainment. Aristocratic women of the period would usually be involved in managing business, as well as domestic staff and accounts. A political wife would contribute further to the success of her husband's career by performing roles now filled by professionals: corporate entertainment manager, advertising campaigner, fund-raiser, image consultant, and public relation expert. Work and home needed never to separate, as they did for middle-class families, and leisure defined the aristocracy. Aristocratic men and women did not "work" but performed inherited duties of landownership and government of people. A Victorian aristocrat never discharged his duties in a place of work—he went from country house to London house to the Houses of Parliament. Aristocratic women were barred from direct participation in the last, but their activities in the first two arenas were crucial to their functioning.

Photomontages of drawing rooms are a recurrent image in aristocratic albums of the period. They can be found, for example, in albums collected by Lady Milles,[28] Lady Jocelyn,[29] and Georgiana Berkeley.[30] As Mark Girouard and Juliet Kinchin demonstrate, the drawing room was the most feminine but also the most public room in a Victorian house.[31] Impressively decorated, it was the room most used for formal socializing. Its style and arrangement represented the woman of the house, showcasing her feminine accomplishments, at a time when personal flair distinguished the tasteful interior from one

that was merely expensive and showy. In nineteenth-century culture, taste and visual literacy were important markers of a woman's knowledge and management skills.

In the album page under investigation, Lady Filmer represents herself standing by her work table, displaying her albums and her tools (a pot of glue and a knife), in a drawing room daringly decorated in cyan and fuchsia, new fashionable colors. Album making is situated in the context of other feminine accomplishments: reading and writing, playing the piano, flower arranging, embroidering fire screens. These, like cutting and pasting paper, drawing and watercolor sketching, were traditional aristocratic skills, imbued with a specific meaning as resistant—whether for good or bad—to the influence of industrial production and as measures of the gentility of the women of the house.

It seems that, among English aristocratic women, photographic albums were all the rage in the 1860s, well before the women depicted in magazine fashion plates were looking at them.[32] As in all other Society matters, the court is supposed to have taken the lead. Prince Albert is usually credited with having stimulated the royal family's interest in photography, but it is also known that Queen Victoria had been introduced to photography as early as 1840, when Lady Mount Edgcumbe, Lady of the Bedchamber and Talbot's half sister, had shown her an album of calotypes.[33] But a crucial royal warranty to photography must be the one reported in 1860 by Lady Stanley, another lady-in-waiting and also an album collector, in a letter from court: "I have been writing to all the fine ladies in London for their or their husband's photographs, for the Queen."[34]

Leonore Davidoff defines "Society" as a set of filters constructed to regulate the advancement of individuals, in particular wealthy middle-class individuals, to the upper echelons of political, social, and economic power.[35] Nineteenth-century English Society was private, in the sense that participation was by invitation only. Its events—from balls to openings of exhibitions—were no longer, as they had been in the eighteenth century, open to anyone with money enough to purchase tickets and the right clothes. Society "proper" consisted of "the Upper Ten Thousand," with its core in the politically active aristocracy. The apex was the court, which legitimized the whole fabric of Society through introductions at court: introductions that involved both the women and the men of the aristocracy. Held during the queen's "drawing rooms," these were negotiated through a complex ritual of card-leaving and female sponsorship. This pattern was repeated in the country houses, which functioned for the local gentry as a kind of court. Like introductions at a royal drawing room, introductions to a

lady's "at home" were crucial and similarly negotiated through female sponsors and card-leaving. A lady was "at home" not when physically there but when prepared to receive vetted visitors. Introductions mediated by men did not count, nor did those that could take place outside Society, although men could petition female relations on behalf of friends and protégées.

Nineteenth-century women were the unofficial specialized personnel in charge of filtering, evaluating, and placing individuals at their "proper level" of Society. They were able to initiate and promote the social advancement of husbands, male relations, and protégées. Their competent management of the family's cultural capital—its "gentility"—would give it opportunities materially to enhance its cultural and financial status. Once established in Society, women could give a lead in behavior, take up new people, and rule who or what was "in" or "out."

Perhaps we can read the photo-album page we are examining as a representation of Lady Filmer's "at home" and imagine ourselves as participants. She is, after all, in the narrative fiction created by the album page, in her own space—the space of the drawing room but also of the album itself—and, through its representation, is making herself available to the gaze of those "visiting" the album. In imagining that we are there, together with a mixture of relations, resident guests, and other visitors, we become more aware of a tension that exists in the album image, caused by the fact that the men and children are looking toward us, but the women, crucial arbiters of our conduct in Society, are not. Conceivably we have just made a faux pas, and the women are politely ignoring it. Perhaps Lady Filmer has gone over to take her album and show it to us. But is this a mark of intimacy, or a way to keep us out of the conversation? And, if we imagine ourselves to be looking at this page of her album in her *actual* drawing room, then we notice its Chinese box visual construction: we see that, in inspecting it, we are scrutinizing an album within a room, represented in an album within a room. Lady Filmer's album-image is, then, no simple attempt to obtain in watercolor what photographic techniques could not yet achieve—a snapshot of people in a (domestic) space—or a sentimental relic, for all that it certainly "causes a sensation." And the heroine of the picture, Lady Filmer, may be demurely turning away from the viewer, but she is proudly displaying her achievements in an activity that at the time was at the height of fashion, combining as it did new technologies with aristocratically feminine skills. Simultaneously greeting and ignoring us, attention seeking and moving away, offering and denying herself,

confusing us yet causing a memorable impression, Lady Filmer is playing, perhaps even flirting, with us, demonstrating and celebrating not the cohesiveness of a family unit but her skills at staging a successful at home.[36]

In some of the other pages from her album, Lady Filmer's juxtaposition of photographs and watercolor seems explicitly to play with the notion of the photographic portrait as a picture of the "loved one": a "map" of the beloved Other "founded on fact" and enmeshed in (feminine) sentimental values. If we consider briefly an untitled page from 1864 (fig. 14.4), the sentimental ties implied by her arrangement are quintessentially ephemeral. In the excess of women revolving around the elegantly hatted young man, the forget-me-not painted at the side becomes almost ironic. The *carte-de-visite* portraits may have been taken according to the stiffest and most stereotyped codes of respectable display, but here they are recontextualized in a suggestive visual narrative as colorful and vague as the best gossip.

To conclude, I want to go back to the images of fashionable women featured in *The Lady's Own Paper*. As Margaret Beetham demonstrates in her study of nineteenth-century women's magazines, the popularizing press reinvented aristocratic femininity as class specific *and* available to the aspirational reader. Portraits of aristocratic women, once exclusive products, became commodities, sold as magazines, engravings, *cartes-de-visite*, and various types of "Books of Beauty."[37] Fashion pages represented a femininity "located in appearance and display, old aristocratic values which, however revised, contradicted the bourgeois ideal of a femininity hidden in the domestic home."[38] The "Lady" of the fashion plates may be shown "at home," but this location is less the product of her moral and domestic management than a theater in which her femininity is displayed, as a highly skilled, accomplished performance, for the benefit of Society. Magazines became the providers of a grammar and vocabulary of appearance used by the reader to produce herself as a visual text and to recognize and read the signs produced by other women. Women's magazines, intent on observing, codifying, and popularizing aristocratic feminine culture, gave wider circulation to nuances of social meaning as they were constantly reinvented in fashionable drawing rooms, domesticating and commercializing such nuances for the benefit of more dominant middle-class ideologies and capitalist concerns.

Photography and photographic albums entered the feminized spaces of the drawing room and the woman's magazine—spaces defined by the women at the center of them—as an emblem of fashionable Society. By the mid-1860s photography was no longer a cipher

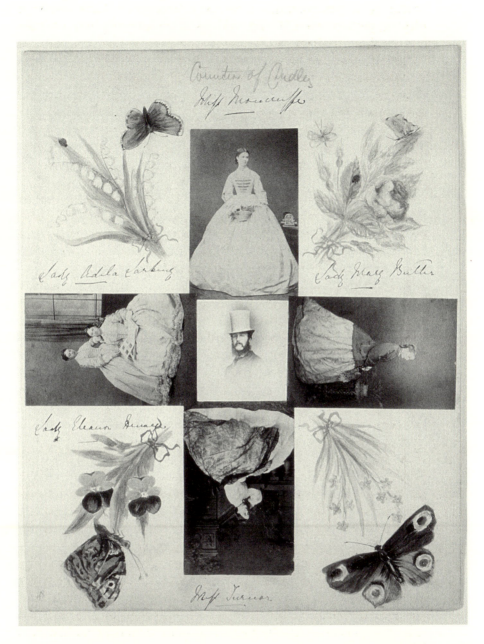

FIGURE 14.4.
Page 48 from Lady Filmer's album, ca. 1864. Albumen print and
watercolor. University of New Mexico Art Museum.

of social exclusivity but the photographic album still was. Perhaps the use of mixed media techniques such as those Lady Filmer employed was, in the context of the album, a sign of feminine accomplishment and of an investment in the photograph as a "really" personal image rather than as a mass-produced token of "connection" to the aristocracy. Such a use restored to photographs their fashionable status, marked by the taste and hand of the "real Lady," for another decade or two, before mixed media albums became a cliché of every debutante's season and before mass-produced albums, already decorated with printed color scenes and floral borders, became available on the market.

With their emphasis on femininity as performative, not only in the domestic arena, but also on the public stage of Society, and with their resistance to the commercialization of feminine culture, these albums established the mixed media photomontage as a narrative mode capable not only of sentimental celebrations of domesticity but also of more subversive meanings: meanings we can detect in *Lady Filmer in Her Drawing Room*. The subversive charge of such albums, embedded in the protofeminist visual gestures they effect, is emblematized by the way in which this mode of photomontage was taken up a few generations later by women artists such as Hanna Höch and Claude Cahun, who would use it to make more explicitly feminist, as well as feminine, visual statements.

Notes

1. Allan Sekula, "On the Invention of Photographic Meaning," in *Thinking Photography*, ed. Victor Burgin (London: Macmillan, 1982), 87.
2. Ibid., 86.
3. Marina Warner, "Parlour Made," *Creative Camera* 315 (1992): 29.
4. Alan Thomas, *The Expanding Eye: Photography and the Nineteenth-Century Mind* (London: Croom Helm, 1978), 64.
5. Janet Wolff, *The Social Production of Art* (London: Macmillan, 1993), 136.
6. Roland Barthes, "The Death of the Author," in *Image—Music—Text*, ed. and trans. Stephen Heath (London: Fontana, 1977), 148.
7. Ibid., 146.
8. Ibid.
9. David Brewster, "Photogenic Drawing, or Drawing by the Agency of Light," *Edinburgh Review* 104 (1843): 330.
10. See Charles Sanders Peirce, "Logic as Semiotic: The Theory of Signs," in *The Philosophy of Peirce*, ed. Justus Buchler (New York: Harcourt Brace, 1950). Peirce was the first to divide signs into icon, index, and symbol: an icon looks like its referent, an index is physically caused by it, and a symbol is agreed to stand for it,

without looking like or being caused by the referent. A photograph is both an icon—it looks like what was photographed—and an index—it is caused by the light reflected off the object being photographed. See also Rosalind Krauss, "Notes on the Index," in *The Originality of the Avant-Garde and Other Modernist Myths* (Cambridge, Mass.: MIT Press, 1985), 215.

11. Elizabeth Eastlake, "Photography," *Quarterly Review* (1857). Reprinted in *Photography, Essays and Images*, ed. Beaumont Newhall (New York: MOMA, 1980), 94.

12. Sarah Ellis, *The Daughters of England* (London: n.p., 1845), 151–52.

13. Charles Eastlake, "How to Observe: An Essay Intended to Assist the Intelligent Observation of Works of Art," in *Charles Eastlake: Contributions to the Literature of the Fine Arts*, ed. Elizabeth Eastlake (London: John Murray, 1870), 213.

14. Photographs could not yet be printed with ink together with text, but they were used by being turned into engravings. Here I am talking about both visual and textual references to photography.

15. August 1861: 122.

16. January 1861: 33.

17. February 1861: 116.

18. February 1863: 285.

19. January 1869: 8–9.

20. In February 1869 *The Lady's Own Paper* started a series of "Lessons for Ladies. On Photographic Colouring, Miniature Painting, Etc.," after having received "numerous letters . . . asking for specific directions as to the colouring of photographs."

21. See, e.g., Anne Higonnet, "Secluded Vision: Images of Feminine Experience in Nineteenth-Century Europe," *Radical History Review* 38 (1987): 16–36.

22. For a full discussion of this, see Elizabeth Langland, *Nobody's Angels* (Ithaca: Cornell University Press, 1995).

23. See, e.g., Lindsay Smith, "'Lady Sings the Blues': The Women Amateur and the Album," in *The Politics of Focus: Women, Children and Nineteenth-Century Photography* (Manchester: Manchester University Press, 1998).

24. Naomi Rosenblum, *A History of Women Photographers* (New York: Abbeville Press, 1994), 50.

25. Conley Vivian, *Some Notes for a History of the Sandys Family* (London: Farmer and Sons, 1907), 205.

26. John L. Filmer, *Seven Centuries of a Kent Family* (London: Research Publishing, 1975), 14.

27. Kim Reynolds, *Aristocratic Women and Political Society in Great Britain* (Oxford: Oxford University Press, 1998).

28. Smith, "Lady Sings the Blues," 66.

29. Isobel Crombie, "The Work and Life of Viscountess Frances Jocelyn," *History of Photography* 22:1 (1998): 46.

30. Françoise Heilbrun and Michael Pantazzi, *Album de collages de l'Angleterre Victorienne* (Paris: Éditions du Regard, 1997), 21.

31. Mark Girouard, *Life in the English Country House* (New Haven: Yale University Press, 1978); Juliet Kinchin, "Interiors: Nineteenth-Century Essays on the 'Masculine' and the 'Feminine' Room," in *The Gendered Object*, ed. Pat Kirkham (Manchester: Manchester University Press, 1996).

32. See, e.g, Christopher Sykes, *Country House Camera* (London: Weidenfeld and Nicolson, 1980); Grace Seiberling, *Amateurs, Photography and the Mid-Victorian Imagination* (Chicago: University of Chicago Press, 1986).

33. Roger Taylor, "Royal Patronage and Photography 1839–1901," in *Crown and Camera*, ed. Frances Dimond (Harmondsworth: Penguin, 1987), 12.

34. Eleanor Stanley, *Twenty Years at Court, 1842–1862* (London: Nisbet, 1916), 377.

35. Leonore Davidoff, *The Best Circles* (London: Croom Helm, 1973).

36. See also Patrizia Di Bello, "The Female Collector: Women's Photographic Albums in the 19th Century," *Living Pictures* 1:2 (2001): 3–20.

37. These were fashionable compilations of portraits and biographies of aristocratic and other famous women.

38. Margaret Beetham, *A Magazine of Her Own?* (London: Routledge, 1996), 34.

Selected Bibliography

Ades, Dawn. "Surrealism: Fetishism's Job." In *Fetishism: Visualising Power and Desire,* ed. Anthony Shelton, 67–87. London: South Bank Centre, 1995.

Aly, Götz. *"Final Solution": Nazi Population Policy and the Murder of the European Jews.* London: Arnold, 1999.

Apollinaire, Guillaume. "Opinions sur l'art nègre." *Action* 3 (April 1920): 23–26.

Apter, Emily. *Continental Drift: From National Characters to Virtual Subjects.* Chicago: University of Chicago Press, 1999.

———. *Feminizing the Fetish: Psychoanalysis and Narrative Obsession in Turn-of-the-Century France.* Ithaca: Cornell University Press, 1991.

Arnal, Ariel. "Mexican Photography: A Bibliography." *History of Photography* 20:3 (1996): 250–55.

Arriola, Enrique. *La rebelión delahuertista.* Mexico City: Martín Casillas/SEP, 1983.

Auster, Paul. *Leviathan.* London: Faber and Faber, 1993.

Bakhtin, Mikhail. *The Dialogic Imagination.* Ed. and trans. Michael Holquist. Austin: University of Texas Press, 1981.

———. *Rabelais and His World.* Trans. Hélène Iswolsky. Bloomington: Indiana University Press, 1984.

Bal, Mieke, Jonathan Crewe, and Leo Spitzer, eds. *Acts of Memory: Cultural Recall in the Present.* Hanover, N.H.: University Press of New England, 1999.

Barthes, Roland. *Camera Lucida: Reflections on Photography.* Trans. Richard Howard. New York: Hill and Wang, 1981.

———. *Camera Lucida: Reflections on Photography.* Trans. Richard Howard. New York: The Noonday Press, 1981.

———. *Camera Lucida: Reflections on Photography.* Trans. Richard Howard. London: Fontana, 1984.

———. *La Chambre claire: Note sur la photographie*. Paris: Cahiers du cinéma/Gallimard/Seuil, 1980.

———. *Image—Music—Text*. Ed. and trans. Stephen Heath. New York: Hill and Wang, 1977.

———. *Image—Music—Text*. Ed. and trans. Stephen Heath. London: Fontana, 1977.

Batchen, Geoffrey. *Burning with Desire: The Conception of Photography*. Cambridge, Mass.: MIT Press, 1997.

Baudrillard, Jean. *Simulations*. Trans. Paul Foss. New York: Semiotext(e), 1983.

Baudry, Jean-Louis. "The Apparatus: Metapsychological Approaches to the Impression of Reality in the Cinema." *Camera Obscura* 1 (1976): 104–26.

———. "Ecriture/ Fiction/ Idéologie." *Afterimage* 5 (1974): 22–39.

———. "The Ideological Effects of the Basic Cinematic Apparatus." *Film Quarterly* 27:2 (1974–75): 39–47.

Bazin, André. *What Is Cinema?* Ed. and trans. Hugh Gray. Berkeley: University of California Press, 1967.

Beetham, Margaret. *A Magazine of Her Own? Domesticity and Desire in the Woman's Magazine, 1800–1914*. London: Routledge, 1996.

Bellour, Raymond. "The Film Stilled." *Camera Obscura* 24 (1990): 99–123.

Bennington, Geoffrey, and Jacques Derrida. *Jacques Derrida*. Paris: Seuil, 1991.

Bensmaïa, Réda. "From Photogram to Pictogram: On Chris Marker's *La Jetée*." *Camera Obscura* 24 (1990): 139–61.

Berger, John, and Jean Mohr. *Another Way of Telling*. New York: Pantheon, 1982.

Bergson, Henri. *Oeuvres*. Paris: Presses Universitaires de France, 1959.

Bhabha, Homi K., ed. *Nation and Narration*. London: Routledge, 1990.

Bird, John, Joanna Isaak, and Sylvère Lotringer. *Nancy Spero*. London: Phaidon, 1996.

Blake, Jody. *Le Tumulte noir: Modernist Art and Popular Entertainment in Jazz-Age Paris, 1900–1930*. University Park: Pennsylvania State University Press, 1999.

Boulé, Jean-Pierre. *Hervé Guibert: Voices of the Self*. Liverpool: Liverpool University Press, 1999.

Brewster, David. "Photogenic Drawing, or Drawing by the Agency of Light." *Edinburgh Review* 104 (1843): 209–344.

Bronfen, Elisabeth. *Over Her Dead Body: Death, Femininity and the Aesthetic*. Manchester: Manchester University Press, 1992.

Brothers, Caroline. *War and Photography*. London: Routledge, 1997.

Buisine, Alain. "Le Photographique plutôt que la photographie." *Nottingham French Studies* 34:1 (1995): 32–41.

Burgin, Victor, ed. *Thinking Photography*. London: Macmillan, 1982.

Calle, Sophie. *Double Game*. Trans. Dany Borash, Danny Hatfield, and Charles Penwarden. London: Violette Editions, 1999.

———. *Doubles-jeux*. Arles: Actes Sud, 1998.

———. *Des histoires vraies*. Arles: Actes Sud, 1994.

Capa, Cornell, ed. *The Concerned Photographer 2*. London: Thames and Hudson, 1972.

Casey, Edward J. "How to Get from Space to Place in a Fairly Short Time." In *Senses of Place*, ed. Steven Feld and Kelth H. Basso, 13–51. Santa Fe, New Mex.: School of American Research Press, 1996.

Caws, Mary Ann. "Ladies Shot and Painted: Female Embodiment in Surrealist Art." In *The Expanding Discourse: Feminism and Art History*, ed. Norma Broude and Mary D. Garrard, 381–96. New York: HarperCollins, 1992.

Chadwick, Whitney. "Fetishizing Fashion/Fetishizing Culture: Man Ray's *Noire et blanche.*" *Oxford Art Journal* 18:2 (1995): 3–17.

Chambers, Ross. *Facing It: AIDS Diaries and the Death of the Author.* Ann Arbor: University of Michigan Press, 1998.

Chicago, Judy. *Holocaust Project: From Darkness into Light.* New York: Penguin Books, 1993.

Cioran, Emile M. *The Temptation to Exist.* Trans. Richard Howard. Chicago: University of Chicago Press, 1998.

———. *The Trouble with Being Born.* Trans. Richard Howard. London: Quartet, 1993.

Ciria, Alberto. *Más allá de la pantalla: Cine argentino, historia y política.* Buenos Aires: Ediciones de la Flor, 1995.

Cixous, Hélène, and Jacques Derrida. *Voiles.* Paris: Galilée, 1998.

Clayborough, Arthur. *The Grotesque in English Literature.* Oxford: Clarendon Press, 1965.

Clifford, James. *The Predicament of Culture: Twentieth-Century Ethnography, Literature and Art.* Cambridge, Mass.: Harvard University Press, 1988.

Coates, Paul. "Chris Marker and the Cinema as Time Machine." *Science Fiction Studies* 14 (1987): 307–15.

Cohen, Jeffrey Jerome, ed. *Monster Theory: Reading Culture.* Minneapolis: University of Minnesota Press, 1996.

Conrat, Maisie, and Richard Conrat. *Executive Order 9066: the Internment of 110,000 Japanese-Americans.* Cambridge, Mass.: MIT Press, 1972.

Copjec, Joan. "The Orthopsychic Subject: Film Theory and the Reception of Lacan." *October* 49 (1989): 53–71.

Cowling, Elizabeth. "Another Culture." In *Dada and Surrealism Reviewed,* ed. Dawn Ades, 451–69. London: Arts Council of Great Britain, 1978.

Crombie, Isobel. "The Work and Life of Viscountess Frances Jocelyn." *History of Photography* 22:1 (1998): 40–51.

Davidoff, Leonore. *The Best Circles: Society Etiquette and the Season.* London: Croom Helm, 1973.

Davidov, Judith Fryer. *Women's Camera Work: Self/ Body/ Other in American Visual Culture.* Durham, N.C.: Duke University Press, 1988.

Deleuze, Gilles. *Cinema 1: The Movement Image.* Trans. Hugh Tomlinson and Barbara Habberjam. London: Athlone, 1989.

———. *Cinema 2: The Time Image.* Trans. Hugh Tomlinson and Robert Galeta. London: Athlone, 1989.

Deleuze, Gilles, and Claire Parnet. *L'Abécédaire de Gilles Deleuze.* Paris: Éditions Montparnasse: 1996.

Derrida, Jacques. *La Carte postale, de Socrate à Freud et au-delà.* Paris: Aubier-Flammarion, 1980.

———. "Entretien avec François Ewald." *Magazine Littéraire* 286 (1991): 18–30.

———. *Right of Inspection.* Photographs by Marie-Françoise Plissart. Trans. David Wills. New York: Monacelli Press, 1998.

———. *Specters of Marx.* Trans. Peggy Kamuf. New York: Routledge, 1994.

———. "Un ver à soie." *Contretemps* 2:3 (1997): 10–51.

Derrida, Jacques, and Safaa Fathy. *Tourner les mots. Au bord d'un film.* Paris: Galilée/Arte Éditions, 2000.

Derrida, Jacques, and Catherine Malabou. *Jacques Derrida: La Contre-Allée.* Paris: La Quinzaine littéraire, Louis Vuitton, Collection "Voyager avec . . . ," 1999.

Doane, Mary Anne. "Film and the Masquerade: Theorising the Female Spectator."
 Screen 23:3–4 (1982): 74–87.
"Dossier Jacques Derrida: La déconstruction de la philosophie." *Magazine Littéraire*
 286 (1991): 16–61.
Doubrovsky, Serge. *Le Livre brisé*. Paris: Livre de Poche, 1989.
Dow-Adams, Timothy. *Light Writing and Life Writing*. Chapel Hill: University of
 North Carolina Press, 2000.
Dubois, Philippe. *L'Acte photographique*. Paris: Nathan, 1983.
Duncan, Carol. "Virility and Domination in Early Twentieth-Century Vanguard
 Painting." In *Feminism and Art History: Questioning the Litany*, ed. Norma Broude
 and Mary D. Garrard, 293–313. New York: Harper and Row, 1982.
Durand, Régis. "How to see (photographically)." In *Fugitive Images: From Photography
 to Video*, ed. Patrice Petro, 141–51. Bloomington: Indiana University Press, 1995.
Duras, Marguerite. *Practicalities: Marguerite Duras Speaks to Michel Beaujour*. Trans.
 Barbara Bray. New York: Weidenfeld, 1990.
Eakin, Paul John. *Touching the World: Reference in Autobiography*. Princeton, N.J.:
 Princeton University Press, 1992.
Eastlake, Charles. "How to Observe: An Essay Intended to Assist the Intelligent
 Observation of Works of Art." In *Charles Eastlake: Contributions to the Literature
 of the Fine Arts*, ed. Elizabeth Eastlake, 199–300. London: John Murray, 1870.
Eastlake, Elizabeth. "Photography." *Quarterly Review* (1857). Reprinted in
 Photography, Essays and Images, ed. Baumont Newhall, 81–95. New York: MOMA,
 1980.
Eisenstein, Sergei. "Film Form." In *Essays in Film Theory*, ed. Jay Leyda, 32–62. New
 York: Harcourt, Brace and World, 1949.
Engel, Pascal. *La Vérité: Réflexions sur quelques truismes*. Paris: Hatier, 1998.
Ezrahi, Sidra. "Revisioning the Past: The Changing Legacy of the Holocaust in
 Hebrew Literature." *Salamagundi* (Fall–Winter 1985–86): 245–70.
Fathy, Safaa, and Jacques Derrida. *D'ailleurs Derrida*. Paris: Gloria Films, La Sept Arte
 Vidéos, 2000.
Fermi, Rachel, and Esther Samra. *Picturing the Bomb: Photographs from the Secret
 World of the Manhattan Project*. New York: Abrams, 1995.
Fierens, Paul. "Des Rues et des Carrefours." *Variétés* (July 1928): 150–54.
Filmer, John L. *Seven Centuries of a Kent Family*. London: Research Publishing Co.,
 1975.
Fisher, Jo. *Out of the Shadows: Women, Resistance and Politics in South America*.
 London: Latin America Bureau, 1993.
Forastelli, Fabricio, and Ximena Triquell, eds. *Las marcas del género: Configuraciones de
 la diferencia en la cultura*. Córdoba: Centro de Estudios Avanzados, Universidad de
 Córdoba, 1999.
Foresta, Merry, ed. *Perpetual Motif: The Art of Man Ray*. Washington, D.C.: National
 Museum of American Art, 1988.
Foucault, Michel. "What Is an Author?" In *The Critical Tradition: Classic Texts and
 Contemporary Trends*, ed. David H. Richter, 978–88. New York: St. Martin's Press,
 1989.
Gaines, Jane M., and Michael Renov, eds. *Collecting Visible Evidence*. Minneapolis:
 University of Minnesota Press, 1999.
Gale, Matthew. *Dada and Surrealism*. London: Phaidon, 1997.
García Rodero, Cristina. *España oculta*. Barcelona: Lunwerg, 1989.

Genette, Gérard. *Palimpsestes*. Paris: Seuil, 1982.

Gevaert, Yves, ed. *Qu'est-ce qu'une Madeleine?* Paris: Centre Pompidou, 1997.

Girouard, Mark. *Life in the English Country House*. New Haven: Yale University Press, 1978.

Golan, Romy. *Modernity and Nostalgia: Art and Politics in France between the Wars*. New Haven: Yale University Press, 1995.

Goldin, Nan. *The Ballad of Sexual Dependency*. New York: Aperture, 1986.

Goldin, Nan, David Armstrong, and Hans-Werner Holzwarth. *I'll Be Your Mirror*. Zürich: Scalo, 1996.

Gratton, Johnnie. "Roland Barthes par Roland Barthes: Autobiography and the Notion of Expression." *Romance Studies* 8 (1986): 57–65.

Grossman, Wendy. "Das Faszinosum Afrikas in den Photographien Man Rays." In *Man Ray 1890–1976 Photographien*, ed. Rudolf Kicken, 15–28. Munich: Hirmer Verlag, 1996.

Guibert, Hervé. *Ghost Image*, trans. Robert Bononno. Copenhagen: Green Integer, 1998.

———. *L'Image fantôme*. Paris: Minuit, 1981.

———. *L'Image de soi, ou l'injonction de son beau moment*. With photographs by Hans Georg Berger. Bordeaux: William Blake and Co, 1988.

———. *La Photo, inéluctablement*. Paris: Gallimard, 1999.

Hales, Peter Bacon. *Atomic Spaces: Living on the Manhattan Project*. Urbana: University of Illinois Press, 1997.

Hammond, Paul, ed. *The Shadow and Its Shadow: Surrealist Writings on Cinema*. London: British Film Institute, 1978.

Hansen, Henning. *Myth and Vision: On "The Walk to Paradise Garden" and the Photography of W. Eugene Smith*. Lund: Aris, 1987.

Hartman, Geoffrey. *The Longest Shadow: In the Aftermath of the Holocaust*. Bloomington: Indiana University Press, 1996.

Haverty Rugg, Linda. *Picturing Ourselves: Photography and Autobiography*. Chicago: University of Chicago Press, 1997.

Heath, Stephen, and Teresa de Lauretis, eds. *The Cinematic Apparatus: Problems in Current Theory*. London: Macmillan, 1980.

Heilbrun, Françoise, and Michael Pantazzi. *Album de collages de l'Angleterre Victorienne*. Paris: Éditions du Regard, 1997.

Higonnet, Anne. "Secluded Vision: Images of Feminine Experience in Nineteenth-Century Europe." *Radical History Review* 38 (1987): 16–36.

Hirsch, Julia. *Family Photographs: Content, Meaning, and Effect*. New York: Oxford University Press, 1981.

Hirsch, Marianne. *Family Frames: Photography, Narrative, and Postmemory*. Cambridge, Mass.: Harvard University Press, 1997.

Holborn, Mark. "Nan Goldin's Ballad of Sexual Dependency." *Aperture* 103 (1986): 43–48.

Hughes, Alex. *Heterographies: Sexual Difference in French Autobiography*. Oxford: Berg, 1999.

Hughes, Jim. *W. Eugene Smith: Shadow and Substance: The Life and Work of an American Photographer*. New York: McGraw Hill, 1989.

Iffland, James. *Quevedo and the Grotesque*. London: Támesis, 1978.

Jacobs, David L. "The Art of Mourning: Death and Photography." *Afterimage* 23 (1996): 8–16.

Jacobus, Mary, Evelyn Fox Keller, and Sally Shuttleworth, eds. *Body/Politics: Women and the Discourses of Science*. New York: Routledge, 1990.

Janus. *Man Ray: The Photographic Image*. Trans. Burtha Baca. London: Gordon Fraser, 1980.

Jennings, Lee Byron. *The Ludicrous Demon: Aspects of the Grotesque in German Post-Romantic Prose*. Berkeley: University of California Press, 1963.

Justman, Stewart, ed. *The Jewish Holocaust for Beginners*. London: Writers and Readers, 1995.

Kaplan, Alice. *French Lessons: A Memoir*. Chicago: University of Chicago Press, 1994.

Kayser, Wolfgang. *The Grotesque in Art and Literature*. Trans. U. Weisstein. Bloomington: Indiana University Press, 1963.

Kear, Jon. *Sunless*. Wiltshire: Flicks Books, 1998.

Keller, Evelyn Fox. *Secrets of Life, Secrets of Death: Essays on Language, Gender and Science*. New York: Routledge, 1992.

Kinchin, Juliet. "Interiors: Nineteenth-Century Essays on the 'Masculine' and the 'Feminine' Room." In *The Gendered Object*, ed. Pat Kirkham, 12–29. Manchester: Manchester University Press, 1996.

King, Nicola. *Memory, Narrative and Identity: Remembering the Self*. Edinburgh: Edinburgh University Press, 2000.

Kingston, Maxine Hong. *The Woman Warrior: Memoirs of a Girlhood among Ghosts*. New York: Vintage International, 1989.

Kotz, Liz. "The Aesthetics of Intimacy." In *The Passionate Camera: Photography and Bodies of Desire*, ed. Deborah Bright, 204–15. London: Routledge, 1998.

Kozloff, Max. *The Privileged Eye: Essays on Photography*. Albuquerque: University of New Mexico Press, 1987.

Krauss, Rosalind. *The Originality of the Avant-Garde and Other Modernist Myths*. Cambridge, Mass.: MIT Press, 1985.

Krauss, Rosalind, and Jane Livingston, eds. *L'Amour fou: Surrealism and Photography*. New York: Abbeville Press, 1985.

Krauss, Rosalind. "The Photographic Conditions of Surrealism." In *October: The Second Decade, 1986–1996*, ed. Rosalind Krauss, 87–118. Cambridge, Mass.: MIT Press, 1997.

Kuhn, Annette. *Family Secrets: Acts of Memory and Imagination*. London: Verso, 1995.

Labanyi, Jo. "Representing the Unrepresentable: Monsters, Mystics, and Feminine Men in Galdos's *Nazarín*." *Journal of Hispanic Research* 1:2 (1993): 225–38.

Lacan, Jacques. *Four Fundamental Concepts of Psychoanalysis*. Trans. Alan Sheridan. Harmondsworth: Penguin, 1994.

Langer, Lawrence. *Preempting the Holocaust*. New Haven: Yale University Press, 1998.

Langer, Suzanne. *Feeling and Form*. New York: Scribner, 1953.

Langland, Elizabeth. *Nobody's Angels: Middle-Class Women and Domestic Ideology in Victorian Culture*. Ithaca: Cornell University Press, 1995.

Lara Klahr, Flora. *Jefes, héroes y caudillos*. Mexico City: INAH/Fondo de Cultura Económica, 1986.

Levi, Primo. *Survival in Auschwitz: The Nazi Assault on Humanity*. Trans. Stuart Woolf. New York: Collier Books, 1960.

Levinthal, David. *Mein Kampf*. Santa Fe, New Mex.: Twin Palms, 1996.

Lewis, Helena. *The Politics of Surrealism*. New York: Paragon House, 1988.

López Mondéjar, Publio. *Historia de la fotografía en España*. Barcelona: Lunwerg, 1997.

McLuhan, Marshall. *Understanding Media: The Extensions of Man*. New York: Mentor, 1964.

Maddow, Ben. *Let Truth Be the Prejudice: W. Eugene Smith, His Life and Photographs*. New York: Aperture, 1985.

Marker, Chris. "A Free Replay (notes on *Vertigo*)." *Positif* 400 (1994): 82–85.

———. *Immemory*. Paris: Centre Pompidou, 1997.

———. *La Jetée*. London: Zone Books, 1996.

Markham, Patrick. *The Death of Jean Moulin*. London: John Murray, 2000.

Mauerhofer, Hans. *The Psychology of Cinematic Experience*. New York: Scribner, 1949.

Maynard, Patrick. *The Engine of Visualization: Thinking through Photography*. Ithaca: Cornell University Press, 1997.

Metz, Christian. *Essais sur la signification au Cinéma*. 2 vols. Paris: Klinkssieck, 1971–2.

Metz, Christian. "The Imaginary Signifier." *Screen* 16:2 (1975): 14–76.

———. *The Imaginary Signifier, Psychoanalysis and Cinema*. Trans. Ben Brewster, Celia Britton, Alfred Guzzetti, and Annwyl Williams. Bloomington: Indiana University Press, 1982.

———. *Language and Cinema*. Trans. Donna Jean. The Hague: Mouton, 1974.

———. "Photography and Fetish." In *The Critical Image: Essays on Contemporary Photography*, ed. Carol Squiers, 155–64. London: Lawrence and Wishart, 1990.

———. "Photography and Fetish." In *Overexposed: Essays on Contemporary Photography*, ed. Carol Squiers, 211–19. New York: New Press, 1999.

Michelson, Annette, ed. *Kino Eye: The Writings of Dziga Vertov*. Berkeley: University of California Press, 1984.

Michelson, Annette. "The Wings of Hypothesis: On Montage and the Theory of the Interval." In *Montage and Modern Life*, ed. Michael Teitelbaum, 60–81. Cambridge, Mass.: MIT Press, 1992.

Migennes, Pierre. "Les Photographies de Man Ray." *Art et Décoration* (November 1928): 154–60.

Milesi, Laurent. "Between Barthes, Blanchot, and Mallarmé: Skia(Photo)-Graphies of Derrida." In *The French Connections of Jacques Derrida*, ed. Julian Wolfreys, John Brannigan, and Ruth Robbins, 175–209. Albany: State University of New York Press, 1999.

Miller, Russell. *Magnum: Fifty Years at the Front Line of History*. London: Pimlico, 1999.

Mitchell, W. J. T. *Picture Theory: Essays on Verbal and Visual Representation*. Chicago: University of Chicago Press, 1994.

Milton, Sybil. "Photography as Evidence of the Holocaust." *History of Photography* 23:4 (1999): 303–12.

Milton, Sybil, and Bernd Hüppauf. "Emptying the Gaze: Framing Violence through the Viewfinder." *New German Critique* 72 (1997): 3–44.

Mirzoeff, Nicholas. *An Introduction to Visual Culture*. London: Routledge, 1999.

Moore, Francis C. T. *Bergson: Thinking Backwards*. Cambridge: Cambridge University Press, 1996.

Mora, Gilles. "La Photographie: Une forme autobiographique?" *Cahiers RITM* 20 (1999) : 183–89.

Morris, Wright. *Time Pieces: Photographs, Writing, and Memory*. New York: Aperture, 1989.

Mraz, John. "Más allá de la decoración: Hacia una historia gráfica de las mujeres en México." *Política y Cultura* 1 (1992): 155–89.

Mullarkey, John, ed. *The New Bergson*. Manchester: Manchester University Press, 1999.

Myers, Joan, and Gary Okihiro. *Whispered Silences: Japanese Americans and World War II*. Seattle: University of Washington Press, 1996.

Noble, Andrea. "Casasola's *Zapatistas en Sanborns* (1914): Women at the Bar." *History of Photography* 22:4 (1998): 366–70.

———. "Photography and Vision in Porfirian Mexico." *Estudios Interdisciplinarios de América Latina y el Caribe* 9:1 (1998): 121–32.

Nora, Pierre. *Les Lieux de mémoire*. Paris: Gallimard, 1984–92.

Odin, Roger. "Le film de fiction menacé par la photographie et sauvé par la bande-son (à propos de *La Jetée* de Chris Marker)." In *Cinémas de la modernité, films, théories*, ed. Dominique Château, André Gardiès, and François Jost, 141–65. Paris: Cerisy, 1981.

Owens, Craig. *Beyond Recognition: Representation, Power and Culture*. Berkeley: University of California Press, 1992.

Paudrat, Jean-Louis. "From Africa." In *"Primitivism" in Twentieth-Century Art: Affinity of the Tribal and the Modern*, 2 vols, ed. William Rubin, 125–75. New York: MOMA, 1984.

Peirce, Charles Sanders. "Logic as Semiotic: The Theory of Signs." In *The Philosophy of Peirce*, ed. Justus Buchler, 98–119. New York: Harcourt Brace, 1950.

Penley, Constance. *The Future of an Illusion, Film, Feminism and Psychoanalysis*. Minneapolis: University of Minnesota Press, 1989.

Phillips, Sandra S. "Themes and Variations." In *Perpetual Motif: The Art of Man Ray*, ed. Merry Foresta, 175–231. Washington, D.C.: National Museum of American Art, 1988.

Plissart, Marie-Françoise. *Droit de regards, suivi d'une lecture par Jacques Derrida*. Paris: Minuit, 1985.

Pollock, Griselda. "Killing Men and Dying Women: Gesture and Sexual Difference." In *The Practice of Cultural Analysis: Exposing Interdisciplinary Interpretation*, ed. Mieke Bal, 75–101. Stanford: Stanford University Press, 1999.

Poniatowska, Elena. *Las soldaderas*. Mexico City: Era/INAH, 1999.

Radstone, Susannah. *Memory and Methodology*. Oxford: Berg, 2000.

Reynolds, Kim. *Aristocratic Women and Political Society in Great Britain*. Oxford: Oxford University Press, 1998.

Rix, Rob, and Roberto Rodríguez-Saona, eds. *Changing Reels: Latin American Cinema against the Odds*. Leeds: Leeds Iberian Papers, 1997.

Roberts, John. *Art of Interruption: Realism, Photography and the Everyday*. New York: St. Martin's Press, 1998.

Roche, Denis. *Le Boîtier de mélancolie: La Photographie en 100 photographies*. Paris: Hazan, 1999.

Rosenblum, Naomi. *A History of Women Photographers*. New York: Abbeville Press, 1994.

———. *A World History of Photography*. New York: Abbeville Press, 1984.

Rossino, Alexander. "Eastern Europe through German Eyes: Soldiers' Photographs, 1939–42." *History of Photography* 23:4 (1999): 313–21.

Rymkiewicz, Jaroslaw. *The Final Solution: Umschlagplatz*. Trans. Nina Taylor. New York: Farrar, Straus and Giroux, 1994.

Said, Edward W. *Out of Place: A Memoir*. New York: Knopf, 1999.

Salas, Elizabeth. *Soldaderas in the Mexican Military: Myth and History*. Austin: University of Texas Press, 1990.

Salomon, Nanette. "Vermeer's Women: Shifting Paradigms in Midcareer." In *The Practice of Cultural Analysis: Exposing Interdisciplinary Interpretation*, ed. Mieke Bal, 44–59. Stanford: Stanford University Press, 1999.

Sander, August. *Men without Masks: Faces of Germany, 1910–1938*. Greenwich, Conn.: New York Graphic Society Ltd., 1973.

Sanouillet, Michel. *391*. Paris: Le Terrain Vague, 1960.

Sarkonak, Ralph, ed. *Le Corps textuel de Hervé Guibert*. Paris: Minard, 1997.

Scarry, Elaine. *The Body in Pain: The Making and Unmaking of the World*. New York: Oxford University Press, 1985.

Schefer, Jean-Louis. *The Enigmatic Body*. Ed. and trans. Paul Smith. Cambridge: Cambridge University Press, 1995.

Schwartz, Arturo. *Man Ray: The Rigour of Imagination*. New York: Rizzoli, 1977.

Scott, Clive. *The Spoken Image*. London: Reaktion Books, 1999.

Seiberling, Grace. *Amateurs, Photography and the Mid-Victorian Imagination*. Chicago: University of Chicago Press, 1986.

Shields, Carol. *The Stone Diaries*. New York: Penguin Books, 1994.

Silver, Kenneth. *Esprit de Corps: The Art of the Parisian Avant-Garde and the First World War, 1914–1925*. Princeton, N.J.: Princeton University Press, 1989.

Silver, Kenneth E., and Romy Golan, eds. *The Circle of Montparnasse: Jewish Artists in Paris, 1905–1945*. New York: Jewish Museum and Universe Books, 1985.

Smith, Lindsay. "'Lady Sings the Blues': The Women Amateur and the Album." In *The Politics of Focus: Women, Children and Nineteenth-Century Photography*, 52–73. Manchester: Manchester University Press 1998.

Smith, W. Eugene. *W. Eugene Smith*. New York: Aperture, 1969.

———. *W. Eugene Smith: Master of the Photographic Essay*. New York: Aperture, 1981.

Smith, W. Eugene, and Aileen M. Smith. *Minamata*. Tucson: Center for Creative Photography, 1981.

Sobiezck, Robert A. *Masterpieces of Photography from the George Eastman House Collections*. New York: Abbeville Press, 1985.

Solnit, Rebecca. "Meridel Rubenstein: 'Critical Mass.'" *Artspace* 16:4 (1992): 46–47.

Solomon-Godeau, Abigail. *Photography at the Dock: Essays on Photographic History, Institutions, and Practices*. Minneapolis: University of Minnesota Press, 1991.

Sontag, Susan. *On Photography*. New York: Farrar, Straus and Giroux, 1977.

———. *On Photography*. New York: Anchor Doubleday, 1989.

Soussloff, Catherine M. "The Turn to Visual Culture." *Visual Anthropology Review* 12:1 (1996): 77–83.

Spence, Jo, and Patricia Holland, eds. *Family Snaps: The Meaning of Domestic Photography*. London: Virago, 1991.

Stacey, Judith. "Is Academic Feminism an Oxymoron?" *Signs* 25:4 (2000): 1189–94.

Stam, Robert. *Film Theory*. London: Blackwell, 2000.

Stanley, Eleanor. *Twenty Years at Court, 1842–1862*. London: Nisbet and Co., 1916.

Steedman, Carolyn Kay. *Landscape for a Good Woman: A Story of Two Lives*. New Brunswick, N.J.: Rutgers University Press, 1994.

Steichen Edward, ed. Catalog to *The Family of Man* exhibition, 1955. Prologue by Carl Sandburg. New York: MOMA, 1996.

Stewart, Susan. *Crimes of Writing*. New York: Oxford University Press, 1994.

———. *On Longing: Narratives of the Miniature, the Gigantic, the Souvenir, the Collection*. Durham, N.C.: Duke University Press, 1993.

Stich, Sidra. *Anxious Visions: Surrealist Art*. Berkeley: University Art Museum, 1990.

Sykes, Christopher. *Country House Camera*. London: Weidenfield and Nicholson, 1980.

Taylor, Diana. *Disappearing Acts: Spectacles of Gender and Nationalism in Argentina's "Dirty War."* Durham, N.C.: Duke University Press, 1997.

———. "Performing Gender: Las Madres de la Plaza de Mayo." In *Negotiating Performance: Gender, Sexuality and Theatricality in Latin America*, eds. Diana Taylor and Juan Villegas, 275–305. Durham, N.C.: Duke University Press, 1994.

Taylor, Roger. "Royal Patronage and Photography, 1839–1901." In *Crown and Camera: The Royal Household and Photography 1842–1910*, ed. Frances Dimond, 11–25. Harmondsworth: Penguin, 1987.

Tec, Nechama, and Daniel Weiss. "The Heroine of Minsk: Eight Photographs of an Execution." *History of Photography* 23:4 (1999): 322–30.

Thomas, Alan. *The Expanding Eye: Photography and the Nineteenth-Century Mind*. London: Croom Helm, 1978.

Thomson, Philip. *The Grotesque*. London: Methuen, 1972.

Torgovnick, Marianna. *Gone Primitive: Savage Intellects, Modern Lives*. Chicago: University of Chicago Press, 1990.

Toussaint, Jean-Philippe. *Autoportrait (à l'étranger)*. Paris: Minuit, 2000.

Tythacott, Louise. "A 'Convulsive Beauty': Surrealism, Oceania and African Art." *Journal of Museum Ethnography* 11 (1999): 43–54.

Vivian, Comley. *Some Notes for a History of the Sandys Family*. London: Farmer and Sons, 1907.

Vogel, Susan. *Baule: African Art Western Eyes*. New Haven: Yale University Press, 1997.

Warner, Marina. "Parlour Made." *Creative Camera* 315 (1992): 29–32.

Wells, Liz, ed. *Photography: A Critical Introduction*. London: Routledge, 1997.

Whitman, Walt. *Collected Poems*. London: Penguin, 1975.

Wilkerson, Donna. "Hervé Guibert: Writing the Spectral Image." *Studies in Twentieth-Century Literature* 19:2 (1995): 269–88.

Willumson, Glenn G. *W. Eugene Smith and the Photographic Essay*. Cambridge: Cambridge University Press, 1992.

Wing, Frank. *"The Fotygraft Album": Shown to the New Neighbor by Rebecca Sparks Peters Aged Eleven*. Chicago: Reilly and Britton Co., 1915.

Wolff, Janet. *The Social Production of Art*. 2d ed. London: Macmillan, 1993.

Wollen, Peter. *Readings and Writings: Semiotic Counter Strategies*. London: Verso, 1982.

———. *Signs and Meanings in the Cinema*. Bloomington: Indiana University Press, 1969.

Worton, Michael, and Judith Still, eds. *Intertextuality*. Manchester: Manchester University Press, 1990.

Young, James. *At Memory's Edge: After-Images of the Holocaust in Contemporary Art and Architecture*. New Haven: Yale University Press, 2000.

Zeitlin, Froma. "The Vicarious Witness: Belated Memory and Authorial Presence in Recent Holocaust Literature." *History and Memory* 10:2 (1998): 5–42.

Zelizer, Barbie, ed. *Visual Representation and the Holocaust*. New Brunswick, N.J.: Rutgers University Press, 2000.

Index

and Marker's cinema, 219, 220–21; and mourning, 75–76, 77–79; and multimedia, 42; and numbers of images, 83; and perpetrator images, 28–29; and postmemory, 29, 42, 83, 85; and testimonial images, 71–72; and textual constructs, 5–6

Menem, Carlos, 67, 73–74

Mes parents (Guibert), 168, 178

Metz, Christian, 190–91, 224–25

Mexican Revolution: and the Casasola Archive, 137; and the de la Huerta uprising, 138–39; and institutionalization of government, 139, 145–46; and the woman warrior, 140–41

Milton, Sybil, 21

Minsk, 35

Mitchell, W. J. T., 3

mixed media: and decontextualization, 57; and Lady Filmer's album, 262; vs. narrative, 109–11; and Victorian technologies, 265; and viewer involvement, 59

Miyatake, Toyo, 53

La Mode au Congo (Ray), 126, 127–28

modernism, 130–31

Montoya, Tilano, 47

Morris, Wright, 99

Les Morts de Roland Barthes (Derrida), 208

Mothers of May Square (Madres de Plaza de Mayo), 67–72, 73–76

movement: and the ballad, 111–14; and the cinematic spectator, 225; and indexicality, 83; in *La Jetée* (Marker), 219–20, 226; and memorializing, 80; and performance, 108–9; and photo-stills, 219–20; and still images, 12–13, 44; and testimonial images, 72; and the viewer, 45, 82–83

Mraz, John, 138

multimedia, 42. *See also* mixed media

music, 108, 109

Myers, Joan, 52–56, 59–61

narrative text. *See also* text; of a family album, 241, 247–48; and flow, 99, 100; and history, 96, 250; and location, 12; meaning in the album, 256; vs. oral tradition, 112–13; and

photographs, 97–99; public and private, 245, 248–49; travel, 202

nationalism, 154–55

Nazi gaze, 25–26, 31–35, 36

Nazis: and individual responsibility, 25–26, 34, 35; photographic practices, 25

Noble, Andrea, 9–10

La noche de los lápices (Olivera), 65

Noire et blanche (Ray), 120, 124–25, 133

Nora, Pierre, 207

nostalgia, 113, 206–8, 215–16

Nouvelle Vague, 218

Nussbaum, Tsvi, 20

Obregón, Alvaro, 138

El ofertorio (García Rodero), 160

Okihiro, Gary, 56, 57

Oppenheimer, Robert: in *Archimedes Chamber* (Rubenstein), 50; and bomb testing, 45–46; coming to Los Alamos, 49; in *Fat Man and Edith* (Rubenstein), 50

oral tradition, 112–13

Ortiz Echagüe, José, 154–55

Ortiz Monasterioi, Pablo, 143

Pan and Cup (Myers), 51–52, 56

pathos, 72–76, 214

Peirce, Charles Sanders, 84, 268–69

perception. *See also* viewer; and blindness, 231–32; in film, 219; and film intervals, 223–24

performance, 108–9, 248–49

Perivolaris, John D., 10–11

perpetrator image: defined, 21; and the Dirty War, 71–72, 85; and gender, 22–23; and memory, 28–29; and spectators, 25; and text, 36; universalizing of, 27–30

photobiography, 183, 192–96

photographer: according to Barthes, 90, 91–92; and authorial intent, 52; and depictive technologies, 188–89; identification with the subjects, 107, 111; identity in Holocaust images, 24; and power, 24–25, 33, 34–35, 39–40; source of Holocaust images, 23–24, 25; women, 196, 254–55

Spero, Nancy, 35–38
The Spoken Image: Photography and Language (Scott), 3
Steedman, Carolyn Kay, 95–96
Stieglitz, Alfred, 90–91
The Stone Diaries (Shields), 97
storytelling. *See* photonarrative
Stroop Report image: as archetypal hero, 30; contemporary use of, 19–21; and infantilization, 27–31, 34–35; and the Nazi gaze, 25–26; origin of, 21; structure of, 24
Sunless (Marker), 219
surrealist movement, 121–22, 131
symbol, 268–69

temporality, 220, 221
testimonial images, 67, 71–72. *See also* memorializing
text. *See also* narrative text; intertextuality in film, 229–30; and memorializing, 57, 59; and perpetrator images, 36; in Ray's photographs, 128–31; and referent, 183; the title, 123–25
text, verbal, 44, 112–13
"The Fotygraft Album" (Wing), *240*
Thinking Photography (Burgin), 1–2, 3
Tilano's Garden (Rubenstein), *48*
time: and García Rodero's work, 161; and *La Jetée* (Marker), 221–22; and mixed media, 111–12; and perception, 231–32; and referent, 183; and retrospective irony, 25; and space, 214–15; and thought, 220, 221
Tisma, Aleksandar, 27–28
The Torture of Women (Spero), 37
Townsend, Chris, 9
trauma, 81–82, 86
travel image, 201, 205–6
travel narrative, 202, 213–14
travelogue, 206, 206–8
truth, 93–95, 97–99. *See also* reality

United Nations, 152
Uno, Tomimaro, 53

Vaskula, Steina, 42
Vaskula, Woody, 42
verbal text, 44, 112–13
Vertigo (Hitchcock), 229–33
victim, 30
Victorian albums. *See also* family album; and drawing rooms, 262, 263–64; and society, 264–65, 266, 268
video, 84
viewer. *See also* spectator; and authorial intent, 53; cinematic spectator, 224–26, 227–29; in documentary film, 71; and family photographs, 75–76, 248–49; and freeze-framing, 65–66; looking and not looking, 190, 191; and movement, 45, 219; and onlookers in the photograph, 144–46; pathos, 72–76, 214; and perception, 219; and power, 50; projected values, 104; vs. reader, 99; and verbal text, 44
Vivos en la memoria, 79–80
Vogue, 122

The Walk to Paradise Garden (Smith), 151–52, *153*
Warner, Edith, 46–48, 60
Warsaw ghetto image: as archetypal hero, 30; contemporary use of, 19–21; and infantilization, 27–31; and the Nazi gaze, 25–26; structure of, 24
Ways of Seeing (Berger), 2
Wells, Liz, 2
Whispered Silences (Myers and Okihiro), 50
Whitman, Walt, 111–12
Winter Garden image (Barthes), 170, 171
The Woman Warrior (Kingston), 92–93
women. *See also* femininity; gender; and aristocracy, 263–64; collectors as authors, 255; and the Dirty War, 67–72; photographers, 196, 254–55; and Victorian magazines, 258–60
Wood Shoe Sole (Myers), 55

Zavala, María, *137*
Zweig, Ellen, 42